*We dedicate*

*this issue*

*to the memory of*

*Brendan K. Bathrick*

*(1963–2021).*

# New German Critique

*An Interdisciplinary Journal of German Studies*

## Number 143 · August 2021

## Adorno's *Aesthetic Theory* at Fifty

Special Issue Editor: Peter E. Gordon

*New German Critique* is the leading journal of German studies. It covers contemporary political and social theory, philosophy, literature, film, media, and art and reads cultural texts in light of current theoretical debates.

**General Article**

# *Adorno's* Aesthetic Theory *at Fifty: Introductory Remarks*

## Peter E. Gordon

"Great works wait. While their metaphysical meaning dissolves, something of their truth content, however little it can be pinned down, does not."[1] This hopeful remark appears in Theodor W. Adorno's *Aesthetic Theory*, a work that was first published in 1970, just a year after the author's death. Fifty years later we can still hear in this remark a double entendre. In both art and personal life, we must surrender any hope for metaphysical eternity, but we can nonetheless affirm the survival of what we might call the "truth content" that is preserved in either an artwork or any "work" that survives long after its creator has passed. It is no less true for great works of philosophy, which are born with an aura at a particular time and place. No doubt this aura, too, is vulnerable to decay, but the work continues to awaken new thoughts well after the aura has dissolved.

We will never be done reading *Aesthetic Theory*. It is admittedly the case for any work of philosophical importance that the task of its interpretation is ongoing and potentially infinite. But for a work such as *Aesthetic Theory* this truism may carry an enhanced truth. Because the author left it unfinished, all of us in the community of readers are burdened with the task of completing the work itself, as if each critical encounter were not only an interpretation but also

---

1. Adorno, *Aesthetic Theory*, 40 (hereafter cited as *AT*). For the original, see Adorno, *Ästhetische Theorie*, 17.

*New German Critique* 143, Vol. 48, No. 2, August 2021
DOI 10.1215/0094033X-8989190   © 2021 by New German Critique, Inc.

an attempt at a conclusion, however provisional our verdict might be. Added to this burden is a further irony: although Adorno finished most of the book, its so-called introduction is only a draft. He gave the book a finale but not an overture, at least not one that was ready for publication. We can hardly be done with our interpretation if the author did not leave us a clear directive as to how we should even begin.

Over the last half century the interpretative literature on *Aesthetic Theory* has flourished, though the lack of any consensus on its meaning is self-evident.[2] When the book was first published by Suhrkamp Verlag in 1970, it was not uncommon (especially among those associated with the radical student movement of the late 1960s) to express regret that its author had retreated from politics into aesthetics. Those who mourned their teacher's early passing when he had not yet reached his sixty-sixth birthday also mourned the apparent gap between theory and praxis that had perhaps only widened thanks to his skeptical remarks on the prematurity of any leap from one to the other. The memory of Adorno's troubled relations with the student Left in Germany only enhanced the sense that his turn to aesthetics had been a turn away from social responsibility. This was especially the case insofar as his distinctive conception of aesthetic autonomy seemed to complicate any strong sense of artistic "engagement." Art, Adorno wrote, is "the plenipotentiary of a better praxis." But he hastened to add that, in its anticipation of a better world, art was also "the critique of praxis," since current modes of social activity only reinforced the status quo. "Art's *promesse du bonheur* means not only that hitherto praxis has blocked happiness but that happiness is beyond praxis" (*AT*, 12). For students of critical theory who felt that any realization of true happiness requires a concrete transformation of existing society, it has been tempting to read Adorno's conception of art as an apologia for political quietism.

No less challenging has been the fact that Adorno's own aesthetic sensibility inclined him to embrace only a rather narrow canon of art, chiefly musical but also literary, confined mostly to the European tradition of high modernism. His interests and also his knowledge of art beyond the European sphere remained limited, and his stringent criterion for what he called "successful" art was so demanding, or discriminating, that very few writers or composers or artists were permitted inclusion. His notorious remarks on jazz, though confined to just a few essays and often misconstrued as symptoms of elitism and anti-Americanism (or worse), illustrate a more general disregard for demotic

---

2. The literature is vast. See, e.g., Zuidervaart, *Adorno's "Aesthetic Theory"*; Huhn and Zuidervaart, *Semblance of Subjectivity*; Endres, Pichler, and Kittel, *Eros und Erkenntnis*.

styles of aesthetic expression and, of course, a pronounced hostility to any trends in art that yield to the pressures of commodification. This hostility may help explain the strange fate of *Aesthetic Theory*, which made its belated appearance at a moment in art history when the modernist values its author cherished were falling into eclipse and competing movements (such as pop art and postmodernism) were already ascendant. In yet another instance of the aging of the avant-garde, Adorno's aesthetic criteria came to seem antiquated right at the moment he announced them. No less significant was his belief in the importance of form. This emphasis is so pronounced that he has often been charged with "formalism," even though this indictment may do a certain injustice to his dialectical conception of the relation between form and content. All the same, it is certainly true that his tastes inclined him toward a distinctive stream of chiefly European high-modernist aesthetics, spanning little more than three centuries, or what he was not ashamed to call "a limited phase of humanity." Repeating a sentiment ascribed to G. W. F. Hegel, Adorno went so far as to speculate that "art may have entered the age of its demise" (*AT*, 3).

It has taken many years for the atmosphere of regret and misunderstanding to dissipate, and the task of reckoning with *Aesthetic Theory* in all its dialectical complexity remains an ongoing and collective effort, of interest to scholars from a variety of disciplines, including but not limited to philosophy, literature, art history, history, and musicology. This wide circle of interpretation surely reflects the erudition of its author, but it also reminds us that the book has lessons that overflow all disciplinary bounds. *Aesthetic Theory*, after all, is not a book confined to the question of art in the narrow sense. Its premise is that art also has implications beyond art, that even when art may seem most hermetic or self-enclosed, it is like a monad: a windowless structure that nonetheless reflects the entire world beyond itself. Works of art are therefore foreign to the world but part of it: "Their truth content cannot be separated from the concept of humanity" (*AT*, 241).

———

This special issue of *New German Critique* originated in a series of lectures on *Aesthetic Theory* that took place at Harvard University during the spring semester of 2019 in anticipation of the book's fiftieth anniversary. The lecture series ran alongside a graduate seminar on the same topic, and it would be a true oversight if I did not express my gratitude to the many students who participated in the seminar and enriched the discussion there and in the lectures. I

must also note that the seminar at Harvard was preceded by an intensive graduate seminar on *Aesthetic Theory* that I had the pleasure of offering at Cornell University in the School of Criticism and Theory in the summer of 2018. The students who participated in the seminar at Cornell also deserve my heartfelt thanks. Many of the same scholars who presented in the Harvard series revised their lectures for publication here, and I am grateful for their dedication, and their patience, as the task of submission and revision proceeded, albeit more slowly and less smoothly than they might have hoped. I am confident that their efforts were worthwhile; the essays published in this special issue are superb, and they testify to the longevity of Adorno's reflections. We can feel confident that the task of understanding will continue in the fifty years to come, and that the truth content of the author's posthumous masterpiece will continue to unfold.

**Peter E. Gordon** teaches social theory, history, and philosophy at Harvard University.

### References

Adorno, Theodor W. *Aesthetic Theory*, translated by Robert Hullot-Kentor. Minneapolis: University of Minnesota Press, 1997.

Adorno, Theodor W. *Ästhetische Theorie*. Vol. 7 of *Gesammelte Schriften*. Frankfurt am Main: Suhrkamp, 1970.

Endres, Martin, Axel Pichler, and Claus Kittel, eds. *Eros und Erkenntnis: Fünfzig Jahre "Aesthetische Theory."* Berlin: de Gruyter, 2019.

Huhn, Tom, and Lambert Zuidervaart, eds. *The Semblance of Subjectivity: Essays in Adorno's Aesthetic Theory*. Cambridge, MA: MIT Press, 1997.

Zuidervaart, Lambert. *Adorno's Aesthetic Theory: The Redemption of Illusion*. Cambridge, MA: MIT Press, 1991.

# "The Primacy of the Object": Adorno's Aesthetic Theory *and the* Return of Form

## Eva Geulen

Half a century after Theodor W. Adorno's death, the forbidding fragments of his *Aesthetic Theory*, whose accessibility may not have improved with the editing that Adorno had planned for the late summer of 1969, have not yet "unfolded its truth."[1] Great works "await their interpretation," Adorno said in *Aesthetic Theory*. "They are unable to lie."[2] Such statements, at once terse and grandiose, are rare today.[3] Their impertinence is untrustworthy, even though—or perhaps because—Twitter comments have become serially ubiquitous.[4] But Adorno's sentences are just the tip of the iceberg that is his excruciatingly scrupulous reworking of the aesthetic tradition and its inherited concepts. Adorno relentlessly reworks and rewrites these concepts. When they have finally turned into aporias, the process of reinterpretation breaks off, and the remaining ambivalence is frozen into aphoristic sentences, such as "Ultimately their [i.e., the works'] development is the same as their process

---

1. Adorno, *Aesthetics, 1958/59*, 47 (hereafter cited as *AA*). That artworks are a site of the unfolding of truth is the only Hegelian theme that Adorno accepted unconditionally.
2. Adorno, *Aesthetic Theory*, 175, 178 (hereafter cited as *AT*).
3. See Düttmann, *Philosophie der Übertreibung*.
4. On the difficulties, the *Verselbstständigung* of value judgments in Adorno, see Geulen and Assmann, "Zur gesellschaftlichen Lage der Literatur."

*New German Critique* 143, Vol. 48, No. 2, August 2021
DOI 10.1215/0094033X-8989204  © 2021 by New German Critique, Inc.

of collapse" (*AT*, 245). Such negative maxims are the price exacted by the "labor of the plains," which, according to Bertolt Brecht, follows the labor of the mountains. With respect to Adorno's insistence on the significance of the concept in the Hegelian sense, an Adorno renaissance seems rather improbable at the moment, even though he was at least theoretically aware of the crises currently facing the humanities. Today, however, neither art nor the disciplines devoted to it can appeal in good conscience to the "function of the functionless,"[5] because our social situation is beset by entirely different crises. Yet Adorno, too, knew that "there are situations in which precisely radical art can become an alibi for an eschewal of an interventional practice" (*AA*, 121–22).

If we do, nonetheless, find unmistakable signs of an Adorno renaissance, then it is due to the resurgence of interest in aesthetic form. This cornerstone of the aesthetics of autonomy—of all things—has for years been the site of comprehensive rehabilitation and wide-ranging reinterpretation under the banner of "New Formalism."[6] Adorno had initially remained untouched by the New Formalists because they largely rejected the notion, which they imputed to Adorno, as well as to the "New Critics" of the "old Formalism," that form is the exclusive preserve of "great works."[7] Adorno has gained in stature as form has more and more become the royal road for politically engaged criticism, which satisfies with surprising explicitness the growing demand for social-critical relevance in the study of literature and culture. Even though Caroline Levine does not discuss Adorno, her work is characteristic for the new concept of form. For her, forms are organizational types and logics of configuration that appear in society as they do in artworks and can therefore be treated in both realms without further distinction.

If today form is discussed without reference to its traditional counterconcepts and opposites (substance, material, content, etc.), then that is not because everyone knows what "form" is. On the contrary, it is because form has lost its defining boundaries and is wielded so dynamically and capaciously that it is no longer opposed to any other concepts at all. The series of nouns in the title of Levine's study *Forms: Whole, Rhythm, Hierarchy, Network* is characteristic of this general tendency. That Levine places ostensibly repressive, suspiciously totalizing forms like "whole" and "hierarchy" together with counterconcepts like rhythm and network (e.g., Gilles Deleuze and Félix Guattari's rhizome) is

5. See Scholze, *Kunst als Kritik*, 102.

6. See Levinson, "What Is New Formalism?," as well as the debate on Kramnick and Nersessian, "Form and Explanation," in *Critical Inquiry* 43, no. 3 (2017) and 44, no. 1 (2017). See also Pfau, "Introduction."

7. The interest of the older Adorno scholarship was focused on the concept of life.

indicative of a massive interpretative shift. The antiformalist affect—the belief that emancipation from formal constraints promotes freedom—has become as obsolete as the doctrine that modernist art exhausts itself in the destruction of and emancipation from traditional forms like genres. Moreover, sociologists have long recognized that supposedly formless networks, gig work, and the share economy hardly contribute to the dismantling of hierarchies. Against this background Levine's rehabilitation and expansion of the concept of form becomes understandable. For Adorno, whose understanding of form was determined by the boundaries set by Immanuel Kant's formalist aesthetics and G. W. F. Hegel's aesthetics of content, such a maneuver would have been unthinkable. Form was for him "the blind spot of aesthetics": it is "the idea of form that first made the wholeness and autonomy of the artwork possible" (*AT*, 193). The centrality Adorno affords to form is what makes him interesting at the present moment. Yet for Adorno, aesthetic form is what distinguishes and separates the artwork from the social world. The new concept of form ignores this fundamental distinction. Instead, everything now turns out to be form. The expanded concept of form absorbs its other so completely that in the current New Formalist discussion, old debates about art as autonomous and as *fait social* (as Adorno called it) are repeated *within* the new paradigm of form— as it were, form-immanently. It is difficult to say what exactly is at stake in the current turn to form in the humanities, both in the United States and in Germany.[8] One may speculate that the attraction of this consists in its double "affordances" (a term from design theory frequently employed by Levine): while "form" harks back to a time-honored foundational concept of the human- ities, its current expansion allows for swift and surprising reconciliation of the usually opposed poles of aesthetics and sociopolitical import.[9]

In any case, the current obsession with form has had considerable impact on the way Adorno is read today. His style and diction are given precedence over conceptual coherence and theoretical consistency. This opposition between Adorno's style and his concepts, philosophemes and theorems, sepa- rates these new readers from older criticism. A 1980 volume devoted to *Aes- thetic Theory* laments the perceived aestheticization of social theory, meaning not only Adorno's stylistic idiosyncrasies but the overall turn toward aesthetics in his later work.[10] Echoes of this critique were still audible at a conference on

8. Ingo Stöckmann offers a concise overview in the introduction to *Texte der formalistischen Ästhe- tik*.

9. For a provocative reading of the history of that opposition, see North, *Literary Criticism*.

10. Lindner and Lüdke, *Materialien zur ästhetischen Theorie*.

Adorno in 2003, on the occasion of his hundredth birthday.[11] By then the concept of aesthetic experience had gained in currency—not only Albrecht Wellmer but also earlier work by Hans Robert Jauß and Rüdiger Bubner challenged the primacy of the object in Adorno's thought and what they perceived to be the attendant hypostasis of "great works."[12] The obvious privilege enjoyed by subjectivity in an idea of aesthetic experience that came to figure as an alternative to autonomous art was unthinkable for Adorno, who persistently refused to anchor aesthetics in subjectivity, and in this regard sided with Hegel against Kant. But back in the early 2000s the fundamental concern of the third generation of the Frankfurt School was to relativize the Hegel-aligned truth claims of *Aesthetic Theory* and make Adorno compatible with a time that was witnessing the blurring of art's boundaries.[13] Today the concept of aesthetic experience seems to have been eclipsed along with its mediating concepts workobjectivity and subjective experience. They collapsed in the idea of relational aesthetics and the art of immersion. Christoph Menke, whose study of Adorno and Jacques Derrida[14] placed Menke at the forefront of the theorization of aesthetic experience, is writing not exactly about form but about force[15]—a concept that can be aligned with form in the contemporary climate.[16] In an entry for a handbook on Adorno, Ruth Sonderegger, another student of Wellmer's and coeditor of an important volume on aesthetic experience,[17] called for a "renewed confrontation with the central position of the art object in Adorno's aesthetics, as well as with the truth claims attached to it."[18] This is what is happening now[19]—though the present, unbounded concept of form must inevitably run up against Adorno's own, and this for a number of reasons, not least among them the demarcation line that form draws between art and society. That this collision has *not* been perceived or recognized marks the departure point of my reflections. In response to the ongoing universalization of the concept of form, my intention is, first, to bring Adorno's agonal aporetics back into view. For Adorno, form's capabilities and the contours of its meaning depend partly on the forms in which it is unfolded. Form exists only in the medium of

11. Honneth, *Dialektik der Freiheit.*
12. See Bubner, "Kann Theorie ästhetisch werden?," as well as Jauß, "Negativität und ästhetische Erfahrung."
13. See the attempts at mediation in Rebentisch, *Aesthetics of Installation Art.*
14. Menke, *Sovereignty of Art.*
15. See Menke, *Force.*
16. See Khurana, "Force and Form." For his part, Josh Robinson identifies form as "a force" (*Adorno's Poetics of Form*, 26; hereafter cited as *APF*).
17. See Kern and Sonderegger, *Falsche Gegensätze.*
18. Sonderegger, "Ästhetische Theorie," 532.
19. See, among others, Quent and Lindner, *Das Versprechen der Kunst.*

other forms from which it delimits itself. This multiplicity, which form owes to its distinction-creating qualities, should not be sacrificed too hastily to an unbounded conception of form. Two recent books on Adorno focus in equally interesting ways on form, and their shortcomings open up new perspectives to address Adorno's notion of form.

While Tilo Wesche and Josh Robinson insist on form, the charge of universalizing form can hardly be made against them. The authors belong to very different academic and intellectual milieus; they emphasize different aspects of Adorno's work; they pursue different goals with their studies; and they diverge considerably in their methodology. That they nonetheless arrive at parallel conclusions about form points inadvertently to a "form formation"—to a "form front," as it were—that transcends not only conceptual and historical differences but also differences of discipline and methodology while inevitably paying a certain price in terms of precision. Both studies are connected to the New Formalism insofar as both authors are invested in the direct social-critical potential of form, thus avoiding form's necessary relation to other forms. What their reconstructions overlook or ignore then becomes my point of departure for a different approach to form in Adorno.

———

Wesche's study, published with Reclam, is a concise and highly readable introduction to Adorno's oeuvre. Unlike the older scholarship, Wesche takes no issue with Critical Theory's turn toward aesthetics. Instead, he affirms this state of affairs without reservation: "For Adorno, the critical theory of society realizes itself in art."[20] To be sure, the reverse is also true, in that autonomous art "only comes into its own as a critique of society" (*WA*, 155). According to Wesche, this critical ability of art is to be found in its capacity for enhancing sensibilities and encouraging communication. Art has nothing to tell us directly; it does not make us into better people; it offers us no assistance regarding decisions, no guidance on how to act or live. However, it is precisely this asceticism that makes art an effective tool against individual and collective "self-delusions" (*WA*, 164).

Whereas in 2005 Wellmer was still arguing for the distinction between a metaphysical and a postmetaphysical Adorno,[21] Wesche integrates the various

20. Wesche, *Adorno*, 150 (hereafter cited as *WA*).
21. Wellmer brackets off what he considers the "illegitimate charging of emphatic artistic experiences with the metaphysics of redemption" ("Über Negativität und Autonomie der Kunst," 245).

elements of Adorno's aesthetic and social theories into a coherent whole. Alongside form Adorno's other key aesthetic categories are discussed in due course: mimesis, natural beauty, art as enigma, and the linguistic character of all art. Nonetheless, form clearly remains the organizing center of Wesche's reconstruction of Adorno's aesthetic theory: "The aesthetics of autonomy in Adorno stands or falls with his concept of aesthetic form" (*WA*, 162). Adorno himself said that "art has precisely the same chance of survival as does form, no better" (*AT*, 194). Form is the origin of aesthetic autonomy because it is qua form that the artwork determines itself as an artwork. In this sense form is a pure end in itself. Form's other is not content but what Adorno calls material. Because material is always historically mediated—for this reason Adorno occasionally refers to material as "the formed" (*AT*, 200)—the critical potential of autonomous art depends exclusively on the form imposed on the material, which is already preformed and processed. With Wesche, one can and must conceive of progress in art in terms of imposing form on material. And despite all that we have heard about the "*Verfransung*" of postmodernity and the blurred boundaries of art, Wesche does not hesitate to assert that "art exists only as an avant-garde" (*WA*, 171).[22]

Wesche's analysis of the long-suspect "rescue of semblance [*Schein*]" in Adorno is equally coherent: "Art is the 'rescue of semblance' in the sense of the cunning, the purposiveness with which aesthetic form allows art to appear *as if* it 'has no purpose'" (*WA*, 165). According to Wesche, the artwork's form is its ruse. It pretends to exist for its own sake, "hiding" the fact that critique and enlightenment are actually its raison d'être. This goal is arrived at by a detour because self-enlightenment is achieved only by the cunning of autonomous form. This concept of form, which Wesche anchors in the last instance within a theory of rationality, also allows him to integrate mimesis as a moment of aesthetic form. He incorporates it through natural beauty. Form, he argues, imitates the beauty of nature, which also appears to have no purpose or intention. Wesche relates this directly to what Adorno called the "linguistic character of art" (*Sprachcharakter der Kunst*). For by virtue of its self-imposed formal laws, art produces a natural language that ensures human intentionality can effect the appearance of something without intention (see *WA*, 167).

---

22. The engagement with Adorno's late text "Art and the Arts," which has been taken up again and again since Christine Eichel's *Vom Ermatten der Avantgarde zur Vernetzung der Künste*, not only was an overdue upgrade to media theory but also stood very much in the service of dissolving the category of the work. This engagement risked, however, the loss of the notion of progress in art. Menke and Juliane Rebentisch intervened against this turn with their volume *Kunst, Fortschritt, Geschichte*.

All that is missing in Wesche's lucid and comprehensive reconstruction are the extremes of Adorno's conception of form. Broadly, these concern the archaic sediment of all art (the "circus act"), the remnants of what Adorno called "mimetic impulses," like absurdity and nonsense, which are always part of but never fully controlled by aesthetic form. In form, their perennial reverse side is violence: "The purer the form, and the higher the autonomy of the works, the more cruel they are" (*AT*, 68). For Adorno, the law of form was not, as Wesche believes, a clever game, the cunning of reason, but suppression and domination, "the ritual of the domination of nature that lives on in play" (*AT*, 68). "The cruelty of formation is mimesis of myth, with which form struggles" (*AT*, 69). Myth and the "mimetic impulses," rendered taboo by the civilization process, are the sedimented content of aesthetic forms,[23] and they constitute the permanent objection of all form against morality. In Adorno's view, the conciliatory aspect of form's cruelty lies only in the fact that something of art's prehistory is rescued during formation, something forgotten, overcome, and suppressed by the organizing effects of form, which is itself also always a tool of suppression. In short, Wesche's study offers up an Adorno who has been somewhat domesticated and desomatized,[24] and a concept of form that is the cunning by which the artwork acts as if it had no purpose, purified of the extremes of cruelty and lust.

The approach taken by Robinson in *Adorno's Poetics of Form*, also published in 2018, is rather different. Whereas Wesche's study is a rational and social-theoretical reconstruction of philosophical provenance, Robinson accesses the universe of Adorno's reflections on form via Werner Hamacher's radically emphatic notion of philology.[25] Robinson is careful never to define form. The term's (considerable) semantic spectrum is disclosed as a constellation through close readings of Adorno's essays on literature (see *APF*, 26). Over several chapters Robinson reconstructs form's relationship to ideas such as content, expression, genre, and material. He also compares and contrasts artistic form with the form of the commodity. Robinson situates his microanalyses in the context of the New Formalism in the United States, which he helpfully recapitulates at the start and end of his study (*APF*, 1–8) to put his contribution to form "in dialogue with Adorno" (*APF*, 217).

23. To the formulation that form is sedimented content belongs, however, the inverse; forms, during the historical process, become second-order material. See *AT*, 198.

24. The category of pain, which plays an important role in the relationship between expression and mimesis, is toned down to the pathologies produced by the capitalist environment and is partly treatable through interaction with art.

25. See Hamacher, *Fünfundneunzig Thesen zur Philologie*.

Although this scrupulous, probing, sometimes convoluted study can hardly be equated with Wesche's comparatively deft and straightforward approach, Robinson too proceeds from Adorno's notion of form. Form's autonomous character consists in its separating itself from the social realm to which it remains dialectically linked. Robinson's interpretation also recognizes art's critique of society by the distance from society achieved through its form. Compared to Wesche's more pragmatic account, in Robinson the artwork's *as if* turns out to be rather more utopian and emphatic. His understanding of Adorno's poetics of form "refuses to lose sight of the possibility that things might one day be different" (*APF*, 206).

When Robinson offers up form as a way to think "poetry and society together" (*APF*, 18), he seems to have arrived at Levine's unbounded conception of form. Still, his astute critical discussion of Levine shows that he, like Wesche, still insists on form as imposing its own law on itself. In Robinson's view, Levine confounds the specifics of literary form (which he also refers to as "technique" [*APF*, 214]) with the forms that we encounter in the social world. By recognizing these same forms in literature and art, she fails to understand the singular character of aesthetic form. Robinson suggests that, as a consequence, Levine's readings of literature remain largely thematic. Her treatment of literature is *not* formal but representational.

In Robinson, as in Wesche's conception of form, neither literature nor art can intervene directly in the world. However, Robinson also believes that it is possible to learn from literature how to intervene in the world. Form "goes beyond the literary expression of moral and political truths, identifying ways which can (help us) identify potential interventions into society" (*APF*, 210). In contradistinction to Wesche's argument that form's purpose is to evoke the impression that the artwork exists for its own sake, Robinson does not have a robust argument to substantiate his claim. For this reason, his individual readings, which enhance the concept of form, tend to dissolve into various models that never reach the aggregate of a theory. One achievement of his study is unquestionably its dismantling of the monolithic understanding of form into a spectrum of object-specific facets, which he develops with and in Adorno. As far as the present interest in form is concerned, this argument could have led to the conclusion that every form, in its turn, depends on other forms in which it can appear and be articulated. What Robinson unfolds in practice falls short of a theoretical argument because the "primacy of the object," which is to say, Adorno's text itself, is so absolute that Robinson has to fall short of a theory of form. Instead, he performs close formal readings of form. But whether what he calls the "metaphysics of the concept" (*APF*, 26) can be

overcome or transcended by an interpretive plenitude of particulars was highly questionable to Adorno himself. The other extreme is to be found in Wesche, whose conceptual reconstruction forgoes textual analyses.

––––––––

Robinson and Wesche emphasize the aesthetic concept of form in Adorno while keeping their distance from its agonal and negative aspects,[26] whether "mimetic impulses" or the inevitability of the concept. In that respect, it is precisely in their difference that they are symptomatic of the widespread faith in the benedictions of form, which, to put it crudely, tend to take on therapeutic qualities.

One epiphenomenon of both scholars' tendency to treat form as a potential is their relaxed treatment of questions of normativity. Robinson wants to learn something positive about form as such from Adorno (see *APF*, 6). Wesche is concerned with the normative possibility of a theory of art that can double as an internally coherent theory of society. Consequently, historicity gets the short end of the stick—though for different reasons in each case. The historicity of *Aesthetic Theory* includes not only the primeval history of the civilization process, to which belong the tabooed "mimetic impulses," but also the historicity of artworks themselves, and finally the historical conditions in which and into which Adorno conceived his last work. That dimension is perhaps most pressing in Adorno's crucial notion of "construction," which is not afforded much consideration by either critic. For Adorno, construction is not only the dialectical counterpart to expression (of pain and suffering) but above all the signature of modern forms, which are no longer "what Hegel termed 'substantial' in his aesthetics with reference to what he considered the great times in art" (*AA*, 62; see *AT*, 77–79). To the extent that Adorno's *Aesthetic Theory* is a confrontation with modernity and with the contemporary art of his day, any normative claims about the artwork are problematic per se. The very first sentence of *Aesthetic Theory* expresses this with unsurpassable drama: "It is self-evident that nothing concerning art is self-evident anymore, not its inner life, not its relation to the world, not even its right to exist" (*AT*, 1). Adorno acknowledges a negative normativity in the bleak alternative offered

26. Perhaps it is necessary to distinguish between *negative* (as in Adorno's own *Negative Dialectics*) and *agonal*. While Khurana et al., *Negativität*, demonstrates once more the enormous span of notions of negativity, *agonal* refers to aporetic impasses resulting from self-imposed constraints, such as Adorno's observance of the primacy of the concept or his symmetrical faith in the survival of mimetic impulses in the sublimated form of art.

by construction's apotheosis in the montage principle and in mathematically serialized forms, which, in his view, exemplifies art's growing compulsion to objectification. "Totally objectified . . . the artwork becomes a mere fact and is annulled as art. The alternative that opens up in this crisis is: either to leave art behind or to transform its very concept" (*AT*, 83). Like art itself, the concept of form is always struggling against its leash (see *AT*, 24). Thus the agonal and the aporetical are not simply disposable anthropological accessories but constitutive of Adorno's attempt to articulate a theory of art at a moment when it is certain neither of its object nor of itself. It is perhaps for this reason that Adorno avoided, at least in name, the notion of philosophical aesthetics.

Adorno's technique of representation—indeed, his own method—is shaken to its core by modern art's fundamental uncertainty. That much is obvious from his reworking of inherited concepts like mimesis and form. On the other hand, the concrete (art) object gains a status equal to that of the concept as a point of departure for theoretical reflection. "[The] objectivity of the aesthetic . . . can result as objectivity only from an analysis of the facts, problems and structures of aesthetic objects. . . . There is no other path to this objectivity than to immerse oneself in the works themselves" (*AA*, 4). Adorno conceives of this immersion as the obliteration of the subject, which he describes quite strikingly in his posthumously published lectures as an experience, akin to a breakthrough, with artworks in which one "dwells" (see *AA*, 122–24).[27] This is an interesting notion, though it is hardly theoretically viable. Adorno says as much: only when one no longer dwells in the artwork is one in a position to say, "What's it all about, what's the point of it, what does it say?" (*AA*, 18). It is only then that reflection begins, initially in the forms of commentary and critique (see *AA*, 18), in which the subjective experience of the artwork is rendered objective for the first time. However, in Adorno's lectures from 1958–59, as well as in *Aesthetic Theory*, commentary and criticism are granted only provisional rights. "They push forwards, they cannot be stopped on the way toward a theory of art, which is where they must end" (*AA*, 18). In *Aesthetic Theory* such a theory realizes its potential only as philosophy: "Aesthetic experience is not genuine experience unless it becomes philosophy" (*AT*, 179). Elsewhere: "It is for this reason that art requires philosophy, which interprets it in order to say what it is unable to say, whereas art is only able to say it by not saying it" (*AT*, 99). That, in a word, is the classical formulation whereby the nondiscursive form of art is aporetically related to philosophy, that is, the

27. On the concept of life in Adorno, see Gordon, *Adorno and Existence*; and Morgan, *Adorno's Concept of Life.*

*most* discursive form, as its necessary supplement. This is unavoidable, because Adorno is not willing to surrender the idea that art is a site where truth unfolds. Only philosophy is capable of seizing that truth. Commentary and critique, perhaps even theory, are at best stations on the way to philosophy.

The crucial question of how *theory*, social *and* aesthetic theory, relates to philosophy has remained largely unexplored, and not only in Adorno. This oversight might have to do with the general refusal to recognize the history of theory as an object in its own right, that is to say, as a form sui generis, and instead to identify it with philosophy. Conversely, theory is reduced to a narrow canon of texts from the 1960s to the 1990s (Critical Theory and "French theory"). By contrast, one might assume that theory and philosophy are "forms in their own right," like commentary and critique. Granting these forms full recognition would, however, require abandoning the strict hierarchy of forms, which would knock philosophy from its perch.

On rare occasion, Adorno does nonetheless gesture toward an idea of form that might be differentiated into equally justified, if not equally weighted, forms of (aesthetic) form. Thus commentary and criticism do partake in the unfolding of a work's truth—albeit its *historical* truth. Adorno contrasts the unfolding of historical truth that takes place in commentary and criticism with the unfolding of the work's truth by its "rescue." Rescue "aims at the truth of false consciousness in the aesthetic experience" (*AT*, 178). While commentary and criticism deal hermeneutically with the unfolding of historical truth, the work's truth content is not strictly speaking "what they mean but rather what decides whether the work in itself is true or false, and only this truth of the work in-itself is commensurable to philosophical interpretation and coincides . . . with the idea of philosophical truth" (*AT*, 179). There are several other passages in *Aesthetic Theory* where Adorno argues for the absolutely exceptional position of the philosophical concept with respect to the aesthetic form of the artwork—for example, that "the progressive self-unfolding truth of the artwork is none other than the truth of the philosophical concept" (*AT*, 178). If for Adorno truth has a "temporal core," commentary and criticism gain in value and, as forms, may be said to be closer to the artwork than the concept. "However, if finished works only become what they are because their being is a process of becoming, they are in turn dependent on forms in which their process crystallizes: interpretation, commentary, and critique. . . . They are the arena of the historical development of artworks in themselves, and thus they are forms in their own right." But even here, philosophy, the rescuer, has the last word: "If the unfolding of the work in these forms is not to miscarry, they must be honed to the point where they become philosophical"

(*AT*, 264). But must they? In the aforementioned entry by Sonderegger, she solves this problem by using philosophy to refer simply to "unprotected, unrestrained thinking."[28] Adorno would hardly have agreed, not least because he held fast to the constellation of thought that opposed Kant to Hegel. The primacy of philosophy is hard to escape. But could philosophy not also be regarded as "a form in its own right," no different from commentary and critique with respect to the aesthetic object?

Much in *Aesthetic Theory* speaks against such a conclusion. But Adorno's remarks in "The Essay as Form" from *Notes to Literature* offer a somewhat more promising outlook. However, the few suggestive passages in *Aesthetic Theory* on the multiplicity of aesthetic form's representational possibilities invite interpretation first. For once, in this one exceptional context, aesthetic form does not culminate in the philosophical concept. By the same token, the question of truth retreats largely into the background because, according to Adorno, art neither individually nor collectively "wills its own concept," which it "develops from within" (*AT*, 200).

In the passage at issue, Adorno elaborates what aesthetic form is and what it can achieve in relation to other forms. He focuses on the relation between the whole and its particulars, as well as on the relationship between form and content (see *AT*, 197–201). The "whole" belongs to form, the form belongs to "the formed," which is to say, material or content. In a formally valid artwork, the whole is marked by cruelty and, less emphatically, by "melancholy," insofar as "form seeks to bring the particular to speech through the whole" (*AT*, 198). This is a violent process because the whole becomes the means by which the particulars are forced to speak. It is not the particular that expresses itself in this process but only the whole. To form here means to select, to trim, to renounce, and also to maim (see *AT*, 198). In principle, however, form is also the exact opposite of this cruel process, namely, "a gapless and unforced unity of form and the formed" (*AT*, 200). Adorno underlines this point elsewhere when he says that this second type of form "emerges" or arises from the works (*AT*, 195). Adorno thereby approximates what in his typology of forms David Wellbery refers to as "endogenous form."[29] By contrast, violent form, which gets its teeth into content or the particular until it "flickers incarnate," recalls the notion of form as eternal "stamping" or imprint on volatile matter and thus the older hyle-morphe type of form. In the absence of eternal and, in Hegel's sense, "substantial" forms, there remains only violent praxis. Endoge-

28. Sonderegger, "Ästhetische Theorie," 528.
29. See Wellbery, "Form und Idee."

nous form, which Adorno calls "the idea of form," has as its goal "in principle" the nonviolent "identity of the identical and the non-identical" (*AT*, 200) and therefore stands opposed to violent form, which regularly fails and consequently becomes determined negatively. Thus content appears as a form of form that can be distinguished from both violent form and ideal endogenous form. And the concept of articulation, which appears somewhat abruptly but is mediated through the metaphor of art's linguistic character, brings the various concepts of form into a typological coherence as various "levels of form" (*Form-Niveaus*) in which the particulars and the whole relate to one another differently. An artwork has attained the highest level of form when "the relation of the parts to the whole, an essential aspect of form, is constituted by way of detours" (*AT*, 201). Referring to Arnold Schoenberg, Adorno adds that "Ariadne provides no thread to follow through the interior of artworks" (*AT*, 201). Because, in a certain sense, all artworks are blind, what is most unique to them—namely, their form—remains inaccessible to them. For this reason, form must refer to other forms in which it might unfold, just as Adorno's remarks on form refer to various conceptions and models of form: "Their form, their whole, and their logicality are hidden from artworks to the same degree as the elements, the content, desire the whole" (*AT*, 201). It is wise not to ask too much of sentences like this one. The upshot is that an aesthetic form can give no more of itself than can a desire. Thus aesthetic forms are in need of other forms.

Adorno adds another form to those listed above in the title of a text in *Notes to Literature*, a form as different from that of the artwork as it is from the form of philosophy: the essay. In "The Essay as Form" the essay's form is initially and largely determined, in agreement with Georg Lukács and Georg Simmel, as a preponderance of already formed objects: "Spellbound by what is fixed and acknowledged to be derivative."[30] What the essay is as form is developed *ex negativo* in the medium of those forms that affect it, forms like "science," "art," and "philosophy," all of which the essay violates, betrays, and corrupts. Consequently, the essay's form consists of having no form at all or, more specifically, of having no form of its own: its "innermost formal law is heresy" (EF, 47).

Adorno's own text, "The Essay as Form," is *not* an example of such heresy and so not itself an essay.[31] On the contrary, Adorno develops his remarks on the essay in a treatise-like manner, systematically and even dogmatically,

---

30. Adorno, "Essay as Form," 36 (hereafter cited as EF).
31. This, at any rate, is the most common interpretation of Adorno's text, including that by Robinson (see *APF*, 130).

with admittedly negative reference to the systems of science, philosophy, and art. There is not a trace of "luck and play" or even of "allotria" in Adorno's strict textual composition (EF, 30). Thus Adorno demonstrates, as it were performatively, that the determination of a form as a *particular* form depends on other forms from which it distinguishes itself in order to be determinable *as* a form.

If today, under the banner of the current formalism, we are once again concerned with "the primacy of the object," and so once again concerned with the primacy of (aesthetic) form, then this primacy can only come into its own, can only show itself, and can only be identified as a form with recourse to other forms. Rather than extend the concept of form, so that it absorbs everything and thereby becomes a bad universal, this conclusion points us to a pluralization of forms that can and ought to remain distinct from one another. And rather than overtax a concept of aesthetic form, or decide between Kant and Hegel, we might appreciate the division of labor among those individuals whose business is the analysis of form, namely, theory, the essay, critique, commentary, and philosophy.

This is an admittedly modest conclusion, and if it is not entirely banal, that is because form and its concept have become so inflated in recent years. What is to be made of the "omnipotence of form," whose disappearance Goethe dramatized in his *Pandora*, from which Adorno takes his epigram for "The Essay as Form": "Destined to see what is illuminated, not the light" (EF, 29)?[32] If commentary, interpretation, and criticism are the areas of the historical unfolding of artworks, and if they are forms in their own right (and not simply on the way to becoming philosophy), that still does not relieve us as critics from the duty to think "unprotected and unrestrained" about the conjuncture of these forms' interests. Is the current obsession with form, my own included, intellectual-historical progress, a sign of increasing insight into the formal nature of all objects? Or is it about the self-assertion of those disciplines concerned with aesthetic form? Is it about the humanities' return to their foundational concepts and self-conceptions, which seem to have become lost in recent years? And lastly, which objects at which levels of form benefit most from the New Formalism? Certainly "works" like Romantic poetry or the Victorian novel, but also the "series," a form that is no longer as new as it once was.

One can say of Adorno's *Aesthetic Theory* that, as far as these questions are concerned, it still harbors enormous disciplinary potential, even and especially in its resistant and unforgiving elements. Something is still lacking in

32. See Vogel and Schneider, *Epiphanie der Form.*

nous form, which Adorno calls "the idea of form," has as its goal "in principle" the nonviolent "identity of the identical and the non-identical" (*AT*, 200) and therefore stands opposed to violent form, which regularly fails and consequently becomes determined negatively. Thus content appears as a form of form that can be distinguished from both violent form and ideal endogenous form. And the concept of articulation, which appears somewhat abruptly but is mediated through the metaphor of art's linguistic character, brings the various concepts of form into a typological coherence as various "levels of form" (*Form-Niveaus*) in which the particulars and the whole relate to one another differently. An artwork has attained the highest level of form when "the relation of the parts to the whole, an essential aspect of form, is constituted by way of detours" (*AT*, 201). Referring to Arnold Schoenberg, Adorno adds that "Ariadne provides no thread to follow through the interior of artworks" (*AT*, 201). Because, in a certain sense, all artworks are blind, what is most unique to them—namely, their form—remains inaccessible to them. For this reason, form must refer to other forms in which it might unfold, just as Adorno's remarks on form refer to various conceptions and models of form: "Their form, their whole, and their logicality are hidden from artworks to the same degree as the elements, the content, desire the whole" (*AT*, 201). It is wise not to ask too much of sentences like this one. The upshot is that an aesthetic form can give no more of itself than can a desire. Thus aesthetic forms are in need of other forms.

Adorno adds another form to those listed above in the title of a text in *Notes to Literature*, a form as different from that of the artwork as it is from the form of philosophy: the essay. In "The Essay as Form" the essay's form is initially and largely determined, in agreement with Georg Lukács and Georg Simmel, as a preponderance of already formed objects: "Spellbound by what is fixed and acknowledged to be derivative."[30] What the essay is as form is developed *ex negativo* in the medium of those forms that affect it, forms like "science," "art," and "philosophy," all of which the essay violates, betrays, and corrupts. Consequently, the essay's form consists of having no form at all or, more specifically, of having no form of its own: its "innermost formal law is heresy" (*EF*, 47).

Adorno's own text, "The Essay as Form," is *not* an example of such heresy and so not itself an essay.[31] On the contrary, Adorno develops his remarks on the essay in a treatise-like manner, systematically and even dogmatically,

---

30. Adorno, "Essay as Form," 36 (hereafter cited as EF).
31. This, at any rate, is the most common interpretation of Adorno's text, including that by Robinson (see *APF*, 130).

with admittedly negative reference to the systems of science, philosophy, and art. There is not a trace of "luck and play" or even of "allotria" in Adorno's strict textual composition (EF, 30). Thus Adorno demonstrates, as it were performatively, that the determination of a form as a *particular* form depends on other forms from which it distinguishes itself in order to be determinable *as* a form.

If today, under the banner of the current formalism, we are once again concerned with "the primacy of the object," and so once again concerned with the primacy of (aesthetic) form, then this primacy can only come into its own, can only show itself, and can only be identified as a form with recourse to other forms. Rather than extend the concept of form, so that it absorbs everything and thereby becomes a bad universal, this conclusion points us to a pluralization of forms that can and ought to remain distinct from one another. And rather than overtax a concept of aesthetic form, or decide between Kant and Hegel, we might appreciate the division of labor among those individuals whose business is the analysis of form, namely, theory, the essay, critique, commentary, and philosophy.

This is an admittedly modest conclusion, and if it is not entirely banal, that is because form and its concept have become so inflated in recent years. What is to be made of the "omnipotence of form," whose disappearance Goethe dramatized in his *Pandora*, from which Adorno takes his epigram for "The Essay as Form": "Destined to see what is illuminated, not the light" (EF, 29)?[32] If commentary, interpretation, and criticism are the areas of the historical unfolding of artworks, and if they are forms in their own right (and not simply on the way to becoming philosophy), that still does not relieve us as critics from the duty to think "unprotected and unrestrained" about the conjuncture of these forms' interests. Is the current obsession with form, my own included, intellectual-historical progress, a sign of increasing insight into the formal nature of all objects? Or is it about the self-assertion of those disciplines concerned with aesthetic form? Is it about the humanities' return to their foundational concepts and self-conceptions, which seem to have become lost in recent years? And lastly, which objects at which levels of form benefit most from the New Formalism? Certainly "works" like Romantic poetry or the Victorian novel, but also the "series," a form that is no longer as new as it once was.

One can say of Adorno's *Aesthetic Theory* that, as far as these questions are concerned, it still harbors enormous disciplinary potential, even and especially in its resistant and unforgiving elements. Something is still lacking in

---

32. See Vogel and Schneider, *Epiphanie der Form.*

Wesche's and Robinson's largely sanitized and positivized interpretations of Adorno. Yet it remains difficult to explain why we ought to hold fast to the agonistic, difficult, and contradictory features of Adorno's thinking right now. Perhaps it is Adorno's perennial cynicism toward the present state of affairs that is the key to his relevance: "Where everything is bad, it must be good to know the worst."[33] But perhaps it is also a matter of showing respect for a great work that cannot lie and in whose "unfolding," even though the work's final revision never took place, limits are set for those who are in the business of commentary and critique.

**Eva Geulen** is director of the Leibniz Center for Literary and Cultural Research.

33. Francis Herbert Bradley, quoted in Adorno, *Minima Moralia*, 89.

## References

Adorno, Theodor W. *Aesthetic Theory*, translated by Robert Hullot-Kentor. London: Bloomsbury, 2013.

Adorno, Theodor W. *Aesthetics, 1958/59*, translated by Wieland Hoban. Cambridge: Polity, 2018.

Adorno, Theodor W. "The Essay as Form." In *Notes to Literature*, edited by Rolf Tiedemann, translated by Shierry Weber Nicholsen, 29–47. New York: Columbia University Press, 2019.

Adorno, Theodor W. *Minima Moralia: Reflections from Damaged Life*, translated by E. F. N. Jephcott. London: Verso, 2020.

Bubner, Rüdiger. "Kann Theorie ästhetisch werden? Zum Hauptmotiv der Philosophie Adornos." In Lindner and Lüdke, *Materialien zur ästhetischen Theorie*, 108–37.

Düttmann, Alexander García. *Philosophie der Übertreibung*. Frankfurt am Main: Suhrkamp, 2004.

Eichel, Christine. *Vom Ermatten der Avantgarde zur Vernetzung der Künste: Perspektiven einer interdisziplinären Ästhetik im Spätwerk Theodor W. Adornos*. Frankfurt am Main: Suhrkamp, 1993.

Geulen, Eva, and David-Christopher Assmann. "Zur gesellschaftlichen Lage der Literatur (mit einer Fallstudie zu Klaus Modick)." *WestEnd* 9, nos. 1–2 (2012): 18–46.

Gordon, Peter. *Adorno and Existence*. Cambridge, MA: Harvard University Press, 2016.

Hamacher, Werner. *Fünfundneunzig Thesen zur Philologie*. Holderbank: Engeler, 2010.

Honneth, Axel, ed. *Dialektik der Freiheit: Frankfurter Adorno-Konferenz 2003*. Frankfurt am Main: Suhrkamp, 2005.

Jauß, Hans Robert. "Negativität und ästhetische Erfahrung: Adornos ästhetische Theorie in der Retrospektive." In Lindner and Lüdke, *Materialien zur ästhetischen Theorie*, 138–68.

Kern, Andrea, and Ruth Sonderegger, eds. *Falsche Gegensätze: Zeitgenössische Positionen zur philosophischen Ästhetik*. Frankfurt am Main: Suhrkamp, 2002.

Khurana, Thomas. "Force and Form: An Essay on the Dialectics of the Living." *Constellations* 18, no. 1 (2011): 21–34.

Khurana, Thomas, Dirk Quadflieg, Francesca Raimondi, Juliane Rebentisch, and Dirk Setton, eds. *Negativität: Kunst, Recht, Politik*. Berlin: Suhrkamp, 2018.

Kramnick, Jonathan, and Anahid Nersessian. "Form and Explanation." *Critical Inquiry* 43, no. 3 (2017): 650–69.

Levine, Caroline. *Forms: Whole, Rhythm, Hierarchy, Network*. Princeton, NJ: Princeton University Press, 2015.

Levinson, Marjorie. "What Is New Formalism?" *PMLA* 122, no. 2 (2007): 558–69.

Lindner, Burkhardt, and W. Martin Lüdke, eds. *Materialien zur ästhetischen Theorie: Theodor W. Adornos Konstruktion der Moderne*. Frankfurt am Main: Suhrkamp, 1980.

Menke, Christoph. *Force: A Fundamental Concept of Aesthetic Anthropology*, translated by Gerrit Jackson. New York: Fordham University Press, 2012.

Menke, Christoph. *The Sovereignty of Art: Aesthetic Negativity in Adorno and Derrida*, translated by Neil Solomon. Cambridge, MA: MIT Press, 1998.

Menke, Christoph, and Juliane Rebentisch, eds. *Kunst, Fortschritt, Geschichte*. Berlin: Kadmos, 2006.

Morgan, Alastair. *Adorno's Concept of Life*. London: Continuum, 2007.

North, Joseph. *Literary Criticism: A Concise Political History*. Cambridge, MA: Harvard University Press, 2017.

Pfau, Thomas. "Introduction." *Republics of Letters* 5, no. 1 (2017): 1–7.

Quent, Marcus, and Eckardt Lindner, eds. *Das Versprechen der Kunst: Aktuelle Zugänge zu Adornos ästhetischer Theorie*. Vienna: Turia + Kant, 2014.

Rebentisch, Juliane. *Aesthetics of Installation Art*, translated by Daniel Henrickson and Gerrit Jackson. Berlin: Sternberg, 2012.

Robinson, Josh. *Adorno's Poetics of Form*. Albany: State University of New York Press, 2018.

Scholze, Britta. *Kunst als Kritik: Adornos Weg aus der Dialektik*. Würzburg: Königshausen und Neumann, 2000.

Sonderegger, Ruth. "Ästhetische Theorie." In *Adorno-Handbuch: Leben, Werk, Wirkung*, edited by Richard Klein, Johann Kreuzer, and Stefan Müller-Doohm, 521–33. Stuttgart: Metzler, 2019.

Stöckmann, Ingo. *Texte der formalistischen Ästhetik: Eine Quellenedition zu Johann Friedrich Herbart und zur herbartianischen Theorietradition*. Berlin: de Gruyter, 2019.

Vogel, Juliane, and Sabine Schneider, eds. *Epiphanie der Form: Goethes "Pandora" im Licht ihrer Form- und Kulturkonzepte*. Göttingen: Wallstein, 2018.

Wellbery, David. "Form und Idee: Skizze eines Begriffsfeldes um 1800." In *Morphologie und Moderne: Goethes "anschauliches Denken" in den Geistes- und Kulturwissenschaften seit 1800*, edited by Jonas Maatsch, 17–42. Berlin: de Gruyter, 2014.

Wellmer, Albrecht. "Über Negativität und Autonomie der Kunst: Die Aktualität von Adornos Ästhetik und blinde Flecken seiner Musikphilosophie." In Honneth, *Dialektik der Freiheit*, 237–78.

Wesche, Tilo. *Adorno: Eine philosophische Einführung*. Ditzingen: Reclam, 2018.

# Natural History and Aesthetic Truth
## in Aesthetic Theory

### Max Pensky

Since at least the beginning of the 1990s, sympathetic readers of Theodor W. Adorno's *Aesthetic Theory* have struggled to make sense of his account of the truth content of the artwork.[1] The seemingly Hegelian commitment to the claim that art has such content stands high on the list of interpretive challenges precluding a full reappreciation of the work.[2]

This article continues that practice, with some differences. The motivating question here focuses on Adorno's insistence in *Aesthetic Theory* that artworks bear a distinctive form of insight. This privileged insight discloses objective conditions about reality that, but for artistic truth, remain cloaked and inaccessible, and that the release or disclosure of truth content requires that the nondiscursive structure of the artwork interact in a specified manner— critical interpretation—with a related form of spirit, namely, the discursively structured practice of philosophical thinking. As I discuss in the final section, this view of art's truth content having an important reference to social condi-

---

1. See Zuidervaart, *Adorno's Aesthetic Theory*, introd. For a representative recent example, see Richter, "Aesthetic Theory and Nonpropositional Truth Content in Adorno," 131–33. For a treatment of *Aesthetic Theory*'s unhappy aging, see Wellmer, "Truth, Semblance, Reconciliation."

2. For a careful and illuminating reception history of *Aesthetic Theory*, see Hohendahl, *Fleeting Promise of Art*, introd. For recent, substantive engagements in English, see Foster, *Adorno and Philosophical Modernism*, introd.; Nicholsen, *Exact Imagination, Late Work*; and Hammer, *Adorno's Modernism*. For a useful recent overview, see Geulen, "Adorno's Aesthetic Theory."

*New German Critique* 143, Vol. 48, No. 2, August 2021
DOI 10.1215/0094033X-8989218   © 2021 by New German Critique, Inc.

tions beyond art, and therefore connected to social critique, is not new, and I review the relevant examples. The article argues that this interpretation of art's truth content is bolstered if we take the model of critical thinking Adorno developed at the beginning of his career, in his 1932 essay "The Idea of Natural History," as a promissory note for the kind of philosophical interpretation whose contact with the artwork was meant to release truth content. Such truth is therefore properly neither aesthetic nor philosophical, neither cognitive nor noncognitive. It is broadly alethic, insofar as it discloses a world bereft of meaning, which otherwise remains ideologically hidden. Moreover, interpretation of aesthetic truth also discloses the contingency of that world and thus has a modal function, translating the seemingly necessary into the possible.[3]

*Aesthetic Theory* argues that art is a form of privileged access to truth that is otherwise inaccessible, or is in a way so diluted by forms of social domination as to be different in kind. In a line of descent tracing back to the origins of contemporary aesthetic theory, the book claims that art *has truth*: that art is not, as for Immanuel Kant, ultimately a medium for the rational subject to employ its own cognitive powers to discover something important about its rational nature and purpose. Further, Adorno argues at length in *Aesthetic Theory* that the enigmatic nature of the artwork is at once the resistance to, but also the condition for, the artwork's truth content.[4] Artworks are enigmatic because they lie at the frontier of opposed conceptual possibilities: form and matter, history and nature, subject and object, freedom and necessity, enlightenment and myth. Art's enigmatic nature is part of art's capacity to intensify the unresolved moments of these opposed possibilities, rather than assist in rationality's preference to resolve them in its own favor. For that reason, art discloses a range of missed, lost, forgotten, or still-undreamed-of possibilities for alternative ways that the rational subject could experience its own exteriority, its own not-I.

*Aesthetic Theory* argues that this enigmatic nature of the artwork, a truth content that resists being brought into fully conceptual terms, maintains both an internal and a historical relationship to philosophy as its privileged partner. In many places in *Aesthetic Theory* Adorno reminds us that art has truth con-

---

3. For a fine recent account of the modal character of much of Adorno's critical thinking, see MacDonald, *What Would Be Different*.

4. "In no less strict terms, artworks are enigmas. They contain the potential for the solution; the solution is not objectively given. Every artwork is a picture puzzle, a puzzle to be solved, but this puzzle is constituted in such a fashion that it remains a vexation, the preestablished routing of its observer. The newspaper picture puzzle recapitulates playfully what artworks carry out in earnest" (Adorno, *Aesthetic Theory*, 121; hereafter cited as *AT*).

# Natural History and Aesthetic Truth
## *in* Aesthetic Theory

## Max Pensky

Since at least the beginning of the 1990s, sympathetic readers of Theodor W. Adorno's *Aesthetic Theory* have struggled to make sense of his account of the truth content of the artwork.[1] The seemingly Hegelian commitment to the claim that art has such content stands high on the list of interpretive challenges precluding a full reappreciation of the work.[2]

This article continues that practice, with some differences. The motivating question here focuses on Adorno's insistence in *Aesthetic Theory* that artworks bear a distinctive form of insight. This privileged insight discloses objective conditions about reality that, but for artistic truth, remain cloaked and inaccessible, and that the release or disclosure of truth content requires that the nondiscursive structure of the artwork interact in a specified manner— critical interpretation—with a related form of spirit, namely, the discursively structured practice of philosophical thinking. As I discuss in the final section, this view of art's truth content having an important reference to social condi-

---

1. See Zuidervaart, *Adorno's Aesthetic Theory*, introd. For a representative recent example, see Richter, "Aesthetic Theory and Nonpropositional Truth Content in Adorno," 131–33. For a treatment of *Aesthetic Theory*'s unhappy aging, see Wellmer, "Truth, Semblance, Reconciliation."

2. For a careful and illuminating reception history of *Aesthetic Theory*, see Hohendahl, *Fleeting Promise of Art*, introd. For recent, substantive engagements in English, see Foster, *Adorno and Philosophical Modernism*, introd.; Nicholsen, *Exact Imagination, Late Work*; and Hammer, *Adorno's Modernism*. For a useful recent overview, see Geulen, "Adorno's *Aesthetic Theory*."

*New German Critique* 143, Vol. 48, No. 2, August 2021
DOI 10.1215/0094033X-8989218    © 2021 by New German Critique, Inc.

tions beyond art, and therefore connected to social critique, is not new, and I review the relevant examples. The article argues that this interpretation of art's truth content is bolstered if we take the model of critical thinking Adorno developed at the beginning of his career, in his 1932 essay "The Idea of Natural History," as a promissory note for the kind of philosophical interpretation whose contact with the artwork was meant to release truth content. Such truth is therefore properly neither aesthetic nor philosophical, neither cognitive nor noncognitive. It is broadly alethic, insofar as it discloses a world bereft of meaning, which otherwise remains ideologically hidden. Moreover, interpretation of aesthetic truth also discloses the contingency of that world and thus has a modal function, translating the seemingly necessary into the possible.[3]

*Aesthetic Theory* argues that art is a form of privileged access to truth that is otherwise inaccessible, or is in a way so diluted by forms of social domination as to be different in kind. In a line of descent tracing back to the origins of contemporary aesthetic theory, the book claims that art *has truth*: that art is not, as for Immanuel Kant, ultimately a medium for the rational subject to employ its own cognitive powers to discover something important about its rational nature and purpose. Further, Adorno argues at length in *Aesthetic Theory* that the enigmatic nature of the artwork is at once the resistance to, but also the condition for, the artwork's truth content.[4] Artworks are enigmatic because they lie at the frontier of opposed conceptual possibilities: form and matter, history and nature, subject and object, freedom and necessity, enlightenment and myth. Art's enigmatic nature is part of art's capacity to intensify the unresolved moments of these opposed possibilities, rather than assist in rationality's preference to resolve them in its own favor. For that reason, art discloses a range of missed, lost, forgotten, or still-undreamed-of possibilities for alternative ways that the rational subject could experience its own exteriority, its own not-I.

*Aesthetic Theory* argues that this enigmatic nature of the artwork, a truth content that resists being brought into fully conceptual terms, maintains both an internal and a historical relationship to philosophy as its privileged partner. In many places in *Aesthetic Theory* Adorno reminds us that art has truth con-

---

3. For a fine recent account of the modal character of much of Adorno's critical thinking, see Mac-Donald, *What Would Be Different*.

4. "In no less strict terms, artworks are enigmas. They contain the potential for the solution; the solution is not objectively given. Every artwork is a picture puzzle, a puzzle to be solved, but this puzzle is constituted in such a fashion that it remains a vexation, the preestablished routing of its observer. The newspaper picture puzzle recapitulates playfully what artworks carry out in earnest" (Adorno, *Aesthetic Theory*, 121; hereafter cited as *AT*).

tent only insofar as art maintains its relation of unresolved tension—of negation and of postponed unity—with philosophical interpretation.

The task of aesthetic philosophy for Adorno is to use philosophical interpretation to release art's truth content, without thereby resolving the tensions and contradictions constitutive to it. "Artworks are enigmatic," Adorno says, "in that they are the physiognomy of an objective spirit that is never transparent to itself in the moment in which it appears" (*AT*, 128). This implies a dynamic and mediated relation between art and philosophy, between aesthetic expression and philosophical insight, both in terms of their conceptual structure and in historical terms, as late institutions, surviving beyond their own historical-cultural window, the triumphal centuries of the European high bourgeoisie: "Artworks, especially those of the highest dignity, await their interpretation. The claim that there is nothing to interpreting them, that they simply exist, would erase the demarcation line between art and non-art. . . . Grasping truth content postulates critique. Nothing is grasped whose truth or untruth is not grasped, and this is the concern of critique" (*AT*, 128–29).

Stranded by the rising tide of social domination, art and philosophy are intimate yet separate, two dark planets orbiting the same dead star. There can be no aesthetic truth content without philosophical, conceptual interpretation, yet all philosophical interpretation, no matter how ingenious, is also a betrayal—a "grasping" rather than releasing—of just what makes true art true. Even given the superannuated, febrile, and self-consuming state Adorno ascribes to it, postidealist philosophy still cannot but assert its priority in the relation to the nonconceptual. It maintains its status as philosophy by betraying the nonconceptual dimension of art's truth content in the act of its interpretive completion. "Philosophy and art converge in their truth content: The progressive self-unfolding truth of the artwork is none other than the truth of the philosophical concept. . . . Aesthetic experience is not genuine experience unless it becomes philosophy" (*AT*, 130).

The "convergence" Adorno speaks of here, despite the constantly iterated qualifications and walk-backs so distinctive in *Aesthetic Theory*, is constitutive for Adorno's Hegelianism. It is certainly Hegelianism of an odd variety, developed as a global and incisive critique of G. W. F. Hegel, in opposition to him, and as an attempt to subvert from within his most valued philosophical commitments. But it is Hegelian nonetheless in its unrelenting view that no nonconceptual mode of "objective Spirit" (and art is the last surviving example of this for Adorno) can be regarded as complete without its philosophical treatment. The quintessence of philosophy, or "thinking," as Adorno increasingly

put it, is irreducibly discursive, the work of the philosophical concept working on the philosophical concept.[5] Hegelian is the idea, too, that dialectics requires that art yield to the philosophical concept.

Yet such a capitulation also contradicts the claim of aesthetic autonomy, the idea that a nonconceptual medium of experience survives, if at all, only as aesthetic comportment. *Aesthetic Theory* is notoriously reticent about how philosophical interpretation can release art's truth content in a way that allows art to remain art. This has to do not only with the highly mediated treatment of the formal parameters of the artwork but also with the strikingly less developed theory of philosophical interpretation that Adorno employs in the book. His attempt to appropriate and transform both Hegelian and Benjaminian sources in the development of a negative dialectics is a recurring theme from the beginning of his work in the early 1930s. A dialectic that generates explosive images, in Walter Benjamin, and one that insists come what may on completing the unfolding of all possible determinations so that all that was potential is actualized, in Hegel (and Georg Lukács), makes for a highly unstable synthesis, to be sure. This is the basis for Adorno's earliest draft of a distinctive method of philosophical interpretation of social reality in the essay on natural history.

"The Idea of Natural History" is the text of a speech Adorno delivered in 1932, when he himself was not yet thirty.[6] Along with his inaugural lecture at the Goethe University in Frankfurt, "The Actuality of Philosophy" from the previous year, the essay can be read as a kind of manifesto for synthesizing two radically different conceptions of dialectical thinking: Benjamin's image-based idea of "dialectic at a standstill," or the construction of shocking and disorienting images from out of the detritus of culture, and the orthodox Hegelian conception—here read through the filter of the pre-Marxist Lukács—that preserves the core Hegelian insight of dialectics as a logic of actualization of conceptual possibilities. This synthesis would be far from simple and in various forms would extend through the following three decades of Adorno's career, culminating in a refractory and inconclusive way in *Aesthetic Theory*. The 1932 essay does not represent a sort of key or legend to interpret Adorno's intellectual development—there is no such key. But the idea of natural history does play a substantive albeit often subterranean role in *Aesthetic Theory*. That role is to be found less in the book's ambivalent recovery of the Kantian theory

---

5. For helpful discussions, see Bernstein, "Negative Dialectics as Fate"; Pinkard, "What Is Negative Dialectics?"; and Stone, "Adorno, Hegel, and Dialectic."

6. Adorno, "Idea of Natural History" (hereafter cited as NH).

of natural beauty—though it is certainly there—than in Adorno's theory of the truth content of the artwork.

As I have argued elsewhere, the idea of natural history that Adorno develops in 1932 is multidimensional and prismatic. Interpreting its origins, structure, and possible scope of application requires exploring different facets or valences, and each facet would require an extensive treatment in its own right.[7] Therefore the reconstruction that follows is compressed and omits many dimensions of natural history that merit attention.

In the 1932 essay Adorno adopts a procedure that would quickly become standard for him: he frames his discussion in terms of the crisis of philosophy. Natural history arises as a response to philosophy's incapacity to respond with interpretive aptness to the transformed conditions of late capitalist society, not least its own looming antiquation. He rejects Heideggerian neo-ontology as merely replicating, rather than solving, the exhaustion of philosophy's paradigm of the sovereign rational subject and its domination over its objects of knowledge. He suggests that philosophy must adopt a version of Hegelian-Marxist dialectical criticism in order to shoot the rapids of impending irrelevance between neo-ontology and positivism. "The Idea of Natural History" offers a methodological proposal for just how such a revised form of dialectical criticism could gain access to its objects without merely reiterating philosophical idealism's reduction of the objects of criticism to reflections of the intent and powers of the rational subject. This is among the factors that make Adorno's deliberate reference to an *idea* of natural history so significant.[8]

Adorno demands that philosophy remain, in essence, a work of discursive reason, of concepts and conceptual analysis, but that concepts must be remobilized, transformed in their most basic nature and function, in order for them to disclose, rather than dominate, the truth content of their objects. The "idea" of natural history that Adorno has in mind is a productive mode of dialectical treatment defamiliarizing and transforming concepts in both content and function, in this case nature and history, the two concepts whose relation is the ultimate topic of metaphysical idealism. Nature is the given, extramental reality, the objective and the taken-for-granted background of sapient life. History is the sphere of the human, of freedom, and hence the realm for the possibility of moral autonomy, of self-creation. Nature, in other words, is the eternal unchanging; history is the possibility of meaningful change, of narrative coherence and affirmation of subjective purpose. By calling natural history

---

7. Pensky, "Natural History."
8. See the discussion in Gordon, *Adorno and Existence*, 50–58.

an idea, Adorno refers to the Kantian view that ideas are concepts for which we are not provided with an accompanying representation, and which therefore are not of use for cognition but play different roles for other forms of mental life. The idea of natural history changes the relation between concepts, rather than determining the range of their legitimate application to empirical experience. This foregrounds the essay's central argument that, as a response to an exhaustion of both philosophical idealism and positivism as ways to cognize the materiality of a commodity-based society, natural history is a method for thinking and experiencing the commodity-based material dimension of modern life differently.

Adorno suggests that the contemporary crisis of philosophy reflects a broader social crisis of meaning synonymous with the (European) modern. This crisis includes the exhaustion of previous efforts to think a social totality from the relation of concepts of objective nature and rational subject. History can no longer plausibly appear as the context for the narrative self-creation of moral subjectivity any more than nature can appear as the taken-for-granted, the given materiality of a found or made world. Heideggerian historicity simply declares nature and history as compatible by fiat; Marxist historiography demands, rather than develops, the narrative meaning of historical processes both objectively and subjectively guaranteed. Positivism reflects the technological ideal of nature as neutral matter on which human ambitions are exercised.

Against this background of intellectual crisis, the idea of natural history is what Fredric Jameson calls a "methodological proposal."[9] What if, the natural history essay proposes, an alternative mode of apprehending the nature-history relation could catapult philosophy beyond these discursive dead ends?

Adorno proposes an alternative mode of the nature-history relation beyond its static antinomic opposition: a mode of dialectical thinking that permits each concept to develop into its most extreme formulation until it "flips" to its opposite, or, as Jameson puts it, the opposed poles of nature and history "be allowed to dialectically short-circuit one another."[10] Thus the subject can "comprehend historical being in its most extreme historical determinacy, where it is most historical, as natural being, or if it were possible to comprehend nature as an historical being, where it seems to rest most deeply in itself as nature" (NH, 117). Precisely as nature, in the form of mythic and endless repetition, the object discloses itself as the realm of human striving. The human world, despite the narrative of purposiveness that sustains its taken-

9. Jameson, *Late Marxism*, 94.
10. Jameson, *Late Marxism*, 98.

for-granted appearance, reappears as a realm of meaningless and unchanging repetition—as myth. Nature, conversely, discloses itself as the most intimate aspect of the human, as a physical being, whose death is no longer its "ownmost possibility" but the most natural of physical events and, as such, no longer in any sense singular but endlessly repeated and deprived of the prerogative of narrative significance.

What would later take shape as the structure of domination and emancipation in *Dialectic of Enlightenment* appears here as a proposal for *comprehending* the human and natural worlds *as* each other—with the clear implication that each, so comprehended, sheds its illusory appearance as a structure capable of bearing either human or natural significance.[11] Humanity-as-nature is dead nature, as in the Christian catechism of *vanitas*, or the specter of radical meaninglessness in the reversion of human to natural being, once the promise of God's grace (or, in secular terms, the narrative of human moral and technological progress) collapses. Nature *as* nature, at its most nonhuman, is the specter of endless repetition, the ever-same: again, the way the world looks once ideologically driven narratives of meaning have collapsed. At its most "natural," then, nature reflects our own disappointed demands for significance. In other words, it is humanity at its most quintessentially human. This suggests the primacy of the *insignificant material* as the dialectical meeting point of natural and historical worlds. The ruin, the fragment, the reviled and meaningless waste products of human-natural interactions, are allegorical contemplative objects, disclosing the failure of the human project of mastering both inner and outer nature. Filling voids of meaning with a profusion of objects (commodities), humans estrange themselves ever farther from their world, from one another, and from any subject-object relation that would offer delivery from material want and fear while reconfiguring a pacific relation to inner and outer nature.[12]

This notion of "comprehending-as" sees the idea of natural history as a transformed mode of experience, as a *way to see* as well as a way to cognize. Adorno also indicates that this mode of thinking-seeing via the idea of natural history transforms not just the representation of the human and natural worlds but also the subjective disposition of the thinker-seer. Referring explicitly to Benjamin's theory of melancholy subjectivity from *Origin of the German Mourning Play*, Adorno specifies that the idea of natural history requires (or

11. On the natural history essay as the precursor of *Dialectic of Enlightenment*, see Buck-Morss, *Origin of Negative Dialectics*, 59.

12. See, in general, Bonss, "Empirie und Dechiffierung von Wirklichkeit," 202–10.

constructs) a melancholy subject. For Benjamin, melancholy is far more than a subjective affect of sadness. It is also a highly productive cognitive attitude that searches for clues of human or divine significance by the ever-deeper contemplative immersion into the realm of degraded and cast-off objects that surround it.[13]

Hence the idea of natural history is, as Adorno makes explicit, an updated and transformed version of the ancient philosophical ambition of *thaumazein*, wonder, astonishment (and not, as Robert Hullot-Kentor's translation puts it, shock, which in the Benjaminian context of this essay would mean something quite distinct [NH, 118]). Natural history is the astonishing transformation of experience via the unfamiliar use of timeworn natural and historical concepts, a maneuver yielding a *change of perspective*, a way to both cognize and behold. As Adorno puts it, "Natural History is not a synthesis of natural and historical methods, but a change in perspective" (NH, 119).[14] Like Jameson and Susan Buck-Morss,[15] I stress here natural history's primary function as an *Entfremdungseffekt*, as a conscious method of defamiliarization. Beyond this, however, we should see the idea of natural history as truth generating.

As explanatory sources and examples for this change of perspective, Adorno draws on two roughly contemporaneous texts. The first is Benjamin's treatment of the baroque dramatists' descriptions of a godforsaken world in *Origin of the German Mourning Play* (1928); the second is the pre-Marxist work of Lukács in *The Theory of the Novel* (1914–15) and his account of the novel's capacity to register on the level of subjective experiences the draining of significance of the human world as the world of convention, of second nature.[16]

One way to understand the perspective change Adorno has in mind is that a natural-historical perception of the phenomena of experience permits them to appear released from conventional cognitive demands, which are themselves thoroughly conditioned by the structural requirements of comprehensive social domination. In natural history, things appear without diffraction through the lens of ideology. They are in this sense wondrous in an archaic sense. In the terms that Lukács would use only ten years after he wrote *The Theory of the Novel*, natural history shows us the human world of second

---

13. For a full treatment, see Pensky, *Melancholy Dialectics*, chaps. 2–3.

14. For an earlier discussion of the significance of this claim of natural history as a "change in perspective," see Schmid Noerr, *Das Eingedenken der Natur im Subjekt*, 28–34.

15. See Buck-Morss, *Origin of Negative Dialectics*, chap. 3.

16. On natural history's use of Hegelian-Lukacian second nature, see MacDonald, *What Would Be Different*, 59–77.

nature in its unreified form: stripped of the appearance of meaning and hence no longer any help in the labor of ideological reproduction. The appearance of the phenomena of experience as radically meaningless also means that objects as they appear to us disappoint our cognitive expectations to integrate themselves into a coherent worldview. In the perspective change of natural history, this disappointment is not to be taken as a failure of the cognizing subject, as a miscognition or misrecognition. On the contrary, the experience of finding oneself in the midst of meaningless things is a cognitive gain. Natural history is truth generating, but the truth it generates is alethic, not propositional. It offers us a fleeting glimpse of the human and natural worlds as they are. The view may be wondrous, but it is not pretty. (In *Endgame*, when Clov finally succeeds in glimpsing the world outside, Samuel Beckett compresses the results into a single word: *corpsed*.)[17]

For Adorno, the object as disclosed through the natural-historical perspective is radically *transient* (*vergänglich*). Transience is the point of contact in the dialectic of nature and history where the two concepts perform their "flip," or transformation, where their polarity reverses.

In Benjamin's earlier analysis, transience was indexed directly to the seventeenth-century theological emergency that Benjamin saw as driving the genre of *Trauerspiel*: the effort to develop a Lutheran aesthetic sensibility and hence the vision of the human realm as not capable of bearing the load of existential or spiritual significance, of meaning for us, that we demand. For the artists of the baroque, transience was the distinctive mode of appearance of the world of human-made things under the corrective perspective of vanity, the world as godforsaken. The overcoming of vanity entails the capacity (or the compulsion) to see how the world is.

In secularized form, this conception of philosophical interpretation of the real as a mode of prayerful tarrying with the reviled, rejected, and demeaned objects otherwise consigned to oblivion brings us back to the prospect of an alternative philosophical criticism. Transience means not just the passing of all things into and then out of existence. It discloses the status of a subject/object as the absolute negation of Spirit, not just as temporary, but as annihilated. The transient object's passage out of existence is its collapse-decay (*Zerfall*): its disappearance leaves no trace; it is obliterated beyond memory, *verschollen*. As an object of contemplation, the transient thing is recuperated as meaningful, but only insofar as its meaning is its utter incapacity to acquire and hold meaning. It points beyond itself, but only by vanishing under the mel-

17. Beckett, *"Endgame" and "Act without Words,"* 29.

ancholy gaze of philosophical interpretation. (Benjamin had described this as the "antinomy of the allegorical.")

This anti-Hegelian advocacy for the transient, for what the dialectic leaves unpreserved, is also just what Adorno appeals to in the final entry of *Minima Moralia*, and the perspective of natural history is the implied topic when he states that "perspectives must be fashioned that displace and estrange the world, reveal it to be, with its rifts and crevices, as indigent and distorted as it will appear one day in the messianic light."[18]

This rather lightly secularized sense of natural history as a response to a crisis of meaning also points to the crucial moment where Adorno's conception diverges from Benjamin's. Transience is a functional equivalent for the kind of radical immanence that, for Benjamin in the *Trauerspiel* book, is the dialectical meeting point between nature as a realm of godforsaken things and human history as a continuum of catastrophe. But for Benjamin's version of the dialectic, this meeting point of the *concepts* of nature and history generates at their moment of dialectical indifference not a higher or more developed, a sublated, concept (as it must for both Hegel and Lukács) but an *image*—an emblem or allegorical visual construct. It is in this image that Benjamin's peculiar Platonism resides. He sees the graphic nature of natural history to be central, not just for the baroque dramatists but for the contemporary recovery of natural history as dialectical social criticism. For Benjamin, the privileged set of emblems generated through the force field of natural and historical perspectives is a graphic expression of the objective situation of a given historical space. This is the Platonic sense in which Benjamin develops his eccentric use of "idea" in the book on tragic drama, a use also deeply influenced by German art history from Riegl to the Warburg School. In this he differs deeply from the Kantian use of that term that Adorno would later make.[19] Hence we should not expect any general emblematics but, rather, remain attuned to the specific character of the emblematic representation of natural-historical transience depending on the aesthetic genre in question and its mediation by its cultural as well as its social and economic constitution.

For the baroque, Benjamin identifies the recurring emblem of the human corpse, the ultimate subject-object of transience: neither really subject nor really object or, abjectly, too much of both at once, situated at the dialectical meeting point of nature and history and "short-circuiting" both. The graphic or dramatic representation of the corpse is the center of the baroque dramatists'

18. Adorno, *Minima Moralia*, 247.
19. For a discussion, see Pensky, *Melancholy Dialectics*, chap. 2.

imagery as the visual representation of the impossibility of transcendence of any kind. But precisely for this reason, the baroque dramatic obsession with the unrepresentable dead body, like the broader Lutheran image economy, circles endlessly around this impossible image, representing it again and again, transmuting it into the allegory of all allegories, the very meaning-giving emblem for the condition of transcendental lack of meaning, an object that stands for a missing subject, death that stands for life, creaturely life that stands for its own overcoming, and the specter of a meaningless history that stands for its own negation.

Benjamin would devote decades to the effort to transpose this critical distillation of seventeenth-century imagery, with all its peculiar theological armature, into the origins of the commodity world in the nineteenth century, where the reified commodity bears the same disclosive range of possibilities for understanding the world of high capitalism that the corpse bore for the baroque. Both are graphic representations of radical transience, and both make the peculiar double gesture of offering but also withdrawing the possibility of discovering human meaning through the material world. Commodities are material embodiments of subjective loss—alienated labor—whose genesis narrative has been forgotten.

Where Benjamin saw transience as a privileged form of emblematics, Adorno, as ever, insists on interpreting transience in discursive terms, as a concept, though one whose uses and effects diverge from the inferential in the operation of what Kant would have called determinative judgment. Benjamin saw transience as a nondiscursive field of appearance and drew conclusions from this about the nature and limits of discursivity for radical dialectical cultural criticism. Adorno follows Benjamin to this point but no farther. He sees transience as a discursive treatment of material objects that releases them from the ideological appearance of reconciliation and discloses them as they would appear without ideology. That is a cognitive gain, and one still falling under the work of the concept. Adorno's work on Søren Kierkegaard from 1933 constitutes a book-length effort to follow just this approach.[20]

Adorno would not repeat the methodological experiment that made *Kierkegaard: Construction of the Aesthetic* so distinctive a work among his early writings. Yet at no point in his later work did Adorno regard the central claims of the natural history essay to have been made superfluous. On the contrary, in his lectures from the 1950s and 1960s, above all the lecture series on history and freedom from 1964–65, he returns to the idea of natural history, quoting at

---

20. Adorno, *Kierkegaard*.

length from his 1932 essay and asserting its continuing validity, but this time emphasizing the Hegelian background of Lukács's conception of second nature as a "Golgotha of rotted interiorities."[21]

In these lectures from the mid-1960s (as Adorno was also working on *Aesthetic Theory*), we still observe Adorno's debt to but also his differences from Benjamin. Benjamin's nonconceptual, visual approach was meant to generate a kind of image-based insight into the condition of the real. Adorno demands a negative-dialectical conception of natural history as a force field between opposed concepts, where their reciprocal sublation into a higher form is momentarily held in arrest. That arrest or hiatus marks the specific cognitive dimension of a heightened perception of breaks or interruptions in the ideologically smoothed-out transmission of experience, and so is also truth generating: not as *presentation of image*, in Benjamin's sense, but in *philosophical interpretation*, which preserves the moment of rationality. Moreover, in the later reference to natural history in the lectures on history and freedom, Adorno is explicit that this rational content is nothing other than the philosophical interpretation of the aesthetic, in the broadest sense of that term.

In the 1965 lecture, as in 1932, the "fact of transience" is the moment of maximum dialectical tension between the concepts of nature and history. The later Adorno continues to describe natural history as a "gaze" with origins tracing back to Benjamin's interpretation of baroque allegory, a model for the philosophical interpretation of aesthetic works and genres.[22] He reminds his audience that "through the medium of aesthetics questions concerning the philosophy of history and even metaphysics become legible."[23] This certainly justifies the appropriation of Lukács's and Benjamin's genre-specific interpretations (applied to baroque drama and the modern novel) of the idea of natural history as part of a far broader program for a new mode of philosophical inter-

---

21. Here, too, a translation quibble. Lukács's phrase to describe second nature is "eine Schädelstätte vermodeter Innerlichkeiten," and the reference to a "place of skulls" is a deliberate reference not to a charnel house (a tomb, or metaphorically a place of death) but to Golgotha or Calvary, literally "the place of skulls," and hence surely also an indirect reference to the closing words of *Phenomenology of Spirit*, where Hegel summons the moment of Absolute Spirit as total reconciliation and the final triumph of Spirit over all contingency, marginality, loss, and forgetting—in other words, the full triumph of History over Nature, whose precise negation is the very quintessence of the Idea of Natural History. See Lukács, *Theorie des Romans*, 55.

22. "We might even say in general that the transition from philosophy to criticism represents something like a secularization of melancholy. This is a melancholy that has become active, not a melancholy that makes do, that remains stuck fast in an unhappy consciousness, not at home with itself, but a consciousness that exteriorizes itself as a critique of existing phenomena. Such a melancholy is probably the pre-eminent critical, philosophical stance" (Adorno, *History and Freedom*, 134).

23. Adorno, *History and Freedom*, 125.

pretation of art in general. At a time when his own work on *Aesthetic Theory* was underway, this also signals that that book, like *Negative Dialectics*, should be seen as yet a further installment in this program. In fact, Adorno is explicit on this point in the history and freedom lectures:

> In general, we might say that interpretation means reading nature from history and reading history from nature. Interpretation teases out of the phenomena, out of second nature, out of what has been mediated, out of the world around us that has been mediated by history and society, the fact that they have evolved—in just the same way as it shows that there can be no evolution without the process being convicted of its own naturalness, while the evolution itself, mediation, must be understood as a prolonged state of immediacy, a natural condition.[24]

Adorno demands that any mode of metaphysics worth pursuing now would reverse the classical demand for transcendence, for the upward-looking gaze, the priority of the subject, the demand for the meaningful whole. Metaphysics has become a downward-gazing practice, an insistence on looking at the most reviled, neglected, and marginalized aspects of material culture, to discharge whatever obligation we still have to the world of things and to our own metaphysical needs.

Yet in *Negative Dialectics*, the experiment in how to conceptualize differently that consumed so much of Adorno's postwar work, this injunction serves as little more than an opening motto. The work itself is devoted nearly entirely to rereading canonical authors and texts of German philosophy and working through the privileged concepts of philosophical idealism. The model of "natural history" in the long section on Hegel consists of reading Hegelian passages removed from their textual context and placed in novel trial combinations with one another. *Negative Dialectics* may be a descendant of the original program of natural history, perhaps, but it is a very distant one.

*Aesthetic Theory*, on the other hand, still shows the strong influence of the proposal for a philosophical interpretation out of fragments, provided that we are willing to see the transitory fragment now in the form of the artwork itself. The book makes virtually no reference to the idea of natural history.

Some readers have taken those few oblique references it does make to be part of Adorno's ambivalent, halfhearted reappropriation of the Kantian concept of natural beauty.[25] But the return of natural history in *Aesthetic Theory*

---

24. Adorno, *History and Freedom*, 134–35.

25. See, among others, Paetzold, "Adorno's Notion of Natural Beauty"; and, more recently, Kreber, "Traces of the Other."

takes a different path. Central to Adorno's theory is the ephemerality of the artwork, and in numerous places in the text Adorno clarifies that this ephemerality is connected to the artwork's historical situation, insofar as the artwork is embedded in contingent historical conditions and hence unable to maintain the "pretense of timelessness" (*AT*, 83). This consigns the artwork to a kind of ultimate temporal irrelevance, the afterlife of rare "famous" individual works nothwithstanding. But ephemerality also endows artworks with a cognitive content. "Unbeknownst to themselves, [artworks] represent the historiography of their times, which is why they are related to knowledge" (*AT*, 84).

The anti-Platonism of the claim that the ephemerality of the aesthetic object underlies artwork's cognitive contents is a crucial connection between Adorno's earlier theory of the fragment as an object of philosophical interpretation and *Aesthetic Theory*'s view that the artwork stands at the frontier of multiple temporalities. Some of these temporal dimensions are internal to the received history of the art institution, a story that ends up in the twin dead ends of postmodern pastiche and modernist nominalism, as Adorno claimed in *Philosophy of Modern Music*. Others connect the institutional story of the vanishing of the authentically new to the larger dynamics of the progressive process of social domination, the *totaler Verblendungszusammenhang*, where artworks both deny and confirm their status as consumable commodities as a precondition for their very existence.

Artworks' eloquence, their capacity to express some version of their cognitive content, is bound up with their ability both to exude and to diffract history. This is what makes them both eloquent and enigmatic as well as ephemeral, urgently offering important information that vanishes in the very act of trying to receive it. (Adorno points out that this is what makes the fairy tale the apt model for thinking through the transmissibility of art's message.)

Art's ephemerality is captured for Adorno in the image of the firework, a physical process that "flashes up," in a decidedly Benjaminian way, both as physical spectacle and as cipher, as an implicit claim to a puzzle to be successfully interpreted even as the light writing vanishes in the instant of its legibility. This momentary incandescent flash—accompanied by the "shudder" of genuine art appreciation—*simply is* the artwork's truth content. The artwork, Adorno says, is consumed by its disclosure, and hence its ephemerality is paradoxically the artwork's most essential determination. This is the determinate negation of the Hegelian demand that the artwork live up to its job and stage the *Durchscheinen der Idee*: there is indeed a moment of the ideal in the artwork's ephemerality, but it is the ideality of the *refusal* of transcendence as a precondition for aesthetic truth.

In recent scholarship, two interpretive paths stand out as ways of understanding this argument for the ephemeral artwork's truth content.

The first of these paths begins by acknowledging the indeterminacy, ambiguity, and evanescence of the artwork's truth content, as well as Adorno's deep reluctance to offer any concrete guidance, in *Aesthetic Theory,* as to how such truth is to be thought of, apart from the familiar gnomic style of negative dialectics, in which a conceptual possibility is both offered and retracted. Nevertheless, this approach sees Adorno's claim of the art's truth content as still tied to rationality: the irrational or nonconceptual mode of aesthetic expression (as in Benjamin's dialectical images) remains off-limits as an option for cognition in a totally administered world, the night in which all cows are black. Truth content retains its rational core, without which there would be no sense in speaking at all of the truth content of art releasing itself, via its ephemerality, as it comes into contact with philosophical interpretation. In other words, the rational core of the artwork's truth content connects it with something other than art—with a critique of social reality and with the search for rational possibilities still able to serve as resources for this critique.

This interpretive path, insisting on the continuing relevance of the *rational* truth content of the artwork, distinguishes Fredric Jameson's *Adorno; or, The Persistence of the Dialectic*, a work that in many respects inaugurated the reappreciation of *Aesthetic Theory* in English at the opening of the 1990s. In this path we should also place J. M. Bernstein's argument that for Adorno the function and value of avant-garde art is its resistance to instrumental reason and its safeguarding for critique of a *rational* alternative.[26] Finally, more recent work by Owen Hulatt maintains the doctrine of art's truth content as a way to keep art and philosophy mutually "porous" in a joint search for a nondominating rationality capable of a nonviolent contact with the nonidentical.[27]

A second interpretive approach, however, embraces a reading of *Aesthetic Theory* that rules out such a direct connection between the ephemeral-enigmatic character of art's truth content and a form of philosophical interpretation that still insists on the discursive nature of any possible knowledge. According to this perspective, Adorno should be taken at his word when he refuses to grant aesthetic truth any determinacy. While artistic truth may "release" ephemerally under the attention of philosophical criticism, the truth that is thereby released only counts as truth from within the limits of the aesthetic sphere. Any connection to rationality—or to the rationally informed cri-

---

26. Bernstein, "Dead Speaking of Stones and Stars," 146–55.
27. Hulatt, *Adorno's Theory of Philosophical and Aesthetic Truth*, xiii.

tique of social domination—would have to be imported from the outside of the aesthetic and imposed on the artwork, thus negating those aspects of ephemerality and enigma that make art's truth true. Art truth, in other words, withholds its consent from being enlisted into critique, a point made by both Christoph Menke and Gerhard Richter.[28]

These two interpretive paths are not entirely mutually exclusive. Peter Uwe Hohendahl attempts to mediate between these positions, suggesting that the nondeterminability of the truth content of artworks places both of these interpretive paths on shaky ground. The relation between aesthetic truth and philosophical interpretation is so cloaked that it may be best for the question to remain aporetic, with the caveat that theological and not philosophical vocabulary may be best suited to give it whatever determination possible.[29]

The mode of philosophical interpretation that Adorno demands as a counterpart to aesthetic truth content in *Aesthetic Theory* still draws heavily, albeit subtly, on the earlier idea of natural history. Appreciating the continued presence of the idea of natural history in Adorno's theory of aesthetic truth will not in itself be definitive for choosing among the interpretive paths described above, or necessarily forge any new ones. But taking seriously the idea of natural history as a form of ideology critique, a conception I introduced at the outset, does count in favor of the first option, in which natural history is an interpretive methodology, a "changed perspective" that comes into contact with its fragmented objects, using them as lenses or correctives that disclose a world thoroughly distorted by social domination.

*Aesthetic Theory* begins in highly characteristic fashion by turning Hegel against himself: "That Hegel considered art transitory while all the same chalking it up to absolute spirit stands in harmony with the double character of his system, yet it prompts a thought that would never have occurred to him: that the substance of art, according to him its absoluteness, is not identical with art's life and death. Rather, art's substance could be its transitoriness" (*AT*, 3). This observation is worth taking seriously.

Transience—the refusal to bear meaning according to the rules of the game—is a word that Adorno appeals to fairly frequently over the course of *Aesthetic Theory* to refer to artworks, though only here at the book's outset does he imply that a form of Hegelianism (negativity) is required to claim that transience could constitute art's very substance. Ephemerality instead

28. See Menke, *Sovereignty of Art*; and Richter, "Aesthetic Theory and Nonpropositional Truth Content in Adorno."
29. Hohendahl, *Fleeting Promise of Art*, chap. 3.

moves to take the place of what in the natural history essay was the transient object of philosophical interpretation. The two terms, ephemerality and transience, are obviously closely related. But they are not equivalent. The latter expresses the dialectic of natural history in a way expressly tailored to the particularities of aesthetics, insofar as the "interpretation from out of fragments" developed earlier now addresses the monadic, lonely, and disparate appearance of art objects that for all the loss and disappointment they evoke are nevertheless connected both to melancholia and to a kind of joy—think fireworks—and here too they make an unexpected contact with philosophical thinking.

Transience is the object's refusal of signification according to any scheme of transcendence. Transience implodes the ideological bulwarks of nature and history, disclosing a glimpse of both the awful deformations formed under their mutual pressure (the world as "corpsed") and that deformity's contingency. All art and philosophy point in this way from what is revealed as contingent toward the radically possible. Natural-historical interpretation invites the melancholic brooder to pore ever more closely over the scrap heap of historical experience, which under that gaze transmutes into glowing ciphers referring to the radically other. Yet in philosophy's interpretation of artistic truth, melancholy cannot have the last word. Fireworks, not the heap of discarded or abandoned artifacts, is the apt metaphor. Art's ciphers of another world blur this one. They also dare to spill the secret that melancholy brooding cannot, that of hope.

Every successful interpretive release of art's truth does bear implications beyond the aesthetic sphere that the perishing artwork itself can neither comprehend nor fully contain. This is how art's fate—the stringency of modernism and the never entirely successful disavowal of artistic pleasure—refers back to its most archaic impulses. As Adorno puts it:

> Art is no more able than theory to concretize utopia, not even negatively. A cryptogram of the new is the image of collapse; only by virtue of the absolute negativity of collapse does art enunciate the unspeakable: utopia. In this image of collapse all the stigmata of the repulsive and the loathsome in modern art gather. Through the irreconcilable renunciation of the semblance of reconciliation, art holds fast to the promise of reconciliation in the midst of the unreconciled: this is the true consciousness of an age in which the real possibility of utopia—that given the level of productive forces the earth could here and now be paradise—converges with the possibility of total catastrophe. In the image of catastrophe, an image that is not a copy of the event but a cipher of its potential, the magical trace of art's most distant prehistory reappears under the total spell, as if art wanted to prevent the catastrophe by conjuring up its image. (*AT*, 32–33)

**Max Pensky** teaches in the Philosophy Department at Binghamton University.

## References

Adorno, Theodor W. *Aesthetic Theory*, edited and translated by Robert Hullot-Kentor. London: Continuum, 2002.

Adorno, Theodor W. *History and Freedom: Lectures, 1964–1965*, edited by Rolf Tiedemann, translated by Rodney Livingstone. Cambridge: Polity, 2008.

Adorno, Theodor W. "The Idea of Natural History," translated by Robert Hullot-Kentor. *Telos*, no. 60 (1984): 111–24.

Adorno, Theodor W. *Kierkegaard: Construction of the Aesthetic*, translated by Robert Hullot-Kentor. Minneapolis: University of Minnesota Press, 1989.

Adorno, Theodor W. *Minima Moralia: Reflections from Damaged Life*, translated by E. F. N. Jephcott. London: Verso, 1974.

Beckett, Samuel. *"Endgame" and "Act without Words."* New York: Grove, 2009.

Bernstein, J. M. "The Dead Speaking of Stones and Stars: Adorno's *Aesthetic Theory*." In *The Cambridge Companion to Critical Theory*, edited by Fred Rush, 139–64. Cambridge: Cambridge University Press, 2004.

Bernstein, J. M. "Negative Dialectics as Fate." In *The Cambridge Companion to Adorno*, edited by Tom Huhn, 19–50. Cambridge: Cambridge University Press, 2004.

Bonss, Wolfgang. "Empirie und Dechiffrierung der Wirklichkeit: Zur Methodologie bei Adorno." In *Adorno-Konferenz 1983*, edited by Ludwig von Friedeburg and Jürgen Habermas, 201–26. Frankfurt am Main: Suhrkamp, 1983.

Buck-Morss, Susan. *The Origin of Negative Dialectics*. New York: Free Press, 1977.

Foster, Roger. *Adorno and Philosophical Modernism: The Inside of Things*. Albany: State University of New York Press, 2016.

Geulen, Eva. "Adorno's *Aesthetic Theory*." In *A Companion to Adorno*, edited by Peter E. Gordon, Espen Hammer, and Max Pensky, 397–412. Hoboken, NJ: Wiley-Blackwell, 2020.

Gordon, Peter. *Adorno and Existence*. Cambridge, MA: Harvard University Press, 2016.

Hammer, Espen. *Adorno's Modernism: Art, Experience, and Catastrophe*. Cambridge: Cambridge University Press, 2018.

Hohendahl, Peter Uwe. *The Fleeting Promise of Art: Adorno's Aesthetic Theory Revisited*. Ithaca, NY: Cornell University Press, 2013.

Horkheimer, Max, and Theodor W. Adorno. *Dialectic of Enlightenment: Philosophical Fragments*, translated by Edmund Jephcott. Stanford, CA: Stanford University Press, 2002.

Hulatt, Owen. *Adorno's Theory of Philosophical and Aesthetic Truth*. New York: Columbia University Press, 2016.

Jameson, Fredric. *Late Marxism: Adorno, or The Persistence of the Dialectic*. London: Verso, 1990.

Krebber, André. "Traces of the Other: Adorno on Natural Beauty." *New German Critique*, no. 140 (2020): 169–89.

Lukács, Georg. *Theorie des Romans*. Berlin: Cassirer, 1920.

MacDonald, Iain. *What Would Be Different: Figures of Possibility in Adorno*. Stanford, CA: Stanford University Press, 2019.

Menke, Christoph. *The Sovereignty of Art: Aesthetic Negativity in Adorno and Derrida*. Cambridge, MA: MIT Press, 1999.

Nicholsen, Shierry Weber. *Exact Imagination, Late Work: On Adorno's Aesthetics*. Cambridge, MA: MIT Press, 1997.

Paetzold, Heinz. "Adorno's Notion of Natural Beauty: A Reconsideration." In *The Semblance of Subjectivity: Essays in Adorno's Aesthetic Theory*, edited by Tom Huhn and Lambert Zuidervaart, 213–36. Cambridge, MA: MIT Press, 1997.

Pensky, Max. *Melancholy Dialectics: Walter Benjamin and the Play of Mourning*. Amherst: University of Massachusetts Press, 1993.

Pensky, Max. "Natural History: The Life and Afterlife of a Concept in Adorno." *Critical Horizons*, no. 5 (2004): 227–58.

Pinkard, Terry. "What Is Negative Dialectics? Adorno's Reevaluation of Hegel." In *A Companion to Adorno*, edited by Peter E. Gordon, Espen Hammer, and Max Pensky, 459–72. Hoboken, NJ: Wiley-Blackwell, 2020.

Richter, Gerhart. "Aesthetic Theory and Nonpropositional Truth Content in Adorno." In *Language without Soil: Adorno and Late Philosophical Modernity*, edited by Gerhard Richter, 131–46. New York: Fordham University Press, 2010.

Schmid Noerr, Gunzelin. *Das Eingedenken der Natur im Subjekt: Zur Dialektik von Vernunft und Natur in der kritischen Theorie Horkheimers, Adornos und Marcuses*. Darmstadt: Wissenschaftliche Buchgesellschaft, 1990.

Stone, Alison. "Adorno, Hegel, and Dialectic." *British Journal for the History of Philosophy*, no. 22 (2014): 1118–41.

Wellmer, Albrecht. "Truth, Semblance, Reconciliation: Adorno's Aesthetic Redemption of Modernity." *Telos*, no. 62 (1984): 89–115.

Zuidervaart, Lambert. *Adorno's Aesthetic Theory: The Redemption of Illusion*. Cambridge, MA: MIT Press, 1991.

# On the "Spiritual" in Aesthetic Experience; or, The "Nonfactual in Facticity"

## Hent de Vries

"Spiritual experience" forms quite literally the pièce de résistance of Theodor W. Adorno's late thought and is, perhaps, the most important part of its enduring legacy. But its very concept and practice is also what—analytically and systematically, dialectically and pragmatically speaking—presents the greatest hurdle to its interpretation. The expression *geistige Erfahrung*, best translated as "spiritual experience," appears in Adorno's 1965–66 lecture course, *Vorlesung über negative Dialektik* (*Lectures on Negative Dialectics*), notably in its appendix "Zur Theorie der geistigen Erfahrung" ("On the Theory of Spiritual Experience"), a title that its otherwise superb translator, Rodney Livingstone, renders as "Towards a Theory of *Intellectual* Experience," which obscures its more salient point, in fact, its conscious provocation. A "translator's note" does little to repair the damage, even though it clearly acknowledges the existing dilemma:

> The German word *Geist* (spirit, mind, intellect) and its adjective *geistig* have presented particular difficulties in this translation. Normally, the translator tries to achieve consistency, but that has proved hard in this instance. *Geist* is commonly translated as "spirit" (as in Hegel's *Phenomenology of Spirit*), and this was an important component of Adorno's intellectual heritage. "Spirit" has therefore been the translation of choice in some instances. But to translate the essay in the Appendix *"Zur Theorie der geistigen Erfahrung"* as "The

*New German Critique* 143, Vol. 48, No. 2, August 2021
DOI 10.1215/0094033X-8989232    © 2021 by New German Critique, Inc.

Theory of Spiritual Experience" would convey entirely the wrong impression in English, because of the strong theological overtones that are quite absent from Adorno's text. In the published version of *Negative Dialectics*, Adorno refers to *Geist* as "a semi-theological word," but those overtones are too intrusive in English. Equally, mind in the sense of mind and matter are normally rendered in German by *Geist und Materie*. "Mind" and "mental" have proved to be possible renditions in a number of passages, but I have opted on the whole for "intellect" and "intellectual" in the example given above ["The Theory of Intellectual Experience"] and elsewhere. However, no single term proved viable in every case. The fact is that the term *Geist* falls somewhere between the available English words—spirit, mind, intellect—with all of which it also overlaps. Each of the terms seems to work in some instances, but not in all.[1]

It is doubtful that we should accept the far-reaching claim that, in *this* instance, seen in light of the broader "intellectual heritage" of which it forms an integral part—and even accounting for subsequent shifts in historical meaning of the terminology in question—the translation *geistig* with "spiritual" would not be far more pertinent.

As it turns out, the passage from Adorno that Livingstone goes on to cite to convey "something of the word's [i.e., *Geist*'s] flavor" also does little to justify his translator's decision. The passage stems from the ninth of the aforementioned lectures on negative dialectics and is taken to resume and clarify earlier references to the expression in question while offering a cautionary note as to how to understand not only the word *geistig* but also *Erfahrung* (here unproblematically rendered as "experience"). "Admittedly," Adorno says and Livingstone translates,

> this concept of intellectual [*geistige*] experience is infinitely [*sic*] far removed from the trivial concept of experience. This is because the concept of what is the case, of fact, of what is given [*der Begriff der Tatsache, des Faktums, der Begebenheit*], that is canonical for empiricist philosophies and which is based on [i.e., finds its original image, its *Urbild*, in] sense experience, that is, on *sense* data, has no validity [*Geltung*] for *intellectual* [*geistige*] experience, which is the experience of something already intellectual [*Erfahrung von bereits Geistigem*] and is an intellectually [*geistig*] mediated experience.[2]

Nothing in this translated passage warrants tilting the meaning of *geistig* and *Geistiges* toward that of "intellectual" or "the intellect," unless it is the last sen-

---

1. Livingstone, "Translator's Note," x.
2. Livingstone, "Translator's Note," xi (translation modified). Cf. Adorno, *Vorlesung über negative Dialektik*, 131.

tence's reference to "mediation." The latter, at least in the Hegelian conception of unfolding of Spirit, carries all the historical and systematic baggage of a mediation *through concepts*, the very *labor* of the concept that—necessary, while insufficient, as it is and always must be—Adorno would for the rest never disparage. The conclusion, that all this pushes Adorno's late thoughts on "the spiritual" and "spiritual experience" dangerously close to the "outbreak attempts [*Ausbruchsversuche*]," notably Henri Bergson's and Edmund Husserl's, with which Adorno so often took critical issue, should perhaps just be acknowledged. But this is a risk that he and most of his interpreters were, perhaps, not always willing to run and that we must now squarely face (discerning of spirits or of, at least, two spirits, as the tradition of spiritual practice and exercise has long insisted).[3]

———

As Roger Foster reminds us, referring in passing to a chapter in Adorno's *Drei Studien zu Hegel* (*Hegel: Three Studies*), titled "The Experiential Content [*Erfahrungsgehalt*] of Hegel's Philosophy":

> Adorno's lectures on negative dialectic delivered in the 1965/1966 winter semester at Frankfurt University, lectures delivered very shortly before the publication of *Negative Dialectics*, provide substantial support for the thesis that this work as a whole can be understood as an elucidation of the idea of spiritual experience. While retaining the basic idea of the earlier Hegel lectures that spiritual experience involves the interpretation of "any and every existing thing as something that is at the same time spiritual [*ein jegliches Seiendes als ein immer zugleich auch Geistiges*],"[4] the lectures on negative dialectic make clear the pivotal role of spiritual experience as a counterconcept to the withering of experience, and provide more explicit details on how it is supposed to work. Adorno describes spiritual experience as a "spiritualization [*Spiritualisierung*] of the world" that goes beyond "mere, immediate sensuous experience."[5]

To complete the picture and give it more background, Foster provides some further elements and offers his—decidedly immanentist and naturalist and

3. For a nuanced account, see Foster, *Adorno*; and Gordon, *Adorno and Existence*, 58–64, 188–93.

4. The reference is to Adorno's chapter "Erfahrungsgehalt," in *Drei Studien zu Hegel*, 56; "The Experiential Content of Hegel's Philosophy," in Adorno, *Hegel*, 57.

5. Foster, *Adorno*, 5–6. The expression "spiritualization of the world" can be found in Adorno, *Vorlesung über negative Dialektik*, 132. The English translation, *Lectures on Negative Dialectics*, 89, renders "*Spiritualisierung*" correctly.

realist, if nonempiricist, but contextualist and even macrocosmic—interpretation as to how to take them in ever fuller "cognitive" terms:

> From the time of the 1931 *Antrittsvorlesung* [the inaugural address, titled "Die Aktualität der Philosophy" ("The Actuality of Philosophy")], Adorno had sought to elucidate a type of reading in which particular items (whether philosophical concepts, musical pieces, artworks, social objects, etc.) would be interpreted as the locus of an immanent universal. Each particular thereby becomes a microcosm, where every element of that particular is a cipher that, when appropriately interpreted, can be made to reveal an aspect of that particular's spiritual significance. The reference to this type of experience as "spiritual," *geistig*, is intended to distinguish it from the empiricist notion of experience. What is distinctive about spiritual experience is that the multilayered relations of a thing with other things outside it, and eventually the entirety of its context, are allowed to inform the cognitive significance of that thing.[6]

While one may wonder whether "the spiritual" is best captured by referencing it in terms of "immanence," that is, of "things," placed in an "entirety of context" and with "cognitive significance"—much of which would seem to be part and parcel of the "sensuous" and "intellectual" nature of experience as we know it beyond its immediacy—Foster makes clear that Adorno's own lexicon leading up to, but also surrounding and building on, the motif of "spiritual experience" does not leave it at that curious expression either. In fact, the term and everything it not so much directly connotes but also more indirectly intimates and pulls into its orbit from a distance shades into further-ranging expressions that we can read as equally important or relevant translations, transpositions, and commentaries on the original terminology. These expressions, names, and concepts, while they are nonsynonymous and nonidentical substitutions of the later or earlier term, are nonetheless answerable to the same overarching idea, imperative, or, indeed, experience.

In addition to the dozen or so times that the phrase *spiritual experience* is deliberately used in *Negative Dialectics*, we find next to "philosophical" and "metaphysical experience"—the two most significant parallels—strikingly similar references to "temporal," "political," "bodily," "full, unreduced," "living," "genuine" and "unregimented" or "unleashed experience."[7] This is the full list of related notions Foster comes up with, limiting himself in the context

6. Foster, *Adorno*, 2.
7. Foster, *Adorno*, 5.

of his study to those expressions that, while being anticipations and prefigurations, resonances and echoes, or also reformulations and reinterpretations of "spiritual experience, likewise, have as their correlative term "experience" in them.

———

The reference to "the spiritual," found notably in two of Adorno's major works, *Negative Dialektik* (*Negative Dialectics*) and *Ästhetische Theorie* (*Aesthetic Theory*), and in the accompanying lecture courses, known for their relentless critique of philosophical idealism as it manifests itself in a host of historical and contemporary guises, poses a potentially perilous problem of translation and, hence, of interpretation, appreciation, and reevaluation of his overall oeuvre. Yet the truth of "the spiritual," its moment and content, conceived metaphysically and pragmatically, first of all, holds up "against something else, not in itself [*gegen ein Anderes, nicht an sich*]."[8] Its counter- or nonfactuality is that of a "resistance," to begin with. Spirit, the spiritual, and a fortiori spiritual experience should nowhere be ontologically hypostatized or, in social and political matters, fetishized. In this respect, it must be distinguished, wrested and protected, from the false or perverse "spiritualization" and "spiritualism" of which Adorno is all too aware and deeply suspicious, even downright dismissive.

A telling possible source for our purposes might be found in Lisa Florman's *Concerning the Spiritual and the Concrete in Kandinsky's Art*, which admirably analyzes this modernist artist's textual, conceptual, and pictorial use of *das Geistige*, notably in his 1911 manifesto *Über das Geistige in der Kunst* (*On the Spiritual in Art*), on which Adorno comments in interesting ways. Florman highlights the manifesto's surprising and largely ignored subtext, namely, G. W. F. Hegel's *Vorlesungen über die Ästhetik* (*Lectures on Aes-*

8. As Gordon reminds us, Adorno considered his introduction to *Zur Metakritik der Erkenntnistheorie* (*Against Epistemology*), alongside "Der Essay als Form" ("The Essay as Form") and *Negative Dialectics*, as a prolegomenon to the overall program of his philosophical and material works project or also, as he wrote to Max Horkheimer, as "a kind of critical, dialectical prelude to a materialist logic." At the same time, he considered the engagement with Husserl's philosophy "the occasion and not the point of the book" (quoted in Gordon, *Adorno and Existence*, 60, 61). By the same token, Adorno's discussions of Hegel, of Kandinsky, and, for that matter, of "spirit" are likely to occasion arguments or, rather, exercises whose "point" lies elsewhere. This is not to say that all textual or contextual occasions are equally opportune at all times, but Adorno's relentless insistence on the "truth content" and "moment" of virtually all of tradition underscores the antihistoricism of his dialectical philosophy and the apparent anachronism it often relies on, strategically and tactically speaking.

*thetics*) and also offers a fleeting but crucial reference to Adorno's *Aesthetic Theory*.[9] Yet these two connections in the context of modern art and its philosophical interpretation, Florman argues, are best explained and interpreted against the background of two writings by Kandinsky's nephew Alexandre Kojève that shed further light on the very theme and argument of *On the Spiritual in Art*: the famous lectures on Hegel, delivered in Paris between 1933 and 1939, published in 1947, and the 1936 essay with extensive commentary on his uncle's nonfigurative paintings.[10]

After an extensive correspondence with his nephew, Kandinsky had asked him in 1936 to contribute a study on painting, including Kandinsky's own works, while making ample study of Hegel's thought, inspired by Kojève's more systematic analyses. In 1929 Kojève had written his uncle that the crucial contemporary questions raised by painting were less concerned with whether the art form should aim to be either figurative or abstract, as neither traditional nor modern art had ever aspired to merely imitate or represent reality per se, such as it is or presents itself to us. Rather, Kojève insisted, the decisive issue was whether art should be conceived of in subjective and idealist terms or in light of an objective realism, whose ultimate metaphysical justification was, perhaps, less speculative—read: Hegelian and dialectical in this sense—than deeply Platonic.[11]

Kojève's essay "Les peintures concrètes de Kandinsky" ("The Concrete Paintings of Kandinsky") was only published in 1966 and then, in a more extensive version, in 1985. As Florman notes: "Had this piece found its way into print when written, in 1936, we might have been left with a very different understanding of both Kandinsky's art and its philosophical implications."[12] It is certainly tempting to surmise that such a different understanding of Kandinsky's art and of *The Spiritual in Art*, by way of his nephew's seemingly Hegelian but deep-down Platonic, Neoplatonic—and, as I show, Solovievian—

9. Florman, *Concerning the Spiritual and the Concrete in Kandinsky's Art*.

10. Kojève, "Les peintures concrètes de Kandinsky"; Kojève, "The Concrete Paintings of Kandinsky," in Florman, *Concerning the Spiritual and the Concrete in Kandinsky's Art*, 151–71. See also, for an extensive earlier account of the exchanges and intellectual relationship between Kandinsky and Kojève, Auffret, *Alexandre Kojève*, 272–92, which is largely absent from the chapter on Kojève in Kleinberg, *Generation Existential*. Jeff Love mentions Kandinsky and his correspondence with Kojève in passing (*Black Circle*, 3) but insists throughout that while the presence of Marx and Heidegger in Kojève's reception of Hegel and wider oeuvre has been widely noted, "one important source of influence has been habitually neglected: the Russian literary, theological, and philosophical tradition from which Kojève sprang" (2).

11. Cf. *Kandinsky: Album de l'exposition*, 64.

12. Florman, *Concerning the Spiritual and the Concrete in Kandinsky's Art*, 2.

philosophical interpretation and revaluation of its meaning and force, might also cast a novel light on Adorno's strangely comparable mention and use of the "spiritual [*geistig*]" in aesthetic and other "experience." Such a hypothesis might further validate the claim that the rendering of *geistig* in *geistige Erfahrung* with "intellectual" is a fateful mistranslation in virtually all relevant contexts.

For all we know, Adorno was not familiar with Kojève's efforts at analyzing and systematizing his uncle's work in "The Concrete Paintings of Kandinsky," or with the correspondence with Kandinsky. Kojève's famous later introductory lectures on the *Phenomenology of Spirit*, by contrast, are an important, if mostly implicit, reference throughout Adorno's own, lifelong engagement with Hegel, which presents itself as a different, presumably more difficult (*skoteinos*) reading than those in vogue at the time (not just Kojève's but also Jean-Paul Sartre's and Maurice Merleau-Ponty's, Jean Hyppolite's, and, of course, Martin Heidegger's).[13] What to make, then, of the traces Kandinsky and, via him, Kojève may have left in Adorno's aesthetic theory and lectures?

––––––

Kandinsky thought that pure art, as expressed in painting, reflected the inner necessity of the soul, as presumably it alone, among the classical and modern art forms, elicits a response *from* and, then again, *to* the soul itself, rather than mirroring, representing, depicting, or so much as even "abstractly" expressing a pregiven natural or artificial object. In this turn to the innermost self by which Kandinsky will hardly have meant "our glassy essence" (to quote Richard Rorty, citing Shakespeare's *Measure for Measure*, in *Philosophy and the Mirror of Nature*),[14] but an infinitely wider dimension and greater depth of and in the soul, "the spiritual" finds the objectivity, universality, absoluteness, and true concreteness (as Kojève will say in his commentary) that modern art, thus defined, is best prepared to aspire to and gesture toward. Kandinsky was at once close and at an infinite remove from Hegel, who, as Florman reminds us, thought of *philosophy* as "the highest form of inwardness," because "it brings to our minds the same content [as we find in art and religion] . . . but makes it its own and knows conceptually what otherwise is

13. As Geroulanos notes, Kojève may have been directly or indirectly familiar with Adorno in the context of several reviews he contributed to the *Zeitschrift für Sozialforschung* (*Atheism*, 360n47). On Kojève's "negative anthropology," as formulated between 1931 and 1939, see Geroulanos, *Atheism*, 130–72. On the Hegel lectures, see Kleinberg, *Generation Existential*, 49–110.

14. Rorty, *Philosophy and the Mirror of Nature*, 42.

only the content of subjective feeling or pictorial thinking."[15] By contrast, no matter how objective and concrete Kandinsky, especially as interpreted by Kojève, thought his modern, pure paintings to be, their "content" was nowhere "conceptual." Nonfigurative, objectless painting, then, was differently inward, namely, spiritual. That is, its referent is "in-existent [*inexistent*]," Kojève writes, deploying an original motif and concept for which, at least in his early writings, he had found a much broader use, well beyond painting and art more generally, and that in recent decades has become a generic designation of programmatic relevance in philosophies and phenomenologies of the event and in so-called speculative realism.[16]

Art, as Kandinsky in his manifesto conceived it—and, in his later art work, also painted it—reveals an "invisible essence" of all forms of life. Yet, Kojève comments, it also, paradoxically, evinces a no-less-compelling "concreteness." What is meant by the latter is a most singular amalgamation of the invisible and the visible, of the spirit and materiality.[17] Kojève thus insists that Kandinsky's "nonrepresentational" painting, as a specimen of an "autonomous art" of "sight," is relentlessly "concrete and objective," as opposed to "abstract and subjective"; as a consequence, it must also be seen as "total and absolute" or "pure."[18] It is important to keep this in mind as we continue to grapple with the essence or meaning and force of the motif of "spirituality." After all, as Kojève goes on to note, Kandinsky's paintings capture and, perhaps, embody "a pictorial Beautiful that is not, has not, and never will be embodied anywhere else: in no real object other than the painting itself, which is to say, in no real, nonartistic object."[19] The spiritual in art, then, has no place in and among objects other than those that artworks offer themselves and hence finds no repose in other beings and things, which by their very nature can neither condition, pro-

---

15. Hegel, *Aesthetics*, 104, cited after Florman, *Concerning the Spiritual and the Concrete in Kandinsky's Art*, 46.

16. Auffret remarks that Kojève's invocation of the motif of "wisdom" joins what he calls a "Buddhist" notion of "In-existence" with a Hegelian notion of "negativity"—all of which, he continues, "renders suspicious all the recent and not so recent attempts to turn Kojève into a Hegelian disciple of Heidegger; for one searches in vain for the *In-existant* in Heidegger" (*Alexandre Kojève*, 243). See also Auffret, "Présentation," 13. The notion of the "in-existent" plays a role in the work of Alain Badiou, Quentin Meillassoux, and Jean-Luc Marion, three thinkers rarely discussed in the context of Adorno's work and its contemporary reception, although—in different registers, together with Emmanuel Levinas and Jacques Derrida, who are part of this dossier—they clearly should be.

17. Coming from a different, phenomenological perspective, Henry, in *Voir l'invisible* (*Seeing the Invisible*), suggests as much.

18. Kojève, "Concrete Paintings of Kandinsky," 171/170. Here and in subsequent citations, a virgule separates the page numbers in the English translation and the original text, respectively.

19. Kojève, "Concrete Paintings of Kandinsky," 163/163.

duce, nor explain it. In Adornian terms, this might be its *u-topian* quality, its "inexistence," as Kojève might have added.

Florman offers a translation and analysis of Kojève's essay to support her radically novel interpretation of the painter's nonfigurative phase and to correct or, at least, nuance the broad generalization that associates Kandinsky's mature work all too quickly with the work of his modernist contemporaries and with the tradition of esotericism (although references in *On the Spiritual in Art*— and only here—are given to theosophy and notably to Rudolf Steiner and Madame Blavatsky, next to very different authors such as Karl Marx and Edgar Allan Poe, suggesting that Kandinsky's interests were eclectic and his investment in esotericism limited).[20]

20. See the editorial note in Kandinsky, *Complete Writings on Art*, 117: "His occult interests were evidently of limited duration: by 1911, when he and [Franz] Marc were considering what material should be included in the *Blaue Reiter Almanac*, Kandinsky was already suggesting that any reference to the theosophists should be 'short and emphatic,' but when the almanac finally appeared, in May 1912, it contained no allusion to theosophy whatever." As Florman recalls, the case for occult influences on Kandinsky, among other modern artists, had been made notably by Ringbom, "Art in 'The Epoch of the Great Spiritual'"; and Ringbom, *Sounding Cosmos*. See also Introvigna, "*The Sounding Cosmos* Revisited." In fact, it seems clear that Kandinsky's ambition ran deeper, just as it reaches farther. Wood highlights the following passage from the *Blaue Reiter [Blue Rider] Almanac* manifesto: "'At a certain point the necessities are ripe. That is, the creative *spirit* (which one could characterize as the abstract spirit) gains access to the soul, later the many souls, and brings about a longing, an inner impulse.' The impulse has 'the power to create in the human spirit a new value.' The new value is then given material form. 'This is the positive, the creative. This is the good. *The white, fertilizing ray.* This ray leads to evolution, to elevation.' So art will transform the world through form" (*History of Art History*, 303). As Wood notes further, in 1912 Franz Marc would mention *On the Spiritual in Art*, next to Wilhelm Worringer's 1908 dissertation, "Abstraktion und Einfühlung (Abstraction and Empathy)," cited by Kandinsky, as one of the theoretical statements that had provided "the groundwork for a 'new dogmatics of the 'republic of the soul'" (304). While Marc and Kandinsky were "drawn not to systems but to anarchic representation . . . where nothing interfered, supposedly, with the expression of the artist's intuition of spirit," they left no doubt that, say, "magic required form. Traditional magic . . . looked to rules to generate the correct forms. The new magic—Kandinsky's—recreated the form anew each time" (305). What the new form expressed, Kandinsky thought, was "newness itself, the promise of the new century." Aesthetic form, then, in Kandinsky's own words, in *Der Blaue Reiter*, must be "always relative, because it is never more than the medium currently necessary through which today's revelation makes itself known, sounds forth'" (305–6). Contrast with this "Hegel's narration of art's registrations of the emergence of spirit (*Geist*) or ideality into history," which, Wood claims, leads inevitably to a "crack in Hegel's golden bowl" and a "faultline," namely, between "emancipatory aspirations and empiricist compunctions" that would haunt the fields and discipline of art history to this day (215, 222). One wonders, however, whether Kandinsky was not a "messianic thinker" in his own right, without buying into historical teleology, to be sure, but convinced, like Hegel, that "historical events point to their own destiny" (221), a destiny without determining causes or all too easily determinable effects, for that matter, but in which, de jure and de facto, "all things are possible," since "reality bursts open" and we are thrust out of it (one is reminded of the concluding lines of Ingmar Bergman's 1961 *Through a Glass Darkly* and the "hint of hope," reverting "emptiness" into "abundance," that it speaks of).

Florman shows that there are precise borrowings in the very opening passages of Kandinsky's manifesto, *On the Spiritual in Art*, from the concluding chapters of Hegel's *Lectures on Aesthetics*. She also convincingly demonstrates that "spiritual" art or "the spiritual in art," for Kandinsky, does not so much stand for "spiritualist" or "spiritualism," with its inevitable association with "Theosophy and Eastern mysticism and various forms of the occult."[21] For while these esoteric spiritualist elements are not fully absent in Kandinsky's major aesthetic essays and manifesto, at least the latter, well beyond its numerous eclectic references, should be seen, Florman claims, as "a fairly direct response" to Hegel's reflections on art. The whole work, then, comes across as "a revision of its historical framework that would culminate not in the end of art proclaimed by Hegel, but rather in something of the order of Kandinsky's own abstract paintings."[22] A useful reminder helps set the stage for this reasoned conclusion: "For Kant, art manifested only a dependent beauty, in contrast to the free beauty of nature. The view held by Hegel was almost the reverse. 'The beauty of art is beauty born of the spirit and born again . . . and the higher the spirit and its productions stand above nature and its phenomena, the higher too is the beauty of art over that of nature.'"[23] As there is no reliance of the artwork, in Kandinsky's own view, on any other object than itself, such that its concrete and universal—or pure—meaning, as Kojève had rightly observed, and aesthetic experience, more broadly, is no longer defined as the *merely* sensuous presentation of the Idea or Absolute, as Hegel had claimed, the former stands no longer in need of "dissolution [*Auflösung*]." "For us," Hegel had added, speaking of our contemporary life, "art counts no longer as the highest mode in which truth procures existence for itself [*Uns gilt die Kunst nicht mehr als die höchste Weise, in welcher Weise die Wahrheit sich Existenz verschafft*]."[24] And Adorno, on grounds internal to his overall theoretical project, which places philosophical, moral, and metaphysical experience on a par with aesthetic experience, would have to agree with Hegel's statement, as does, in sum, Kojève. For Kandinsky, however, nothing is less evident, and art—pure art—overtakes all other registers of experience, broadly conceived.

21. Florman, *Concerning the Spiritual and the Concrete in Kandinsky's Art*, 1.

22. Florman, *Concerning the Spiritual and the Concrete in Kandinsky's Art*, 1.

23. Florman, *Concerning the Spiritual and the Concrete in Kandinsky's Art*, 46. See also Pippin, "What Was Abstract Art?" and his 2011 book based on the Adorno lectures, *After the Beautiful*.

24. Hegel, *Vorlesungen über die Ästhetik*, 141; Hegel, *Aesthetics*, 103.

Kojève's essay does not *explicitly* draw on Hegel or even mention the concept of *Geist*. And while he seems to propose somewhat of a "'corrective'" to Kandinsky's own earlier writings and especially self-interpretation—attempting to "reconcile some of the inconsistencies or contradictions in those works, to make their arguments more conceptually coherent," as Florman says—Kojève nonetheless sees as his fundamental task in the essay to present a "more fully realized (if still accessibly written) response to Hegel's *Aesthetics*,"[25] with his uncle's mature paintings as the prime witnesses.

To begin with, the "essence" of art and the "motor of historical change" Kojève introduces here is not Hegel's Spirit at all but "the Beautiful [*le Beau*]." On this reading, the beautiful in art is "uncoupled . . . from any connection to *Geist*," yet—unlike natural beauty, as Hegel would surely have agreed—it already manifests "a certain freedom from nature."[26] In making this surprising claim, "The Concrete Paintings of Kandinsky" relies heavily on Kojève's dissertation completed under the supervision of Karl Jaspers in Heidelberg in 1926, on the Russian Orthodox thinker Vladimir Soloviev.[27] As Kojève reworked the dissertation in two articles published in 1934 and 1935, he had already discovered Hegel. Yet, as Dominique Auffret notes, Kojève "does not make use of Hegel to show eventual contradictions in the doctrine of the theologian [i.e., Soloviev] even though certain passages in the text warrant the supposition of a knowledge of Hegel, close to the reading of the *Phenomenology of Spirit* begun in 1933."[28] Hegel is thus introduced as a source for Soloviev's thinking, in addition, by the way, to Jakob Böhme and Friedrich Wilhelm Joseph von Schelling, who would influence the conception of Spirit, Wisdom or *Sophia*, in the "Sophiology of the Russian theosophist."[29]

Soloviev conceived of Beauty as one element of a "hypostatic trinity," next to the Good and the True, whose constitutive moments guide humanity toward the Absolute and do so *simultaneously* and *equiprimordially*, as in different but "equally vital aspects," which, following a long tradition of theolog-

25. Florman, *Concerning the Spiritual and the Concrete in Kandinsky's Art*, 45.

26. Florman, *Concerning the Spiritual and the Concrete in Kandinsky's Art*, 45.

27. For a summary account of that earlier project, *Die religiöse Philosophie Wladimir Solowjeffs*, by his own hand, see Kojève, "La métaphysique religieuse de V. Soloviev"; Kojève, *Religious Metaphysics of Vladimir Solovyov*. On Soloviev's early influence on Kojève, see Roth, *Knowing and History*, 83–124; and Auffret, *Alexandre Kojève*, 220–44.

28. Auffret, *Alexandre Kojève*, 221.

29. Kojève, "La métaphysique religieuse de V. Soloviev," 125, quoted in Auffret, *Alexandre Kojève*, 223.

ical doctrine, are "the same in *substance*." In other words, at no point does Soloviev assume a successive resumption of art and religion under the conceptual regimen of philosophy in Absolute Knowledge, which, as Hegel's *Phenomenology of Spirit* had explicitly claimed and as the *Lectures on Aesthetics* reiterate, was required for the Spirit (now translated in Soloviev's idiom as Wisdom) to reign supreme eventually.[30] Consequently, Kojève, drawing on Soloviev even more than on Hegel, will insist that the Beautiful in art, here, notably in the nonrepresentational, nonfigurative painting of his uncle Kandinsky, ought itself, that is, on its own terms, to be regarded as a fundamental "facet of the Absolute—something on par with *Geist* but possessing its own distinct, sensuous content."[31]

But what could such sensuous content possibly be and intelligibly mean if the "concrete and objective" art and painting in question—in its very definition as pure and absolute, as Wisdom or *Sophia*—is deemed to either lack or resist concepts and figures, intuition, including intellectual intuition, and a priori form? If pure art exists in offering nothing but a "facet" of the Absolute in terms of its "content" and "form," if we can still say so, then these latter cannot be defined, whether conceptually, normatively, or by any other criteriological means. Adorno's "nonidentical" claims nothing else, however, without hypostatizing the other in its "other theology" into some grand, existing "totally Other."

———

There are several direct and indirect textual references—the use of "the spiritual [*das Geistige*]" to begin with—next to other shared connections and interests that make it possible and, perhaps, necessary to bring up Kandinsky in the context of the later Adorno's surprising, yet extensive, use of the expression "spiritual experience," not only or primarily in the context of aesthetic theory and experience but also in that of "metaphysical experience" and in moral matters.

As to the connection with Kandinsky, perhaps, the most tangential reference would be that his 1911 *Composition IV* was deemed the appropriate image adorning the compact disc of a 1988 performance of the philosopher's own artistic *Kompositionen*, suggesting an unexpected synesthetic relationship

30. Florman, *Concerning the Spiritual and the Concrete in Kandinsky's Art*, 47.
31. Florman, *Concerning the Spiritual and the Concrete in Kandinsky's Art*, 47.

Kojève's essay does not *explicitly* draw on Hegel or even mention the concept of *Geist*. And while he seems to propose somewhat of a "'corrective'" to Kandinsky's own earlier writings and especially self-interpretation—attempting to "reconcile some of the inconsistencies or contradictions in those works, to make their arguments more conceptually coherent," as Florman says—Kojève nonetheless sees as his fundamental task in the essay to present a "more fully realized (if still accessibly written) response to Hegel's *Aesthetics*,"[25] with his uncle's mature paintings as the prime witnesses.

To begin with, the "essence" of art and the "motor of historical change" Kojève introduces here is not Hegel's Spirit at all but "the Beautiful [*le Beau*]." On this reading, the beautiful in art is "uncoupled . . . from any connection to *Geist*," yet—unlike natural beauty, as Hegel would surely have agreed—it already manifests "a certain freedom from nature."[26] In making this surprising claim, "The Concrete Paintings of Kandinsky" relies heavily on Kojève's dissertation completed under the supervision of Karl Jaspers in Heidelberg in 1926, on the Russian Orthodox thinker Vladimir Soloviev.[27] As Kojève reworked the dissertation in two articles published in 1934 and 1935, he had already discovered Hegel. Yet, as Dominique Auffret notes, Kojève "does not make use of Hegel to show eventual contradictions in the doctrine of the theologian [i.e., Soloviev] even though certain passages in the text warrant the supposition of a knowledge of Hegel, close to the reading of the *Phenomenology of Spirit* begun in 1933."[28] Hegel is thus introduced as a source for Soloviev's thinking, in addition, by the way, to Jakob Böhme and Friedrich Wilhelm Joseph von Schelling, who would influence the conception of Spirit, Wisdom or *Sophia*, in the "Sophiology of the Russian theosophist."[29]

Soloviev conceived of Beauty as one element of a "hypostatic trinity," next to the Good and the True, whose constitutive moments guide humanity toward the Absolute and do so *simultaneously* and *equiprimordially*, as in different but "equally vital aspects," which, following a long tradition of theolog-

25. Florman, *Concerning the Spiritual and the Concrete in Kandinsky's Art*, 45.
26. Florman, *Concerning the Spiritual and the Concrete in Kandinsky's Art*, 45.
27. For a summary account of that earlier project, *Die religiöse Philosophie Wladimir Solowjeffs*, by his own hand, see Kojève, "La métaphysique religieuse de V. Soloviev"; Kojève, *Religious Metaphysics of Vladimir Solovyov*. On Soloviev's early influence on Kojève, see Roth, *Knowing and History*, 83–124; and Auffret, *Alexandre Kojève*, 220–44.
28. Auffret, *Alexandre Kojève*, 221.
29. Kojève, "La métaphysique religieuse de V. Soloviev," 125, quoted in Auffret, *Alexandre Kojève*, 223.

ical doctrine, are "the same in *substance*." In other words, at no point does
Soloviev assume a successive resumption of art and religion under the concep-
tual regimen of philosophy in Absolute Knowledge, which, as Hegel's *Phe-
nomenology of Spirit* had explicitly claimed and as the *Lectures on Aesthetics*
reiterate, was required for the Spirit (now translated in Soloviev's idiom as
Wisdom) to reign supreme eventually.[30] Consequently, Kojève, drawing on
Soloviev even more than on Hegel, will insist that the Beautiful in art, here,
notably in the nonrepresentational, nonfigurative painting of his uncle Kandin-
sky, ought itself, that is, on its own terms, to be regarded as a fundamental
"facet of the Absolute—something on par with *Geist* but possessing its own
distinct, sensuous content."[31]

But what could such sensuous content possibly be and intelligibly mean if
the "concrete and objective" art and painting in question—in its very definition
as pure and absolute, as Wisdom or *Sophia*—is deemed to either lack or resist
concepts and figures, intuition, including intellectual intuition, and a priori
form? If pure art exists in offering nothing but a "facet" of the Absolute in
terms of its "content" and "form," if we can still say so, then these latter cannot
be defined, whether conceptually, normatively, or by any other criteriological
means. Adorno's "nonidentical" claims nothing else, however, without hypos-
tatizing the other in its "other theology" into some grand, existing "totally
Other."

———

There are several direct and indirect textual references—the use of "the spiri-
tual [*das Geistige*]" to begin with—next to other shared connections and inter-
ests that make it possible and, perhaps, necessary to bring up Kandinsky in the
context of the later Adorno's surprising, yet extensive, use of the expression
"spiritual experience," not only or primarily in the context of aesthetic the-
ory and experience but also in that of "metaphysical experience" and in
moral matters.

As to the connection with Kandinsky, perhaps, the most tangential refer-
ence would be that his 1911 *Composition IV* was deemed the appropriate
image adorning the compact disc of a 1988 performance of the philosopher's
own artistic *Kompositionen*, suggesting an unexpected synesthetic relationship

30. Florman, *Concerning the Spiritual and the Concrete in Kandinsky's Art*, 47.
31. Florman, *Concerning the Spiritual and the Concrete in Kandinsky's Art*, 47.

between the two.[32] That Adorno's music and Kandinsky's painting should thus indirectly—and posthumously—meet need not surprise us. After all, the painter gave three titles, inspired by music, to different categories of his oeuvre, namely, compositions, improvisations, and impressions, just as he characterized his own account of the spiritual in art as a "doctrine of musical harmony," first and foremost. Yet another *musical* reference to Kandinsky's late work is made by Adorno himself and can be found in the latter's *Musikalische Schriften I*, under the title *Klangfiguren* (*Sound Figures*), in the essay devoted to Anton Webern.[33]

There are also stringent conceptual considerations to bring Adorno and Kandinsky together more systematically, even relatively independent from their shared involvement with Hegel, as influenced by the kind of reading we find in Kojève's lectures and correspondence with Kandinsky and throughout the sustained investment in the *Phenomenology of Spirit*, *Wissenschaft der Logik* (*Science of Logic*), and *Lectures on Aesthetics* that we find in Adorno's *Hegel: Three Studies*, *Negative Dialectics*, *Aesthetic Theory*, as well as in the lecture courses accompanying the writing of these theoretical matrices of his material works.

———

The "spiritual" in Kandinsky's *On the Spiritual in Art*, seen against the Hegelian backdrop and read by Florman with the help of Kojève's commentaries, reveals itself as an idea of which Adorno, in his *Aesthetic Theory*, seems downright dismissive. By contrast, the *Aesthetics* 1958–59 lecture course leading up to it offers a more expository and nuanced treatment of the motif of the spiritual, this time in view of what Adorno, dialectically, characterizes as a deeply ambiguous process of "spiritualization." *Aesthetics* presents not merely a first running commentary on the dense text of the unfinished, posthumously published *Aesthetic Theory* itself but also an earlier, if tentative, development of its overall argument in which the explicit reference to Kandinsky and *On the Spiritual in Art* plays a crucial role.

32. The concert, which took place on September 17, 1988, in the Alten Oper in Frankfurt am Main, featured Adorno's *Zwei Stücke für Streichquartett*, op. 2 (1925–26); *Sechs kurze Orchesterstücke*, op. 4 (1929); *Drei Gedichte von Theodor Däubler für vierstimmigen Frauenchor a cappella* (1923–45); *Zwei Lieder mit Orchester aus dem geplanten Singspiel "Der Schatz des Indianer-Joe" nach Mark Twain* (1932–33); and *Kinderjahr: Sechs Stücke aus op. 68 von Robert Schumann, für kleines Orchester gesetzt* (1941). The CD was produced by WERGO Schallplatten, Mainz, 1990.

33. See Adorno, *Musikalische Schriften I–III*, 123; and Adorno, *Sound Figures*, 107.

While Adorno, in the lectures, confesses to his "technical incompetence in matters of painting," he does not hesitate to point—well beyond the realm of music, where, he says, he "feel[s] most at home in terms of [his] skills"—to "those elements where the construction [of works of art] has been slapped on from the outside rather than developed from the matter itself."[34] This would hold true for the visual arts no more and no less than for others. Adorno notes that, mutatis mutandis, "the same structures which exhibit this [in painting as in music] are also those that give the impression of lacking any tension,"[35] thus leading to a false "spiritualization." When and where this happens, he goes on to note, taking issue with Kandinsky's later works, the "so-called abstract constructs in which we observe the loss of tension are generally those that have been removed from the dialectical relationship with tradition."[36] Modern or modernist art, then, stands and falls with the negatively defined, dialectical— that is, paradoxical or, more precisely, aporetic—relationship to so-called tradition. As Adorno says:

> To me, the great products of the new art almost always seem to have been those which still had tradition as an essential force within them and then negated it on their own strength. The great revolutionary artists of the period—such as Picasso, such as Braque, such as Schönberg and so forth— were all within tradition, and, by locking horns with it, they essentially brought about something like an induction of tension. . . . Where tradition no longer exists as an aspect, however sublimated, the power of true revolutionary art does not really exist. . . . Precisely the most significant of modern painters stopped short of complete abstraction, of severing all connections to concrete representation, Klee as much as Picasso. And . . . in Klee's late period, when that decreased, but most of all in Kandinsky's development, this progression would not necessarily have been a blessing. This hesitation is not . . . out of cowardice or weakness or inconsistency; rather, these great artists were evidently driven by the knowledge that it requires a kind of resistance to the heteronomous to make the concept of autonomy meaningful in the first place. This means that, at the moment when the autonomy of creation becomes absolute and idles, as it were, it cancels itself out and no longer becomes freedom if this freedom cannot exert itself in relation to something from which it differs.[37]

Aesthetic freedom requires "the act of art repelling from tradition,"[38] absolving itself—in more than merely determined or abstract negation, Adorno

34. Adorno, *Aesthetics*, 243/152.
35. Adorno, *Aesthetics*, 243/152.
36. Adorno, *Aesthetics*, 243/152.
37. Adorno, *Aesthetics*, 244/152–53.
38. Adorno, *Aesthetics*, 244/153.

implies—from a past, an archive, a resource and repository, technique and method, material and form, that it nonetheless ignores, forgets, or represses at its peril, doomed as it then is to mere mimicry, to always repeat the worst of tradition while forgoing the best of its constitutive elements. We would need to be as commemorative of "tradition"—in quasi-Platonic *anamnesis*—as we must surely be of "nature" in and for the subject (the *Eingedenken der Natur im Subjekt* thus finding a parallel or belated echo in the anamnetic solidarity with second nature that spirit, in the Hegelian and Adornian register, also must be).

But for all its insistence on "tradition," on "Cabbala"—including the earliest sources of art and aesthetic experience in the archaic motif of "fetishism"[39]—such thinking and freedom must also require that we eventually leave even all that (i.e., all past, like all that presently is) firmly behind. In a last resort of conceptual, no less than deeply pragmatic, *askesis*, with a quasi-phenomenological *epoché* that suspends—indeed, crosses out (i.e., annihilates and destructs, in Lutheran-Heideggerian parlance, as least as much it negates in the sense of preserves and sublates, in the dialectical lingo)—it fundamentally brackets all that exists and all that has happened. In thus upending much more than the naturalist interpretation of world and of life, of things and objects, self and others, beings and givens, Adorno thus insists on a simple injunction that is much older than the venerable phenomenological reduction, to wit: "Throw away in order to gain [*Wirf weg, damit du gewinnst*],"[40] cited also in Georg Lukács's *Theorie des Romans* (*Theory of the Novel*) and mimicking Friedrich Hebbel's "Throw away so as not to lose [*Wirf weg, damit du nicht verlierst*]."

Kandinsky, in *Concerning the Spiritual in Art*, comes close to formulating the very same insight with regard to "tradition," as if preempting Adorno's scathing critique of pure abstractness and, more specifically, of the falsely—mythically and acosmically—"spiritual" while shifting the very balance between tradition and the new, rather than insisting on a simple renewal of art on its own account, if not for its own sake (i.e., the mistaken autonomy of *l'art pour l'art*). Having affirmed that "spiritual freedom is as necessary in art as it is in life," and taking the distinction between mere mechanical reproduction in science and its wholesale rejection as his lead example, Kandinsky suggests that a certain reliance on previously established knowledge and know-how carries its weight, even holds a certain privilege:

39. See the editorial note in Adorno, *Aesthetics*, 465–66n416 / 312–13n8, and the references, noted there, in Adorno, *Ästhetische Theorie*, 33, 308, 480–89, 506; and Adorno, *Aesthetic Theory*, 24, 310, 429–38, 449.

40. Adorno, *Aesthetics*, 183, 462–63n407 / 114, 311n24. See also Silberbusch, *Adorno's Philosophy of the Nonidentical*, 139–40.

> Blind following of scientific precepts is less blameworthy than its blind and
> purposeless rejection. The former produces at least an imitation of material
> objects which may be of some use. The latter is an artistic betrayal, which as
> sin brings a long chain of harmful effects in its train. The former leaves the
> moral atmosphere empty, it reifies [*versteinert*] it; the latter poisons and
> spoils it.
>
>   Painting is an art, and art is not vague production, transitory and isolated,
> but a power which must be directed to the improvement and refinement of the
> human soul. . . . It is the language that only in its own form speaks from
> things to the soul and that, for the soul, is its daily bread, which only in this
> form it can receive.
>
>   If art refrains from doing this work, a chasm [*eine Lücke*] remains open,
> for no other power can take the place of art in this activity.[41]

Yet Adorno, for his part, is far from sharing this fundamentally aestheticist
view. Neither painting nor art more generally has a "power" that nothing can
substitute for. On the contrary, it is the generic and strangely generative concept
of "spiritual experience" that holds the place for countless other contenders—
"metaphysical experience" and moral "models" of freedom certainly being the
most prominent among them—in principle and structurally open wherever and
whenever their fundamentally *contingent* discursive, normative, or imagina-
tive registers reveal themselves as *necessary*, or of greater *pragmatic* relevance
(for us or future generations, that is).

------

In the context in which Adorno addresses Kandinsky's "concept of spirit"
somewhat obliquely, a certain ambiguity and thus tension is noticeable. Flor-
man references the crucial passage in Adorno's *Aesthetic Theory*, which, as
mentioned, finds parallels in the somewhat more elaborate remarks in *Aes-
thetics* and in isolated observations found here and there. The passage, dense
as it is, sheds yet another light on the meaning and force of "spirit" and "the
spiritual" as privileged exemplars of "the in-existent," this time associating it
with an *irreality* or a *virtuality*, an "as if," whose counterfactuality reorients the
seemingly impossible relationship between self (or same) and other, between
the identical and nonidentical, the conceptual and the nonconceptual. And it
is in this scansion alone, I claim, that "spirit," "the spiritual"—and, by exten-

41. Kandinsky, *Concerning the Spiritual in Art*, 53–54 (translation modified); Kandinsky, *Über das Geistige in der Kunst*, 123. See also Kandinsky, *Complete Writings on Art*, 119–219.

sion, "spiritual experience"—can be found by anyone who is inspired or who, in turn, aspires to acclaim or proclaim its concrete, objective, and universal truth:

> That through which artworks, by becoming appearance, are more than they are, this is their spirit. The determination of artworks by spirit is akin to their determination as phenomenon, as something that appears and not as blind appearance. What appears in artworks and is neither to be separated from their appearance nor to be held simply identical with it—the nonfactual in their facticity [*das Nichtfaktische an ihrer Faktizität*]—is their spirit. It makes artworks, things among other things, something other than thing. Indeed, artworks are only able to become other than thing by becoming a thing, though not through their localization in space and time but only by an immanent process of reification that makes them self-same, self-identical. Otherwise one could not speak of their spirit, that is, of what is utterly unthinglike [*schlechterdings Undingliches*]. Spirit is not simply *spiritus*, the breath that animates the work as a phenomenon; spirit is as much the force or the interior of work, the force of their objectification; spirit participates in this force no less than in the phenomenality that is contrary to it.[42]

The contradiction of the opposite poles and tendencies in any genuine, distinctively modern artwork remains thus fully in place and is nowhere—prematurely—denied and safely set aside. It is this very separation or chasm between the factual and nonfactual, between the thing and the unthinglike, that inscribes and proscribes an indelible *askesis* or *prohibition of any idolatrous imagery* of such overcoming and, a fortiori, redemption all over it, for all eyes to see (i.e., for all eyes that are not just able but willing, inspired and aspiring, to see and set things aright).

The aesthetic concept of spirit, then, requires this self-reservation as much as it requires the thinglike object, matter and form, with its intrinsic mediations, which alone gives the artwork its consistency and resistance, enabling it not only to come into existence and into its own but also to persevere as it must, against all the odds (i.e., fetishization and reification, trivialization and normalization, appropriation and, in sum, "spiritualization"). As in Hegel's *Lectures on Aesthetics* and in the objective or absolute and speculative idealist system throughout, in Kandinsky's absolutist modernist understanding of "spirit" or "the spiritual," this fragile balance or unstable mix that Adorno deems crucial for genuine "spiritual experience" (aesthetic and other) is severely "compromised."

42. Adorno, *Aesthetic Theory*, 134/86–87.

**Hent de Vries** is Paulette Goddard Professor of the Humanities at New York University and director of the School of Criticism and Theory at Cornell University.

## References

Adorno, Theodor W. *Aesthetics*, edited by Eberhard Ortland, translated by Wieland Hoban. Cambridge: Polity, 2018.

Adorno, Theodor W. *Aesthetic Theory*, edited and translated by Robert Hullot-Kentor. Minneapolis: University of Minnesota Press, 1997.

Adorno, Theodor W. *Ästhetik*, edited by Eberhard Ortland. Frankfurt am Main: Suhrkamp, 2009.

Adorno, Theodor W. *Ästhetische Theory*. Frankfurt am Main: Suhrkamp, 1970.

Adorno, Theodor W. *Drei Studien zu Hegel*. Frankfurt am Main: Suhrkamp, 1971.

Adorno, Theodor W. *Hegel: Three Studies*, translated by Shierry Weber Nicholsen. Cambridge, MA: MIT Press, 1993.

Adorno, Theodor W. *Lectures on Negative Dialectics: Fragments of a Lecture Course, 1965–1966*, edited by Rolf Tiedemann, translated by Rodney Livingstone. Cambridge: Polity, 2008.

Adorno, Theodor W. *Musikalische Schriften I–III*. Vol. 16 of *Gesammelte Schriften*, edited by Rolf Tiedemann. Frankfurt am Main: Suhrkamp, 1997.

Adorno, Theodor W. *Sound Figures*, translated by Rodney Livingstone. Stanford, CA: Stanford University Press, 1999.

Adorno, Theodor W. *Vorlesung über negative Dialektik: Fragmente zur Vorlesung, 1965–1966*, edited by Rolf Tiedemann. Frankfurt am Main: Suhrkamp, 2003.

Auffret, Dominique. *Alexandre Kojève: La philosophie, l'État, la find de l'Histoire*. Paris: Grasset et Fasquelle, 1990.

Auffret, Dominique. "Présentation." In *L'idée du déterminisme dans la physique classique et dans la physique modern*, by Alexandre Kojève, 9–26. Paris: Librairie Générale Française, 1990.

Florman, Lisa. *Concerning the Spiritual and the Concrete in Kandinsky's Art*. Stanford, CA: Stanford University Press, 2014.

Foster, Roger. *Adorno: The Recovery of Experience*. Albany: State University of New York Press, 2007.

Geroulanos, Stefanos. *An Atheism That Is Not Humanist Emerges in French Thought*. Stanford, CA: Stanford University Press, 2010.

Gordon, Peter. *Adorno and Existence*. Cambridge, MA: Harvard University Press, 2016.

Hegel, G. W. F. *Aesthetics: Lectures on Fine Art*, translated by T. M. Knox. 2 vols. Oxford: Clarendon, 1975.

Hegel, G. W. F. *Vorlesungen über die Ästhetik*. Vol. 1 of *Werke*, edited by Eva Moldenhauer and Karl Markus Michel. Frankfurt am Main: Suhrkamp, 1970.

Henry, Michel. *Seeing the Invisible: On Kandinsky*, translated by Scott Davidson. London: Continuum, 2009.

Henry, Michel. *Voir l'invisible: Sur Kandinsky*. Paris: François Bourin, 1988.

Introvigna, Massimo. *"The Sounding Cosmos* Revisited: Sixten Ringbom and the 'Discovery' of Theosophical Influences on Modern Art." *Religio Nova: The Journal of Alternative and Emerging Religions* 21, no. 3 (2018): 29–46.

*Kandinsky: Album de l'exposition.* "Deux lettres inédites d'Alexandre Kojève à Vassily Kandinsky." Centre Georges Pompidou, Musée National d'Art Moderne, Paris, 1984.

Kandinsky, Wassily. *Complete Writings on Art,* edited by Kenneth C. Lindsay and Peter Vergo. Cambridge, MA: Da Capo, 1994.

Kandinsky, Wassily. *Concerning the Spiritual in Art,* translated by M. T. H. Sadler. New York: Dover, 1977.

Kandinsky, Wassily. *Über das Geistige in der Kunst, insbesondere in der Malerei.* 3rd ed. Hansebooks: Middletown, 2019.

Kleinberg, Ethan. *Generation Existential: Heidegger's Philosophy in France, 1927–1961.* Ithaca, NY: Cornell University Press, 2005.

Kojève, Alexandre. "La métaphysique religieuse de V. Soloviev." *Revue d'histoire et de philosophie religieuses* 14 (1934): 534–54; 15 (1935): 110–52.

Kojève, Alexandre. "Les peintures concrètes de Kandinsky." *Revue métaphysique et de morale* 90, no. 2 (1985): 149–71.

Livingstone, Rodney. "Translator's Note." In *Lectures on Negative Dialectics: Fragments of a Lecture Course 1965–1966,* by Theodor W. Adorno, edited by Rolf Tiedemann, translated by Rodney Livingstone, ix–x. Cambridge: Polity, 2008.

Love, Jeff. *The Black Circle: A Life of Alexandre Kojève.* New York: Columbia University Press, 2018.

Pippin, Robert B. *After the Beautiful: Hegel and the Philosophy of Pictorial Modernism.* Chicago: University of Chicago Press, 2014.

Pippin, Robert B. "What Was Abstract Art? (From the Point of View of Hegel)." In *The Persistence of Subjectivity: On the Kantian Aftermath,* 279–306. Cambridge: Cambridge University Press, 2005.

Ringbom, Sixten. "Art in 'The Epoch of the Great Spiritual': Occult Elements in the Early Theory of Abstract Painting." *Journal of the Warburg and Courtauld Institutes* 29 (1966): 386–418.

Ringbom, Sixten. *The Sounding Cosmos.* Turku: Åbo Akademi, 1970.

Rorty, Richard. *Philosophy and the Mirror of Nature.* Princeton, NJ: Princeton University Press, 2009.

Roth, Michael S. *Knowing and History: Appropriations of Hegel in Twentieth-Century France.* Ithaca, NY: Cornell University Press, 1988.

Silberbusch, Oshrat C. *Adorno's Philosophy of the Nonidentical: Thinking as Resistance.* Cham: Palgrave, 2018.

Solovyov, Vladimir. *The Religious Metaphysics of Vladimir Solovyov,* translated by Ilya Merlin and Mikhail Pozdniakov. Cham: Palgrave, 2018.

Wood, Christopher S. *History of Art History.* Princeton, NJ: Princeton University Press, 2019.

# Adorno and the Role of Sublimation in Artistic Creativity and Cultural Redemption

## Martin Jay

"Artists do not sublimate," Theodor W. Adorno insisted in *Minima Moralia*; "that they neither satisfy nor repress their desires, but translate them into socially desirable achievements, their works, is a psycho-analytic illusion. . . . Their lot is rather a hysterically excessive lack of inhibition over every conceivable fear; narcissism taken to its paranoiac limit. To anything sublimated they oppose idiosyncrasies."[1] However much he may have embraced the Frankfurt School's hope that Marxism could be enriched through insights from psychoanalysis, here and elsewhere in his work Adorno challenged Sigmund's Freud's theory of sublimation to explain artistic creation.[2] What were his objections, and how plausible were they? And for all his explicit condemnation, did he also express a more-nuanced appreciation of aesthetic sublimation understood dialectically? To answer these questions requires moving beyond Freud's analysis of sublimation in the act of artistic creation to consider the posterior sublimation of once-potent cultural phenomena—especially

---

1. Adorno, *Minima Moralia*, 212–13 (hereafter cited as *MM*). On the value of idiosyncrasy for Critical Theory, see Honneth, "Idiosyncrasy as a Tool of Knowledge." For a discussion of its contradictory implications as a concept that signifies resistance to conceptuality, see Plug, "Idiosyncrasies: of Anti-Semitism."

2. For an account of the Frankfurt School's integration of Karl Marx and Freud, see Jay, "'In Psychoanalysis Nothing Is True but the Exaggerations.'" For a discussion of Adorno's particular response, see Dahmer, "Adorno's View of Psychoanalysis."

*New German Critique* 143, Vol. 48, No. 2, August 2021
DOI 10.1215/0094033X-8989246    © 2021 by New German Critique, Inc.

objects that served devotional, magical, or cultic purposes—which are rescued by resituating them in aesthetic contexts.

Although Freud never used the term *sublimation* with perfect consistency after he introduced it in *Three Essays on the Theory of Sexuality* in 1905, he typically defined it as "a process that concerns object-libido and consists in the instinct directing itself towards an aim other than, and removed from, that of sexual satisfaction."[3] Based on a hydraulic model of flow, pressure, blockage, and release and applied to innate, somatically generated instincts or drives, it assumed that at least the libido or erotic drive was plastic in terms of its object choice. According to Jean Laplanche and Jean-Bertrand Pontalis, *sublimation* borrowed some of its meaning from the aesthetic term "sublime . . . to qualify works that are grand and uplifting," as well as the chemical process of causing a body to pass directly from solid to gaseous state, which implied the spiritualization of materiality.[4] In its most general terms applied to artistic creation, it can be called the transformation of private emotion into cultural meaning, subjective desire into artworks with enduring communal value.

Although apparently unfazed by the elitist and misogynist implications that have often troubled other critics of Freud's theory of aesthetic sublimation, Adorno had three major complaints against it.[5] First, he charged that by claiming that the artist's transgressive impulses can be successfully channeled into culturally admirable works of art in lieu of being directly expressed or ascetically repressed, the theory of sublimation tacitly invited acceptance of what the Frankfurt School had called since the 1930s the "affirmative character of cul-

3. Freud, "On Narcissism," 94. Many commentators have noted the underdeveloped, and even at times contradictory, quality of Freud's theory of sublimation. For a trenchant account, see Goebel, *Beyond Discontent*, chap. 4. Goebel also insightfully analyzes what he calls "Adorno's dialectical understanding of the concept of sublimation" (61).

4. Laplanche and Pontalis, *Language of Psychoanalysis*, 432. They concede that the theory of sublimation in Freud is never fully coherent.

5. Freud's elitism is evident in his observation that "mastering [the sexual drive] by sublimation, by deflecting the sexual instinctual forces away from their sexual aim to higher cultural aims, can be achieved by a minority and then only intermittently" ("'Civilized' Sexual Morality and Modern Nervousness," 193). His gender bias is evident, inter alia, in *Civilization and Its Discontents*, where he wrote, "Women represent the interests of the family and of sexual life. The work of civilization has become increasingly the business of men, it confronts them with the ever more difficult tasks and compels them to carry out instinctual sublimations of which women are little capable" (50); and in *New Introductory Lectures on Psychoanalysis*, where he wrote, "We also regard women as weaker in their social interests and as having less capacity for sublimating their instincts than men" (134). Feminists, in response, have sometimes sought to affirm women's more direct connections with their bodies in defiance of the norm of conventional sublimation. See, e.g., Kahane, "Freud's Sublimation."

ture."[6] The unfulfilled yearnings of men and women in a still-unfree society are said to be transfigured through sublimation into an allegedly "higher" realm of beauty, a realm of disinterested transcendence beyond base needs. But in fact, such a transfiguration offers only weak consolation for the oppressive social conditions that thwart real emancipation, which would honor the validity of those needs.[7] Negation is only negated in sublimation by premature, conformist positivity, and contradiction falsely overcome by ideological reconciliation. "If successful sublimation and integration are made the end-all and be-all of the artwork," Adorno argued in *Aesthetic Theory*, "it loses the force by which it exceeds the given, which it renounces by its mere existence."[8]

For all its alleged distinction from repression, sublimation is, according to certain psychoanalytic theorists, no less of a defense mechanism against the immediate realization of desire and thus hard to distinguish from symptom formation as such.[9] There is in Freudian theory, Adorno charged, "a total lack of adequate criteria for distinguishing 'positive' from 'negative' ego-functions, above all, sublimation from repression."[10] Or, if there is such a criterion, it is external to psychological processes and located entirely in the society. The model of psychological "health" or "normality" underlying the ideal of cultural sublimation is thus based on a conformist adaptability to society. The logic of affirmative adaptation was even clearer, Adorno contended, in the work of so-called neorevisionist analysts, such as Karen Horney and his erstwhile colleague Erich Fromm, who wrongly discarded Freud's libido theory as inherently biologistic.[11] If there can be no fully realized individual psychological health in a pathological society, there is concomitantly no aesthetic compensation for the discontents of at least this civilization.[12]

---

6. The classic account is Marcuse, "Affirmative Character of Culture."

7. Adorno was not alone in lamenting the renunciation inherent in sublimation. In *Life against Death*, Norman O. Brown would charge that "sublimation is the search for lost life; it presupposes and perpetuates the loss of life and cannot be the mode in which life itself is lived. Sublimation is the mode of an organism which must discover life rather than live, must know rather than be" (171).

8. Adorno, *Aesthetic Theory*, 12 (hereafter cited as *AT*).

9. The inclusion of sublimation along with repression as a defense mechanism was made by Anna Freud in *The Ego and the Mechanisms of Defense*. Some analysts distinguish between repression as an unsuccessful defense mechanism and sublimation as a successful one, since the latter finds a nonsexual outlet through a cathexis of a substitute object. See, e.g., Fenichel, *Psychoanalytic Theory of Neurosis*.

10. Adorno, "Sociology and Psychology," 86.

11. Adorno, "Revisionist Psychoanalysis."

12. On the theme of social pathology in Critical Theory, see Honneth, *Pathologies of Reason*. Adorno's hostility to the therapeutic function of psychoanalysis, which is evident throughout *Minima Moralia*, can be explained by its dependence on a kind of sublimation. As Philip Rieff noted, "The psychoanalytic resolutions of conflict are embodied in a dialectical therapy which is itself a kind of subli-

Second, according to Adorno, sublimation transfigures the corporeal desires unmet in the current world through spiritualization, producing an idealist pseudosolution to the material injuries produced by capitalism. Sublimation may be seen to feed the inner soul, but it ignores the legitimate demands of the desiring body. To be sure, Freud registered the corporeal origins of art in a way that Immanuel Kant, who is pitted against him in *Aesthetic Theory*, did not. "The psychoanalytic theory of art is superior to idealist aesthetics in that it brings to light what is internal to art and not itself artistic. It helps free art from the spell of absolute spirit. . . . But psychoanalysis too," Adorno then added, "casts a spell related to idealism, that of an absolutely subjective sign system denoting individual instinctual impulses" (*AT*, 8–9). The alleged sublimation of baser desires into higher works of art parallels the dubious distinction often made between "culture" and "civilization"—the former understood as the realm of noble ideas and beautiful forms, the latter as the locus of technological improvements, superficial social interactions, and political machinations— that was a standard trope of reactionary antimodernism. Rather than serving as a placeholder for genuine happiness in the future, that *promesse du bonheur* the Frankfurt School so often evoked, art understood in terms of sublimation was reduced to a surrogate pleasure in the present, scarcely less ideological in function than the popular entertainment provided by the culture industry. In contrast, Adorno argued in *Minima Moralia*, "he alone who could situate utopia in blind somatic pleasure, which, satisfying the ultimate intention, is intentionless, has a stable and valid idea of truth. In Freud's work, however, the dual hostility towards mind and pleasure, whose common root psychoanalysis has given us the means for discovering, is unintentionally reproduced" (*MM*, 61).

Finally, the theory of sublimation fails, for Adorno, to take into account the crucial distinction between the artwork and the artist who created it. It hurries past the former, which it reduces to a mere document of displaced neurosis, to decode what it takes to be the deeper motives of the latter. It repeats the errors of what has been damned for more than a century as "psychologism," reducing the validity of an idea or artwork to its genesis, a fallacy that had been the bugaboo of the modernist aesthetics in which Adorno had been steeped since his musical training in the 1920s.[13] "Psychoanalysis treats art-

---

mation, a transferring of the patient's conflicts to 'higher levels,' a new 'battlefield' where the forces contending for his mind must meet" (*Freud*, 69).

13. For an account of the modernist critique of psychologism, see Jay, "Modernism and the Specter of Psychologism." Adorno, to be sure, never went as far as, say, Kant in denying the inevitable entan-

works as nothing but facts," Adorno wrote in *Aesthetic Theory*, "yet it neglects their own objectivity, their inner consistency, their level of form, their critical impulse, their relation to nonpsychical reality, and, finally, their idea of truth" (*AT*, 9). Stressing the subjective production of artworks as projective day-dreaming rather than their integrity as such, it fails to register their resistance to the domination of the production principle, the elevation of labor over play,[14] as well as their refusal to reduce happiness to an effect of praxis alone. Instead of preserving the nonidentity of the artwork and the artist, it collapses one into the other. Because of its dogged adherence to an anti-utopian understanding of the reality principle, which validates the status quo, psychoanalysis reduces imagination to mere escapism and fails to appreciate its ability to envisage an alternate reality. "If art has psychoanalytic roots, then they are the roots of fantasy in the fantasy of omnipotence," Adorno argued. "This fantasy includes the wish to bring about a better world. This frees the total dialectic, whereas the view of art as a merely subjective language of the unconscious does not even touch it" (*AT*, 317–19). Paradoxically, it is only by reminding the subject of the object world's resistance to the narcissistic fantasy of omnipotence that art-works can foreshadow a better world in which subjective domination will be overcome.

The damage done by the ideology of aesthetic sublimation, Adorno argued in *Aesthetic Theory*, had in fact already begun as early as Aristotle's *Poetics*. Whatever contribution it may have made to the progress of civilization and art itself, the implicit ideal of sublimation found there "entrusts art with the task of providing aesthetic semblance as a substitute satisfaction for the bodily satisfaction of the targeted public's instincts and needs" (*AT*, 238). No better example of this failing was Aristotle's claim that catharsis is inherent to an audience's experience of tragic drama. Producing a surrogate, false satisfaction, cathartic release purges rather than validates the affects and is thus tacitly allied with renunciation and repression. "The doctrine of catharsis," Adorno charged, "imputes to art the principle that ultimately the culture industry appropriates and administers. The index of its untruth is the well-founded doubt whether the salutary Aristotelian effect ever occurred; substitute grati-fication may well have spawned repressed instincts" (*AT*, 238). Catharsis

---

glement of validity and genesis, but he was always anxious to avoid simply reducing the former to the latter.

14. Although Adorno was critical of the traditional Marxist heroization of labor and production, he did not simply turn to play as the alternative, as his critical remarks on Friedrich Schiller's *Aesthetic Education* and Johan Huizinga's *Homo Ludens* make clear. See *AT*, 317–19.

depends on the logic of sacrifice, which was so much a part of the problematic dialectic of enlightenment.[15]

For all these reasons, Adorno disdained theories of artistic creation that drew on a reductive notion of sublimated desire. Yet, as was typical of his relentlessly dialectical method, he also acknowledged the critical potential in the concept as well. Thus he could say, building on his analysis of the contradictory implications of the idea of "progress," that "the ambiguity of 'sublimation' is the psychological symbol of social progress."[16] Defenders of Freud's notion of sublimation against his critics, such as Joel Whitebook, have therefore perhaps gone too far in identifying Adorno's attitude entirely with unalloyed disdain.[17] One indication of the complexity of his position appeared in Adorno's critique of its apparent opposite, desublimation, in the contemporary world. If sublimation could function affirmatively in an unfree society, providing spiritualized consolations for unfulfilled desires, he never conceptualized a truly emancipatory alternative as their immediate, direct gratification under current social conditions. What Herbert Marcuse had famously condemned as "repressive desublimation" in *One-Dimensional Man*[18] was echoed in *Aesthetic Theory*, where Adorno argued that "the desublimation, the immediate and momentary gain of pleasure that is demanded of art, is inner-aesthetically beneath art; in real terms, however, that momentary pleasure is unable to grant what is expected of it" (*AT*, 319). Or as he put it in *Minima Moralia*, "Ascetic ideals constitute today a more solid bulwark against the madness of the profit-economy than did the hedonistic life sixty years ago against liberal repression" (97).

Until such a time as "blind somatic pleasure" could be enjoyed in a society that allowed all of its members equal opportunity to do so—or in other words, until the realization of utopia—the nonrepressive potential in sublimation must also be acknowledged. In *Minima Moralia* Adorno allowed us a glimpse of what this might mean. "Talent," he conjectured, "is perhaps nothing other than successfully sublimated rage, the capacity to convert energies once intensified beyond measure to destroy recalcitrant objects, into the concentra-

15. Horkheimer and Adorno, "Excursus I."

16. Adorno, "Progress"; Adorno, *Prisms*, 85 (hereafter cited as *P*).

17. Whitebook, *Perversion and Utopia*, 258–62. He argues that Adorno tacitly assumes a positive notion of the noncoercive integration of ego and drives in order to challenge the dissociation of the self in the modern world and the pseudoreconciliations that compensate for it. Drawing on the analyst Hans Loewald's *Sublimation*, Whitebook supports a notion of sublimation that "does not envision a transcendence of inner nature but a fully embodied integration of the ego and drives" (258).

18. Marcuse, *One-Dimensional Man*, 75–78.

tion of patient observation, so keeping a tight hold on the secret of things, as one had earlier when finding no peace until the quavering voice had been wrenched from the mutilated toy" (*MM*, 109). In a passage in his later essay "Resignation," in which Adorno defended himself against the charge that he had retreated into pure theory and neglected radical praxis, he employed a similar argument: "Whoever thinks is without anger in all criticism; thinking sublimates anger. Because the thinking person does not have to inflict anger upon himself, he furthermore has no desire to inflict it upon others."[19]

By foregrounding in these remarks the sublimation of rage he identified in both talent and thought, Adorno went beyond Freud's most frequent equation of the term with the cultural transcendence and spiritual channeling of libido. Although Freud sometimes acknowledged that aggressive instinctual behavior could also be sublimated, when it came to its aesthetic expression, as classically demonstrated in his 1910 study of Leonardo da Vinci, the sexual drive predominated.[20] In the passages just quoted from *Minima Moralia* and "Resignation," however, the emotion that is sublimated, according to Adorno, is not libidinal desire but the fury at being thwarted by the present order. The result is anything but the sublime elevation of desire, to recall the words of Laplanche and Pontalis, into something "grand and uplifting."[21] For even in a more just and happier society than our own, Adorno soberly cautioned, art will remain the commemorative repository of past suffering, which can never be rendered beautiful, let alone redeemed or justified. *Aesthetic Theory*, in fact, ends with the defiant words "It would be preferable that some fine day art vanish altogether than that it forget the suffering that is its expression and in which form has its substance. This suffering is the humane content that unfreedom counterfeits as positivity. . . . what would art be, as the writing of history, if it shook off the memory of accumulated suffering" (*AT*, 260–61).

In so arguing, Adorno was also tacitly restating his insistence on the autonomous artwork as more than a symptomatic expression of the artist's desires, for it was through its stubborn irreducibility, the block it provides to consoling idealist metaphysics, that the aesthetic object resists the total domi-

19. Adorno, "Resignation," 175.

20. Freud, "Leonardo da Vinci." Adorno, however, was not alone in applying the idea of sublimation to more than libidinal desire. Friedrich Nietzsche, for example, wrote of the sublimation of cruelty in his genealogy of morality. See the discussions in Goebel, *Beyond Discontent*, chap. 3; and Gemes, "Better Self."

21. It would, of course, be necessary to parse all the meanings of "the sublime" to illuminate its links with sublimation. For a discussion of its importance for Adorno, see Wellmer, "Adorno, Modernity, and the Sublime."

nation of the subject who created it. That is, the suffering it remembers is not only that of the damaged lives of humankind but also that of the natural environment. As a placeholder for the suffering of the material world resulting from that domination of nature against which Max Horkheimer and Adorno had railed in *Dialectic of Enlightenment*, artworks turned one kind of sublimation into another. Rather than the sublimation of subjective desire, they could also be understood as expressing the sublimation of the suffering of nature, both within and outside the human being. And as such, they managed, to repeat the words from *Minima Moralia* just quoted, to "convert energies once intensified beyond measure to destroy recalcitrant objects, into the concentration of patient observation, so keeping a tight hold on the secret of things."

There is, I want to suggest, also a second way to wrest a more positive reading of sublimation from Adorno's critique of its conventional Freudian reduction. Instead of focusing on the creative artist, whose desires are channeled into culturally acceptable forms, or the thoughtful person of talent who does the same with his or her rage against suffering, it examines the collective aesthetic transfiguration of prior cultural expressions that have lost their efficacy or experienced decline. Here the emphasis is not on production or creation but on reception and aesthetic experience. "When an experience of beauty takes place," Adorno wrote in *Aesthetic Theory*, "they [drive energies] are not repressed, suppressed, or diverted by force but rather, to use the psychological term, 'sublimated': this means they are retained and preserved in a certain sense" (*AT*, 34). In addition to informing an individual experience of beauty, sublimation can also be a retrospective, rescuing operation, communal in nature, in which historically exhausted cultural phenomena can endure, even find new life, in different discursive and institutional contexts. Going beyond the function of release Freud himself had identified in his account of aesthetic reception when he wrote that "our actual enjoyment of an imaginative work proceeds from a liberation of tensions in our minds,"[22] Adorno argued in typically Hegelian manner that sublimations both transcend and preserve what they transfigure. As he put it in *Aesthetic Theory*, "No sublimation succeeds that does not guard in itself what it sublimates" (94). Although drawing on prior sublimations, second-order aesthetic redescriptions can still retain some of the displaced instinctual energy whose traces they bear, perhaps in the way that contemporary "affect theory" understands the impersonal—or better put, interpersonal—residues of subjective emotions.

---

22. Freud, "Creative Writers and Day-Dreaming," 153. This interpretation is developed by Goebel, "On Being Shaken," 161.

Cultural sublimation in this sense can take many forms, but perhaps two are worth singling out as significant for our argument. The first is the redefinition of devotional religious art from within the Western tradition in aesthetic terms or as examples of cultural patrimony. The second is the redefinition of so-called primitive objects or practices, which once served religious, magical, or other purposes, as also valuable in purely formal terms and capable of being appreciated as such when extracted from their functional context. In other words, it has been possible to rescue and revalorize objects that appeared to have had outlived their devotional or cultic functions and turn them into what aesthetic theory since Kant had called embodiments of "purposiveness without purpose." Another way to characterize the change is to say that objects and practices that once had potent performative powers could be revalued after their ability to do something in the world had waned by turning them into objects or practices of aesthetic contemplation. Or to give the transformation one more twist, objects and practices that were once embedded in liturgical or cultic practices and interpreted as such by theological or ethnological discourses could be resituated as aesthetically valuable in the discourse of art history. Here sublimation is not of the artist's libidinal desires or rage at suffering but of the prior works that may have once resulted from them. Here new meaning is derived from the waning, but still meaningful, sublimation of prior emotional drives.

The iconoclastic smashing of what were considered dangerous idols has been a frequent practice of both intrareligious iconoclastic movements, such as those in the Byzantine Church during the eighth and ninth centuries and the European Reformation in the sixteenth century, and self-proclaimed virtuous political movements, such as those arising during the French Revolution.[23] Taken as more than harmless symbolic representations or mimetic images, idols were understood by their foes as variously fetishistic embodiments of false gods, dubious intercessors between the human and the divine, and remnants of irrational superstition.[24] In addition to problematic religious functions, they also were often understood as legitimating hierarchical political power. For the critics of the ancien régime who dreamed of a new republic of virtue, "the arts were a result of luxury and vice, that . . . flourished only in decadent, over-civilized societies and provided opiates for the subjects of tyrannical rulers."[25]

23. The iconoclastic impulse in religion and politics has had many interpreters and attracted many historians. For a useful overview, see Besançon, *Forbidden Image*.
24. For an excellent analysis of the stakes involved in the Byzantine Iconoclastic Controversy, see Alloa, "Visual Studies in Byzantium."
25. Idzerda, "Iconoclasm in the French Revolution," 19 (hereafter cited as IFR).

The impulse to smash idols led to the actual destruction of many objects whose performative potency was seen as either literally or symbolically nefarious. Attempts to save them thus had to disrupt their power to make something happen (or at least neutralize the belief that they had that power) and then redescribe them as objects of disinterested aesthetic contemplation. The needed change was more than merely taxonomic or categorical, as something of the aura that had informed their ability to enable devotional respect had to be retained to secure their new value. Here what might be called aesthetic sublimation avoided the lamentable effects of outright cultural repression. Churches might be stripped of their excessive ornamentation, but altarpieces, statues, and the like could find new sanctuaries on or within the walls of secular museums. In Europe, a crucial turning point in the visual arts, often acknowledged by cultural historians, came during the de-Christianizing fervor of the French Revolution. As Stanley Idzerda noted in his pioneering study of revolutionary iconoclasm:

> The sale of many church buildings to private individuals raised fears that the mosaics, stained-glass windows, statues, and paintings in these buildings would be either destroyed or dispersed. To avoid the danger of such an artistic loss to the nation, the Constituent Assembly in 1790 created a Monuments Commission composed of members of several royal academies. The chief duty of this group was to inventory and collect in various depots those works of art thought worthy of preservation by the state. (IFR, 14)

The transformation of the Louvre in Paris from a royal palace into a repository of the people's cultural patrimony was the capstone of these efforts. It was inaugurated on August 10, 1793, the first anniversary of the expulsion of Louis XVI, and marked by the placement of a large plaque announcing the transformation over the entrance to the Gallery of Apollo, a royal reception hall originally dedicated to the Sun King, Louis XIV. Although the iconoclastic impulse was slow to disappear, the effect of the transformation was profound. Again, according to Idzerda,

> while many *sans-culottes* admired symbols of "royalty, feudalism, and superstition" inside the museum, they continued to engage in iconoclastic activities outside of it. This paradoxical activity need not imply a contradiction in attitudes. It seems probable that when these works were seen in the museum, torn out of their cultural context, they were regarded only as "art"; their significance as tokens, symbols, or *mana* had been drained away because of their placement in an artificial situation, a strange milieu. (IFR, 24)

By disentangling the sacred or political function of works from their aesthetic value and distinguishing between corrupt luxury, the emblem of aristocratic privilege, and disinterested beauty available for appreciation by all, it was possible to allow them to earn a different kind of respect in the semisacred space of a public museum. By the 1820s G. W. F. Hegel could confidently say that in front of formerly devotional images, "we bow the knee no longer."[26] To be sure, such treasures could now be called "ornaments of the State" (quoted in IFR, 23) and gain economic value in the more profane space of the capitalist art market. But they could also serve as embodiments of aesthetic value in an immanent realm of art for its own sake. As such, they drew on a kind of cultural sublimation, which could produce a collective version of the receptive pleasure that Freud saw derived "from a liberation of tensions in our minds."

A similar story, although one less marked by the threat of puritanical or revolutionary violence, has often been told of the aesthetic transformation of sacred music. Here the emblematic case is the history of Johann Sebastian Bach's great oratorio *St. Matthew's Passion*, written in 1727 to present a musical version of the Passion of Christ for Good Friday vesper services in the St. Thomas Church in Leipzig. A little more than a century later Felix Mendelssohn conducted a somewhat streamlined version of it for a secular audience at the Sing-Akademie in Berlin, the first time it had been moved from the sacred space of a church to the secular confines of a concert hall. Here it no longer served liturgical purposes for a religious congregation but could instead function for a general audience as an exemplar of what soon would be called "absolute music." As Celia Applegate has shown, the concert was instrumental in creating the national image of Germans as the people of music and launching a revival of interest in Bach, whose reputation had been languishing, that has continued to this day.[27]

Although other examples can be adduced of the aesthetic sublimation of Western religious material, such as reading the Bible as literature,[28] the second major example is the redescription of so-called primitive artifacts in purely formal terms or as exemplars of universal archetypes. After being grouped under the generic category of primitive, their performative functions as literal instruments of magic or objects of religious worship were then sublimated into the metaphorical magic of autotelic works of art commanding a different kind of devotion. In fact, the literal transfer of those artifacts from natural history or

26. Hegel, *Aesthetics*, 103.
27. See Applegate, *Bach in Berlin*.
28. See Norton, *History of the English Bible as Literature*.

ethnographic museums, where they served as "documents" of exotic cultures, to art museums, where they became "artworks" in their own right, gathered momentum in the early twentieth century. Celebrating "noble savages" as the antidote to exhausted Western civilization had, of course, already enjoyed a long history,[29] but modernist artists were more inspired by the formal properties of the objects they had produced, which had hitherto been of interest only to anthropologists or collectors of exotic curiosities.[30] Although anticipated by Paul Gauguin's fascination for the South Seas, the canonical turning point is often said to be the inspiration of African masks at the Trocadéro Museum in Paris in Pablo Picasso's *Les demoiselles d'Avignon* in 1907.

Much has been made by postmodernist and postcolonial theorists, and justly so, of the costs of this aesthetic recoding and displacement, whose entanglement with the European imperialist appropriation of the material wealth of exotic cultures has not gone unremarked.[31] The elevation of so-called primitive objects with originally ritual, decorative, apotropaic, or magical functions into works of high art, theorists point out, may have been inspired by formalist intentions, but also led to the insertion of works into the art market as commodities, a fate already suffered by aesthetically sublimated religious objects rescued from iconoclastic destruction. Ironically, so-called primitive objects were stripped of one fetishistic function only to be endowed with another. In addition, when read as instances of species-wide mythic or psychological archetypes, their irreducible otherness was subsumed under a dubious notion of ahistorical universality or alleged common "affinity,"[32] which tacitly imposed Western values on them. They were turned into fungible exemplars of the vapid humanism of "the family of man" ethos, notoriously expressed in the photographic exhibition organized by Edward Steichen in the 1950s.[33] Thus, although as in the case of Western religious artifacts, they may have

29. See, e.g., Lovejoy and Boas, *Primitivism and Related Ideas in Antiquity.*

30. The classic account is Goldwater, *Primitivism in Modern Art.* See also Rubin, *"Primitivism" in Twentieth-Century Art*; and Rhodes, *Primitivism and Modern Art.* In literature as well, primitivism had its lure. See, e.g., Torgovnick, *Gone Primitive*; Pan, *Primitive Renaissance*; and Etherington, *Literary Primitivism.*

31. See, e.g., Foster, "Primitive Unconscious of Modern Art"; and Clifford, *Predicament of Culture.*

32. This frequently used term, as Clifford points out (*Predicament of Culture,* 190), suggests a natural kinship relationship beyond mere resemblance.

33. Interestingly, Horkheimer wrote an admiring introduction to Steichen's exhibition *The Family of Man* when it came to Frankfurt in 1958. For an account of the ambiguities of his defense, see Jay, "Max Horkheimer and *The Family of Man.*" This collection aims to resurrect the reputation of the exhibition against its legions of detractors.

gained something by being taken seriously as objects of the highest aesthetic value, it was not without a cost.

How, we now have to ask, does Adorno's dialectical critique of sublimation comport with the posterior aesthetic redemption of traditional religious or "primitive" objects, with all its ambiguities? Does his hostility to the claim that artists sublimate their desires extend to sublimation understood in this very different sense? Does his more positive claim that talent and thought can be understood as sublimations of rage at suffering, both of humans and of nature, translate into a more generous attitude toward the aesthetic sublimation of religious or cultic objects in the modern world? Does it extend beyond the sublimation of subjective desires to the spiritual transfiguration of the material world, the world of a nature that is more than dominated or repressed in the name of human self-preservation?

Although there are few explicit answers to these questions, we can find hints of Adorno's likely position in several of his related arguments. Although rarely commenting on the visual arts, he did ponder the implications of the sequestration of artworks in museums in an essay he wrote pitting Paul Valéry's stress on the priority of aesthetic objects against Marcel Proust's on subjective experience. In it Adorno argued that

> works of art can fully embody the *promesse du bonheur* only when they have been uprooted from their native soil and have set out along the path to their own destruction. . . . The procedure which today relegates every work of art to the museum, even Picasso's most recent sculpture, is irreversible. It is not solely reprehensible, however, for it presages a situation in which art, having completed its estrangement from human ends, returns, in Novalis' words, to life. (*P*, 185)[34]

A similar argument informed his defense in 1951 of Bach against his contemporary devotees, who wanted to find in him the Pietist believer, whose music expressed the revelation "of time-honored bounds of tradition, of the spirit of medieval polyphony, of the theologically vaulted cosmos" (*P*, 135).[35] Those who insisted on playing Bach's music only with original instruments and in sacred settings, hoping to restore its "authenticity," were betraying, so Adorno charged, his compositional innovations, which still resonate today: "They have

---

34. Adorno's appeal to Stendhal's phrase *promesse du bonheur*—incorrectly cited by Nietzsche and then Marcuse as *promesse de bonheur*—is discussed in Finlayson, "Artwork and the *Promesse du Bonheur* in Adorno."

35. For discussions of his attitude toward Bach, see Paddison, *Adorno's Aesthetics of Music*, 225–32; and Berry, "Romantic Modernism."

made him into a composer for organ festivals in well-preserved Baroque towns, into ideology" (*P*, 136). Despite their historicist pretensions, they are more like purveyors of an allegedly timeless ontology, who fail to acknowledge the movement of history, which compels form to develop with variations rather than remain static. "No matter how it is done in the Church of St. Thomas, a performance of the *St. Matthew Passion*, for instance, done with meagre means sounds pale and indecisive to the present-day ear. . . . such a performance thereby contradicts the intrinsic essence of Bach's music. The only adequate interpretation of the dynamic objectively embedded in his work is one which realizes it" (*P*, 144). Artworks transcend not only the context out of which they are created but also their performance history, which manifests only some of the ways in which they can be realized. To be true to Bach's genius, Adorno concluded, is to recognize the inspiration he provided to modernist music. "Justice is done Bach . . . solely through the most advanced composition, which in turn converges with the level of Bach's continually unfolding work. . . . his heritage has passed on to composition, which is loyal to him in being disloyal; it calls his music by name in producing it anew" (*P*, 146).

When religious impulses apparently inspired later works, such as Beethoven's *Missa Solemnis*, which Adorno called his "alienated masterpiece," it did so only in ways that betrayed the impossibility of reversing the transition from the devotional to the aesthetic. "The religiosity of the *Missa*, if one can speak unconditionally of such a thing," Adorno wrote, "is neither that of one secure in belief nor that of a world religion of such an idealist nature that it would require no effort of its adherent to believe in it. . . . In its aesthetic form the work asks what and how one may sing of the absolute without deceit, and because of this, there occurs the compression which alienates it and causes it to approach incomprehension."[36] Here aesthetic sublimation meant the opposite of affirmative reconciliation, as the work expressed the impossibility—at this moment of historical development—of an organic totality unifying subject and object that had been achieved in Beethoven's earlier symphonies. Instead, in the *Missa* "he exposed the classical as classicizing. He rejected the affirmative, that which uncritically endorsed Being in the idea of the classically symphonic."[37]

If there is a later equivalent of Christ's Passion, which had once been capable of musical expression with still-sacred intent by Bach, it appeared, so Adorno argued in 1929, in Alban Berg's human-all-too-human opera *Wozzeck*. The very character of the work, Adorno wrote,

36. Adorno, "Alienated Masterpiece," 120.
37. Adorno, "Alienated Masterpiece," 122.

is *Passion*. The music does not suffer within the human being, does not, itself, participate in its actions and emotions. It suffers over him; only for this reason is it able, like the music of the old passion plays, to represent every emotion without ever having to assume the mask of one of the characters of the tragic drama. The music lays the suffering that is dictated by the stars above bodily onto the shoulders of the human being, the individual.[38]

Suffering rather than desire, Adorno implied, can be understood as the affect that fuels aesthetic sublimation in a secular world, which transcends the emotional life of the creative subject.

Did a similar attitude inform Adorno's response to the modernist appropriation of so-called primitive culture? To provide a detailed answer would require parsing his subtle and complicated analysis of related terms such as *archaic* and *barbaric* in works such as *Dialectic of Enlightenment*, but a few basic points can be ventured. In *Aesthetic Theory*, while arguing against an ahistorical definition of art, Adorno noted that "much that was not art—cultic works, for instance—has over the course of history metamorphosed into art; and much that once was art is that no longer" (*AT*, 3). If "art" defied easy definition, no less dubious was the search for its origins in some primeval need. Nonetheless, Adorno did hazard a speculation about one element in its urhistory that still echoed in the art of today: "It is doubtless that art did not begin with works, whether they were primarily magical or already aesthetic. The cave drawings are stages of a process and in no way an early one. The first images must have been preceded by mimetic comportment—the assimilation of self to its other—that does not fully coincide with the superstition of direct magical influence" (*AT*, 329). The residue of such benign mimesis, which Adorno often contrasted with the subjective domination of nature serving self-preservation, meant that "aesthetic comportment contains what has been belligerently excised from civilization and repressed, as well as the human suffering under the loss, a suffering already expressed in the earliest forms of mimesis" (*AT*, 330). Although such a residue might be called irrational from the viewpoint of the instrumental rationality pervading the modern world, it was actually an indication of a more profound and emancipatory ideal of reason preserved in art. Here the relevant sublimation was not of libidinal desire or the memory of suffering but of the mimetic faculty that had been sacrificed—with the exception of children's play[39]—to the demands of instrumental ratio-

---

38. Adorno, "Opera *Wozzeck*," 625.

39. For a critique of Adorno's appeal to childhood experience in his treatment of sublimation, see Connell, "Childhood Experience and the Image of Utopia."

nality and the domination of nature. As Peter Uwe Hohendahl has put it, "By remaining attached to the primitive, for Adorno the advanced artwork resists the process of Enlightenment. . . . Adorno recognizes the ambiguity of the modern artwork, its tendency to return to the logic of mimesis."[40]

There was, to be sure, also a regressive potential in the modernist exaltation of the primitive or even more generally the "pre-capitalist," against whose dangerous political implications Adorno warned in an aphorism in *Minima Moralia* called "Savages are not more noble" (52–53). In aesthetic terms, Adorno most explicitly discerned it in his relentless critique of the music of Igor Stravinsky, which he invidiously compared with Arnold Schoenberg's atonal alternative in *Philosophy of New Music*. Likening *The Rite of Spring* to the visual modernists' discovery of African sculpture, Adorno wrote: "It belongs to the years in which 'savages' were first called 'primitives,' to the world of Sir James Frazier, Lucien Lévy-Bruhl, and Freud's *Totem and Taboo*. . . . When the avant-garde avowed its attachment to African sculpture, the reactionary aim of the movement was still entirely hidden."[41] It was, however, on full display in Stravinsky's embrace of the sacrifice of the individual to the collective, which is enacted without protest in *The Rite of Spring* with its brutal rhythms and convulsive shocks, anticipating the slaughter of World War I.

But unlike postcolonial and postmodernist critics, Adorno refused to advocate the reembedding of what came to be called primitive artifacts in their allegedly "authentic" contexts of origin, de-aestheticizing them to restore cultic wholeness. In *The Jargon of Authenticity* and elsewhere, he was highly suspicious of attempts to grant priority to the original over the copy, the genuine over the derived, the pure over the impure. As in his insistence on distinguishing between artworks and the psychology of their creators, he refused to reduce the validity of aesthetic objects to their genetic matrix.[42] Whatever the limits of aesthetic sublimation, it was superior to the repressive desublimation that sought to reverse the historical process and regain some sort of libidinal immediacy, a caution that extended to naive attempts to return to a pristine version of nature before its domination.[43] Adorno's much-derided hostility to jazz can be at least partly understood in these terms, for, so he claimed, "jazz is the false liquidation of art—instead of utopia becoming reality it disappears from the picture" (*P*, 132). In *Dialectic of Enlightenment* he and Horkheimer could

40. Hohendahl, *Fleeting Promise of Art*, 96.
41. Adorno, *Philosophy of New Music*, 111–12.
42. Adorno, *Jargon of Authenticity*; see also Jay, "Taking on the Stigma of Authenticity."
43. See Cook, *Adorno on Nature*.

in contrast define "the secret of aesthetic sublimation" as the ability "to present fulfillment in its brokenness," something denied to the culture industry, which "does not sublimate: it suppresses."[44]

Thus, despite the reservations Adorno expressed against the Freudian reduction of artistic creation to sublimated desire, he could say in *Aesthetic Theory* that "by re-enacting the spell of reality, by sublimating it as an image, art at the same time liberates itself from it; sublimation and freedom mutually accord" (*AT*, 130). Even Stravinsky's appropriation of primitivism had to be understood dialectically as a placeholder for a more emancipatory liquidation. For despite its regressive dangers, it also expresses "the longing to abolish social appearances, the urge for truth behind bourgeois mediations and its masks of violence. The heritage of the bourgeois revolution is active in this disposition of mind" (*AT*, 112). It is for this reason that Stravinsky's music was denounced by fascists, who preferred the restoration of classical kitsch in their art and literal barbarism in their violent actions. "In the Third Reich of countless human sacrifice," Adorno noted, "*The Rite of Spring* would not have been performable" (*AT*, 112).

In light of the three objections Adorno made to Freud's theory of aesthetic sublimation when it was used reductively to explain artistic creativity, a somewhat more complicated picture emerges. As in the case of Marcuse, who had defended "nonrepressive sublimation" in *Eros and Civilization*, Adorno distinguished between versions in terms of their affirmative or critical potential.[45] Rather than adapt to the status quo and seamlessly channel the transgressive idiosyncrasies of artists into culturally uplifting consolations for the renunciation of desires, sublimation can also mean preserving the potential of past sources of dissatisfaction with the present, such as religious yearning and the primitivist disdain for contemporary civilization, for future appropriation. This is why it presents "fulfillment in its brokenness," rather than as fully realized. Not only are the memory of past suffering and the rage against its continuation in the present preserved, but traces of the mimetic impulse that inspired art in the first place are kept alive. Thus Adorno can define successful sublimating as guarding in itself "what it sublimates."

This survival also means that despite Adorno's fear that the theory of sublimation can spiritualize what was originally a corporeal or material interest,

---

44. Horkheimer and Adorno, *Dialectic of Enlightenment*, 111. For a critique of the distinction between culture and the culture industry in these terms, see Huhn, "Sublimation of Culture in Adorno's Aesthetics."

45. Marcuse, *Eros and Civilization*, 190.

the second of his complaints against psychoanalytic reductionism, he never endorsed a simple reversal of that hierarchy. Art, indeed culture in general, did involve a certain renunciation of bodily desires or at least their immediate realization. And as a result civilization did, as Freud memorably argued, bring with it inevitable discontents. But the alternative was certainly not a simple restoration of dominated nature or the unmediated desublimation of instinctual desire. Instead, it was necessary to heal the wound with the weapon that had caused it. As Eckart Goebel notes:

> Adorno moves beyond the antithesis of sublimation and the drives. Only false
> sublimation, with adaptation and integration (in Freud: narcissistic idealiza-
> tion) as its aim, reproduces the archaic desires of the drives as they once
> were, because they were never changed. Aesthetic experience as conceived
> by Adorno differentiates instinctual desire by comprehending sublimation
> both as differentiation and as a protest against the world under "the rule of
> brutal self-preservation," which corresponds to the identical, rigid self.[46]

Finally, because the sublimation of reception rather than production, the posterior rescue of exhausted cultural traces of prior sublimations, focuses on the artworks rather than the artists, it avoids the dangers of excessive subjectivism. Instead, it acknowledges the primacy of the object, the resistance that the world, both natural and cultural, presents to the domination implied in the quest for self-preservation at all costs. What is sublimated need not be reduced to the libidinal needs of the thwarted subject but can be understood as the delicate mixture of spiritual and corporeal, rational and sensual, formal and substantive that humankind has come to call art. Against any narcissistic regression, it posits an encounter with otherness that honors the nonidentity of subject and object.

An example of what Adorno may mean is presented in *The Freudian Body*, Leo Bersani's discussion of psychoanalysis and art. Imaginatively reading Stéphane Mallarmé's "L'après-midi d'un faune" as less a transcendence of desire than its active extension, Bersani argues that "the sublimating conscious described by the faun operates on what might be called a principle of accelerating supplementarity. . . . Mallarmé encourages us to view sublimation not as a mechanism by which desire is denied, but rather as a self-reflexive activity by which desire multiplies and diversifies its representations."[47] With a certain

46. Goebel, *Beyond Discontent*, 224.

47. Bersani, *Freudian Body*, 48–49. For another suggestive reading of sublimation, which draws on the work of Julia Kristeva, see Russell, "Strange New Beauty."

irony, the faun's desire is neither realized nor repressed; rather, it proliferates, which works to undermine his boundaried, integral selfhood. The "blind somatic pleasure" that Adorno identified with utopia turns out to be less the restoration of primary narcissistic oneness than an open-ended play of mimetic repetition and displacement. Rather than a defense mechanism or a version of symptom formation, sublimation in this larger sense draws on the legacy of past cultural creation to enable a future in which happiness may, against all odds, still be achieved.

**Martin Jay** is Sidney Hellman Ehrman Professor Emeritus of History at the University of California, Berkeley.

## *References*

Adorno, Theodor W. *Aesthetic Theory*, edited by Gretel Adorno and Rolf Tiedemann, translated by Robert Hullot-Kentor. Cambridge, MA: MIT Press, 1997.

Adorno, Theodor W. "Alienated Masterpiece: The *Missa Solemnis.*" *Telos*, no. 28 (1976): 113–24.

Adorno, Theodor W. *The Jargon of Authenticity*, translated by Knut Tarnowski and Frederic Will. London: RKP, 1973.

Adorno, Theodor W. *Minima Moralia: Reflections from Damaged Life*, translated by E. F. N. Jephcott. London: NLB, 1974.

Adorno, Theodor W. "The Opera *Wozzeck.*" In *Essays on Music*, edited by Richard Leppert, translated by Susan H. Gillespie, 619–26. Berkeley: University of California Press, 2002.

Adorno, Theodor W. *Philosophy of New Music*, translated by Robert Hullot-Kentor. Minneapolis: University of Minnesota Press, 2006.

Adorno, Theodor W. *Prisms*, translated by Samuel Weber and Shierry Weber. London: Spearman, 1967.

Adorno, Theodor W. "Progress." *Philosophical Forum* 15, no. 1 (1983): 55–70.

Adorno, Theodor W. "Resignation." In *Critical Models: Interventions and Catchwords*, translated by Henry Pickford, 289–93. New York: Columbia University Press, 2005.

Adorno, Theodor W. "Revisionist Psychoanalysis," translated by Nan-Nan Lee. *Philosophy and Social Criticism* 40, no. 3 (2014): 326–38.

Adorno, Theodor W. "Sociology and Psychology (Part II)." *New Left Review*, no. 47 (1968): 79–97.

Alloa, Emmanuel. "Visual Studies in Byzantium: A Pictorial Turn *Avant la Lettre.*" *Journal of Visual Culture* 12, no. 1 (2013): 3–29.

Applegate, Celia. *Bach in Berlin: Nation and Culture in Mendelssohn's Revival of the "St. Matthew Passion."* Ithaca, NY: Cornell University Press, 2005.

Berry, Mark. "Romantic Modernism: Bach, Furtwängler, and Adorno." *New German Critique*, no. 104 (2008): 71–102.

Bersani, Leo. *The Freudian Body: Psychoanalysis and Art*. New York: Columbia University Press, 1986.

Besançon, Alain. *The Forbidden Image: An Intellectual History of Iconoclasm*, translated by Jean Marie Todd. Chicago: University of Chicago Press, 2000.

Brown, Norman O. *Life against Death: The Psychoanalytic Meaning of History.* Middletown, CT: Wesleyan University Press, 1959.

Clifford, James. *The Predicament of Culture: Twentieth-Century Ethnography, Literature, and Art*. Cambridge, MA: Harvard University Press, 1988.

Connell, Matt. F. "Childhood Experience and the Image of Utopia: The Broken Promise of Adorno's Proustian Sublimations." *Radical Philosophy*, no. 99 (2000): 19–30.

Cook, Deborah. *Adorno on Nature*. Durham, NC: Duke University Press, 2011.

Dahmer, Helmut. "Adorno's View of Psychoanalysis." *Thesis Eleven* 111, no. 1 (2012): 97–109.

Etherington, Ben. *Literary Primitivism*. Stanford, CA: Stanford University Press, 2017.

Fenichel, Otto. *The Psychoanalytic Theory of Neurosis*. New York: Norton, 1945.

Finlayson, James Gordon. "The Artwork and the *Promesse du Bonheur* in Adorno." *European Journal of Philosophy* 23, no. 3 (2015): 392–419.

Foster, Hal. "The Primitive Unconscious of Modern Art." *October*, no. 34 (1985): 45–70.

Freud, Anna. *The Ego and the Mechanisms of Defense*. London: Hogarth, 1979.

Freud, Sigmund. *Civilization and Its Discontents*, translated by James Strachey. New York: Norton, 1961.

Freud, Sigmund. "'Civilized' Sexual Morality and Modern Nervousness." In *Civilization, Society, and Religion: "Group Psychology," "Civilization and Its Discontents," and Other Works*, edited by Albert Dickson, translated by James Strachey et al., 27–56. London: Penguin-Pelican, 1985.

Freud, Sigmund. "Creative Writers and Day-Dreaming." In vol. 9 of *The Standard Edition of the Complete Psychological Works of Sigmund Freud*, edited and translated by James Strachey et al., 143–53. 24 vols. London: Hogarth, 1956–74.

Freud, Sigmund. "Leonardo da Vinci and a Memory of His Childhood." In vol. 11 of *The Standard Edition of the Complete Psychological Works of Sigmund Freud*, edited and translated by James Strachey et al., 29–139. 24 vols. London: Hogarth, 1956–74.

Freud, Sigmund. *New Introductory Lectures on Psychoanalysis*, translated by James Strachey. New York: Norton, 1965.

Freud, Sigmund. "On Narcissism." In vol. 14 of *The Standard Edition of the Complete Psychological Works of Sigmund Freud*, edited and translated by James Strachey et al., 67–102. 24 vols. London: Hogarth, 1956–74.

Gemes, Ken. "A Better Self: Freud and Nietzsche on Sublimation." In *The Oxford Handbook of Philosophy and Psychoanalysis*, edited by Richard G. T. Gipps and Michael Lacewing, 107–29. Oxford: Oxford University Press, 2018.

Goebel, Eckart. *Beyond Discontent: "Sublimation" from Goethe to Lacan*, translated by James C. Wagner. New York: Continuum, 2012.

Goebel, Eckart. "On Being Shaken: Theodor W. Adorno on Sublimation." *Cultural Critique*, no. 70 (2008): 158–76.

Goldwater, Robert. *Primitivism in Modern Art*. Cambridge, MA: Harvard University Press, 1986.

Hegel, G. W. F. *Aesthetics: Lectures on Fine Arts*, translated by T. M. Knox. Vol. 1. Oxford: Oxford University Press, 1988.

Hohendahl, Peter Uwe. *The Fleeting Promise of Art: Adorno's Aesthetic Theory Revisited*. Ithaca, NY: Cornell University Press, 2013.

Honneth, Axel. "Idiosyncrasy as a Tool of Knowledge: Social Criticism in the Age of the Normalized Intellectual." In *Pathologies of Reason: On the Legacy of Critical Theory*, translated by James Ingram, 179–92. New York: Columbia University Press, 2009.

Horkheimer, Max, and Theodor W. Adorno. *Dialectic of Enlightenment: Philosophical Fragments*, edited by Gunzelin Schmid Noerr, translated by Edmund Jephcott. Stanford, CA: Stanford University Press, 2002.

Huhn, Thomas. "The Sublimation of Culture in Adorno's Aesthetics." tomhuhn.com /includes/pdf/publications/articles/15_sublimation_culture_A.pdf.

Idzerda, Stanley. "Iconoclasm in the French Revolution." *American Historical Review* 60, no. 1 (1954): 13–26.

Jay, Martin. "'In Psychoanalysis Nothing Is True but the Exaggerations': Freud and the Frankfurt School." In *The Oxford Handbook of Philosophy and Psychoanalysis*, edited by Richard G. T. Gipps and Michael Lacewing, 179–201. Oxford: Oxford University Press, 2018.

Jay, Martin. "Max Horkheimer and *The Family of Man*." In *"The Family of Man" Revisited: Photography in a Global Age*, edited by Gerd Hurm, Anke Reitz, and Shamoon Zamir, 57–70. London: Routledge, 2018.

Jay, Martin. "Modernism and the Specter of Psychologism." In *Cultural Semantics: Keywords of Our Time*, 165–80. Amherst: University of Massachusetts Press, 1998.

Jay, Martin. "Taking on the Stigma of Authenticity: Adorno's Critique of Genuineness." In *Essays from the Edge: Parega and Paralipomena*, 9–21. Charlottesville: University of Virginia Press, 2011.

Kahane, Clare. "Freud's Sublimation: Disgust, Desire, and the Female Body." *American Imago* 49, no. 4 (1992): 411–25.

Laplanche, Jean, and Jean-Bertrand Pontalis. *The Language of Psychoanalysis*, translated by Donald Nicholson-Smith. New York: Norton, 1973.

Loewald, Hans. *Sublimation: Inquiries into Theoretical Psychoanalysis*. New Haven, CT: Yale University Press, 1988.

Lovejoy, Arthur O., and George Boas. *Primitivism and Related Ideas in Antiquity*. Baltimore: Johns Hopkins University Press, 1935.

Marcuse, Herbert. "The Affirmative Character of Culture." In *Negations: Essays in Critical Theory*, translated by Jeremy J. Shapiro, 88–133. Boston: Beacon, 1968.

Marcuse, Herbert. *Eros and Civilization: A Philosophical Inquiry into Freud*. Boston: Beacon, 1955.

Marcuse, Herbert. *One-Dimensional Man: Studies in the Ideology of Advanced Industrial Society*. Boston: Beacon, 1964.

Norton, David, ed. *A History of the English Bible as Literature*. 2 vols. Cambridge: Cambridge University Press, 2012.

Paddison, Max. *Adorno's Aesthetics of Music*. Cambridge: Cambridge University Press, 1997.

Pan, David. *Primitive Renaissance: Rethinking German Expressionism*. Lincoln: University of Nebraska Press, 2001.

Plug, Jan. "Idiosyncrasies: of Anti-Semitism." *Monatsfheft* 94, no. 1 (2002): 43–66.

Rhodes, Colin. *Primitivism and Modern Art*. London: Thames and Hudson, 1994.

Rieff, Philip. *Freud: The Mind of a Moralist*. Garden City, NY: Anchor, 1961.

Rubin, William, ed. *"Primitivism" in Twentieth-Century Art: Affinity of the Tribal and the Modern*. 2 vols. New York: Museum of Modern Art, 1984.

Russell, Francey. "Strange New Beauty: In Defense of Kristevan Sublimation." *Cincinnati Romance Review* 35 (2013): 135–50.

Torgovnick, Marianna. *Gone Primitive: Savage Intellects, Modern Lives*. Chicago: University of Chicago Press, 1991.

Wellmer, Albrecht. "Adorno, Modernity, and the Sublime." In *Endgames: The Irreconcilable Nature of Modernity*, translated by David Midgley, 155–81. Cambridge, MA: MIT Press, 1998.

Whitebook, Joel. *Perversion and Utopia: A Study in Psychoanalysis and Critical Theory*. Cambridge, MA: MIT Press, 1995.

# *Teddie's* Landschaft

## Sherry Lee

Adorno opened his draft introduction to *Aesthetic Theory* with the recognition that it might well seem like an outdated project, given the disdain toward the very concept of the aesthetic that had grown in recent decades, a skepticism that has scarcely subsided since.[1] He was correct if he anticipated that many readers, whether in his own moment or fifty years on, might be surprised (or outright nonplussed) to encounter a discussion of beauty in art and nature, involving Immanuel Kant and G. W. F. Hegel no less, that must seem like a historical throwback from the critical concern with the modern art movement's relations to pressing sociocultural issues. But for Adorno the appreciation of beauty in art is predicated on the appreciation of natural beauty, and thus the reflections on this traditional dimension in the early pages of his text highlight the capacity of the aesthetic to illuminate the human relationship to nature: a challenge that was both historical and ongoing from his vantage point over fifty years ago—was, in fact, gaining new relevance in that very moment— and has attained an obvious urgency today. In *Aesthetic Theory*'s discussion of beauty, that relationship crystallizes in a concept of landscape, which comprises both nature and art. If this is indeed a central concern of *Aesthetic Theory* that suddenly flashes out with present-day resonance, it is also among

An earlier version of this article was presented at Harvard University on March 5, 2019. I wish to thank Peter Gordon and also Alex Rehding, Stephen D. Smith, and an anonymous reader for helpful suggestions on the text. This article is written in gratitude to Richard Leppert.

1. Adorno, *Aesthetic Theory*, 332 (hereafter cited as *AT*).

*New German Critique* 143, Vol. 48, No. 2, August 2021
DOI 10.1215/0094033X-8989260    © 2021 by New German Critique, Inc.

those that are not just products of late reflection but that echo motifs from among Adorno's earliest writings, which recur throughout his oeuvre. In what follows I offer a selective account of earlier roots of his concepts of natural beauty and landscape as they appear in the late and hefty fragment of *Aesthetic Theory*, traced not only in his earlier work and in the prior influence of the thought of others but also in his life experience.[2] Along the way, I excavate some Adornian moments that pull away from the stereotype of a powerfully abstract mechanism of philosophical thought toward an investment in experience, emergent in peripatetic listening moments.

Because so much recent interest in landscape is related to the typically urgent (and often rhetorically apocalyptic)[3] concerns of the environmental humanities, I should acknowledge that it would be a stretch to attempt to cast Adorno as a kind of ecocritic (let alone ecomusicologist) *avant la lettre*, despite the undeniable precedent of the *Dialectic of Enlightenment*'s recognition of the long-standing and far-reaching consequences of human domination of the natural world,[4] and also despite the sometimes slightly queasy feeling of recurrence that Adorno scholars frequently experience, that there is something "already" in Adorno about many apparently contemporary topics. Such a reconstitution is not my goal here, but landscape does crop up repeatedly in his copious writings. In *Aesthetic Theory* it is invoked first in relation to beauty and ugliness, where he describes industrial landscapes as "devastated" terrain whose ostensible ugliness "cannot be adequately explained in formal terms . . . [but] stems from the principle of violence and destruction" wrought on a natural environment (*AT*, 46). More revealing is the subsequent discussion of landscape in terms of natural beauty, and the relationship of art to nature. The most signal category here is the *Kulturlandschaft*, "cultural landscape," which Adorno defines as an artifactitious, hybrid domain dating from the nineteenth century, its likely origin, he suggests, in the cult of the ruin (*AT*, 64). The German geographer Otto Schlüter, credited for first using the term *Kulturlandschaft* in the 1920s, defined it as a landscape created by humans, in opposition to an *Urlandschaft* ("original landscape") that had existed before substantial human intervention.[5] Adorno understands it as a domain in which historical built environments have some relation, particularly material, to their surrounding geographic environment—hillside towns built with local

2. The larger goal of restoring experience to life forms is, according to Roger Foster, "the unifying core" of Adorno's "strikingly multidisciplinary oeuvre" (*Adorno*, 2).

3. See Rehding, "Ecomusicology between Apocalypse and Nostalgia."

4. See, e.g., Cook, *Adorno on Nature*; or Biro, *Critical Ecologies*.

5. See James and Martin, *All Possible Worlds*, 177.

stone is one example he offers—that is perceived as beautiful. Such beauty is
not least the recognition that, unlike the industrial landscape, it models a for-
mal integration that mediates the violence of the domination of nature in
appearing to heal the wound inflicted by the technical production process.
Adorno offers an understanding of the concept that inscribes multiple and con-
flicted qualities of the human relationship to nonhuman nature: the violence of
rationalized productivity exercised on the nonhuman world, with a simulta-
neous longing for relationship with nature, and the consequent suffering inher-
ent in the recognition of loss (*AT*, 64–65). The *Kulturlandschaft* thus holds out
the beautiful possibility of reconciliation. Landscape, then, models the central
point of the aesthetic in terms of art, natural beauty, and history, as a locus
mediating the seeming opposites of history as human time and nature as non-
human givenness and permanence.

What one might not readily guess is that this late manifestation of the crit-
ical investment in an aesthetic landscape has musical origins (visual assump-
tions notwithstanding), and from decades prior. Consider this passage from
an essay that belongs to a moment much earlier in Adornian history:

> He who crosses the threshold between the years of Beethoven's death and
> Schubert's will shiver, like someone emerging into the painfully diaphanous
> light from a rumbling, newly formed crater frozen in motion, as he becomes
> aware of skeletal shadows of vegetation among lava shapes in these wide,
> exposed peaks, and finally perceives those clouds drifting near the mountain,
> yet far above his head. He steps out from the chasm into the landscape of
> immense depth bounded by an overwhelming quiet at its horizon, absorbing
> the light that earlier had been seared by blazing magma. Although Schubert's
> music does not contain the power of active will that rises from the inmost
> nature of Beethoven, its chasms and shafts lead to the same chthonic depth
> where that will had its source, and reveal the demonic image that active prac-
> tical reason managed to master again and again; yet the stars that shine for
> Schubert's music are the same as those towards whose unattainable light Beet-
> hoven's fist reached out to grasp. So this is how we must speak of Schubert's
> landscape.[6]

The connection between Franz Schubert's music and landscape is unsurprising
now, as it must have been in 1928, when the twenty-five-year-old Adorno
penned this essay commemorating the centennial of Schubert's death. Those
deeply forested German scenes, the rustling leaves of trees (perhaps festooned

6. Adorno, "Schubert," trans. Dunsby and Perrey, 7; translation modified.

with green ribbon) near the village boundaries restlessly crossed by the Romantic wanderer, the lucid brooks and buoyant streams, the snow and icy wind of winter: not only do we know them well, but such images of the subject within nature as conveyed to us in the contours of a Romantic landscape spring readily to mind with the topic of Schubertian song especially. But all these seem absent from Adorno's perspective: there is nothing obviously Schubertian about the seared and calcified volcanic landscape he invokes. In relation to our typical understanding of Schubert—in Adorno's words, "the Biedermeier dreamer who is always found sitting by that brook, listening to it babble"[7]—this landscape of extreme alienation is all but unrecognizable.

Charles Rosen suggests what a Schubertian landscape should look like and what it signifies. Much of his massive study "Mountains and Song Cycles" is devoted to working through the Schubertian ingredients of rustling leaves, bird and horn calls, running water, as steadily as the tread of the wanderer, as the subject moving through the landscape.[8] Throughout the references to musical temporality and the descriptions of Schubert's sonic-pictorial gestures in *Die schöne Müllerin* (*The Beautiful Maid of the Mill*) and the *Winterreise* (*Winter's Journey*) as ways to evoke both memory and experience, Rosen argues for the animation of romantic landscape, demonstrating how a musical landscape is capable of, or consists in, superimposing movement and temporal experience and rendering the lyrical developmental. This stands in stark contrast to Adorno's hearing, which refuses to mediate between what sounds like a crystalline stasis of lyrical repetition and a history-making teleology of dialectical development; the memory he invokes is that of the moment, fleeting, lost. The mountain is there—and the mountain matters, it will return—but the branches rustling in the wind disappear into some fissure within a cratered landscape of frozen lava.

In the summer of 1925, after several months' composition study with Alban Berg, the earnest and studious young Teddie went on holiday, leaving Vienna for Italy in the latter part of August, with the best of intentions to keep up his composing while he traveled. He headed first for the Dolomites, where he had also visited the previous summer at the invitation of Else Herzberger, a friend of the Wiesengrund family; he then continued on a tour of some six weeks in the Italian south, traveling with his older friend and philosophical mentor Siegfried Kracauer. They met in Genoa—an opportunity to visit the Palazzo Adorno—then went to Capri, Pompeii, and Naples, where they met

7. Adorno, "Schubert," trans. Dunsby and Perrey, 8.
8. Rosen, *Romantic Generation*, 116–236.

up with Walter Benjamin. As a proper tourist, Adorno sent postcards, including some to Berg, from Madonna di Campiglio and also from Genoa. He then wrote at greater length from Capri. After a discussion of metaphysics, subjectivity and objectivity in relation to a recent essay on Arnold Schoenberg, and the "dialectic of reality" as debated in beachside cafés, he continues:

> The mountains would be the right thing for me, I realized this once again in Madonna [di Campiglio], and I think I need not fear any loss of originality if I should plan later on to divide my time between South Tyrol and Vienna. . . . In the meantime Italy, in particular southern Italy, has taken up a rather skewed position among my categories. A land in which the volcanoes are institutions, and the swindlers are saved, goes against my public spirit just as fascism conflicts with my inflammatory tendencies. And yet I am very well here. Though one does not get around to composing, as the external distractions are too strong and too alien, and whereas I could spend entire nights sketching in Madonna, I now lie beneath the zanzariera, relishing my protection from the mosquitoes.
>
> Your demonic taste for civilization and illusion would find ample sustenance here, for nowhere is civilization more glassy than in Italy, and intense, though in a different, more positive sense than with us, for the whole of life, lived as it were to the point of destruction, resists constant stabilizations and mirrors its own transience in illusion.[9]

Here is an echo from among the alien, volcanic, and obsidian elements of this landscape of destruction Teddie's letters sketched for Berg. Martin Mittelmeier has argued that roots of Adorno's philosophy can be found in this touristic experience of southern Italy, shaped by the coincidence of captivating foreign landscape and the intellectual ferment of Adorno's conversations with Kracauer and Benjamin, as communicated especially in his daily diaries.[10] Some may be hesitant to position the entirety of Critical Theory as an outgrowth of a sightseeing trip, but Mittelmeier's study clearly recognizes that this travel had no small impact, not least in terms of the encounter of philosophy with particular music: one can descry some contours of the strange, non-Germanic Schubertian landscape Adorno surveys in 1928. Even so, this estrangement remains difficult to account for, especially considering that, in light of the philosopher's early home life, Schubert ought to have seemed utterly native. The 1933 essay "Vierhändig, noch einmal" testifies to the centrality of Schubert's music in Teddie's childhood and his musical upbringing at the piano, playing

9. Adorno and Berg, *Correspondence*, 14.
10. See Mittelmeier, *Adorno in Neapel*.

duets with his mother and his aunt. "That music we are accustomed to call classical I came to know as a child through four-hand playing," he asserts:

> There was little symphonic and chamber music literature that was not moved
> into home life with the help of those oblong volumes, bound uniformly green
> in landscape format. They appeared as if made to have their pages turned, and
> I was allowed to do so, long before I knew the notes, following only memory
> and my ear. . . . Four-hand playing was the gift the geniuses of the bourgeois
> nineteenth century placed at my cradle at the beginning of the twentieth. . . .
> It is no coincidence that the literature of "original compositions" for four
> hands is limited to this period [of authentic bourgeois musical practice]. Its
> true master is Schubert.[11]

Moreover, the gesture invoked by the "Four-Hands" essay is not only that of memory but that of belonging, family, and community: "If the lonesome, who do not have to hope for listeners and have none to fear, were now and then to give four-hand playing a try, it would not necessarily be to their harm. In the end, a child might be found to turn the pages for them."[12] Actually, Schubert's Vienna *was* a place distinctly "other" from Frankfurt, as Adorno learned firsthand when he studied there with Berg, and some hint of that difference registers in motifs of distance—indeed, in terms of dialect—near the closing of the "Schubert" essay;[13] yet here, in the 1933 reminiscence of childhood four-hand playing, the music of Schubert seems irretrievably entwined with the remembered image of home. The later experience of exile, however, would throw into relief the complex tracery of the motifs of home with distance.

The house in Frankfurt into which Teddie was born was on a street called Schöne Aussicht (beautiful prospect). It runs roughly parallel to the river. No. 9, situated along the Main embankment, was not far from the Alte Brücke, almost across from the Maininsel. The "beautiful prospect" is situated as a view*point* from which to look out; the landscape of home itself is valued, at least before the experience of exile, as a distinctly interior one—a house with a gramophone, in which concerts were sometimes held, and with multiple levels of wine cellar, part of the inherited family business dating back over a century. Frankfurt, within two weeks of Adorno's return from the striking Italian

11. Adorno, "Four Hands, Once Again," 1–2.
12. Adorno, "Four Hands, Once Again," 3.
13. "The language of this Schubert is in dialect, but it is a dialect from nowhere. It has the flavour of the native, yet there is no such place, only a memory. He is never further away from that place than when he cites it" (Adorno, "Schubert," trans. Dunsby and Perrey, 14). Thanks to Stephen D. Smith for this observation.

landscape in the early fall of 1925, was characterized in his letters as "this dreadful city" with "crass, ugly people on the street," the experience exacerbated by annoyances in personal, musical, and intellectual surroundings. "I am homesick for Vienna," he wrote to Berg, "the city one complains of as long as one is there, and which one only learns to appreciate once more in exile."[14] Within a few years, when the exiled Max Horkheimer and Adorno took up the concept of the place of home—that is, of *Heimat* (homeland)— in *Dialectic of Enlightenment*, they considered it within a constellation of nature, history, nomadic wandering, and settlement, the latter of which of course transforms the natural landscape into a cultural one. But perhaps most important to their discussion of *Heimat*, as Wesley Phillips notes, is its connotation of loss, their recognition that the longing for it is that for a "lost primal state"—perhaps like the longing for nature itself.[15] The very concept of *Heimat* here, states Phillips, "arises from the experience of its loss."[16] So in the wake of his experience of successive displacements, of study away from home followed by travel in the more distant and foreign landscape of Italy, the young Adorno came to recognize the Vienna of his temporary sojourn as a *Heimat*, the concept that spurs the sense of homesickness; paradoxically, he felt as if in exile on returning to his native cityscape, a *Landschaft* both cultural and industrial, which itself is barely invoked. Thus "Schöne Aussicht" is understood as a point commanding an outward view of landscape, rather than constituting a landscape in itself. Landscape, then, is conceptualized as what is looked at *from* here, necessarily at some degree of elsewhere; what the prospect affords is the possibility for the subject of framing experience. This is, of course, an essential quality of the very concept of landscape, as opposed to "the land" or the earth as a physical entity, as many have emphasized. The crucial distinction was the starting point for Georg Simmel's 1913 essay "The Philosophy of Landscape," which analyzes "the peculiar mental process that generates a landscape out of . . . an ensemble of all kinds of things spread out side-by-side over a piece of ground and which are viewed in their immediacy."[17] A land-scape (the *schaft* of *Landschaft* connoting creative making) comprises elements subjectively confined as a view, necessarily from some distance. It has to do, in other words, with the framing of subjective experience. "As far as landscape is concerned," asserts Simmel, "a boundary, a way of being

14. Adorno and Berg, *Correspondence*, 21.
15. Horkheimer and Adorno, *Dialectic of Enlightenment*, 61.
16. Phillips, *Metaphysics and Music in Adorno and Heidegger*, 123.
17. Simmel, "Philosophy of Landscape," 21.

encompassed by a momentary or permanent field of vision, is essential."[18] This framing quality fixes the landscape as an *image*. In *Aesthetic Theory* this image character becomes crucial to Adorno's theorization of the relation between natural beauty and aesthetic experience, because of the nonobjective nature of an aesthetic stance toward nature, one not oriented toward its domination for use. "Occupations in which nature as it appears is an immediate object of action allow little appreciation for landscape," he notes; however, "like the experience of art, the *aesthetic* experience of nature is that of *images*. Nature, as appearing beauty, is not perceived as an object of action" (*AT*, 65; emphasis added).

The nonobjective quality of the image is also vital for Simmel, for whom the subjective constitution of landscape remains the central point.[19] Similarly, Richard Leppert highlights this subjective element in a gloss on Adorno's "Schubert" essay. Leppert notes some of the same characteristic imagery that Rosen does—brooks, mill wheels, the figure of the Wanderer—but crucially, he recognizes that Schubert "looks to the horizon while gazing inward": "It's all in his head (how modern is that?), and it's outside him as well. It's all there in a landscape. But just what *is* Schubert's landscape? For starters, if it really involves land/nature, that's not what's interesting. Whatever it is, it's out *there*: it's an other, but it's also partly the otherness of the self."[20] Whether or not the involvement of land and/or nature in a conception of Schubertian landscape is uninteresting, Leppert's recognition of the central quality of being "out there," of the awareness of the self in the context of otherness, is astute. This recognition impinges on the question of how we understand Schubert's music to implicate landscape in works connected to conceptions of natural environment and subjecthood within it. In relation to Adorno hearing landscape in Schubert, too, the landscape concept appears to arise from being somewhere other. Mittelmeier identifies landscape as emerging from the experience of travel; I would add—crucially, I think—the later experience of exile. What comes to the fore in Adorno's reflection on "glassy" Italy's volcanic landscape is partly a material experience of the confrontation with both nature and history: the mass and sublime natural force of Vesuvius, and civilization within the shadow of natural destruction. When Adorno invokes "landscape," he also invokes the space-time dialectic that is characteristic of his conception of the relationship between nature and history, for the landscape is not least a representation of nature that captures it in time. I have discussed elsewhere Adorno's

18. Simmel, "Philosophy of Landscape," 21.
19. Simmel, "Philosophy of Landscape," 27.
20. Leppert, "On Reading Adorno Hearing Schubert," 58.

idea of the dialectical relationship of nature and history in musical terms of space and time,[21] arising from his interrogation of the conceptual relation of history, understood as dynamic, and nature as the emblem of the static and unchanging, "what has always been."[22] This theory, we know, was strongly shaped by Benjamin's concept of history, which Adorno was very much immersed in around the time of the "Schubert" essay. The subject of Benjamin's *Habilitation*, written in Capri in 1924, was part of their intense philosophical discussions during the southern holiday of 1925. Not coincidentally, their correspondence shows that Adorno sent Benjamin a copy of the Schubert manuscript early in 1928, before it was published.[23] And some forty years on, when the temporal configuration of nature and history reappears in *Aesthetic Theory*, Schubert, too, suddenly resurfaces in a discussion of art's connection to natural beauty: "Natural and historical elements interact in a musical and kaleidoscopically changing fashion. Each can step in for the other, and it is in this constant fluctuation, not in any unequivocal order of relationships, that natural beauty lives." Music's mimetic affinity with natural beauty is further revealed in a shared quality of evanescence:

> Natural beauty is suspended history, a moment of becoming at a standstill. Artworks that resonate with this moment of suspension are those that are justly said to have a feeling for nature. Yet this feeling is—in spite of every affinity to allegorical interpretation—fleeting to the point of déjà vu and is no doubt all the more compelling for its ephemeralness. . . . As indeterminate, as antithetical to definitions, natural beauty is indefinable, and in this it is related to music, which drew the deepest effects in Schubert from such nonobjective similarity with nature. Just as in music[,] what is beautiful flashes up in nature only to disappear in the instant one tries to grasp it. (*AT*, 71, 72)

This is also how the *Kulturlandschaft* reveals its significance as a locus of the relationship of nature and history. A dialectic of temporal and static, the combination of the time implications of natural history and the effect of fixity of the subjective framing of a landscape that itself presents images of solidification, emerges discursively from Adorno's meditation on Schubert, much of which hinges on time. The time dimension has of course long been central in discourse on Schubert's music, which has foregrounded his lyricism, and a sense of stasis arising from repetition as differentiated from developmental

21. See Lee, "Minstrel in a World without Minstrels."
22. Adorno, "Idea of Natural-History," 253.
23. Adorno and Benjamin, *Complete Correspondence*, 3–5.

dynamism—Beethoven develops, Schubert (merely) repeats—or in formal terms, a binary between teleologically developing and "merely" additive or variational forms.[24] In Adorno this understanding juxtaposes organic development with a mineral metaphor of inorganic growth. "Even conceding that everything in Schubert's music is natural rather than artificial," he asserts, "this growth, entirely fragmentary, is not plantlike, but crystalline."[25] If the dream of the lyric is to halt time,[26] the lyrical in Schubert is the momentary crystallization of a subjective reflection on an object of external reality, outside the self. So the lyric is an image, a subjectively framed construct of landscape itself. Similarly, Adorno surveys Schubertian thematic and formal repetition as a landscape of solidified moments. "Schubert's themes wander like the miller," he suggests, "or he whose beloved abandoned him in winter. Those themes know of no history, but only a journey with shifts in perspective: the only change is a changing light." Not only do themes tend to repeat within a given work, but they are reused in different works, too—"passages that are timeless and occur in isolation," listened to as though by a wanderer who recognizes the same surrounding features, only differently illuminated. "Instead of developing mediations," Adorno realizes, conceding the critical disparity noted again and again between Schubert's and Beethoven's musical structures, "harmonic shifts appear, lighting up different aspects in turn, and leading us into a new landscape that is as bereft of any progression as what went before it."[27]

Critically, because of these very qualities, the nonteleological form as inorganic and the lyrical as image, Schubert's music lends itself to a banal reception that atomizes thematic moments and understands subjectivity as emotive sentimentality: "The socially determined affinity of Biedermeier with genre postcards, which generates the impulse to associate Schubert with kitsch, turns out in the works themselves to be the continuity of the isolated individual that inhabits Schubert's landscape."[28] For Adorno, the emblem of this absorption was the hugely popular Viennese operetta *Das Dreimäderlhaus* (*House of the Three Maidens*),[29] a 1916 adaptation of Rudolf Hans Bartsch's 1912 novel about Schubert titled *Schwammerl* (*Little Mushroom*) that was set

---

24. See Burnham, "Landscape as Music, Landscape as Truth."

25. Adorno, "Schubert," trans. Livingstone, 306; translation modified.

26. Baker, "Lyric Poetry and the Problem of Time," 29.

27. Adorno, "Schubert," trans. Dunsby and Perrey, 10.

28. Adorno, "Schubert," trans. Livingstone, 302.

29. The highly successful operetta was also adapted into French under the title *Chanson d'amour* (*Love Song*, 1921) and twice into English under the titles *Blossom Time* (New York, 1921) and *Lilac Time* (London, 1922).

to a pastiche of Schubert's music (arranged by Heinrich Berté). Thus *potpourri* becomes a keyword in Adorno's Schubert meditation on the conceptual proximity of inorganic musical construction in the "medley" to the mixture of dried flower petals that are images of death retrieved from a landscape outside time. "Potpourris," he insists,

> do not carry time within themselves, [as shown by] the perfect interchangeability in their thematic detail, . . . [which] intersects perfectly with the crystals of Schubert's landscape. Here, fate and reconciliation lie side by side; the potpourri shatters their ambiguous eternity so that this landscape can be recognized. What we have before us is the landscape of death. . . . Remember that both of the great [song] cycles are stimulated by poems in which again and again images of death appear before the person who sees them and who wanders among them as demeaned as the Schubert of *Dreimäderlhaus*.[30]

In this kitsch factor, too, Schubert's atomized landscape comes to resemble the history of the *Kulturlandschaft* itself, commodified in the service of tourism: in *Aesthetic Theory* Adorno notes that "with the collapse of romanticism, that hybrid domain, cultural landscape, deteriorated into an advertising gimmick for organ festivals and phony security"; however, "if a bad conscience is therefore admixed with the joy of each old wall and each group of medieval houses, the pleasure survives the insight that makes it suspicious" (*AT*, 64). Adorno's work in the Schubert essay is of course less to rescue Schubert from kitsch than to rehabilitate kitsch, or perhaps better to find value in it through its constitutive, subjective-objective relation to the Schubertian lyric, so like the touristic picture postcard in its image character. For finally, because the lyric image is constituted as the subject's interiorizing of the image of objective presence, it represents a kind of reciprocity toward otherness—as in the otherness of nature within which there is a simultaneous sense of belonging—and thus, somewhat like the *Kulturlandschaft*, it holds out the promise of reconciliation. This is the source of the hope for consolation that finds relief in what is for Adorno the appropriate response to hearing Schubert: "The right response is tears: the desperately sentimental tears of *Dreimäderlhaus*, and tears from the trembling body. . . . We weep without knowing why, because we have not yet become what this music promises . . . We cannot read them, but the music holds out to our fading eyes, brimming with tears, the ciphers of reconciliation at last."[31]

30. Adorno, "Schubert," trans. Livingstone, 9–10.
31. Adorno, "Schubert," trans. Livingstone, 313.

Adorno left Italy on September 30, 1925, and returned via Amorbach to Frankfurt, where he penned another letter to Berg in which he dwelt on his recent memories of the Italian landscape:

> The countryside in Positano is one that one knows only from one's dreams, and the people there adapt themselves to this; the Byzantine Ravello—above Amalfi—offers a glance of the East for an evening, before closing in Italian fashion once more with its fountain, cool upon its hill. In Paestum, near Salerno, I had my first view of Greek temples, which remained mute and alien in the solitude of this feverish region. . . . Then Naples was initially a threatening chaos, the roads there look like forests. . . . Even the kitsch of the buildings, which purport to be classical in style, excessively ruptures all civilizatory security.[32]

Clearly the dominant impression he retained was that of a cultural landscape, filled with elements of human civilization. He was in southern Italy again in 1928, the year of the "Schubert" article; a slightly blurry photograph of Gretel on a bench also captures the *Kulturlandschaft* of Capri, affording a wide prospect of a populated hillside and an ocean horizon.[33] Proof of the enduring quality of the impressions made by that volcanic landscape resurfaces in 1933, the same year as not only the evocative "Four-Hands" piece but also the publication of his lecture "On the Idea of Natural-History," and another composer-anniversary piece so brief it is barely more than a trifle. Pietro Mascagni turned seventy in 1933, and Adorno penned for the occasion an enigmatic, aphoristic piece titled "Mascagnis Landschaft," which has barely even been noticed, let alone translated or commented on, in the literature. Focused on Mascagni's famous 1890 opera *Cavalleria rusticana*, it imaginatively revisits the foreign landscape of cooled lava while presaging *Aesthetic Theory*'s commentary on the kitschification of the *Kulturlandschaft*:

> Throughout its long, ageless life, it feels most comfortable in the café, with Carmen's handed-down cigarette as the slim *magna mater* of all Verismo; one would like to say a few words about it and merely say, the *Cavalleria*! How well it still looks. . . . Mt. Etna, Faraglioni, and sea serpent—those are the true accessories of *Cavalleria rusticana*. In the south of Italy it was revealed to me once. Back then I noticed how unseemly was our talk of kitsch in view of those odd buildings erected along the coastline following the pattern of Greek temples; so incredibly white as only the gulf here shines incredibly blue. They can only be endured because they are located in a volcanic

32. Adorno and Berg, *Correspondence*, 20.
33. Mittelmeier, *Adorno in Neapel*, 85.

landscape. Their expression, condensed in the brightening of the moment, ready to turn from blessed light to savage fire, the cloud of Mt. Vesuvius ruffling above, lends their appearance the right of a sudden eternity [*das Recht jäher Ewigkeit*] by visibly exposing it to catastrophe. . . . It is exactly this expression that the *Cavalleria* bears.[34]

The opera's huge international box office draws and its early history of recordings and broadcasts made it prime fodder for the stuff of popular background music since around the turn of the century; thus Adorno's seemingly trivializing references to its proximity to café environs evoke not only the criticisms—heard since its premiere—of its ostensible coarseness and vulgarity but its commercial success. Might the puzzling formation of a "sudden eternity" hint, alongside the effects of light, at the eternal capture of the tourist's photograph or the landscape postcard? This critical sketch—complete, like the opening of the Schubert essay, with volcanoes, high-drifting clouds, and bright light, thus tellingly shaped by Teddie's youthful touristic experiences—removes the *Cavalleria* from the realm of kitsch, resituating it within its Sicilian cultural landscape.

The very next year, landscape reappears as an emblem of the relation of subject and object in Adorno's essay on Beethoven's late works: "No longer does he gather up the landscape, now abandoned and alienated, into an image. He irradiates it with the fire that subjectivity ignites by bursting out and colliding against the walls of the work." Although figures of ephemerality and death emerge, and development is set aside, the historical opposition between Beethoven and Schubert that Adorno had retained in the "Schubert" essay a few years prior endures here, as the nonobjective character of the image is discarded: "Late Beethoven is called both subjective and objective. What is objective is the fractured landscape; the subjective side is the light that alone illuminates it. He does not synthesize them harmoniously. Through the power of dissociation he tears them apart in time, perhaps to preserve them like that for eternity." The violence that marks this cultural landscape is not that of natural destruction. "In the history of art, late works are the catastrophes."[35] There is no ideal of reconciliation here.

By this time Adorno had emigrated, beginning fifteen years in exile, a tourist on holiday no longer. When in 1940 he welcomed his parents to America, where they had followed, a few years behind and in some peril, his own

34. Adorno, "Mascagnis Landschaft," 271–72. "Carmen" references Georges Bizet's 1875 opera.
35. Adorno, "Late Style in Beethoven," 567.

emigration with Gretel, the new land seemed "ugly, and inhabited by drug-stores, hot dogs and cars, but at least safe to some extent at the moment!" Adorno crossed the country from New York to California, finding monotony along the way in Nebraska ("Who eats all that corn?" he wondered) and alien-ation in Utah, where "the landscape seems strange, with those mountains that suddenly shoot up out of the plain like pyramids"—here the real, natural "new" land resembling a kind of ancient *Kulturlandschaft*. The landscape of exile had its beauties, of which Adorno wrote by postcard to his parents after his arrival on the American west coast, whose mountain- and oceanscapes he compared to southern European ones along the Riviera or in Tuscany, and in relation to whose architecture he invoked again the term *Kulturlandschaft*. The palms and orange groves were lush, "the latter all admittedly in the posses-sion of Mr. Sunkist," as he noted wryly. Far outside the sphere of any previous life experience, musical listening here became precarious. The Brentshire Motel on the famous Wilshire Boulevard, where the Adornos overnighted on first arrival, advertised not only "completely equipped kitchens with Frigi-daire" and "closed, locked garages" but, ominously for an exile from Nazi Ger-many and a developing theorist of the Culture Industry, "radios in all units."[36] Though Adorno wrote of spending whole days outside, "relative safety" was not, apparently, synonymous with freedom in a place where, as he commented in *Minima Moralia*, "music does the listening for the listener"[37]—or as in the following, near-opposite impression recorded in *Minima Moralia* over twenty years after the Schubert essay:

> The shortcoming of the American landscape is not so much, as romantic illu-sion would have it, the absence of historical memories, as that it bears no traces of the human hand. This applies . . . above all to the roads. These are always inserted directly into the landscape, and the more impressively smooth and broad they are, the more unrelated and violent their gleaming track appears against its wild, overgrown surroundings. They are expressionless. Just as they know no marks of foot or wheel, no soft paths along their edges as a transition to the vegetation, no trails leading off into the valley, so they are without the mild, soothing, unangular quality of things that have felt the touch of hands or their immediate implements. It is as if no-one had ever passed their hand over the landscape's hair. It is uncomforted and comfortless. And it is perceived in a corresponding way. For what the hurrying eye has seen merely from the car it cannot retain, and the vanishing landscape leaves no more traces behind than it bears upon itself.[38]

36. Adorno, *Letters to His Parents*, 68–70.
37. Adorno, *Minima Moralia*, 201.
38. Adorno, *Minima Moralia*, 48.

The lack of history and its traces of human expression give way to an unful-filled longing for consolation; at the same time, the natural landscape is con-signed to a historical-temporal dimension in its quality of vanishing, as in *Aesthetic Theory*'s account of natural beauty's ephemerality. Unsurprising, then, that this motif of the untouched landscape, and some of the exact wording—"nature over which no human hand has passed"—recurs in *Aesthetic Theory* in the midst of the discussion of natural beauty (*AT*, 68).

Having crossed the vast country, like those roads, Adorno found himself once again in a foreign southern environment shaped by ocean and mountains. But the images of a solidified mineral landscape also resurfaced, its traces most evident this time in his work with Thomas Mann on the writing of *Doktor Faustus*. Whether Adorno gave Mann a copy of the Schubert essay itself to read, or simply relayed its features in the midst of philosophical-musical consultation and conversation, it made its way out of the realm of Biedermeier kitsch into that of a musical modernism in league with the devil. Early in the book Serenus Zeitblom shares the following childhood memory from a visit to Adrian Leverkühn's home:

> [Father Jonathan Leverkühn] had succeeded in making a most singular cul-ture; I shall never forget the sight. The vessel of crystallization was three-quarters full of slightly muddy water . . . and from the sandy bottom there strove upwards a grotesque little landscape of variously coloured growths: a confused vegetation of blue, green, and brown shoots which reminded one of algae, mushrooms, attached polyps, also moss, then mussels, fruit pods, little trees or twigs . . . when Father Leverkühn asked us what we thought of it and we timidly answered him that they might be plants: "No," he replied, "they are not, they only act that way." . . . He showed us that these pathetic imitations of life were light seeking, heliotropic, as science calls it. He exposed the aquar-ium to the sunlight, shading three sides against it, and behold, toward that one pane through which the light fell, thither straightway slanted the whole equiv-ocal kith and kin. . . . Indeed, they so yearned after warmth and joy that they actually clung to the pane and stuck fast there. "And even so they are dead," said Jonathan, and tears came into his eyes.[39]

Here it all resurfaces, variations on a theme: the motifs of inorganic growth, the shifting light, the glassy surface, the crystalline mineral landscape. Alongside all these, perhaps the most striking reminiscence with Adorno's Schubertian landscape is the response of tears. In the literature surrounding *Doktor Fau-*

---

39. Mann, *Doctor Faustus*, 19–20.

*stus*, the text by Adorno that receives the most attention in relation to his music-advisory role in the novel is the "Schoenberg and Progress" essay of the first part of the *Philosophy of New Music* of 1948—with good reason, considering the kerfuffle that ensued.[40] Erhard Bahr argues also for the influence on the novel of ideas and concepts that appeared later in *Aesthetic Theory*: "Although it was published posthumously in 1970, it is safe to assume that its central ideas were existent, at least in embryonic form, at the time Thomas Mann wrote *Doktor Faustus* and that its ideas formed part of the two authors' discussions in the 1940s."[41] Glancing back, I am convinced that central themes from the far earlier and less-known essay on Schubert wandered their way in, too. So much so that when Mann, through Wendell Kretschmar's lecture on Beethoven's op. 111, invokes Adorno's patronymic "meadow-land" (Wiesengrund) as a verbal-rhythmic equivalent of the opening shape of the Arietta theme, he must have been pleased to have so encapsulated his collaborator's influence in a form that, dialectically, at once invoked the notion of landscape that proved so important to their communication, and placed it in a context in which its dialectical significance was musically so evident: that of the superimposition of development, the paradigmatic Beethovenian principle, with that of variation, that repetitive formal feature which captured the long-held distinction of the lyrical Schubert from the teleological Beethoven.[42] Just a few pages later, within the account of the intensity of Adrian Leverkühn's early musical training, the connection with a Schubertian landscape is made explicit, encapsulated in the invocation of death. Adrian speaks of "Schubert's always twilit genius, death-touched," and he quotes to himself the second stanza of "Der Wegweiser" from *Winterreise*:

> I have done no wrong
> that I should shun mankind—
> What senseless craving
> drives me into the wilderness?[43]

And as Adrian murmurs the phrases of the lied, Serenus watches, in unforgettable amazement, the tears springing to his eyes.[44]

---

40. The controversy between Schoenberg and Mann over the latter's portrayal of his fictional composer in *Doktor Faustus* is now documented by Randol Schoenberg in *The Doctor Faustus Dossier*.

41. Bahr, *Weimar on the Pacific*, 254.

42. Mann, *Doctor Faustus*, 54.

43. "Hab' ja doch nichts begangen, / daß ich Menschen sollte scheun— / welch ein törichtes Verlangen / treibt mich in die Wüstenein?" (Schubert, *Winterreise*, 179).

44. Mann, *Doctor Faustus*, 77.

Throughout this excursion I realize that I may have invited critical dis- ·
missal by so freely combining elements of biography with philosophy—never
really an acceptable means of reading Adorno until now (surely not a truly rig-
orous one). Worse, I have probably risked courting the accusation of a dehis-
toricizing collapse of Adorno's thought. Inasmuch as many of my reflections
were stimulated by shocks of recognition in reading, at different times, from
passages on widely disparate subjects that Adorno wrote decades apart, my
point has never been to suggest that these motivic recurrences leading to *Aes-
thetic Theory*'s end point are instances of the same. Still, they are in some
respects like the repeated Schubertian themes Adorno describes, their appear-
ance changing through shifts in lighting cast as the subject travels through his-
tory, wanders through personal experience. A kind of music landscape constel-
lation emerges, and it often includes a composer who, after all, is rather distant
from the typical focus of Adorno's writings yet whose music was clearly expe-
rienced in formative ways; it encompasses genres of vocal music, too, not only
opera but song and song cycle, which were more peripheral in his field of atten-
tion than instrumental music. It is probably no coincidence, then, when the
trope of landscape resurfaces years later in the context of poetry and song.
The essay "In Memory of Eichendorff"—yet another anniversary piece, pub-
lished in the first volume of the *Notes to Literature* but first delivered in 1957
as a radio lecture commemorating the centenary of the poet's death—dwells on
the lyrical tonal qualities of Eichendorff's images of nature and landscape.
Those images, as Adorno notes, retain their atmospheric and sensuous magic
despite their construction from stock elements, not only the natural ones of
moonlight, brooks, and forests, but those that are both cultural and sonorous:
the mandolins and singing wanderers, and the hunting horns and post horns
that sound out the space of the landscape. Adorno hears a quality of renuncia-
tion in the poetry that resonates for him with the tone of the end of Schumann's
*Piano Fantasy*, a reference to an instrumental work that is unexpected in the
context of a subject that revolves around lyric and song.[45] But unsurprisingly,
among the poems Adorno quotes from in particular, several are those set by
Schumann in his Eichendorff *Liederkreis* op. 39, a cycle on poems of the com-
poser's selection that begins from invocations of a lost *Heimat* and forest
sounds and ends, again, with a whispering forest and a nightingale's song.

The Eichendorff essay dates from after Adorno's return from exile, a
return "home" that would seem proof of the inextricability of the concept of
*Heimat* with its loss. In November 1949 he went back to a Frankfurt whose

45. Adorno, "In Memory of Eichendorff," 64.

cultural landscape had been utterly transformed by the violence of war; he found the old town center "a desolate dream where everything is in a terrible mess," and the house at 9 Schöne Aussicht, where he had grown up as "Teddie," was "absolute nothingness." Yet there was still a homecoming: within his very first days in Germany he visited his mother's family and played four-hand piano duets with his uncle Louis Calvelli-Adorno.[46] No particular mention is made of Schubert this time (though they played "a great deal"), but they did play some Gustav Mahler—perhaps some of the songs? And a few years on, in Adorno's *Mahler: Eine musikalische Physiognomik*, written for the 1960 Mahler centennial, landscape does return, if not with the frequency one might expect given the ready affinity of Mahler's music-programmatic content with nature- and mountainscapes. It combines kaleidoscopically with motifs heard before, of natural beauty, childhood, death, and consolation, and with the concept of *phantasmagoria*—thus again with time, temporality's suspension in musical-timbral stasis as the sonic illusion of time standing still.[47] But landscape references are overshadowed by another theme: in his preface to the book's second edition, Adorno notes that it draws much closer to its subject than his other writings on Mahler, hence the titular concept of physiognomy in which the object's contour is traced from a close perspective rather than as a distant prospect.[48] Perhaps physiognomy inspired an inward turn also for Adorno's late imagination of landscape as he recalled experiences of 1925, traveling not to Italy but to Vienna. As the distance of perspective closes in, his monograph on Berg, assembled in 1968 while Adorno was also at work on *Aesthetic Theory*, makes just one musical reference to landscape explicitly. Again, it is both historical and phantasmagoric; and once more, it is in relation to song—Berg's early songs op. 2, whose "historical landscape," he says, is "that of late- and neo-Romanticism" (a cultural landscape being demolished at the very time of their composition, between 1908 and 1910).[49] But tellingly, in the long section of personal remembrances of his beloved teacher, he invokes, in comparing Berg with Mahler, the concept of an inner landscape. This shift from distance to proximity, from "out there" to interiority, produces a portrait-as-landscape recalled subjectively from beyond death and the experience of exile: "Rarely have I met anyone who so resembled his name. . . . Berg: his face was a mountain-face [*Berg-Gesicht*], mountainous in the twofold

---

46. Adorno, *Letters to His Parents*, 377, 375.
47. See Adorno, *Mahler*, 15, 57, 152.
48. Adorno, *Mahler*, ix.
49. Adorno, *Alban Berg*, 47.

sense that his features were those of someone who is at home in the Alps, and that he himself, with the nobly arched nose, the soft, finely chiseled mouth, and the abyss-like, enigmatically empty eyes like lakes, had something of a mountain landscape."[50] Tellingly, it is the memory of the sonority of Berg's voice on the telephone, speaking "with infinite warmth" yet over a distance, that gives rise to this cascade of now-familiar imagery: mountains, being at home, and eyes that, lake-like, are liquid filled. Thus, as physiognomy transforms back into a mountainous landscape, consolation arises through brimming tears.

It would seem that, after Adorno's return from exile and through the years that *Aesthetic Theory* continued to develop, music, nature, and beauty remained important in his writings, yet the perspective of musical landscape images was subtly transformed as if in response to closing distance. If the *Kulturlandschaft* was always something "out there," as Leppert suggested of Schubert's song landscapes, something other even when within it as Adorno was when traveling in the mountainous scapes of Italy or America, it was distance in turn that rendered home itself both a *Heimat*, something lost and longed for, and a *Landschaft*, something viewed from a distance.

**Sherry Lee** teaches musicology at the University of Toronto.

---

50. Adorno, *Alban Berg*, 15–16.

## References

Adorno, Theodor W. *Aesthetic Theory*, edited by Gretel Adorno and Rolf Tiedemann, translated by Robert Hullot-Kentor. London: Continuum, 1997.

Adorno, Theodor W. *Alban Berg: Master of the Smallest Link*, translated by Juliane Brand and Christopher Hailey. Cambridge: Cambridge University Press, 1991.

Adorno, Theodor W. "Four Hands, Once Again," translated by Jonathan Wipplinger. *Cultural Critique*, no. 60 (2005): 1–4.

Adorno, Theodor W. "The Idea of Natural-History," translated by Robert Hullot-Kentor. In *Things beyond Resemblance: Collected Essays on Theodor W. Adorno*, edited by Robert Hullot-Kentor, 252–69. New York: Columbia University Press, 2006.

Adorno, Theodor W. "In Memory of Eichendorff." In vol. 1 of *Notes to Literature*, translated by Shierry Weber Nicholsen, 55–79. New York: Columbia University Press, 1991.

Adorno, Theodor W. "Late Style in Beethoven," translated by Susan Gillespie. In *Essays on Music*, edited by Richard Leppert, 564–68. Berkeley: University of California Press, 2002.

Adorno, Theodor W. *Letters to His Parents, 1939–1951*, edited by Christoph Gödde and Henri Lonitz, translated by Wieland Hoban. Cambridge: Polity, 2006.

Adorno, Theodor W. *Mahler: A Musical Physiognomy*, translated by Edmund Jephcott. Chicago: University of Chicago Press, 1992.

Adorno, Theodor W. "Mascagnis Landschaft." In vol. 18 of *Gesammelte Schriften*, edited by Rolf Tiedemann and Klaus Schultz, 271–72. Frankfurt am Main: Suhrkamp, 1984.

Adorno, Theodor W. *Minima Moralia: Reflections from Damaged Life*, translated by E. F. N. Jephcott. London: Verso, 2002.

Adorno, Theodor W. "Schubert," translated by Rodney Livingstone. In *Can One Live after Auschwitz? A Philosophical Reader*, edited by Rolf Tiedemann, 299–314. Stanford, CA: Stanford University Press, 2003.

Adorno, Theodor W. "Schubert," translated by Jonathan Dunsby and Beate Perrey. *Nineteenth-Century Music* 24, no. 1 (2005): 7–14.

Adorno, Theodor W., and Walter Benjamin. *The Complete Correspondence, 1928–1940*, edited by Henri Lonitz, translated by Nicholas Walker. Cambridge, MA: Harvard University Press, 1999.

Adorno, Theodor W., and Alban Berg. *Correspondence, 1925–1935*, edited by Henri Lonitz, translated by Wieland Hoban. Cambridge: Polity, 2005.

Bahr, Erhard. *Weimar on the Pacific: German Exile Culture in Los Angeles and the Crisis of Modernism*. Berkeley: University of California Press, 2007.

Baker, David. "Lyric Poetry and the Problem of Time." *Literary Imagination* 9, no. 1 (2007): 29–36.

Biro, Andrew, ed. *Critical Ecologies: The Frankfurt School and Contemporary Environmental Crises*. Toronto: University of Toronto Press, 2011.

Burnham, Scott. "Landscape as Music, Landscape as Truth: Schubert and the Burden of Repetition." *Nineteenth-Century Music* 29, no. 1 (2005): 31–41.

Cook, Deborah. *Adorno on Nature*. Durham, NC: Acumen, 2011.

Foster, Roger. *Adorno: The Recovery of Experience*. Albany: State University of New York Press, 2007.

Horkheimer, Max, and Theodor W. Adorno. *Dialectic of Enlightenment*, translated by Edmund Jephcott. Stanford, CA: Stanford University Press, 2002.

James, Preston E., and Geoffrey J. Martin. *All Possible Worlds: A History of Geographical Ideas*. 2nd ed. New York: Wiley, 1981.

Lee, Sherry D. "A Minstrel in a World without Minstrels: Adorno and the Case of Schreker." *Journal of the American Musicological Society* 58, no. 3 (2005): 639–96.

Leppert, Richard. "On Reading Adorno Hearing Schubert." *Nineteenth-Century Music* 29, no. 1 (2005): 56–63.

Mann, Thomas. *Doctor Faustus: The Life of the German Composer Adrian Leverkühn, as Told by a Friend*, translated by H. T. Lowe-Porter. New York: Vintage, 1992.

Mittelmeier, Martin. *Adorno in Neapel: Wie sich ein Sehnsuchtslandschaft in Philosophie verwandelt*. Munich: Siedler, 2013.

Phillips, Wesley. *Metaphysics and Music in Adorno and Heidegger*. New York: Palgrave Macmillan, 2015.

Rehding, Alexander. "Ecomusicology between Apocalypse and Nostalgia." *Journal of the American Musicological Society* 64, no. 2 (2011): 409–14.

Rosen, Charles. *The Romantic Generation*. Cambridge, MA: Harvard University Press, 1995.

Schoenberg, E. Randol, ed. *The Doctor Faustus Dossier: Arnold Schoenberg, Thomas Mann, and Their Contemporaries, 1930–1951*. Berkeley: University of California Press, 2018.

Schubert, Franz. *Winterreise*. Poems by Wilhelm Müller. *Neue Schubert-Ausgabe*, series 4, vol. 4A, edited by Walther Dürr, 110–91. Kassel: Bärenreiter, 1979.

Simmel, Georg. "The Philosophy of Landscape," translated by Josef Bleicher. *Theory, Culture and Society* 24, nos. 7–8 (2007): 20–29.

# Kant and Adorno on Mind and World: From Wild Beauties to Spiral Jetty

## J. M. Bernstein

### The Authority of Nature and the Meaning of Modernism

This article is about mutilated nature, that is, the utter destruction of Holocene nature in the modern world, in relation to the meaning of modern art, especially in its modernist phase. Theodor W. Adorno's theory of natural beauty is the focus of the argument. Considering modernist art as a stand-in for the repressed authority of (now deauthorized and mutilated) nature is a rarely pursued interpretive framework. My orienting claim comes from a surprising locale that equally anticipates the interpretive stakes of the thesis.

In the middle of *The World Viewed*, Stanley Cavell—whose absence from the world my few words here are meant to mark—provides an excursus on modernist painting. In a form not anticipated elsewhere in his thought, Cavell locates modernism's quest in a manner that explicitly and emphatically joins the idea of beauty with an idea of nature. Following the lead of Clement Greenberg and Michael Fried (while departing wildly from their reading), he offers Morris Louis's late Unfurleds (1960–61) for consideration, since they seem to represent the last gasp of (American) high modernism, modernist painting at its limit. Cavell's intention is to place Louis in the tradition of Jackson Pollock (*Autumn Rhythm [Number 30]*, 1950), Clyfford Still (*1957-D-No. 1*, 1957), and Helen Frankenthaler (*Mountains and Sea*, 1952). Cavell states that "only *Sigma* strikes me as of overpowering beauty among the Unfurleds I have seen, though all are beautiful. . . . But to speak of an automatism [an authentic art

*New German Critique* 143, Vol. 48, No. 2, August 2021
DOI 10.1215/0094033X-8989274   © 2021 by New German Critique, Inc.

medium] which admits of a sometimes overpowering beauty *is a way of characterizing nature.*"[1] In the accounts of Cavell's aesthetics I have read, no one seems to have even noticed that last thought: an authentic art medium that can admit of works having overpowering beauty is "a way of characterizing nature." Three overfast thoughts may help motivate Cavell's claim. First, Cavell takes as obvious that the notions of the beautiful and the sublime are joined in modernist art; beauty needs to be overpowering, sublime, if it is not to disintegrate into the merely tasteful; conversely, unlike the mathematical and dynamic sublime in Immanuel Kant's aesthetics, modernist artworks are intended as difficult objects of sustained visual *attention*. The modernist sublime is thereby a formation of beauty.[2]

Second, the function of beauty here is to generate an authoritative claim that cannot be further rationalized. If art is meant to house authority independently of rationalized reason, to be the anticipation of a formation of reason beyond rationalized reason, then, in the first instance, beauty and its various surrogates and displacements—sublimity, dissonance, ugliness—arose as *authority functions*, as claims to authority that rationalized reason could not get on level terms with, that evaded and parried rationalized reason's grasp while still lodging an overpowering *claim*, a claim to significance and mattering however initially opaque.

Third, if a judgment of beauty is a form of "acknowledgment," Cavell's term for a nonmastering mode of cognitive encounter, for parrying instrumental reason's appropriation of nature, hence to *situate* knowledge in order to remove such knowledge's worldlessness, then the authority signified by the beauty function is the authority of nature. The experience delivered by modernist works in its American phase "*is the release of nature from our private holds*" (*WV*, 114; my italics), which is not the same as getting nature back. Because the experience of modernist artworks is not one of readily surveyable and appropriable objects but, in their *overpowering beauty*, one of (unconditioned) conditions of experience, we are abruptly put in mind of the now-absent dependency relation between mind and nature, mind and world. The sublime address of such art enables us to experience that and how we have become lost to nature, and nature lost to us. American modernism at its height intrigued experiences that entailed that this loss need not be final: "That nature's

---

1. Cavell, *World Viewed*, 113 (my italics; hereafter cited as *WV*).

2. Adorno presses hard on this thought: "Works in which the aesthetic form, under pressure of the truth content, transcends itself occupy the position that was once held by the concept of the sublime. In them, spirit and material polarize in the effort to unite" (*Aesthetic Theory*, 196; hereafter cited as *AT*).

absence . . . is only the history of our turnings from it, in distraction or denial, through history or industry with words and works." Conversely, the affirmative claim of such works is that "however we may choose to parcel or not to parcel nature among ourselves, nature is held—we are held by it—only in common" (*WV*, 114). Cavell is here lodging a simultaneous critique of capitalist property relations and rationalized scientific reason—"such art will not repeal the enclosure acts, but it seeks to annul our spiritual-biological-political accommodations and attachments to enclosure" (*WV*, 114)[3]—that terminates in the claim that if we are to hold nature in our possession in a manner that is not self-defeating, mutilating, then it will have to be held in common.

Cavell is contending that artistic modernism should be interpreted as a decisive moment of social epistemology in which "we" acknowledge the authority of nature against culture. That is not how, standardly, we now tell the history of modernism. The elements for a vindication of this claim requires two steps, the first reconstructing how Kant's conception of judgments of taste, judgments of natural beauty, intend to secure and resource our cognitive access to living nature. The second step, which in fact amounts to the project of Adorno's *Aesthetic Theory*, is an explicit exercise in social epistemology that involves demonstrating how modern art inherited the functional task originally assigned to judgments of natural beauty by Kant under conditions in which living nature's claim to be authoritative over the necessary conditions for social reproduction has undergone savage repudiation. The cornerstone of Adorno's argument appears in the portion of *Aesthetic Theory* titled "Natural Beauty."

### Kant's Aesthetics: Rows of Peppercorns and Wild Beauties

It is almost impossible not to read the *Critique of Judgment* as a grand effort to heal the breach between scientific rationalism and romanticism before it commences. Roughly, Kant contends that aesthetic reflective judgments, judgments of beauty, involve an *emphatic encounter* between mind and world, where mind and world find themselves utterly attuned to each other, thereby demonstrating that further conceptualization of nature, when it occurs, is the elaboration of this original aesthetic encounter. Thus in the midst of appropriating all authority from nature, of positing that "objects must conform to our knowledge," Kant tacitly cedes some authority back to nature.[4] Transcendental idealism is haunted by skeptical nominalism; this threat can be warded off if in its most naked encounter with nature, a categorial distinction can be drawn

---

3. For Fried's opposing grand accounting, see "Morris Louis."

4. Kant, *Critique of Pure Reason*, Bxvi.

between mere subjective responsiveness and objective appreciation. Aesthetic reflective judgments of natural beauty are a first exposition of the mind revealing itself to be quasi-cognitively aligned with, as we might say, what is there anyway.

In section 35, as Kant sets out the terms for a deduction of taste, he states that the subjective principle of taste is nothing else but the power of judgment itself. "Now since a judgment of taste is not based on a concept of the object . . . it can consist only in the subsumption of the very imagination [the faculty of passive synthesis] under the condition . . . for the understanding [the faculty of conceptual unification] to proceed in general from intuition to concepts."[5] Because a judgment of taste is not a question of bringing the sensory presentation under a concept, all that can be at stake is the movement *in general* by which the imagination and the understanding coordinate with each other in their standard cooperative endeavor of engendering a conceptualization of the sensory manifold. In the aesthetic case, the peculiarity of this cooperative endeavor is that the movement *toward* conceptualization, from intuition to concept, is to take place without ever arriving at the moment in which the intuitive manifold is conceptualized; the movement of preparing the sensory manifold for cognitive consumption itself becomes total.

Because the work of aesthetic estimation is not one of imposing explicit conceptual order on a manifold, then it makes sense to say that reflective judging is in the business of detecting or locating what might be called instances of *material-sensible order* in the sensory manifold: an order in nature that anticipates or adumbrates cognitive order through its material-sensible arrangement of unity in the midst of diversity. With Cavell, we might say that an aesthetic reflective judgment involves the active *acknowledgment* of the integrity of a material-sensible order representing an object independently of an explicit conceptualization of it. If the intelligibility and integrity of the object is not imposed on it by conceptual representation, then it follows that the object itself must be taken to possess or to spontaneously give rise to—to enable and elicit— a kind of intelligible integrity, although that intelligible integrity can be found only in our experience of the object, not in the object itself. So the bearer of that intelligible integrity of the object is the reflective judgment itself; in the act of aesthetic reflective judging a representation's unity-amid-diversity is actively held in mind and thereby is a function or correlate of mindful attention.

In the conclusion to the "Analytic of Aesthetic Judgment," rather than summarizing the four moments of the judgment of taste—a liking that is: dis-

---

5. Kant, *Critique of Judgment*, §35, A287.

interested, universal but without a concept, internally purposive but without an external purpose, and subjectively necessary—Kant focuses solely on the idea of "free lawfulness," that is, in aesthetic reflective judgments everything turns on the imagination engaging with what is sensibly present in a manner that appears *as* "lawful" (as if under the sway of an effective but unknown rule) that nonetheless escapes the dictates of explicit conceptual judgment; it is "free" from conceptual determination. Throughout the comment, Kant warns against the temptation of claiming to find aesthetic satisfaction in phenomena that in fact solicit what we might call "the appreciation of the understanding"—an experience that feels aesthetic but is in fact dictated by antecedent conceptual and categorial commitments, for instance, finding beauty in perfect geometric figures.

Pressing the issue one step farther, Kant records how the ethnologist William Marsden complained that in Sumatra "free beauties of nature there surround the beholder everywhere, so that there is little left in them to attract" the beholder.[6] Marsden then claims that in the midst of such wild beauty, an encounter with a pepper garden and its staked rows of climbing plants captured his aesthetic appreciation, and that we like "wild and apparently ruleless beauty" only as a diversion. Kant's response is emphatic:

> And yet he need only have made the experiment of spending one day with his pepper garden to realize that, once regularity has [prompted] the understanding to put itself into attunement with order which it requires everywhere, the object ceases to entertain him and instead inflicts on his imagination an irksome constraint; whereas nature in those regions, *extravagant in all its diversity* to the point of opulence, *subject to no constraint by artificial rules*, can nourish his taste *permanently*. (my italics)

Kant is contending that even when there is a feeling of satisfaction from regularity and order, it is only apparently aesthetic because the order found is one that the understanding "requires everywhere"; hence, these are cases of the appreciation of the understanding. Wild beauties, on the contrary, are of such extravagance that no artificial rules can encompass them, which is as much as to say, although they can be aesthetically judged, they *cannot be* conceptually subsumed.[7] And it is because their wildness disallows conceptual subsumption that we can feel confident that our experience of sensuous diversity within

6. This and all further quotations in this paragraph can be found at Kant, *Critique of Judgment*, A243.

7. For a fine account of the role of wild beauty, see Gashé, *Idea of Form*, chap. 3.

imaginative unity, the sensible experience of free lawfulness, is an attunement *with the world, with nature*, rather than the mind finding its own a priori demands mirrored in the natural world because imposed on it. The moment of conceptual imposition is blocked by nature's "opulence." The beautiful-sublime presentation—"extravagant in all its diversity"—imposes *itself* on the mind in a manner that is riveting, binding us to it so that we feel as if we cannot bear to withdraw our attention. Because the riveting and binding are not causal, the mind filled by the object must insinuate a mode of minded satisfaction with the presentation itself; its grip on the mind feels as if the object were imposing its order, its sensible-intelligible integrity on the mind. The further characterization of this binding also matters: the imposition/attraction relation disallows reason to proceed from it, to employ it as a cognitive means, say, as a premise for an inference.

If we were searching for a moment in which the mind could reassure itself that in its encounter with the world it was perceiving the world and not merely itself once again, then wild beauties, sublime beauties would appear to uniquely fit the case. Wild beauties are the signature moment of Kant's cognitive romanticism.

### Adorno's Aesthetics: Modernism as the Afterlife of Living Nature

This thought undergoes a further torsion when, within a generation, and certainly no later than, say, 1835—the date of the first publication of G. W. F. Hegel's lectures on aesthetics—the very idea of natural beauty as a proper object of aesthetic reflection had been submitted to radical questioning, with the very idea of *aesthetics* as a region of philosophy becoming systematically displaced by the *philosophy of art*. The displacement of aesthetics by the philosophy of art, of natural beauty by art beauty, marks a moment in which the very possibility of the human mind encountering wild nature has undergone erasure, in part critically and skeptically, and in part as question of what deserves rational attention. But this is equally to say that by the early nineteenth century the whole question of mind and world in the form posed by Kant's aesthetics has begun migrating to become one *internal* to the arts themselves. This is how the arts became, sotto voce, a branch of social epistemology.

The first pure landscape painting in the West is credited to Albrecht Altdorfer, *Landscape with Footbridge* (1518–20). In his monograph on Altdorfer, Christopher Wood contends that "landscape in the West was itself a symptom of loss, a cultural form that emerged only after humanity's primal relationship with nature had been disrupted by urbanism, commerce and technology. For when mankind still 'belonged' to nature in a simple way, nobody needed to

paint a landscape."[8] However we interpret landscape painting between Altdorfer's work and Hegel's defense of art beauty against natural beauty, and the history of landscape painting is rich and complex,[9] there is no doubt that landscape painting, by the nineteenth century, was explicitly becoming a symptom of loss, a work of counterculture, critique, memory, reminder, all leavened with the simultaneous insistence, at least in some quarters, *on the authority of nature over culture* amid the disappearance of nature.

If one were to rewrite that history of modern art from the viewpoint of social epistemology and extend it right through to late modernism, through to Louis's *Sigma*, say, one would be writing Adorno's *Aesthetic Theory. Adorno's aesthetics is Kant's implicit aesthetic epistemology where modernist art beauty replaces natural beauty as the exemplary locale for the binding of mind and world.* But with Adorno the implicit loss of nature as recorded in the devolution of landscape into landscape art and then into a certain kind of abstraction also records art's grief over that loss; that grief, Adorno argues, *becomes* (or perhaps: can now be understood to have become) the cultural/ethical meaning of modern art—as revealed by artistic modernism—*überhaupt.* Here are a few unequivocal statements from the lectures on aesthetics Adorno gave in 1958–59:

One cannot make unmutilated nature speak, for this unmutilated nature, a pure nature—that is to say, a nature that has not gone through the mediation processes of society—does not exist. . . . it is the task of art to give voice to mutilated nature.[10]

One could say that art is an attempt to do justice to all that falls victim to this ongoing concept of control over nature, to give nature its due. (*A*, 47–48)

. . . it would be more accurate to say that control over nature . . . has actually increased the alienation of humans from one another and from nature, and that art, at every level, has the task of revoking this process. (*A*, 147)

Adorno is not claiming that giving voice to mutilated nature has been the conscious intention or quest of modern art, but only that, as modern art comes to full self-consciousness about its meaning in modernist art, this work of bearing the burden of the mutilation of nature by scientific, technological, and economic processes implicitly *becomes* its primary or organizing mode of cultural

8. Wood, *Albrecht Altdorfer*, 25.

9. Apart from monographs on particular artists, Clark's *Landscape into Art*, if dated, remains a good starting place. A conceptually sophisticated overview is provided by Andrews, *Landscape and Western Art*.

10. Adorno, *Aesthetics, 1958/59*, 77 (hereafter cited as *A*).

significance—what it was aiming at in its practices all along even as it again and again took itself to be bound to distinctly other ends and distinctly different values. Revoking the mastery of nature is the inconstant but recurrent drive of modernist art or, more precisely, what categorially matters in its achievements.

Hence central to the project of *Aesthetic Theory* is salvaging the significance of natural beauty *for* the intelligibility of art beauty without naïveté or regression about natural beauty, since only if that is accomplished can the further claim be vindicated that the task of sustaining the encounter between mind and world has been transmitted from natural beauty to art beauty.

Adorno's first line of analysis is the effort to bring the experience of natural beauty into view even in its now tawdry, dilapidated state. "The 'how beautiful!' at the sight of a landscape insults its mute language and reduces its beauty; appearing nature wants silence at the same time that anyone capable of its experience feels compelled to speak in order to find a momentary liberation from monadological confinement" (*AT*, 69). By "monadological confinement" Adorno means the experience in which perception is felt to be confined within the irreducible perspective of an individual subjectivity, the "I think" that must accompany all my representations. But this, as idealism insists, makes objectivity a function of subjectivity. Natural beauty comes into being, is sought after, and is experienced as a moment of breakout. *What* is experienced appears as not qualified by the possessive pronoun *mine*: the object of experience appears in the mode of unpossessable, as incommensurable with subjective incorporation, as sublimely not me and not mine. Part of this is to say that natural beauty is already a *reduction* of nature to a social function whose significance is to dispute its undergoing, as if it were nature itself that "wants silence" rather than the communicative expression of beauty. In this respect "natural beauty remains the allegory of this beyond in spite of its mediation through social immanence" (*AT*, 69); natural beauty is the way that nature comes to appearance *as* the other of culture. Natural beauty is not the appearance of nature in itself but the appearance of nature's absence from society.

This speaks immediately to the ontological deficiency of natural beauty, namely, "it is exclusively appearance, never the stuff of labor and the reproduction of life, let alone the substratum of science. Like the experience of art, the aesthetic experience of nature is that of images" (*AT*, 65; see also *AT*, 63). Because nature in itself has been covered over, we glimpse it solely in a mode of the virtual, as images, as what is to be merely contemplated but not otherwise used or encountered. This is equally why nature as something beautiful cannot be copied: "Its portrayal is a tautology that, by objectifying what appears, eliminates it" (*AT*, 67). If natural beauty is the appearance of nature

in its withdrawal or absence from society, then to create an image of *this* is to copy what is already an aesthetic image and not an object. That is the pathos of even heroic landscape painting and why, for example, the efforts of the Hudson River School haplessly alternate between sublimity and kitsch, the feeling of uplift and a naive deception.

The deficiencies of natural beauty are what turn aesthetics into a form of social epistemology. As a term of social epistemology, natural beauty refers to nature under the heading of beauty. This entails that the very idea of beauty as it transforms from natural beauty to art beauty is going to be the bearer of nature's social absence. Art beauty, despite itself, is the bearer of the insistence of nature for culture in the era of its domination, mutilation, and suppression. Art came to be about the beautiful as the way in which the claim of nature continued to reverberate in culture. Art beauty is the return of repressed nature in the culture of its repression: "Art stands in for nature through its abolition in effigy" (*AT*, 66). The section titled "Natural Beauty as Suspended History" begins to provide an exposition of this claim:

> Every individual object that is experienced as beautiful presents itself as if it were the only beautiful thing on earth; this is passed on to every artwork. Although what is beautiful and what is not cannot be categorically distinguished in nature, the consciousness that immerses itself lovingly in something beautiful is compelled to make this distinction. A qualitative distinction in natural beauty can be sought, if at all, in the degree to which something not made by human beings is eloquent: in its expression. (*AT*, 70)

Part of the claim of natural beauty is its curious self-sufficiency: the beautiful is not for the sake of anything else; it does not lead to a further thought or a further act or a further item but stands on its own as if nothing else were needed. This is both a model of human satisfaction and a model of how nature can be experienced in a noninstrumental manner. At a certain moment (with Kant), as art broke from religion and became an autonomous social practice, the requirement for artworks to be beautiful came to mean their being ends in themselves in this way—as self-sufficient in the way a natural beauty is self-sufficient, which itself is the sign of nature being perceived in a noninstrumental manner against its usurpation by rationalized reason. Why else would the requirement for beauty, uniqueness, and nonconceptuality—Kant's "free lawfulness" once more—seem to matter in art? Why should this constellation come to form an ideal of art—the art of beautiful semblance—on its own? The initial puzzle about the meaning of modern art commences with this experience: if not for

the sake of anything further, then why? This question can become searing, as it does at the moment of high modernism's waning that is recorded in the first sentence of *Aesthetic Theory*: "It is self-evident that nothing concerning art is self-evident anymore, not its inner life, not its relation to the world, not even its right to exist." The binding of modernist art to elaborating the categorial authority of art beauty, the tethering of art beauty to natural beauty, and, finally, the critical genealogy demonstrating that natural beauty is the return of repressed nature is the truth content of the modernist arts. It is the solution to the enigma of their meaningfulness; it is the burden lodged in the form of autonomy and meaninglessness.

Adorno thinks that we could not be drawn to natural beauty without its having some nondiscursive expressive dimension that, in its turn, will have a constitutive significance for art beauty:

> What is beautiful in nature is what appears to be *more* than what is literally there. Without receptivity there would be no such objective expression, but it is not reducible to the subject; natural beauty points to the primacy of the object in subjective experience. Natural beauty is perceived both as authoritatively binding and as something incomprehensible that unquestionably awaits its solution. Above all else it is this double character of natural beauty [as binding and enigmatic] that has been conferred on art. Under its optic, *art is not the imitation of nature but the imitation of natural beauty.* (*AT*, 70–71; my italics)

Adorno begins here by restating what have come to appear as grammatical features of judgments of natural beauty: an emphatically subjective experience (of pleasure, say) that nonetheless claims objectivity for itself; the sublime experience of nature's primacy; the sense of natural beauty as claiming and binding; and the puzzle as to the content or meaning of that claim, its practical emptiness, without purpose. Patently, the art of beautiful semblance constitutively inherits the binding and the enigmatic without purpose. The final thesis is meant as the fundamental elaboration of this transfer; it is immense, since it solders the meaning of modern art as such to natural beauty as the voice of mutilated nature in a manner that no other account of modern art even approximates. It provides an explanation of how the movement from realism to abstraction can be seen as an advance without essentialism (of the Greenberg variety). Again, Adorno's claim is that we have the institution of the modern arts as a culturally demanding and epistemologically significant *only* in relation to the very possibility of art beauty and the series of declensions from art beauty, together with, finally, the very idea of art beauty being an imitation or

deciphering or disenchanting of natural beauty: "Nature is beautiful in that it appears to say more than it is. To wrest this more from that more's contingency, to gain control of its semblance, to determine it as semblance as well as to negate it as unreal: This is the idea of art" (*AT*, 78). These are the opening sentences of the chapter "Art Beauty" that immediately follows the chapter "Natural Beauty." Adorno's thesis here is that elaborating, making good on, and exemplifying the *more* of natural beauty is the constitutive lining and impulse of modern art making irrespective of whatever other ends it might pursue.

*More*, then, is Adorno's term for what appears in the factual that is not merely factual. Adorno intends his locution of "what appears to be more than what is literally there" to enable a series of inferences: what is there has meaning even if no explicit meaning is evident; the *more* of that meaning is a depth or in-itselfness that is intrinsic to the object even if not directly available to the agent or appropriable by the agent; the *more* generates an invitation to stay and linger and thereby also performs a kind of pledge or promise that *this* is not all there is or could be, that this present possesses hidden potentialities for meaning and hence incubates the needfulness of some future; *more* is the actual as itself expressing an indeterminate potential. *More* is meaning beyond given discursive meaning, an expressive/mimetic way of meaning differently. *More* is a claim to authority.[11] Feminine beauty has been the most evident exemplification of the *more*, which quickly topples into the second thought that the tradition has routinely purveyed the claim that female beauty and the beauty of nature were somehow indistinguishable, that female beauty was nothing but a version or piece of natural beauty.

The *more* of natural beauty requires reception but is not reducible to subjectivity: this is the exact locale of Kant's separation of the pepper rows from wild beauty. It leads immediately to Adorno's imploring *critical* thesis, that natural beauty points to "the primacy of the object in subjective experience." In the midst of an account of the mutilation of nature and its vanquishing beneath the ordinances of scientific-capitalist civilization, Adorno contends that art beauty matters in the way it does because it instantiates the categorial naturalist claim that *all* perception is *dependent* on its object—even against the continuing philosophical and cultural claiming that the work of perception is for the sake of enclosing the object within the schemata regulating its subservience to social use. This is part of what it means to think of nature in contrast to society and hence to recognize natural beauty as a category of social epistemology rather than a source of cultural satisfaction.

11. A contemporary version of "more" can be found in Nehamas, *Only a Promise of Happiness.*

And it is that social epistemological function of natural beauty that Adorno broaches in the following sentence as he provides the already affectively charged *more* with a cognitive profile: "Natural beauty is perceived both as authoritatively binding and as something incomprehensible that unquestionably awaits its solution." This too is an elaboration of Kant's wild beauty: a judgment of beauty that is wholly objective, experienced as beyond the capacity of the agent undergoing and experiencing it to imagine what it would mean to refuse the claim, hence the experience of one's sensuously replete and affectively charged experience as bearing in itself a cognitive register *as* binding and so *as* objective while what appears in this cognitive color nonetheless remains incapable of discursive elaboration. These features of natural beauty—the elaboration of the *more* as receptive but not subjective, as not reducible to the subject; as pointing to the primacy of the object; as authoritatively binding; as inaccessible to discursive elaboration—are imitated, copied, taken over, and worked through by art beauty. Art beauty is the disenchantment of natural beauty.

Adorno extends the thesis that modernist art bears the burden of repressed nature through art beauty being the imitation natural beauty by contending that art's imitation of natural beauty "denominates not only the aporia of natural beauty but the aporia of aesthetics as such. Its object is determined negatively, as indeterminable. It is for this reason that art requires philosophy, which interprets it in order to say what it is unable to say, whereas art is only able to say it by not saying it" (*AT*, 72).[12] The exposition of how the procedures of modernist art develop in the direction of practically elaborating natural beauty, and so disenchanting it, is the effort of *Aesthetic Theory* as a whole. The moment of the aporia of what is binding but indeterminate, nondiscursive, explicitly calls for philosophical accounting: artworks can forward a categorial claim to meaning but cannot raise it *as categorial*; that is philosophy's task. And here the starting point in my analysis of Adorno returns: natural beauty "recollects a world without domination, one that probably never existed" (*AT*, 66), a world we call "Sumatra" or "The Heart of the Andes." As Adorno bluntly presses the thought:

---

12. The last sentence refers to art's inability to *vindicate* the claim of the mimetic function other than by not being art at all but philosophy. Philosophy discursively legitimates mimesis, while it is barred from directly instantiating it; art does that. Philosophy's claim for mimesis, for art beauty as a function of natural beauty, *depends on* natural and art beauty, even as they fall silent at the moment when asked to justify themselves, to explain what they are *about*. The relation between art and philosophy is thus a microcosm of the relation between concept and intuition, subject and object, culture and nature that Adorno argues for generally.

> Nature, as it stirs mortally and tenderly in beauty, does not yet exist. The shame felt in the face of natural beauty stems from the damage implicitly done to what does not yet exist by taking for existent. The dignity of nature is that of the not yet existing; by its expression it repels intentional humanization. The dignity has been transformed into the hermetic character of art, into . . . art's renunciation of any usefulness whatever, even if it were sublimated by the addition of human meaning. (*AT*, 74)

In all his locutions about living nature, Adorno's thought is that all our existing nonaesthetic ways to apprehend it are for the sake of apprehending it by using, reducing, and exploiting it. It is the by-now-familiar story: "They paved paradise and put up a parking lot."

Adorno's more technical register is meant to begin the explication of the aporia of the experience of natural beauty and art beauty being now, at the most intense, binding but indeterminate. The indeterminacy is a consequence of what we think rationality is and how rationality operates. Instrumental rationality presumes to exhaust purposive meaningfulness; hence, what is not instrumentally purposive is without meaning. This contrasts with art beauty's flagrant insistence of meaningfulness without any evident practical meaning. Adorno always supposes that aesthetic production and reception possess a distinctive implicit rationality that hibernates an alternative explicit social rationality—the kind that would be fit for apprehending without reducing the "nature" that does not yet exist. Although he runs the thought through numerous variations, at the center of the idea of aesthetic rationality is the idea of "a disposition over materials *that fits them together according to their own immanent tendencies*" (*AT*, 66; my italics), a practice that enables the materials it works on to be expressively revealed by their partly determining the form of what is to be shaped from them, hence an image of making as a joint endeavor between (collective) human doing and the material nature of which it is a part. Art's implicit rationality invokes the possibility of creating procedures that are for the sake of expressively and cognitively releasing the potentials for expression and meaning latent in natural materials rather than mastering them for the sake of purposes that are wholly extrinsic to their own. The appearance of meaningfulness without meaning is meant to be an actualizing of that potentiality for meaning otherwise.

This same experience must also speak to the loss that natural beauty instantiates. Adorno assumes that the precise uselessness of the products and objects of aesthetic rationality speaks not to a natural division of labor between aesthetic and cognitive judgment but to the disenfranchisement of the rationality potential of mimetic apprehension (a.k.a. reflective judging) by actualizing

the claim to authority of what it presents as irresistibly beautiful. Uselessness solders authority to appearance in the mode of loss and grief. Judgments of beauty express nature's repression and consequent current unavailability for noninstrumental cognitive inspection. And it is this that most fully explains the indeterminacy of the binding judgment of beauty:

> Natural beauty is the trace of the nonidentical in things under the spell of universal identity. As long as this spell prevails, the nonidentical has no positive existence. Therefore natural beauty remains as dispersed and uncertain as what it promises, that which surpasses all human immanence. The pain in the face of beauty, nowhere more visceral than in the experience of nature, is as much the longing for what beauty promises but never unveils as it is suffering at the inadequacy of the appearance, which fails beauty while wanting to make itself like it. (*AT*, 73)

This passage is spelling out the consequences of a thesis Adorno first raises in *Negative Dialectics*: nonidentity is opaque solely in relation to rational identity's claim to be total.[13] Adorno presumes that what has been covered over, repressed, and mutilated by the identity thinking of instrumental reason does not, for all that, disappear without a trace. But what we experience of what has been exiled from the precincts of existing reason is precisely *a trace*, a remnant and reminder. The authority of the binding character of natural and art beauty is the return of the repressed, the insistence of what has been exiled, while its opacity speaks to and expresses both its mutilation and its incommensurability with identity thinking, with a rationality that classifies and subsumes, that sacrifices sensuous particularity to abstract universality and the necessity of abstract unity. The pain of beautiful appearance is that the beautiful is not itself, not yet existing, but only an appearance.

### How Modernism Ends
In his still-disturbing comments on the origins of modernism in relation to the emergence of site-specific art, Robert Smithson states, first, that "Cézanne and his contemporaries were forced out of their studio by the photograph. They were in actual competition with photography, so they went to the sites, because photography does make Nature an impossible concept. It somehow mitigates the whole concept of Nature in that the earth after photography becomes more of a museum."[14] Whatever other crises and cultural transformations contrib-

---

13. Adorno, *Negative Dialectics*, 163.
14. Smithson, "Fragments of a Conversation," 188 (hereafter cited as FC).

uted to the emergence of modernism, Smithson is here supporting the argument that the invention of photography provided an essential spur not because it could effortlessly achieve the task of creating a resemblance or likeness of the world that no painting could match but because photography made "Nature an impossible concept." For him, "photography squares everything. Every kind of random view is caught in a rectangular format so that the romantic idea of going to the beyond, of the infinite is checked by this so that things become measured" (FC, 188). The terms of Smithson's thought here are metaphorical—"the beyond," "the infinite"—but after the mention of nature becoming more of a museum, how it becomes measured, it should be evident that he is struggling with the claim of the authority of nature as being antecedent to culture, as posed as outside and beyond culture, against culture's claim to authority: to square, to measure, to place in a museum drawer. Photography is a bearer of Kantian categorial synthesis; squaring nature is placing nature in the frame of the human, of removing us from nature by forcing nature to conform to the demands of human intelligibility; once nature is squared, its standing as an object opposing a subject collapses; it becomes an impossible object.

In opposition to this civilizational appropriation of living nature, Smithson contends that Cézanne's landscapes, above all his Mont Sainte-Victoire paintings, seek a recovery of nature's authority through a more emphatic placement of the artist *in* the landscape. Such placement means a certain physicality, where the two being joined—placement and physicality—become the terms through which painting becomes a site-determined practice. Making landscape painting a site-determined practice is for the sake of acknowledging the authority of nature: being in an actual place in nature is presented as a categorial condition for rendering nature. This interpretation of Cézanne's landscapes is not uncommon. It is defended by Meyer Schapiro—nature in Cézanne "exists in a kind of prehuman, natural disorder. . . . Unlike the nature in traditional landscape, it is often inaccessible and intraversable [*sic*] . . . [having a] nonhuman essence"[15]—and Maurice Merleau-Ponty: "Nature itself is stripped of the attributes which make it ready for animistic communions: there is no wind in the landscape, no movement on the *Lac d'Annecy* (1896); the frozen objects hesitate as at the beginning of the world."[16] *Inhuman nature* is a term for what Cézanne sought; it is nature as, again, somehow beyond the human and as a condition of the human. It is the experience of that conditionality that, again, Louis wanted to insinuate.

15. Schapiro, *Cézanne*, 15.
16. Merleau-Ponty, "Cézanne's Doubt," 66.

Smithson's second gesture is to dismiss the modernist reception of Cézanne as a wrong turn that failed to comprehend the significance of his practice: cubism takes art indoors again, into the studio, making it "decorative," an "empty formalism" (FC, 188). Smithson can then claim that the correct response to Cézanne's incitement is "to reintroduce a kind of physicality; the actual place rather than the tendency to decoration" (FC, 188). *Site-specific art, land art, environmental art is the true heir to the inauguration of modernist painting in Cézanne.* Perhaps this is too much of a shortcut for launching the thought that earth and land art, environmental art, should be taken as the authentic continuation of high modernism; with the further implied lemma, and much more demanding claim, that if earth art is the authentic continuation of modernism, it follows that the underlying impetus of modernist practice was the recovery of the authority of nature, of nature as the condition of the human that is not fully at the disposal of the human. Adorno certainly did not anticipate *Spiral Jetty* (1970); it came into being eight months after his death. However fast, it is worthwhile claiming that the emergence of earth art tallies with Adorno's claim about natural beauty as the origin and meaning of modernist art, making that claim suddenly appear less polemical and less idiosyncratic than it might at first sight—or at least no more idiosyncratic and polemical than the upsurge of earth art itself.

It is nonetheless hard not to wonder whether Adorno might not have been harshly critical of *Spiral Jetty*: does it not appear, despite itself, as a form of bulldozer art whose saving gesture forcefully manipulates given nature to all-too-human ends as thoroughly as what it claims to despise?[17] Alongside that critique is another: does not Smithson continue the identification of "nature" with dead nature rather than the living earth? But if that question is apt, could one not equally worry that Adorno's own use of the concept of nature is too indeterminate, or worse: too set on the idea of natural beauty as the placeholder for a nature that does not exist and too little interested in the actual mutilations of *living* nature. Of course, Adorno did not know all that we have come to know about the devastations to the living earth, but equally we should not rush to the conclusion that we now know what *nature* means in a way he did not. At best, and perhaps this is what Adorno finally believed, *nature* is now no more than the name for a formation of the earth whose power of recognition we have yet to recognize.[18] Perhaps there is an inflection of this thought in Ana Mendieta's *Silueta* series in which we perceive the outline or silhouette of the

17. Jennifer Mazza pressed on me the limits of *Spiral Jetty* in this setting. Gregg Horowitz suggested the phrase *bulldozer art*.

18. I owe this phrasing to Gregg Horowitz. It nicely captures what later critical theorists, especially Jürgen Habermas, so distrust about Adorno's conception of nature.

now-absent body of a woman in or on an earthly natural place, or those works where we see the woman's body itself being rejoined to the earth. Mendieta's haunting images remind us that women have been taken as nothing but nature in the midst of culture, that in truth the human is part of nature, that our finitude is our belonging to living nature; above all, these images of the still or absent woman in her earthly habitation, joined to the earth once more, form a quiet work of grieving as living nature comes to appear in the form of the no longer or not quite living woman—absent nature, absent life.

**J. M. Bernstein** is University Distinguished Professor of Philosophy at the New School for Social Research.

## *References*

Adorno, Theodor W. *Aesthetic Theory*, translated by Robert Hullot-Kentor. Minneapolis: University of Minnesota Press, 1997.

Adorno, Theodor W. *Aesthetics, 1958/59*, translated by Wieland Hoban. Cambridge: Polity, 2018.

Adorno, Theodor W. *Negative Dialectics*, translated by E. B. Ashton. London: Routledge, 1973.

Andrews, Malcolm. *Landscape and Western Art*. Oxford: Oxford University Press, 1999.

Cavell, Stanley. *The World Viewed: Reflections on the Ontology of Film*. Enl. ed. Cambridge, MA: Harvard University Press, 1979.

Clark, Kenneth. *Landscape into Art*. Harmondsworth: Penguin, 1956.

Fried, Michael. "Morris Louis." In *Art and Objecthood*, 100–131. Chicago: University of Chicago Press, 1998.

Gashé, Rodolphe. *The Idea of Form: Rethinking Kant's Aesthetics*. Stanford, CA: Stanford University Press, 2003.

Kant, Immanuel. *Critique of Judgment*, translated by Werner S. Pluhar. Indianapolis, IN: Hackett, 1987.

Kant, Immanuel. *Critique of Pure Reason*, translated by Norman Kemp Smith. New York: St. Martin's, 1965.

Merleau-Ponty, Maurice. "Cézanne's Doubt," translated by Hubert Dreyfus and Patricia Allen Dreyfus. In *The Merleau-Ponty Aesthetics Reader: Philosophy and Painting*, edited by Galen A. Johnson, 59–75. Evanston, IL: Northwestern University Press, 1993.

Nehamas, Alexander. *Only a Promise of Happiness: The Place of Beauty in a World of Art*. Princeton, NJ: Princeton University Press, 2007.

Schapiro, Meyer. *Cézanne*. New York: Abrams, 1988.

Smithson, Robert. "Fragments of a Conversation." In *Robert Smithson: The Collected Writings*, edited by Jack Flam, 188–91. Berkeley: University of California Press, 1996.

Wood, Christopher. *Albrecht Altdorfer*. London: Reaktion, 1993.

# Social Suffering and the Autonomy of Art

## Peter E. Gordon

> Was aber wäre Kunst als Geschichtsschreibung, wenn sie
> das Gedächtnis des akkumulierten Leidens abschüttelte.
> —Theodor W. Adorno, *Ästhetische Theorie*

> Wahr spricht wer Schatten spricht.
> —Paul Celan, "Sprich auch du," in *Von Schwelle zu Schwelle*

"Art is autonomous and it is not."[1] Compressed into a single sentence, this seemingly paradoxical claim from Theodor W. Adorno's *Aesthetic Theory* (1970) encapsulates *in nuce* the argument of the entire book. It might even serve as a helpful point of entry into an unfinished work that, decades after its original publication, still leaves readers in a state of perplexity. The question of whether an artwork can rightly be termed *autonomous* is likely to provoke controversy, not least because today the very notion of aesthetic autonomy may strike critics as a remnant of antiquated values of social elitism and context transcendence that we often associate with the artwork in the age of high modernism. Adorno was well aware of such problems. As a theorist who willfully adopted a precarious stance in a "force field" between sociology and philosophy, he never presumed that art could claim for itself a privileged exemption to the fact of its social conditioning, but he also resisted the bad inference that

---

1. Adorno, *Aesthetic Theory*, 6 (hereafter cited as *AT*). The original phrase is somewhat different: "Sie ist für sich, und ist es nicht" (Adorno, *Ästhetische Theorie*, 17; hereafter cited as *ÄT*).

*New German Critique* 143, Vol. 48, No. 2, August 2021
DOI 10.1215/0094033X-8989288   © 2021 by New German Critique, Inc.

because art is a social product its aesthetic validity is therefore reducible to its social genesis. Hence the well-known dictum that art has a "double character," that it is both autonomous and a *"fait social"* (*AT*, 210, 225). The great challenge for readers of *Aesthetic Theory* today is to reckon with this unresolved dialectic. We need to grasp what its author could have meant when he simultaneously affirmed and denied the autonomy of art.[2]

In what follows, I revisit some of Adorno's philosophical motivations for this claim. The question of aesthetic autonomy recurs with some frequency in his oeuvre, and it remained a preoccupation throughout his career, from the early phase of his debate in the mid-1930s with Walter Benjamin on the "decay of the aura" to *Negative Dialectics* (1966), when he characterized aesthetics as "the salvation of appearance [*die Rettung des Scheins*]" and assigned it an "incomparable metaphysical relevance."[3] In *Aesthetic Theory* Adorno continued to refine this dialectical conception of the artwork, though he offered different arguments on its behalf, not all of which are philosophically compatible. In what follows I shall focus on his striking claim that an artwork is "successful" only insofar as it is responsive to social suffering. Here we find the key to Adorno's dialectical conception of the artwork as both autonomous *and* nonautonomous. An artwork can respond in a genuinely critical fashion to social suffering only if it also sustains its relative independence from society, and it achieves this independence only when it subscribes to its own work-immanent principles. Adorno's conception of the artwork thereby seeks to combine aesthetic formalism with social critique; it preserves the artwork's autonomy while charging it with a full measure of responsibility for the society from which it is born.

### Intimations of Autonomy

Adorno's reflections on the autonomy of art are traceable at least as far back as the mid-1930s, when he engaged in his memorable debate with Benjamin on the so-called aura of the traditional artwork and the aura's decay in the modern era when the artwork undergoes a thoroughgoing transformation. On February 27, 1936, Benjamin sent Adorno a typescript of the second, revised version of his still-unpublished essay, "Das Kunstwerk im Zeitalter seiner technischen Reproduzierbarkeit," in which he argued for an overcoming of the bourgeois

2. For closely related arguments, see Hulatt, "Aesthetic Autonomy"; and Hohendahl, "Human Freedom and the Autonomy of Art."
3. Adorno, *Negative Dialektik*, 384 (hereafter cited as *ND*). On art as the "rescue of semblance," see also *AT*, 141.

cult of aesthetic veneration as a prerequisite to any revolutionary aesthetics.[4] Any such advance would require a dissolution of the aura. Emancipated both from tradition and from its own work-immanent rules, the artwork would escape from its mythic isolation, and, thanks to the new technologies of reproduction, it would circulate in the collective realm of "immediate" experience. Modern conditions promised new possibilities for aesthetic encounter: the artwork no longer required the concentration of the isolated bourgeois subject; instead, the artwork could be absorbed by the masses in a state of "distraction [*Zerstreuung*]."[5]

Adorno objects to this program of revolutionary aesthetics for various reasons, not least for its reliance on what he considers its naive and linear model of progress. In a letter of March 18, 1936, he writes that Benjamin is mistaken to believe that the auratic element in bourgeois modernism entails a submission to the artwork as a fetish.[6] This belief arises from Benjamin's deeper, quasi-historical view that the aura is little more than the antiquated remnant of ancient practices of veneration, magical or religious, that once accompanied aesthetic experience in traditional society. Benjamin sees the modern ideal of aesthetic autonomy as a further sign that we have not yet liberated ourselves from their authority. The bourgeois cult of *l'art pour l'art* represents an enduring mystification, or even a "negative theology," as it confines the artwork to an occluded realm beyond human agency. For Benjamin, it follows that a true emancipation in aesthetic experience would involve the complete dissolution of artwork's aura or a "stripping-away of its veil [*Entschälung*]." With the rise of new techniques of reproducibility, especially in photography and film, the conditions for such an emancipation now emerge in history for the first time. Inherited norms of aesthetic authenticity are thereby poised for collapse. Rather than experiencing art as a mode of ritual, we can see it as founded on politics. "The whole social function of art is revolutionized."[7]

For Adorno, this argument betrays a unidirectional and nondialectical model of aesthetic progress. Benjamin's notion of the dissolution of the aura as a "stripping-away" of the artwork's veil looks suspiciously like a Weberian process of world "disenchantment [*Entzauberung*]."[8] It equates aesthetic autonomy with a mythic or magical power that has no place in a fully rational-

---

4. The best translation is Benjamin, "Work of Art."
5. Benjamin, "Work of Art," 119.
6. Adorno and Benjamin, *Complete Correspondence*, 128; *Briefwechsel*, 168.
7. Benjamin, "Work of Art," 106.
8. Benjamin, "Work of Art," 128: "der dialektischen Selbstauflösung des Mythos, die hier als Entzauberung der Kunst visiert wird" (Adorno and Benjamin, *Briefwechsel*, 168).

ized society. Adorno contests this linear narrative of aesthetic disenchantment. The ideal of aesthetic autonomy is not the vestige of mythic or authoritarian tradition that must be peeled away to set the artwork free into the volatile space of modern politics. On the contrary, this achievement is intrinsically dialectical insofar as the artwork's distance from the sphere of social circulation is *also* a gesture of resistance against the overwhelming risk of aesthetic commodification. "The heart of the autonomous work of art [*autonomen Kunstwerks*] does not itself belong to the dimension of myth . . . but is inherently dialectical." Rather, the autonomous artwork "compounds within itself the magical element with the sign of freedom [*Zeichen der Freiheit*]."[9] The freedom of humanity is prefigured in the artwork's capacity to exemplify a Kantian ideal. In practical reason as in art, autonomy means obedience to one's self-prescribed laws. "The uttermost consistency in the pursuit of the technical laws of autonomous art actually transforms this art itself." By obeying its own formalist principles, the artwork does not become a "fetish or taboo." Rather, it anticipates "a state of freedom."[10]

Adorno does not ignore the fact that his appeal to aesthetic freedom bears some resemblance to an antiquated ideal of aesthetic transcendence, as if art could subsist untroubled and uncontaminated in a "reserve" beyond the social realm. "I would not wish to secure the autonomy of art as a special prerogative [*als Reservat*]," he explains.[11] He agrees with Benjamin that "the auratic element of the artwork is vanishing," but he introduces a striking revision into this shared theme. Pace Benjamin, Adorno places greatest emphasis not on the beneficial prospects for the artwork as an instrument for mass mobilization but on the bad implications when the artwork enters the circuit of capitalist exchange. The aura's dissolution would not necessarily enhance the power of the social masses; rather, the historical process by which the artwork detaches itself from its traditional moorings would leave it all the more vulnerable to commodification. The aura is therefore a dialectical concept that implies both liberation *and* capitulation. Adorno is even willing to entertain the thought that the aura signifies something like the "good" moment in reification, or *Verdinglichung*, a proposal that would have struck a Marxist theorist of reification such as Georg Lukács as anathema. Reification, Adorno explains, is not only a capitalist affliction; it also describes the artwork's ability to sustain itself *against* capitalism. "The reification of a great work of art," he concludes, "is not simply

9. Adorno to Benjamin, *Complete Correspondence*, 28; *Briefwechsel*, 169.
10. Adorno to Benjamin, *Complete Correspondence*, 129; *Briefwechsel*, 171.
11. Adorno to Benjamin, *Complete Correspondence*, 129; *Briefwechsel*, 171.

a matter of loss," since this reification also means the durability of the artwork's *form*. It is on the basis of form that an artwork might fulfill its own autonomous laws.[12]

This is a dramatic revision, not only in Benjamin's conception of auratic decline but also in the phenomenon of reification that Adorno (following Lukács) associated with the rise of fetishism in the capitalist commodification of art. This latter understanding of reification comes squarely into view in "On the Fetish-Character in Music and Regression in Listening" (1938), the essay in which Adorno offers an explicit rejoinder to Benjamin about the risks that attend the increasing social circulation of art in an age of technological reproducibility.[13] Where Benjamin sees the promise of revolutionary experience in the increased availability of modern art to the social masses, Adorno fears that this availability may only enhance the artwork's transformation into a commodity. To judge the artwork in accordance with its exchange value threatens its use value, since the imperative that it be exchanged colonizes the integrity of its form from the inside. This imperative helps explain why pieces of commodified music all come to resemble one another, and why any formal criteria of aesthetic merit start to lose their relevance. "The categories of autonomously oriented art," Adorno writes, "have no applicability to the contemporary reception of music." The only categories of art that survive in a capitalist order are those that facilitate the artwork's circulation in a commodity form. Thus the form of exchange alone assumes primacy. "The familiarity of the piece is a surrogate for the quality ascribed to it."[14]

Benjamin was therefore mistaken to imagine that the dissolution of the aura under conditions of capitalist exchange could anticipate the overthrow of these conditions. For the commodity form also dissolves the aesthetic principles allied with freedom: "But what are emancipated from formal law are no longer the productive impulses which rebelled against conventions. Impulse, subjectivity and profanation, the old adversaries of materialistic alienation, now succumb to it. In capitalist times, the traditional anti-mythological ferments of music conspire against freedom, as whose allies they were once proscribed."[15] This argument turns against the premise of technological progress that had inspired Benjamin's theory of auratic decay. While Benjamin saw this decay as an opportunity for aesthetic innovation, Adorno adopts the critical

---

12. Adorno to Benjamin, *Complete Correspondence*, 129; *Briefwechsel*, 171.

13. Adorno, "Über den Fetischcharakter in der Musik," in *Gesammelte Schriften*, 14:14–50 (hereafter cited as *GS*).

14. Arato and Gebhardt, *Essential Frankfurt School Reader*, 271.

15. Arato and Gebhardt, *Essential Frankfurt School Reader*, 273.

posture of a grim realist who recognizes how the logic of exchange will sabotage any bid for freedom. Even the most "rebellious" artwork threatens to devolve into nothing but another commodity.

### The Criterion of Negation

In *Aesthetic Theory* Adorno continues to refine his argument against the linear and "undialectical" model of aesthetic progress that he associates with the thesis of auratic decline. On the notion of progress itself, Adorno remains conflicted. Whatever progress may be ascribed to art, it cannot be understood as an uninterrupted advance, since art never sheds its "double character" (as both autonomous and socially conditioned), and this conditioning belies any narrative of unidirectional emancipation. Nor would it be right to say that aesthetics consists in a progressive "resolution" of previous aesthetic difficulties. "Problems can be forgotten," and innovators in art "rarely have more power over what is old than their predecessors" (*AT*, 210; *GS*, 312). Thus aesthetics does not follow an upward trajectory of problem-solving: "No aesthetic progress without forgetting; hence, all progress involves regression." Adorno grants that in matters of aesthetic *technique* we might discern something like progress, for example, in perspective in painting and polyphony in music (*AT*, 210; *GS*, 313). But technical progress does not justify a general verdict on advances in quality. "However much works are distinguished from each other by their quality, they are at the same time incommensurable. They communicate with each other exclusively by way of antitheses" (*AT*, 211; *GS*, 313).

This understanding of art history as a series of unresolved contests or antithetical statements reflects Adorno's broader understanding of progress in history.[16] While it may be tempting to read Adorno as an unqualified critic of *all* notions of progress, such a reading misconstrues his negative-dialectical criticism as mere negation. His well-known aphorism "Progress occurs where it ends" should not be seen as wholesale rejection, since it clearly suggests that progress can indeed still *occur*, though this possibility comes into view only once the one-sided or ideological concept is dismantled.[17] Here as elsewhere in his work, Adorno discerns a dialectic without resolution: progress is not merely an apologetic veil draped over the mechanisms of world domination; it is also an anticipatory name for our release from this very domination. If we do

16. I would like to thank one of the anonymous readers for *New German Critique* who pressed me to develop this point. The paragraph that follows should help clarify why it would be a mistake to read Adorno as *either* a one-sided partisan of progress or its one-sided critic.

17. Adorno, "Progress," 150. For a reading of Adorno that portrays him chiefly as a skeptic of any notions of historical progress, see Allen, *End of Progress*.

not wish to surrender entirely to despair, such a concept resembles a regulative ideal, and Adorno sees it as indispensable:

> The temporal nature of progress, its simple concept . . . binds it to the empirical world. Without such a temporal dimension, in other words, without the hope that things might improve with time, the heinous aspects of the world and its ways would become immortalized in thought and creation itself would be turned into the work of a gnostic demon. . . . Too little that is good has power in the world for the world to be said to have achieved progress, *but there can be no good, not even a trace of it, without progress.*[18]

Adorno does not seek to mediate between these two senses of the term: in history as in aesthetics, he discerns repeated instances of "non-identity" that resist all mediation.[19] Although Adorno does not wish to abandon the concept of progress altogether, his dialectical conception of progress in the history of aesthetics only enhances his skepticism of Benjamin's attempt to celebrate the modern artwork's release from tradition as an unambiguous advantage. In aesthetics as in society, the concept of progress is *at once* true and false: it orients us toward freedom even while it serves ideological purposes that cannot be ignored. "In art," writes Adorno, "there is as much and as little progress as in society" (*AT*, 208; *GS*, 308).

This dialectical critique of progress is especially evident in those passages of *Aesthetic Theory* where Adorno revisits the question of auratic decay. Adorno grants that Benjamin was partly correct: "The phenomenon of aura, which Benjamin described at once nostalgically and critically, has become bad wherever it is instituted and simulated" (*AT*, 45). The artwork's claim to uniqueness can serve an ideological purpose insofar as in an administered world the artwork transforms into a commercial product and cannot sustain its true individuation. The promise of immediacy becomes mere "semblance," an illusion that does not resist but only enhances the surrounding

---

18. Adorno, *History and Freedom*, 148–49; my emphasis.

19. For Adorno's critique of Hegelian mediation, see, e.g., the arguments on progress and Hegel's dialectic in Adorno's lectures from 1964–65, published as *History and Freedom*. Adorno does not reject the concept of progress as such, but he insists that it is "dialectical" and that it contains an "anti-mythological element." He thus rejects the "dangerous" assertion that progress "has no right to exist." Any such surrender to totalizing skepticism would transform Adorno into a Heideggerian, but this is an association he explicitly rejects: "This excuse thrives on the fallacy that, because there has been no progress up to now, there will be none in the future. It proclaims that the dreary recurrence of the same is the message of Being that must be heard and taken to heart. In reality, Being itself, which has this message foisted upon it, is a cryptogram of myth, *and if we could free ourselves from it, it would be something of a liberation*" (*History and Freedom*, 158; my emphasis).

illusions of the social whole. Yet the thesis of auratic decline can be easily abused if we do not grasp it dialectically, as if the quasi-magical element in an artwork could be wholly expunged without any negative consequences. Disenchantment, or *Entzauberung*, would mean the dissolution of art as such:

> Conceived nondialectically the theory of aura lends itself to misuse. It becomes a slogan for the deaestheticization of art [*Entkunstung der Kunst*] that is under way in the age of the technical reproducibility of the artwork. Aura is not only— as Benjamin claimed—the here and now of the artwork, it is whatever goes beyond its factual givenness, its content; *one cannot abolish it and still want art.* (*AT*, 45; my emphasis)

In this belated rejoinder to Benjamin, Adorno sets forth the crucial themes in his defense of aesthetic autonomy. This is by no means an appeal to the traditional notion of aesthetic transcendence, as if we could assign to the artwork a quasi-metaphysical power to float free from its social origins. Adorno explicitly warns against this misunderstanding, and he recognizes that in an administered society the claim to aesthetic transcendence serves only as an ideological justification for the current order. But this acknowledgment only underscores the point that Adorno must have in mind a rather different concept of autonomy.

To appreciate what Adorno actually means when he insists that art might still be autonomous, we first need to see that "art" for Adorno plays the role of a normative category. "The concept of an artwork implies that of its success. Failed artworks are not art" (*AT*, 188). Art merits the status of art only if it fulfills its own concept, while art that does not merit this status lapses into mere entertainment and assumes its role alongside other commodities that circulate in the culture industry. The chief feature of such commodities is that they affirm society as it currently exists. This suggests that a genuine artwork must satisfy at least one negative criterion: it is successful qua artwork only if it manages to *resist* its own collapse into commodification and affirmation. If an artwork is to succeed, it must somehow effect a gesture of negation, by pulling away in a nonaffirmative or critical fashion from the falsity of the social world of which it is nonetheless a part. Again, on this definition, merely *affirmative* art is *not* really art at all, since it merely affirms the world as it is. Successful art refuses any such affirmation. Adorno suggests this minimalist criterion in a brief line clearly meant to imply the bad alliance between affirmation and philosophical positivism: "Even disenchanted works are more than what in them is the case [*Auch die entzauberten Werke sind mehr, als was an ihnen bloß der*

*Fall ist*]" (*AT*, 45; *ÄT*, 73). For Adorno, a philosophical positivist is someone who affirms the world as it is given and assents to the sentiment stated in brutal shorthand by Ludwig Wittgenstein in the first line of the *Tractatus*: "Die Welt ist alles, was der Fall ist." A successful artwork is one that resists this sentiment: it has the capacity to negate what is given.

In light of this negative criterion for aesthetic success, we can appreciate why Adorno cannot countenance the possibility of a wholly affirmative art. "All artworks," he writes, "are a priori polemical," because they "bear witness that the world itself should be other than it is" (*AT*, 177). At the same time, Adorno warns against the naive thought that in their task of "bearing witness," artworks can beckon to us as islands of utopia or total fulfillment. On the contrary, he insists, "there are no perfect works." For if an artwork could actually serve as an image of unblemished perfection, this would imply that "reconciliation would be possible in the midst of the unreconciled" (*AT*, 190). But all art is human; it is scored by the wounds of the world out of which it is born. In an imperfect world, art, too, must be imperfect, lest it surrender its truth content and become merely an ideological affirmation of social untruth. It is in this sense that successful art is and must be *negative*. This criterion applies even to seemingly "beautiful" and "harmonious" works of art such as the music of Mozart, whose compositions may sound to us as if they were "unpolemical," as if they floated in a "pure sphere of spirit" beyond social contamination (*AT*, 177; *GS*, 264). But even Mozart's music is negative, insofar as it stages a contest between reconciliation and social reality, and this is why we experience the contest as "painful sweetness [*schmerzhafte Süße*]" (*AT*, 177; *GS*, 264).

## Suffering and Truth

But if successful art must sustain negation, then how should we imagine that such a negation could even be possible? After all, we know that Adorno disallows any and all gestures of actual (metaphysical) transcendence. In aesthetic experience as in all experience, personal and collective, we find ourselves amid material conditions that always outstrip the subject's powers of self-assertion and reflection. This basic premise, or what Adorno calls "the primacy of the object [*Vorrang des Objekts*]," is what distinguishes him as an ally to materialist and neo-Marxist currents in philosophy, notwithstanding the many objections that he raised against the reductive implications of materialism when it assumes the force of ideology.[20] The thesis of object primacy is chiefly meant

20. In *Philosophische Terminologie* Adorno warns that "the idea of the materiality (*Stoffhaftigkeit*) of human beings can be extremely repressive" insofar as it turns them into "pure objects of domination." On this theme, see the excellent discussion in Cook, *Adorno on Nature*, 29.

to alert us to the prevailing role that inherited social and historical conditions play in all thought and action. But there is a further implication of this thesis that comes into view most of all in *Negative Dialectics*. This is the claim that object primacy is something that we can detect *somatically*, in our sensual being and most of all in our experience of suffering. For it is chiefly our vulnerability and our capacity to suffer that alerts us to our status as embodied creatures. Adorno sees this as far more than a truism; it alerts us to the deepest truth about the constitution of our world. "Suffering," he writes, is "the objectivity which weighs on the subject." To be sure, he also insists that this truth is not an invariant fact of the human condition; it reflects the terrible events in modern history that have exposed traditional metaphysical reflections on meaning culture as a sham. "The somatic layer of living beings, distant from meaning, is the staging-grounds of suffering, which burned everything assuaging of the Spirit and its objectification, culture, without consolation in the camps" (*ND*, 358–61). The deepest alliance between Adorno and the Marxist tradition may lie here, in Adorno's conviction that no philosophy can be "true" or can escape the spell of ideology and social apologetics, if it does not somehow commit itself to exposing the suffering that pervades the human world. "The need to give voice to suffering is the condition of all truth" (*ND*, 29).

Adorno does not only see our capacity to suffer as merely a descriptive truth; he also assigns it a normative force insofar as it announces protest against the world that has caused suffering. The very recognition of suffering is already a critique of the conditions of its emergence. This critique calls into question the broad tradition of "identity" thinking in philosophy that would see subject and object as reconciled: "The smallest trace of senseless suffering in the experienced world condemns the whole of identity-philosophy, which would like to talk experience out of this, as a lie" (*ND*, 202–4). But this is not only a critique of identity-philosophy. It implies a protest and a demand for practical action that would seek to eradicate the historical conditions in which suffering may appear inevitable. Our protest against suffering is already built into the experience of suffering itself: "The corporeal moment registers the cognition, that suffering ought not to be, that things should be different. 'Woe speaks: go' [*Weh spricht: vergeh*]." For Adorno, then, any philosophy that could qualify as genuinely materialist in its commitments must take the acknowledgment of human suffering as the highest criterion of truth.[21] Our recognition of suffering makes possible both social critique and "socially transforming practice" (*ND*, 201).

---

21. On this point, see the excellent reconstruction in Shuster, *Autonomy after Auschwitz*, esp. 114.

The demand that art must acknowledge suffering is built into Adorno's conception of aesthetic truth. A false society is one predicated on social suffering, while a work of art is "true," or has "truth content," if and only if it somehow bears witness to the truth of a false society. While this requirement surely explains why there is art in our unredeemed world, it prompts us to ask whether we could imagine any place for genuine art in a society that had somehow achieved utopia. Although such a scenario is wildly counterfactual, even as a thought experiment it tells us something important about Adorno's concept of aesthetic experience. His criterion of aesthetic truth suggests that in a world without suffering, art might lose its negative relation to the social whole and be robbed of its critical task. Adorno is acutely aware of this dilemma. If the artwork retains its highest meaning only insofar as it thematizes social suffering, then if it were bereft of this meaning, the artwork would either lapse into affirmation or simply disappear:

> It would be preferable that some fine day art vanish altogether than that it forget the suffering that is its expression. . . . This suffering is the humane content that unfreedom counterfeits as positivity [*der humane Gehalt, den Unfreiheit zu Positivität verfälscht*]. If in fulfillment of the wish a future art were once again to become positive, then the suspicion that negativity were in actuality persisting would become acute. (*AT*, 260–61)

Without this content, the animating purpose of aesthetic experience would become something entirely other than what it has always been throughout history: "But then what would art be, as the writing of history, if it shook off the memory of accumulated suffering [*Was aber wäre Kunst als Geschichtsschreibung, wenn sie das Gedächtnis des akkumulierten Leidens abschüttelte*]" (*AT*, 260–61; *GS*, 387).

Adorno finds such a transformation in aesthetic experience barely imaginable, since in such a circumstance art would no longer fulfill its critical task of thematizing our present suffering.[22] Given the stubborn and enduring character of systemic social irrationality, the prospects for a genuinely rational society that has put an end to suffering may strike us as highly unlikely, but (at least as a thought experiment) Adorno is willing to entertain what this circumstance would mean for aesthetics. In a true society, seemingly irrelevant or obsolete

22. As an answer to this question, Adorno hesitates to draw the bold conclusion "daß eines besseren Tages Kunst überhaupt verschwände [that some better day art as such would vanish]." Instead, he contemplates the utopian scenario: "Möglich, daß einer befriedeten Gesellschaft die vergangene Kunst wieder zufällt [the possibility that the art of the past would once again fall to a society at peace" (*GS*, 386).

artworks would regain a new life: they would undergo a kind of "resurrection." The suggestion is indeed messianic, and Adorno recognizes that even to imagine such a scenario carries the risk of apologetics, since we are too easily tempted to apply the counterfactual to the actual, as if our *current* aesthetic experience could dispense with the obligation to acknowledge human suffering. This is the current function of art, which today has become "the ideological complement of a world not at peace [*die heute zum ideologischen Komplement der unbefriedeten geworden ist*]" (*AT*, 260; *GS*, 386). Adorno thus condemns any and all artworks under current social conditions that strive to thematize *only* social reconciliation and fail to interlace the homage to an unrealized utopia with the forthright acknowledgment of current suffering. Such artworks devote themselves only to an aesthetic of perfect "harmony" as if the artwork had no higher task than an "affirmative replication [*affirmative Abbildlichkeit*]" of the world as it is. But with this affirmative function the artwork willfully commits a "sacrifice of its freedom [*Opfer ihrer Freiheit*]" and simply ceases to be art (*AT*, 260; *ÄT*, 386).

### Autonomy and Critique

The third and final component in Adorno's argument for aesthetic autonomy unites the first two criteria into the claim that an artwork can fulfill its critical role as a seismograph for social suffering only if it holds itself apart from society. This claim admittedly verges on paradox, as it seems to imply that art is social only insofar as it is asocial, that it can uphold its responsibilities to the extra-aesthetic sphere only by withdrawing from that sphere and isolating itself within the purely aesthetic. Adorno is well aware that this claim may invite a charge of self-contradiction, since he insists that art is both immanent to society and transcendent to it. But it is the dominant theme of *Aesthetic Theory* that successful artworks do in fact exhibit a "dual nature," since they are both "autonomous structures *and* social phenomena" (*AT*, 248; my emphasis). Adorno refuses to surrender either moment in the unreconciled dialectic between autonomy and heteronomy that defines the aesthetic realm. What may appear to the skeptical reader as an illicit attempt to have one's cake and eat it too is better understood as a consummate illustration of Adorno's negative-dialectical thinking.

But how could such a claim possibly be justified? The strong premise that underwrites the claim would seem to be that criticism *requires* autonomy. To take up a posture of critical distance toward the social world is something that can be achieved only if one allows for the possibility that one's views on the world are not wholly determined *by* the world. Adorno insists, however, that

this possibility is not something that we can easily abandon. To surrender the prospect of nonheteronomous determination would be to surrender the prospect of freedom that animates us as human beings. Adorno regards this prospect as embattled and increasingly rare, to the point that he sees freedom chiefly as an anomalous and ever-dimming light that we glimpse in the darkness through the bars of our collective prison cell.[23] The idea of our freedom may seem impossible, but "even its own impossibility" is something we must comprehend "for the sake of the possible [*um der Möglichkeit willen*]."[24] The kind of possibility that guides us should not be construed as merely a vain hope or an abstract "ought" that opposes the actual world like an extramundane idea. Rather, it must be what Iain Macdonald has called a "*real* possibility."[25] Such a possibility is more than a mere ideal but should be understood as a "*blocked possibility*" insofar as it has been "*socially suppressed*."[26]

When considering in greater depth why Adorno subscribes to this idea of freedom as indispensable to our conception of ourselves as human beings, we should not neglect the affinity between this idea and the concept of freedom as presented by Immanuel Kant in his moral philosophy, especially in the so-called formula of humanity.[27] This is the interpretation of the categorical imperative according to which we are enjoined to treat humanity never as a means but always as an end in itself. For Kant, too, this conception of ourselves as beings of ultimate worth is quite simply constitutive of ourselves as moral agents. If it were deemed invalid, we would have to surrender the concept of moral action altogether. The formula of humanity is one interpretation of the categorical imperative, namely, it expresses the thought that *autonomy* demands a view of ourselves as ends rather than means.

It may come as a surprise to suggest that Adorno owes any substantive debt to Kant's moral philosophy, especially if one considers the rather sobering assessment of Kantian moralism in an early work such as *Dialectic of Enlightenment* (1944), where, in the well-known second "excursus," Kant appears alongside the Marquis de Sade as furnishing a rationale for our domination of nature.[28] However seriously we take this comparison, we would nonetheless do

23. Adorno, "Bourgeois Opera," 21.
24. Adorno, "Finale," in *Minima Moralia*, 247; "Zum Ende," in *Minima Moralia*, 334.
25. Macdonald, *What Would Be Different*, 4–6.
26. Macdonald, *What Would Be Different*, 6.
27. See, e.g., Allison, *Kant's Groundwork*, chap. 8, "The Formula of Humanity."
28. Horkheimer and Adorno, "Excursus II: Juliette, or, Enlightenment and Morality," in *Dialectic of Enlightenment*, 63–93 (hereafter cited as *DE*); *Dialektik der Aufklärung*, 88–127 (hereafter cited as *DA*).

well to recall that it was a coauthored work published more than twenty-five years before *Aesthetic Theory*, and editorial analysis suggests that the primary author of this excursus was Max Horkheimer, not Adorno. More important, we should not neglect the final passage of the excursus, where we are enjoined to "liberate from its shell the utopia [*die Utopie aus ihrer Hülle zu befreien*]" that is "contained in every great philosophy, as it is in Kant's concept of reason," namely, "the utopia of a humanity which [is] no longer distorted" (*DE*, 93; *DA*, 127). Here we can see that even in what Jürgen Habermas called "their blackest, most nihilistic book," Adorno and Horkheimer still held fast to the utopian ideal of an undistorted humanity as the polestar of their critical efforts.[29] In later works by Adorno, Kant reemerges with renewed interest as a reference point for Adorno's own efforts to reconsider the foundations of epistemology, moral philosophy, and aesthetics. In 1959 Adorno offered a lecture course on Kant's *Critique of Pure Reason*; in 1963 he offered lectures on Kant's moral philosophy; and he offered lectures on aesthetics on no fewer than six occasions, beginning in 1950 and ending in the winter semester of 1967–68.[30] As Peter Uwe Hohendahl has observed, Adorno's frequent lectures on aesthetics in the postwar years reveal not only a preoccupation with Kant's aesthetic philosophy but also a certain rapprochement with its claims.[31]

More surprising, if also more subtle, is the reprisal in Adorno's aesthetic work of themes that we might associate with Kantian moral philosophy.[32] The ideal of the artwork's autonomy can be understood as an homage to the Kantian categorical imperative and its concept of moral autonomy, as expressed in the formula of humanity. Max Paddison comments on Adorno's "irritating stylistic tendency to anthropomorphize the aesthetic sphere," as if artworks such as music were animistic beings that possessed the magical ability to perform themselves apart from human agents.[33] But this is more than a stylistic idiosyncrasy. Adorno means to alert us to a deep and instructive analogy between the artwork and human agency. To see an artwork as autonomous is to see it as a practical agent that can posit its own laws. A true artwork exhibits a kind of "lawfulness," or *Gesetzlichkeit*, by following the principles of its own "inner-technical" form. This ideal of autonomy bears a striking resemblance to the

29. Habermas, *Philosophical Discourse of Modernity*, chap. 8.

30. The lectures were delivered in 1950, 1950–51, 1955–56, 1958–59, 1961–62, and 1967–68. See the editor's foreword in Adorno, *Aesthetics*, ix–xii.

31. Hohendahl, "Human Freedom and the Autonomy of Art."

32. See, e.g., Adorno's extensive and highly critical reflections on Kant in the 1963 lecture series, *Probleme der Moralphilosophie*.

33. Paddison, *Adorno's Aesthetics of Music*, 233.

Kantian definition of enlightenment as the human being's "emergence from [his] self-incurred tutelage" and a readiness to assume "responsibility for one's own conduct."[34] This definition recurs in Adorno's claim that artworks can emerge as autonomous only by overcoming "the disgrace of their ancient dependency on magic, their servitude to kings and amusement [*die Schmach ihrer alten Abhängigkeit von faulem Zauber, Herrendienst und Divertissement*]" (*AT*, 3; *ÄT*, 12). Insofar as an artwork strives for this autonomous ideal, it approximates the status of an end in itself, and it resists its reduction to a means. For Adorno, such a reduction occurs whenever an artwork ceases to obey its self-prescribed laws and obeys the laws of the market instead. The commodified products of the culture industry are means in precisely this sense. They are mere instruments that both depend on and help confirm the authority of society as it is given. For Adorno as for Kant, autonomy in this sense is a precondition for criticism. According to Kant, only those who are truly free to make public use of their reason can engage in "candid criticism [*freimütigen Kritik*]" of their society and its "already given [*der schon gegebenen*]" basic laws.[35] According to Adorno, only artworks that exhibit autonomy can resist the spell of commodification and articulate a critique of the surrounding world.

With this definition of aesthetic freedom Adorno has refined a key theme in his early debate with Benjamin. The disenchantment of the artwork does not mean a loss of its aura and its consequent release from singularity into politicization. Rather, an artwork is *disenchanted* in Adorno's sense only when it seeks to draw back from its own social conditioning and obey its own self-prescribed laws. This refinement alerts us to Adorno's implicitly Kantian ideal of enlightenment as a release from the condition of social dependency, or *Unmündigkeit*.[36] Disenchantment is now reconfirmed as a necessary moment in what Horkheimer and Adorno elsewhere call "the positive concept of enlightenment," namely, an enlightenment that retains the capacity to "reflect on itself [*auf sich selbst besinnen*]" (*DE*, xviii, xvii; *DA*, 6, 5). Disenchantment now marks a stage in the emergence of aesthetic freedom. According to this new definition, art should be seen as a secularized promise of redemption. However, Adorno warns that the promise of aesthetic autonomy itself is also susceptible to a dialectical reversal, and, if it does not remain true to its critical mission, it can end up serving the same apologetic function as religion once did:

34. Kant, "Was ist Aufklärung?"
35. Kant, "An Answer to the Question: What Is Enlightenment?," 22; "Was ist Aufklärung?," 27.
36. See Adorno, *Erziehung zur Mündigkeit*.

> As a result of its inevitable withdrawal from theology, from the unqualified claim to the truth of redemption [*Erlösung*] without which art would never have developed, art is condemned to provide the world as it exists with a consolation that—shorn of any hope for an Other [*der Hoffnung auf ein Anderes*]—strengthens the spell of that from which the autonomy of art wants to free itself. The principle of autonomy is itself suspected of giving consolation. (*AT*, 2; translation modified based on *GS*, 10)

But this fear of its apologetic function is hardly sufficient to make Adorno reject the ideal of autonomy tout court. He insists nevertheless that the autonomous artwork, however partial and precarious, can stand as a sign of freedom in an unfree world.

Here we arrive at the final and most challenging question in *Aesthetic Theory*. In what sense can it be said that an autonomous artwork fulfills the task of responding to society? The answer makes explicit Adorno's principled commitment to aesthetic formalism. An artwork is autonomous only insofar as it strives to obey its own self-prescribed rules. But in this way the ideal of autonomy demands that an artwork concern itself with the rules that are immanent to its own structure qua artwork. An artwork is autonomous only by virtue of what Adorno calls "the law of form" (*AT*, 9). Just as the Kantian moral agent sustains its freedom by obeying its self-prescribed laws, so too the artwork draws back from its social determination only through the laws of its own self-imposed form. Without this self-legislative capacity an artwork would lapse into heteronomy. "The concept of form marks out art's sharp antithesis to an empirical world in which art's right to exist is uncertain. Art has precisely the same chance of survival as does form, no better" (*AT*, 141).

It should hardly surprise us, then, that Adorno goes so far as to declare that "form is *the central concept of aesthetics*" (*AT*, 141; my emphasis). But he immediately adds to this claim the dialectical proviso that an aesthetics of pure formalism also risks asserting the artwork's right to unqualified isolation:

> If aesthetics is not to be trapped in tautologies it must gain access to what is not simply immanent in the concept of form, yet the concept of form refuses to grant a voice to anything aesthetic that claims independence from it. *An aesthetics of form is possible only if it breaks through aesthetics as the aesthetics of the totality of what stands under the spell of form. Whether art is in any way still possible depends precisely on this.* (*AT*, 141)

Although art can be art only if it subscribes to the rules of its form, this same requirement, if it were fulfilled without self-criticism or "breakage," would

turn the artwork into a solipsistic and self-referential whole. Such an artwork could no longer meet the obligation of responding to the outside world; it would lapse into ideology and would no longer be art. Adorno states this dilemma succinctly in a passage from *Philosophy of New Music* (first published in 1949): "Music protects its social truth by virtue of its antithesis to society, by virtue of [its] isolation, yet by the same measure this isolation lets music wither."[37] In *Aesthetic Theory* he reformulates the dilemma as a constitutive feature of modern art. "It is for this reason that socially the situation of art is today aporetic. If art cedes its autonomy, it delivers itself over to the machinations of the status quo; if art remains strictly for-itself [*für sich*], it nonetheless submits to integration as one harmless domain among others" (*AT*, 237; *GS*, 352–53).

How, then, can art sustain the distinctive kind of autonomy that Adorno's formalism demands without collapsing into solipsism? Adorno's answer to this question brings us at last to the core premise of *Aesthetic Theory*. If an artwork exists only *as* an artwork in virtue of its form yet will "wither" or lapse into untruth if it does not respond to social suffering, then it must register this suffering in accordance with the immanent principles of its own formal structure. At the same time, however, Adorno insists that nothing in the artwork's form arises from its social conditions in a strictly "causal" manner, since this reductive model of social causation would divest the artwork of its autonomy. Instead of causality Adorno proposes a dialectical understanding of the artwork that acknowledges *both* its status as autonomous *and* its facticity as social product. "The immanence of society *in the artwork*," he explains, "is the essential social relation of art, not the immanence of art in society" (*AT*, 232; my emphasis). To motivate this claim, he compares the artwork to a Leibnizian monad, whose contents are not *caused* by the outside world but nonetheless represent the world. Much like a monad, the artwork represents society "windowlessly [*fensterlos*]" within the bounds of its own structure (*AT*, 236; *GS*, 350). And, like a monad, the artwork "must go within in order to go beyond itself" (*AT*, 260). The artwork remains an artwork only if it obeys its own laws, but in so doing it also reflects the social world that transcends it.[38] "The unresolved antagonisms of reality return in artworks as immanent problems of form" (*AT*, 6).

Adorno does not pursue this "social-representationist" theory of aesthetic form to its extreme conclusion, as if each and every feature of an artwork

---

37. Adorno, *Philosophy of New Music*, 20.
38. "The elements of an artwork acquire their configuration as a whole in obedience to immanent laws that are related to those of the society external to it" (*AT*, 236).

would correspond strictly to a specific feature of society. Such an interpretative method would violate our sense of aesthetic autonomy by reducing the artwork's form to little more than a "copy" or "reproduction" of its social context (*AT*, 260). But even while "in art formal characteristics are not facilely interpretable in political terms," Adorno is still willing to insist that "everything formal in art nevertheless has substantive implications [that] extend into politics" (*AT*, 255). This is so because "art, as a form of knowledge, implies knowledge of reality, and there is no reality that is not social." The knowledge of society expressed in art should not be understood as "illustrating" or "somehow imitating" it. Rather, "art becomes social knowledge by grasping [society's] *essence*" (*AT*, 258; my emphasis). ·

The emphatic claim that art expresses only the essence of society but does not provide a picture or map of society in all its empirical detail is crucial to Adorno's argument, not least because it protects it from the charge of vulgar sociological reductionism. But this claim has advantages and disadvantages. Even though it extends the social significance of an artwork so that it seizes on society as a whole, this meaning becomes so generalized that it loses nearly all determinate content. Indeed, it may be hard to avoid the suspicion that by emphasizing social essence at the expense of social particularity, Adorno's social understanding of form itself becomes formalistic. Art tells us everything that we might want to know about society in general, but it tells us nothing in particular. This disadvantage, however, may be the price that art must pay for its autonomy. By withdrawing from the details of the social world, art gains a broadened perspective on society that it could not achieve were it to annul this distance and strive for total and unmediated identification.

In *Aesthetic Theory* Adorno seldom exploits the analogy between social and aesthetic form as a license for what he liked to call "micrological" interpretation (*AT*, 101). Instead, he offers little more than what we might call a statement of method, or a propaedeutic to any future aesthetics. His analogy informs only the generic claim: modern society is fractured, riven with antagonism and suffering; modernist art is likewise broken and thereby replicates as a monad the brokenness of its social surroundings. But even this rather formalistic statement may suffice to explain why Adorno feels justified in offering the categorical remark that "there are no perfect works." The existence of a perfect work of art would imply the possibility of "reconciliation . . . in the midst of the unreconciled" (*AT*, 190). But any artwork that would hold out such an image of perfection would immediately betray its obligations to social truth and thereby lose its status as successful art. While Adorno entertains the idea

that an artwork might serve as a "promise of happiness," this much-cited claim should not be misconstrued as affirming art as an island of perfection.[39] In one of the "Paralipomena" to *Aesthetic Theory* he denies this possibility: "Stendhal's dictum of art as the *promesse du bonheur* implies that art does its part for existence by accentuating what in it prefigures utopia. But this utopic element is constantly decreasing, while existence increasingly becomes merely self-equivalent. . . . *Because all happiness found in the status quo is an ersatz and false, art must break its promise in order to stay true to it*" (*AT*, 311; my emphasis). Art can succeed as an expression of social truth only if it sustains the dialectic between the unfulfilled promise of happiness and the reality of social suffering. Hence Adorno's great admiration for the music of the Second Viennese School, in which he hears not only sounds of despair but also a "precarious happiness."[40]

### Concluding Remarks

Fifty years since its publication, Adorno's *Aesthetic Theory* remains riven with controversy, not least because it appeared only a year after the student rebellions in Frankfurt that sent its author fleeing from the lecture hall. In the spring of 1969, not long after the interruption of his lectures, Adorno sat for an interview with reporters from *Der Spiegel*, and he declared, not without a note of defiance, that "I am not in the least bit ashamed to state in public that I am working on a long study in aesthetics."[41] After his death, activists such as Hans-Jürgen Krahl condemned their former teacher for his "aesthetic abstractions" and for embracing the "monadological fate" of bourgeois individualism despite Adorno's own attempt to develop a philosophical critique of the modern subject.[42] *Aesthetic Theory* contains a passing remark on this controversy: "For contemporary consciousness, and especially for student activists, the immanent difficulties of art, no less than its social isolation, amount to its condemnation" (*AT*, 251). Adorno knew only too well that his appeal to the autonomy of art could appear to his critics as a flight from political reality. But this did not deter him from sustaining a dialectical conception of the artwork as social *and* asocial. Although he readily acknowledged that autonomous artworks are "socially culpable," he insisted that, as a transcript of social suffer-

39. See Finlayson, "Artwork and the *Promesse du Bonheur.*"
40. Adorno, "Kriterien der neuen Musik," in *GS*, 16:227.
41. Quoted in Wiggershaus, *Frankfurt School*, 636.
42. Krahl, "Political Contradictions."

ing, "each [artwork] that deserves its name seeks to expiate this guilt" (*AT*, 234). But in the last analysis this guilt cannot be expelled, since it is thematized within the monad-like sphere of the artwork itself.[43] What Adorno calls art's "double character," namely, its status as both autonomous and *fait social*, is not a dualism of two distinctive parts, since its social origin is "incessantly reproduced *on the level of its autonomy*" (*AT*, 5).[44]

It remains an unfortunate commonplace that Adorno was a man of great privilege and wealth who luxuriated in the sublime artifacts of "high" culture. That this caricature persists tells us a great deal, if not about Adorno, then about the difficulty that must confront any social theory that refuses to surrender the aesthetic ideals that were once self-evident on the political left. We should not forget that Karl Marx himself looked forward to the possibility of an "emancipation of the senses" and made space in his critique of capitalism for a consideration of artistic pleasure.[45] But this is because Marx sustained a dialectical conception of human flourishing; he did not seek simply to annul but actually wished to salvage the ideal of aesthetic autonomy that had developed in tandem with bourgeois society. Today, however, when a species of so-called populism has seized so much of political discourse on both the left and the right, the aspiration to aesthetic freedom as a necessary component to human freedom has grown unfamiliar, and it is often dismissed as a symptom of an intolerable elitism. It is one of the greatest distinctions of *Aesthetic Theory* that it refuses to surrender the ideal of aesthetic autonomy, even while it also honors art's deepest obligations to our common world.

**Peter E. Gordon** teaches social theory, history, and philosophy at Harvard University.

43. In an important passage from the "Paralipomena" to *Aesthetic Theory*, Adorno praises Paul Celan's poetry, in which the traditional ideal of a "windowless" and "monadic" artwork is both honored and dialectically transformed or even reversed until it becomes a critique of this very ideal, injecting guilt into autonomy even while sustaining it. Celan's poetry is "the most important contemporary representative of German hermetic poetry," but in his work "the experiential content of the hermetic was inverted. His poetry is permeated by the shame of art in the face of suffering that escapes both experience and sublimation" (*AT*, 322; *GS*, 477).

44. The original reads: "Der Doppelcharakter der Kunst als autonom und fait social teilt ohne Unterlass der Zone ihrer Autonomie sich mit" (*GS*, 16). My thanks to the anonymous reader for calling my attention to this passage.

45. For "emancipation of the senses," see Marx, "Economic and Philosophic Manuscripts," 87; for "artistic pleasure," see Marx, *Grundrisse*, 111.

## References

Adorno, Theodor W. *Aesthetic Theory*, translated by Robert Hullot-Kentor. Minneapolis: University of Minnesota Press, 1997.

Adorno, Theodor W. *Aesthetics*, edited by Eberhard Ortland, translated by Wieland Hoban. Medford, MA: Polity, 2018.

Adorno, Theodor W. *Ästhetische Theorie*. Vol. 7 of *Gesammelte Schriften*. Frankfurt am Main: Suhrkamp, 1970.

Adorno, Theodor W. "Bourgeois Opera." In *Sound Figures*, translated by Rodney Livingstone, 15–28. Stanford, CA: Stanford University Press, 1999.

Adorno, Theodor W. *Erziehung zur Mündigkeit: Vorträge und Gespräche mit Hellmut Becker 1959 bis 1969*. Frankfurt am Main: Suhrkamp, 1971.

Adorno, Theodor W. *Gesammelte Schriften*, edited by Rolf Tiedemann. 20 vols. Frankfurt am Main: Suhrkamp, 1970–86.

Adorno, Theodor W. *History and Freedom: Lectures, 1964–1965*, edited by Rolf Tiedemann, translated by Rodney Livingstone. Malden, MA: Polity, 2006.

Adorno, Theodor W. "Kriterien der neuen Musik." In *Gesammelte Schriften*, 16:227.

Adorno, Theodor W. *Minima Moralia: Reflections from Damaged Life*, translated by E. F. N. Jephcott. London: New Left Books, 1974.

Adorno, Theodor W. *Minima Moralia: Reflexionen aus dem beschädigten Leben*. Frankfurt am Main: Suhrkamp, 1969.

Adorno, Theodor W. *Negative Dialektik*. Frankfurt am Main: Suhrkamp, 1966.

Adorno, Theodor W. *Philosophy of New Music*, translated by Robert Hullot-Kentor. Minneapolis: University of Minnesota Press, 2019.

Adorno, Theodor W. *Probleme der Moralphilosophie*. Frankfurt am Main: Suhrkamp, 1996.

Adorno, Theodor W. "Progress." In *Critical Models: Interventions and Catchwords*, translated by Henry W. Pickford, 143–60. New York: Columbia University Press, 2005.

Adorno, Theodor W. "Über den Fetischcharakter in der Musik und die Regression des Hörens." In *Gesammelte Schriften*, 14:14–50.

Adorno, Theodor W., and Walter Benjamin. *Briefwechsel, 1928–1940*. Frankfurt am Main: Suhrkamp, 1994.

Adorno, Theodor W., and Walter Benjamin. *The Complete Correspondence, 1928–1940*. Cambridge, MA: Harvard University Press, 2001.

Allen, Amy. *The End of Progress: Decolonizing the Normative Foundations of Critical Theory*. New York: Columbia University Press, 2016.

Allison, Henry. *Kant's Groundwork for the Metaphysics of Morals: A Commentary*. Oxford: Oxford University Press, 2011.

Arato, Andrew, and Eike Gebhardt, eds. *The Essential Frankfurt School Reader*. New York: Continuum, 1982.

Benjamin, Walter. "The Work of Art in the Age of Its Technological Reproducibility," translated by Edmund Jephcott and Harry Zohn (second version). In vol. 3 of *Selected Writings*, edited by Howard Eiland and Michael W. Jennings, 103–33. Cambridge, MA: Harvard University Press, 2002.

Cook, Deborah. *Adorno on Nature.* New York: Routledge, 2011.

Finlayson, James Gordon. "The Artwork and the *Promesse du Bonheur* in Adorno." *European Journal of Philosophy* 23, no. 3 (2012): 392–419.

Habermas, Jürgen. *The Philosophical Discourse of Modernity,* translated by Frederick G. Lawrence. Cambridge, MA: MIT Press, 1987.

Hohendahl, Peter Uwe. "Human Freedom and the Autonomy of Art." In *The Fleeting Promise of Art: Adorno's Aesthetic Theory Revisited,* 33–56. Ithaca, NY: Cornell University Press, 2013.

Horkheimer, Max, and Theodor W. Adorno. *Dialectic of Enlightenment: Philosophical Fragments,* translated by Edmund Jephcott. Stanford, CA: Stanford University Press, 2007.

Horkheimer, Max, and Theodor W. Adorno. *Dialektik der Aufklärung: Philosophische Fragmente.* Frankfurt am Main: Fischer, 1969.

Hulatt, Owen. "Aesthetic Autonomy." In *A Companion to Adorno,* edited by Peter E. Gordon, Espen Hammer, and Max Pensky, 351–64. Hoboken, NJ: Wiley and Sons, 2020.

Kant, Immanuel. "An Answer to the Question: What Is Enlightenment?" In *Practical Philosophy,* edited by Mary J. Gregor, 11–22. Cambridge: Cambridge University Press, 1999.

Kant, Immanuel. "Was ist Aufklärung?" In *Ausgewählte kleine Schriften,* edited by Horst D. Brandt, 20–27. Hamburg: Meiner, 1999.

Krahl, Hans-Jürgen. "The Political Contradictions in Adorno's Critical Theory." *Sociological Review* 23, no. 4 (1975): 307–10.

Macdonald, Iain. *What Would Be Different: Figures of Possibility in Adorno.* Stanford, CA: Stanford University Press, 2019.

Marx, Karl. "Economic and Philosophic Manuscripts." In *The Marx-Engels Reader,* edited by Robert C. Tucker, 66–125. New York: Norton, 1978.

Marx, Karl. *Grundrisse: Foundations of the Critique of Political Economy,* translated by Martin Nicolaus. London: Penguin, 1993.

Paddison, Max. *Adorno's Aesthetics of Music.* Cambridge: Cambridge University Press, 1993.

Shuster, Martin. *Autonomy after Auschwitz: Adorno, German Idealism, and Modernity.* Chicago: University of Chicago Press, 2014.

Wiggershaus, Rolf. *The Frankfurt School: Its History, Theories, and Political Significance,* translated by Michael Robertson. Cambridge, MA: MIT Press, 1995.

# Adorno's Magic Lantern:
## On Film, Semblance, and Aesthetic Heteronomy

### Ricardo Samaniego de la Fuente

Can film, as a nonautonomous form of art, be a medium for social critique? For a long time it was thought that for Theodor W. Adorno the answer was a clear no. There is much evidence to support this position: his polemics with Walter Benjamin, his writings on the "culture industry," and his association with "high" modernism are just a few examples. "Every visit to the cinema, despite the utmost watchfulness, leaves me dumber and worse than before," Adorno comments in *Minima Moralia*.[1] Similarly, in the famous "Culture Industry" chapter from *Dialectic of Enlightenment*, Adorno contends that the experience of a sound film "positively debars the spectator from thinking."[2] By blocking the development of our cognitive capacities, film acts as an ideological mechanism and furthers the "compulsive character of a society alienated from itself" (*DE*, 95). From these passages, we get the sense that, for Adorno, the possibility that film could become a critical medium was foreclosed due to its dependency on the culture industry, with its rationality of domination.

I wish to thank Plamen Andreev, Jakub Kowalewski, John Lumsden, and Maite Rodríguez Apólito for their feedback on previous versions of this article, and the two anonymous reviewers for their helpful suggestions. I am particularly grateful to Fabian Freyenhagen for his constructive and insightful comments on various drafts.

    1. Adorno, *Minima Moralia*, 5.
    2. Horkheimer and Adorno, *Dialectic of Enlightenment*, 100 (hereafter cited as *DE*).

*New German Critique* 143, Vol. 48, No. 2, August 2021
DOI 10.1215/0094033X-8989302    © 2021 by New German Critique, Inc.

However, largely thanks to the work of Miriam Hansen, some cracks have appeared in that interpretation.[3] Her work marked the beginning of a reading of Adorno's writings on film "against the grain," which has revealed that much of what Adorno has to say about film is more nuanced than what an oversimplified reading of his work—which portrays Adorno *merely* as a ruthless critic of the culture industry—would have us believe. Crucially, it is now acknowledged that this nuance was already present in his early writings. In the 1930s, for example, Adorno suggests that in *The Gold Rush*, Charlie Chaplin, as a "ghostly photograph," makes the spectator experience what lies beyond the screen.[4] Like the best of artworks, for Adorno, Chaplin could testify for the possibility of a different reality.[5] The continuity in Adorno's thought becomes tangible in his late essay "Transparencies on Film" (1966), where he returns to this image. Adorno mentions that Chaplin's work—filmic despite its "photographic" character—is an exemplar of what an "emancipated film" could be.[6] In *Composing for the Films* (1947), a book he cowrote with the composer Hanns Eisler, they assert that there is a critical potential in film that is not limited to any specific type of film. "Technology opens up unlimited opportunities for art in the future," they write, "and even in the poorest motion pictures there are moments when such opportunities are strikingly apparent."[7]

Still, even Adorno's most positive inquiries into the medium need to be taken with caution. After all, in *Composing for the Films*, Adorno suggests that film's critical potential is a matter for art *in the future*. As late as "Transparencies on Film," he was still contending that "every commercial film is actually only the preview of that which it promises and will never deliver" (205). This line could easily be part of his critique of the culture industry from *Dialectic of Enlightenment*. Adorno insisted that film's dependency on capital and the culture industry made it part of a unified system whose main goal was to reproduce the audience as consumers, something that hindered film's aesthetic opportunities (cf., e.g., *DE*, 99, with TF, 199–200, 202). Moreover, he never stopped claiming that film's dependency on technologies of mechanical reproduction make it present an illusory semblance of reality.

3. See Hansen, "Introduction to Adorno"; and Hansen, *Cinema and Experience* (hereafter cited as *CE*).

4. Adorno, "Chaplin Times Two," 58.

5. Adorno speaks of emancipatory art as what "testifies to the possibility of the possible" in *Aesthetic Theory*, 174 (hereafter cited as *AT*).

6. Adorno, "Transparencies on Film," 200 (hereafter cited as TF).

7. Adorno and Eisler, *Composing for the Films*, lii–liii.

While it is clearly an overstatement to claim that Adorno *ontologizes* film as a mechanism which duplicates reality,[8] it is not difficult to see why for decades his comments on film's aesthetic potential flew below the radar. However, a different side of his thought on film has gained recognition.[9] Once considered an elitist, a mandarin too comfortable to leave the "grand hotel abyss" (to recall Georg Lukács's famous phrase) and pay any serious attention to mass media, Adorno is now considered a thinker whose ideas on film are relevant in areas as diverse as cultural and film studies, aesthetics, and critical social theory.[10]

Nevertheless, not all the parts of that "old" image of Adorno have been transcended. The assumption that, for Adorno, only autonomous art can be critical or emancipatory still weighs heavily on the reception of his work and on the understanding of his relation to film. This can be seen in the general strategy that is usually deployed to salvage Adorno's reflections on film. Whether by showing that his position changed, or that elements throughout his work point to a different conception of the medium, the most common assumption is that if, for Adorno, film is to acquire an emancipatory potential, it must be able to transcend its position *within* the culture industry and become an autonomous art form.[11] Similarly, if perhaps less often argued, a critical film would

8. See, e.g., Waldman, "Critical Theory and Film," 49.

9. Besides the aforementioned works by Hansen, see also Levin, "For the Record"; Wall, *Theodor Adorno and Film Theory*; Rodowick, *What Philosophy Wants from Images*, chap. 4; and Seel, "Sitting Unobserved."

10. See During, *Cultural Studies Reader*, especially During's comments for a paradigmatic reading of Adorno and Horkheimer as naive cultural elitists, and Irr and Nealon, *Rethinking the Frankfurt School*, where this position is questioned and debated. See especially chapters 2 and 3, by Douglas Kellner and Imre Szeman.

11. Andreas Huyssen, for example, reproduces the idea that Adorno, championing a total negation, "veers into an idealist aesthetic," and implies that a "genuine" work of art requires technical autonomy ("Introduction to Adorno," 6–7). Zuidervaart also argues that Adorno found no "heteronomous" art, much less that of the culture industry, socially significant, because he relied on aesthetic truth as a criterion ("Social Significance," 69–72). Habermas also reads Adorno as tied to such a dichotomy between high and low, autonomous and mass art, something that shows clearly when he claims that for Adorno "only the formalistic work of art, *inaccessible to the masses*, can withstand the forces assimilating it to the market-determined wants and attitudes of the consumer" ("Consciousness-Raising," 43). But even Alexander Kluge, who was otherwise instrumental for Adorno's reevaluation of techniques like montage, reads Adorno this way (Liebman and Kluge, "On New German Cinema," 42). Even more, at least Adorno's early cinematic projects operated under the assumption of a break between the "articulated expression" of modernism and art that responds to the taste of the masses. Art—autonomous art, that is—can no longer respond to modern society, according to Kluge (see Bray, "Openness"). An important exception is David Jennemann's *Adorno in America*, where, in Wall's words, it is argued that Adorno was "engaged finally with tracing the democratic and cultural possibilities that might emerge from a technological mass culture" (*Fingerprint*, 2). Wall himself is another important exception. While his book on Adorno and film is not concerned with the question

have to transcend its dependence on the technologies of mechanical reproduction. Both positions, therefore, buy into the idea that for art to be critical, it must be autonomous. While it is now acknowledged that Adorno's relation to film is much more complex than was once thought, the correlation between critique and autonomy is still presupposed. With this presupposition, the separations between autonomous art and the culture industry, "good" and "bad," or "critical" and "ideological" art go unproblematized. The possibility that film, *as a heteronomous medium*—dependent either on extra-aesthetic technologies or on the culture industry—can still be critical is rarely considered. Yet it is this possibility that makes Adorno's reflections on film so relevant, since it shows that his aesthetic theory concerns not merely autonomous art but also nonautonomous media.

Hansen's work—perhaps the most insightful and detailed analysis of Adorno's relationship to film to date—approaches the strategy outlined above. Hansen shows how, for Adorno, film's critical potential can be reached by finding alternative practices "under the given social and economic conditions," and thus this potential is not blocked by film's commodity character.[12] Furthermore, she indicates that the central question is whether and how film could develop its technique given its technological limitations. Adorno's main problem with film "pivots on the assumption that reproduction technology forecloses the autonomous development of cinematic technique" (*CE*, 215). Hansen's interpretation implies that, for Adorno, whether film can become a critical medium depends on whether it can transcend its reliance on extra-aesthetic technologies that, as Adorno puts it, "densely and completely . . . duplicate empirical objects" (*DE*, 99). Thus what had appeared as an irremediable block to technique becomes problematized by Adorno in "Transparencies on Film," Hansen notes. It becomes an open question whether filmmakers can counterbalance the "irreducible semblance of objectivity" inherent to film, something that points toward the possibility of a critical *and* heteronomous filmmaking.[13]

Hansen's interpretation, however, is not without its ambiguities: for example, it is not clear whether she believes that by regaining technical control film would also regain its status *as* autonomous. This is partly because she does

---

of film's autonomy or even with the question of film's status as art, his project does rely on the possibility that "there persists in some filmic commodities a truth that resists commodification and exchange value" (4).

12. Hansen, "Introduction to Adorno," 187.

13. Hansen, "Introduction to Adorno," 190.

not cast the debate in terms of film's autonomy, something that requires supplementing her account with a thorough consideration of what Adorno means by "aesthetic autonomy." Furthermore, it is not completely clear why she regards montage as a technique superior to, say, those of expressionist films such as F. W. Murnau's or Fritz Lang's, or to the naturalism of Terrence Malik or Carlos Reygadas. This points to certain gaps in her argument on the impossibility (and undesirability) of either a completely "subjective" or "objective" film. Hansen's argument moves too quickly over certain key issues to give a comprehensive picture of Adorno's understanding and critique of film.

The aim of the present article is to build on Hansen's work to gain a better understanding of what Adorno considered film's critical potential. In the first section, "Film's Dependency on Mechanical Reproduction," I argue that to best understand Adorno's criticism of film, it should be interpreted as concerned with the medium's "objective" and "subjective" limitations, that is, limitations imposed by the filmic material and by the author, respectively. For Adorno, the subject's technical manipulation of the filmic material is limited by film's representational base. Since the object cannot be detached from the empirical, Adorno argues, the aesthetic material cannot become a pure aesthetic value. Therefore the author cannot have complete control over its product. But neither can there be a purely "objective" film, in other words, a film where the apparatus acts neutrally, making it possible to capture reality as it is. This, for Adorno, is impossible, since the subjective counterpart, however weakened, always filters through the material. Adorno sees both the subject limited by the object and the object limited by the subject. His concern with film is more serious than it appears on a superficial reading, and points to the conditions that an "emancipatory" film would have to fulfill.

The following section, "Montage, Discontinuity, and the Aesthetic Fragmentation of Reality," takes up the possibility to work through this tension. In contrast to other commentators, the present article shows that Adorno's main concern was not whether film could become autonomous. If film is to become a medium for criticism and reflection, filmmakers should stop attempting to achieve autonomy and focus on what the medium can do given its limitations. To do this, he contends, film must find a way to "arrange" its material without interfering with it (TF, 203).

Key in understanding what this arrangement might mean is film's relation to "natural beauty," that element *within* nature that points toward the possibilities hidden beyond nature's surface appearance. According to Adorno, film can objectify our experience of natural beauty—as it appears in dreams

and daydreams—and, in so doing, give an aesthetic expression to what would otherwise remain inarticulate and fleeting. But to do so, rather than attempt to modify the filmic image—itself only a reproduction of reality's surface appearance—the subject must try to create a gap between the different images. This allows the artist to construct a space where the familiar can become unfamiliar and where the spectator can experience reality critically. This points to the use of techniques like discontinuity and montage, which, as Adorno argues, can break through the semblance of immediacy of reality. Through these techniques films can make the spectator conscious that another reality is still possible. Instead of pursuing autonomy, Adorno writes, film should "discard its artlike qualities." If it succeeds, film would "[remain] art in its rebellion and even [enlarge] art."[14]

Adorno's comments on film are important not only because they problematize film's aesthetic limitations but because they have implications that touch on the relation between autonomy of art and critique. They put into question the contention that underlying Adorno's work is a clear-cut separation between autonomous art and the culture industry, a contention present in the work of some of the most astute commentators.[15] Furthermore, a reassessment of Adorno's work on film shows that in aesthetics, the relation between technique and technology is not one-directional. For Adorno, film can become a critical medium while remaining dependent on extra-aesthetic technologies. His aesthetics can no longer be called "rigid" and "artificial," nor can it be claimed that Adorno has an ahistorical understanding of the culture industry. Contra commentators like Albrecht Wellmer, for example, Adorno was not a "traditionalist" whose criticism of film—as a popular art—was "[adopted] *a priori*."[16] These interpretations, given the influential reading of commentators like Jürgen Habermas, Peter Bürger, or Wellmer, have persisted even after Adorno's relation to film has been reassessed.[17] It is time to put them, finally, to rest.

### Film's Dependency on Mechanical Reproduction: Abstraction and the "Illusion of Intentionlessness"

For Adorno, art plays a critical role in exposing the social construction and the contingency of reality and, thus, in triggering processes of self-awareness and reflection. This activity is necessary, since whatever art is representing will be

14. Adorno, "Art and the Arts," 386 (hereafter cited as AA).

15. See, e.g., Habermas, "Consciousness-Raising," 43–44; Habermas, *Reason and the Rationalization of Society*, 370–71; and n. 11 above.

16. Wellmer, "Truth, Semblance, Reconciliation," 30.

17. Wellmer, "Truth, Semblance, Reconciliation," 1–2.

always already charged with meaning and therefore preshaped by the expectations created by such meanings. Film, if striving to be critical, should problematize our conventional ways of seeing to show the hidden relations behind what has become second nature in the spectator's eyes. Adorno's criticism of film depends on what he considers the medium's failure to achieve technical control and mimetic comportment, conditions that, according to his *Aesthetic Theory*, are central for this critical task.[18]

For Adorno, an artwork is successful when the technical element allows the subject to manipulate the material and wrest it from its heteronomy. That is, in forming the material, the artwork is transformed into an aesthetic element that no longer follows the meanings or laws assigned outside it. In passing through the subject, the material is liberated. Hence, in a successful artwork the subject must be capable of synthesizing the object that stands opposed to it. However, this subjective freedom has to be a freedom toward the object. In constructing the artwork, the subject should not arbitrarily impose its will but follow the demands of the material. Only by achieving this would the subject become a self, Adorno writes, and "[exit] from its imprisonment in itself" (*AT*, 356). Were the technical element in art to remain purely a means for control, art could not be distinguished from something like engineering. But most important, without this openness to otherness, the subjective freedom from its (natural) compulsion achieved through technique would turn on itself. Technical domination, as a blind mastery for its own sake, becomes a new form of compulsion. In this case, Adorno writes, the "spell that the subject casts over nature imprisons the subject as well" (*AT*, 356). A successful artwork is one where the subject uses technique to achieve a nonviolent synthesis of heterogeneous and diverse material, thus criticizing the actually existing social structures (characterized, according to Adorno, by a violent synthesis). Artworks prefigure a possible reconciliation between subject and object—between humans and nature, but also among humans themselves.

Film, according to Adorno, fails in this double imperative. This is because for Adorno, as Hansen and Thomas Y. Levin have noted, film's dependency on technologies that mechanically reproduce the empirical object do not allow the subject to gain the sufficient distance necessary to negate or criticize the structures that constitute what we perceive as "reality." Instead, the subject is forced to work with a representation of reality as it appears to the naked eye. According to Adorno, because of this, the subject cannot—through technical

---

18. For a thorough exploration of the role of "mimesis" in Adorno's writings on film, see Koch, "Mimesis and *Bilderverbot*."

manipulation—seize the material from its heteronomy, nor can the "demands" of the latter, which point toward that surplus that wants to transcend what appears, be followed. At the same time, these technologies cannot achieve the ideal of objectivity that postulates that the filmic apparatus, supposedly neutral, can capture the true essence of reality. Thus the subject's control is limited by objective components, but the object, for its part, cannot be rendered meaningful without subjective manipulation. In film, Adorno argues, subject and object push each other away, yet they also need each other to be rendered meaningful.

As in his early criticisms, Adorno's main concerns with film are related to the problem of mechanical reproduction and how this limits film's potential. In a passage from "Transparencies on Film," Adorno expresses this with clarity:

> The photographic process of film, primarily representational, places higher intrinsic significance on the object, *as foreign to subjectivity*, than aesthetically autonomous techniques; this is the retarding aspect of film in the historical process of art. Even where film dissolves and modifies its objects as much as it can, the disintegration is never complete. Consequently, *it does not permit absolute construction*. (TF, 202; my emphasis)

Here Adorno not only claims that film's representational basis is its primary limitation; he also provides a characterization of what he considers film's essence. According to him, the fact that film is based on moving photographs, that is, on the sequential display of reproductions of empirical objects, is unavoidable and irreversible. However the filmmaker tries, through technical devices, to modify or disintegrate the object, this is never complete. Hence Adorno continues to claim that aesthetic technique depends on extra-aesthetic technology. This is something that he had found problematic in his earlier writings, notably *Dialectic of Enlightenment* and *Minima Moralia*. The problem there was that film's technology blocked it from fulfilling one of the central imperatives of critical art, an imperative that what he calls "autonomous" art did fulfill. Contrary to autonomous art, Adorno wrote, the technique of film "remains external to its object."[19] This is why film could not create the awareness of the social contradictions necessary to trigger a critical thought process.

Films, as the outcome of mechanical reproduction, cannot express the contradictions that permeate society and therefore cannot achieve the mediation that Arnold Schoenberg's *Erwartung* (or Samuel Beckett's *Endgame*,

19. Adorno, "Culture Industry Reconsidered," 14.

Pablo Picasso's *Guernica*, Franz Kafka's *The Trial*, to name a few works of art from other mediums) achieved. In the writings where Adorno collapses all film under the tag "culture industry," this argument depends on the fact that "it lives parasitically from the extra-artistic technique of the material production of goods, without regard for the obligation to the internal artistic whole implied by its functionality [*Sachlichkeit*], but also without concern for the laws of form demanded by aesthetic autonomy."[20] In "Transparencies on Film," instead of mellowing the critique, he seems to strengthen it: if film was limited, according to his earlier argument, by socioeconomic pressures (in the early works he concedes that the potential of technique is "shielded" by the industry), now the limitations are considered internal to the medium.[21] Adorno speaks of the technological base of film itself as what blocks the artistic techniques—the means through which the artist manipulates and transforms its object. At face value, it appears that for Adorno, given film's dependency on an object foreign to subjectivity, it loses its power to negate (and thus criticize) reality. Given that mechanical reproduction blocks the development of an autonomous technique, film seems to lose the possibility to have "conscious free control over the aesthetic means" (TF, 202).

In linking film's technical limitations to its technology rather than to external economic pressures, this argument would seem to reinforce Adorno's opposition to film. Yet it actually leads him to reassess the medium's critical possibilities. Given the unavoidability of film's heteronomy, in "Transparencies on Film" Adorno engages with the possibility of this limitation becoming something productive. Instead of pursuing autonomy, artists should problematize film's limitations, playing with the degree of freedom that film still affords them. Given that film is so deeply related to the appearance of the object, that is, to the phenomenal surface of empirical reality, can film still problematize such reality? Can it expose the underlying relations that structure how we perceive it? Isn't it the case that only autonomous art can do this? And what about technique? Can a medium in which technique cannot develop freely synthesize its material and produce a coherent piece?

To answer these questions, Adorno considers two ways in which film could gain an "aesthetic" character: "abstract-subjective" or "formalist" solutions and "realist" or "naturalist" solutions. *Abstract-subjective* here refers to

20. Adorno, "Culture Industry Reconsidered," 14.
21. Adorno writes: "The culture industry finds ideological support precisely insofar as it carefully shields itself from the full potential of the techniques contained in its products" ("Culture Industry Reconsidered," 14).

an abstract negation of the dependency on the object (through, e.g., formalism). Conversely, *realism* or *naturalism* refers to the attempt to negate subjective intention. Both of these fail, however, since instead of dealing with the tension between film's subjective and objective components, they each negate one of the two poles.

### "Autonomous" Film or Abstract Subjectivity?

If film wants to move past its dependency on external pressures and become a critical medium, could not one solution be to shape the material through complete technical mastery (i.e., through an "absolute construction") and thus become autonomous? This would require breaking from the dependency on the image, since this is one aspect that makes film heteronomous. Might not formalism and a negation of the mechanically reproduced image achieve this? Can filmmakers emulate the techniques of abstract or formalist art—which have proved successful in other media like music or painting? For those who see a necessary connection between autonomy and critique in Adorno's aesthetic theory, this would seem the only way out. However, Adorno argues that this is both impossible and undesirable. Yet he contends that film can become a medium for critique.

For Adorno, it is impossible for film to become autonomous, since the photographic process—which makes it dependent on empirical reality—is an essential characteristic of the medium, and thus *as film* it is always limited by something foreign to subjectivity. The photographic process on which film is based "places a higher intrinsic significance on the object, as foreign to subjectivity, than aesthetically autonomous techniques." Film, therefore, "does not permit absolute construction" (TF, 202).

But what does the notion of "absolute construction" mean? Hansen links it to the modernist rejection of representation and organicism and points to a tension with film's medium-specificity, but it is never made clear what exactly Adorno means (see *CE*, 210, 217). To understand the concept, we need to put it in the context of Adorno's discussion of the tension between expression and imitation. According to Adorno, the aesthetic subject can turn critically against reality only if it can express what lies inside itself, something achieved through the technical manipulation of the aesthetic material (*AT*, 152). In this way, the material is wrested from its heteronomy. Yet Adorno contends that this must be achieved without abstractly negating what stands outside the subject. Rather, it is "the full experience of external life returning inwardly" that succeeds in "[negating] what is opaque" (*AT*, 152). The moment of mimesis or imitation

is not to be "repressed" but "maintained in the objectivation of the tension between itself and its antithesis" (*AT*, 153).

"Absolute construction" refers to this autonomous shaping of the material through technical manipulation, whereby the empirical object is not negated but sublimated, transformed, and thus becomes an aesthetic object. For Adorno, as Owen Hulatt explains, "heteronomous contents are not present to the artistic process of formation as heteronomous contents, but rather are reduced to formal, aesthetic properties."[22] It is this process of transformation that is achieved through absolute construction. This does not mean, however, that Adorno believes autonomous art can (or should) completely detach itself from the empirical, whereas film cannot do so. The mimetic or imitative element in art should be preserved, since otherwise technique becomes blind domination, emptying the composer's expression of its subjectivity. As Max Paddison comments, according to Adorno, "the total domination of material is at the same time the self-domination of the expressive subject. . . . [This] results in the subject's loss of freedom."[23] This is why, for Adorno, the task of the subject entails "displacing, dissolving, and reconstructing" the elements of empirical reality, making them aesthetic objects while following "the work's *own* law" (*AT*, 335; my emphasis). The problem with film, then, is not the impossibility to completely dominate the object through technique but that heteronomous contents *always* appear as heteronomous contents. As Adorno writes, in film "the disintegration [of the object] is never complete" (TF, 202).

But even if such a disintegration could be achieved, the constructive or formal break from the object would not amount to solving the aesthetic tension within film. This is because—contrary to other art forms like poetry, music, even painting—film has a representational basis that makes it lag behind other art forms and precludes the use of solutions from other media (see, e.g., AA, 382). To achieve pure absolute construction would be undesirable, since it would amount to an abstract negation of its material, which is photographically based. Therefore, as Hansen notes, rather than achieving absolute construction in film, Adorno contends that the medium must find ways to navigate *between* modernist norms—including absolute construction—and the medium specificity of film (*CE*, 217). A turn toward formalism or abstraction negates the dependency on the mechanically reproduced image, which constitutes the medium. Moreover, filmmakers who turn toward abstraction or formalism cannot explore film's medium-specific potential. This potential, as Hansen claims,

22. Hulatt, "Critique through Autonomy," 174.
23. Paddison, *Adorno's Aesthetics of Music*, 267.

is related to film's ability to convey sensual immediacy (*CE*, 210), but more important, it regards the affinity between the aesthetic and the social subject. If the former is powerless vis-à-vis extra-aesthetic technologies, then so is the latter powerless vis-à-vis an alienating social totality.

Given that in modernity subjects (and this includes the artists) are not independent or autonomous, they should try, Adorno writes, to "speak through things, through their alienated and mutilated form," instead of seeking absolute construction (*AT*, 154). Only by starting from what is outside can the modern subject gain some degree of autonomy, and this is something that film, given its situation, could project to the spectator. Absolute construction—a complete turn toward form, toward a rational organization that disavows the object— must fail, since instead of doing so, it merely eliminates one of the poles of tension. Without an external object, film would have nothing to organize in the first place. For Adorno, in the pursuit of autonomy, film that turns toward abstraction or nonrepresentation, instead of solving the problem, merely turns away from it.

Instead of negating its object, Adorno writes in *Aesthetic Theory*, the subject must give it a voice through reflection—in other words, through formal procedures. But Adorno makes it clear that reflection in this case does not mean the pregiven, formalism of abstract art: "The supposedly pure form that disavows expression rattles mechanically" (*AT*, 149). Form, Adorno contends, must not be imposed from the outside, as a preconceived idea that shapes the material arbitrarily. Instead, the subject should follow the leads given by the material, shaping it technically along the way. This is where the technical element allows reason to enter the artwork not as the violent (because arbitrary, dominating) synthesis of the material but as mimesis. Where "order is derived from the need for order and not from the truth of the matter," Adorno writes in one of his essays on postserial music, the subject ends up disavowing the expressive and mimetic moment of rationality, turning aesthetic technique into the arbitrary domination of the object.[24] The attempt to gain autonomy from the object—in the case of film, by breaking with representation and mechanical reproduction—turns into a pure formalism that locks up the subject in its own rational system.

"Abstract" or "formalist" film here refers neither to a specific aesthetic movement in film nor to any school. Rather, the reference is to those works that attempt to break with the dependency on reality through the formal control and dissolution of the photographic representation. Those films attempt to convey

24. Adorno, "Vers une musique informelle," 275.

something symbolic, allegorical, something about the interiority of the subject rather than about the object, or try—in their effort to become "artistic"—to "sound" novelistic, to "look" like paintings. But this, Adorno argues, amounts to film's self-deception. One example is the expressionist film *The Cabinet of Dr. Caligari* (1920), where the highly stylized sets, or the shadows of the characters that try to emulate a painting, appear as the attempt to break from film's "semblance of immediacy." The film is so thoroughly designed and arranged in advance because it tries to achieve a turn from the outside (the object) toward the subject. But while its noncinematic characteristics might be of value, as a film *Dr. Caligari* would fail, since it would not succeed in negating its dependency on the empirical. A more extreme example can be found in experimental films like Hans Richter's *Rhythmus 21* (1921), where black, gray, and white squares move rhythmically—and where film is used as "painting in motion" or, in Siegfried Kracauer's words, to bring drawings to life.[25]

Films like Richter's, or Luis Buñuel and Salvador Dalí's *Un chien andalou* (1929), attempt to break away from representation through a turn toward pure form. In so doing, however, film's specific potential—the recognition of the dependency on the object—is also lost. As Adorno mentions in his lectures on aesthetics, "The concept of construction in art really becomes meaningless when there is nothing left to construct."[26] Given that, for Adorno, film is inherently connected to the empirical, by (falsely) negating this and aspiring to the completely abstract—by fetishizing technique, through a seamless set design, through recourse to novelistic dialogues, for example—the filmmaker's critical intentions threaten to turn into society's affirmation: the illusion of subjective control would hide its dependency on society's structures, giving the illusion that the subject is already liberated. Crucially, film's dependency on something foreign to the subject gives aesthetic representation to a real situation—one where the social structures push the subject into a state of powerlessness. Instead of trying to break from that dependency, then, film might do better if it finds a way to articulate this predicament, rendering the situation visible, and thus show that there is still a way for the subject to recover some critical distance and autonomy.

For Adorno, if film is to do this *and* remain heteronomous, it must make transparent the entwinement between a subject that tries to liberate itself and its object on which it nevertheless remains dependent. Film should also show the contingency of these constraints and thus that social conditions are historical

---

25. Kracauer, *Theory of Film*, 177.
26. Adorno, *Aesthetics*, 81.

and can be changed. An "emancipatory" film, that is, should acknowledge the subject's powerlessness yet, by showing that what appears immediate is actually mediated, recover some of its autonomy. This implies that, for Adorno, art could be critical and emancipatory *even while remaining nonautonomous*.

Nevertheless, this seems to require the type of technical control that, apparently, is negated by mechanical reproduction. This is because only through the technical mastery of its material can the artist turn instrumental rationality into the nonviolent synthesis of its material—and thus show that rationality (in this case, the instrumental rationality that constitutes our current social reality) could become something more than a tool to dominate and control the other. In this way an artwork could pair a critical and a utopian stance. But for film, at face value, this seems unachievable. At least from Adorno's perspective, to demand technical control would seem to require a type of subjective freedom that, as seen, is blocked. However, film can achieve *some* subjective synthesis. To explain how this is possible, it is necessary to assess Adorno's criticism of another "false" solution to film's dependency on the extra-aesthetic object—the attempt to produce an "objective" film through the absolute subtraction of the subject. This "solution" must fail, since technical manipulation (performed by the subject), as Adorno argues, is *also* irreducible and "inevitably feeds elements of meaning into the final product" (AA, 386).

*The Illusion of Intentionlessness*

If mechanical reproduction places intrinsic limitations on the technical and formal control of the material, could not a solution be to embrace film's inherent relation to empirical reality and to use film as a way to capture reality "objectively"? If film, by virtue of its technology, can really capture reality *as it is*, perhaps the subject should not intervene at all—through stylization, construction—with the images. Should film, therefore, get rid of technique and construction altogether? Can film really capture reality unfiltered, unmediated, and thus salvage the "extra-aesthetic world of things" (AA, 386)?

André Bazin, one of the most influential film theoreticians of the twentieth century, has usually been read as someone who would support similar conclusions. Like Adorno, Bazin sees as an essential characteristic of film the inherent relation between it and reality. Yet, unlike Adorno, Bazin contends that there is actually a strong ontological connection between the filmic image and its object. In similar terms to how Adorno describes Kracauer's theory of film, Bazin finds that through the "intention-free immersion of the camera," film could capture reality "in its raw state prior to all subjectivity" (AA, 386).

This is why Bazin reads positively a type of filmmaking that attempts to capture reality without intervention.[27] Adorno, for his part, finds this type of filmmaking suspicious and problematic. Without the subjective moment of aesthetic construction, he argues, the possibility to unearth the object's hidden relations vanishes—and with it, the possibility to produce a critical work. If the objective world is marked by (ethical and epistemic) falseness, only by passing through the subject will the phenomenal surface of society be penetrated and "reality's" ideological core exposed.

Bazin's theory, like Adorno's, starts from the assumption that what characterizes film is its reproductive or representational capacities, derived from the mechanical recording of reality. On the most basic level, for both, regardless of how distorted, modified, or fuzzy a film photography is, it will still be a reproduction of an empirical object. This perspective is also shared by theoreticians like Kendall Walton, for whom a photograph is "transparent," meaning that "we [can] see their objects through them."[28] Because of this assumption, Bazin has usually been read as someone who believes that there is an indexical relation between object and image, the latter being a representation of the former.[29] However, as commentators like Daniel Morgan have shown, for Bazin, this connection between image and object is actually stronger, the two being "identical" or "equivalent."[30] There is evidence in Bazin's work to support that claim, as when he writes, for instance, that the filmic image shares "by virtue of the very process of its becoming, the being of the model of which it is the reproduction." Indeed, Bazin claims that the "photographic image is the object itself, the object freed from the conditions of time and space that govern it."[31] According to this view, the relation of identity between image and object depends on the reproductive process of film and not on the mediating agent. "For the first time an image of the world is formed automatically, without the creative intervention of man," he writes.[32] While the artist can choose which

27. As with Adorno's work, research on Bazin has now problematized this position. However, while those reassessments make it possible to understand differently Bazin's "realism," they do not modify the core of his analysis. Furthermore, my intention here is to use Bazin to present and clarify Adorno's position on realism. For a more detailed account, see Morgan, "Rethinking Bazin"; and Morgan, "Bazin's Modernism." I thank the second reviewer of the present article for pointing me toward Morgan's work.

28. Thomson-Jones, *Aesthetics and Film*, 17.

29. See Morgan, "Rethinking Bazin," 448.

30. Morgan, "Rethinking Bazin," 449.

31. Bazin, quoted in Thomson-Jones, *Aesthetics and Film*, 22.

32. Bazin, "Ontology of the Photographic Image," 13.

object to photograph, he or she cannot intervene in the creation of the image, which is formed immediately.

This position has broad implications for Bazin's theory of film and calls for a reinterpretation of assumptions that depend on an "indexical" realism. For Bazin, it is this ontological relation that allows film to have a "critical" or "revelatory" function, insofar as the medium can present the object in its whole being or essence. "Only the impassive lens, stripping its object of all those ways of seeing it, those piled-up preconceptions, that spiritual dust and grime with which my eyes have covered it, is able to present it in all its virginal purity to my attention and consequently to my love."[33] The "impassive lens," as Bazin calls it, can reveal the true nature of reality to the spectator by stripping it away from all prejudice, from the habitual ways of seeing it. By extracting the object from the temporal contingencies that usually surround it, film shows another aspect of the object: it now appears, as Morgan puts it, as something "real but outside (historical) time altogether." In so doing, Bazin contends, film cleanses the object from its "embeddedness in ordinary perception" and exposes reality without prejudices.[34]

Given the above, Bazin is neither a direct realist—advocating that film should preserve the appearance of the world as accurately as it can—nor a perceptual realist, advocating that film should replicate our experience of reality.[35] Rather, his ontology of film implies that the "reality" of the object transcends its appearance and escapes our ordinary perception of it. According to him, reality's "being" or "essence" must first be stripped away from the (social and historical) contingencies that permeate our everyday perception for it to be properly experienced. Film's relevance lies in the potential to unearth this reality, something that the camera could achieve if left to its own devices. This is why Bazin defends films where the author's intentions and where technical manipulation were avoided.[36] Italian neorealism, for example, approached this ideal of allowing reality, through the immediacy of the apparatus, to

---

33. Bazin, "Ontology of the Photographic Image," 15.

34. Morgan, "Rethinking Bazin," 452.

35. For example, Thomson-Jones reads him closer to the first position when she claims that for Bazin, the "natural purpose [of film] is to re-present reality in an 'objective' and thus insightful way" (*Aesthetics and Film*, 18). Carroll, for his part, approaches the perceptual realist reading (*Engaging the Moving Image*, esp. 253).

36. This is not to say that he *only* defended this style or that he did not come to appreciate the relevance of more experimental or modernist films. However, when praising Chris Marker's use of montage in *Letter from Siberia* (1957) or Jacques Tati's *M. Hulot's Holiday* (1953), for instance, he does this because of the way they capture "conceptual" and nonphysical objects like "intelligence" or "time." See Morgan, "Bazin's Modernism," 13–14.

emerge in its true nature.[37] The same could be said of Orson Welles, Jean Renoir, Vittorio de Sica, or Roberto Rossellini, with their use of long, uninterrupted shots, which feature prominently in Bazin's writings.

In "Art and the Arts," Adorno characterizes film in a way that seems similar to Bazin's own understanding. A closer reading, however, reveals the central differences between them. There Adorno writes that film "comes closest to its own essence where it ruthlessly eliminates the attribute of aura . . . that illusion of transcendence" (AA, 386). Film is at its most "filmic" or "cinematic" when it renounces those symbolic and other elements that confer meaning—allegorically, metaphorically, through external suggestion—that poetry, literature, painting, and music require to construct meaning. What makes film *film* is its capacity to present its object without that feeling of distance that is present in other art forms. This is why Adorno would not have found the experiments of Richter or the surrealist films of Buñuel successful. Arguably, Bazin would also reject those experiments as distancing themselves from the essence of film and thus as noncinematic. Like Bazin, Adorno believes that we must not confuse the object as it appears to our everyday perception with the true nature of the object.

Nevertheless, despite their shared presuppositions, Adorno and Bazin derive completely opposite conclusions. While Adorno contends that the photographic image copies the "empirical object," this should be taken to mean that it copies the phenomenal surface but not the "object itself." Thus nothing like Bazin's ontologizing claims can be found in Adorno. While both criticize technical manipulation, Adorno does so only insofar as it is used to negate film's necessary reproduction of empirical reality. For him, it is just as problematic to claim that mechanical reproduction, if left to itself, can tell us anything meaningful about reality—what happens is the complete opposite. Mechanical reproduction, when left to itself, merely reinforces the confusion between essence and appearance. From Adorno's perspective, therefore, a filmic realism that attempts to "transcend the illusion of transcendence" by refusing technical intervention ends up naturalizing the presently existing context of experience—thus reinforcing another illusion, that of a total immanence. Realist or naturalist films that attempt to reproduce the essence of reality are only "simulating a continuity between screen and everyday life," as Hansen puts it. These films "[pretend] to surface a coherence of social reality and human activity" and reproduce the status quo by making history appear as second nature.[38]

---

37. Even Morgan's more nuanced account points to this reading. For Bazin, writes Morgan, the artists should "[respect] the reality of objects in the image." Morgan continues: "Bazin describes this achievement as the refusal to impose a viewpoint on reality" ("Rethinking Bazin," 463).

38. Hansen, "Alexander Kluge," 170.

Adorno's position is thus closer to that of the filmmaker and theoretician Alexander Kluge—a student and friend of Adorno, and a big influence on the development of the latter's ideas on film—who is aware that what is depicted in film is not reality but the filmmaker's relation to it. "There is no direct depiction," Kluge writes.[39] According to Kluge, in line with Adorno, film creates a reproduction from which the author cannot detach "subjectively and arbitrarily." Nevertheless, Kluge contends, for film to be true to reality, the author's viewpoint is indispensable: "This copying doesn't occur in a direct and mechanical fashion, however; what the camera records isn't yet a copy. Something like a setup for the experiment is needed in the first place."[40]

Arguably, it would be an oversimplification to associate Bazin with what Kluge, in defense of his own "relational" realism, calls the pursuit for an "exactitude in the representation," that is, a type of realism that confuses what our senses can grasp with what is real.[41] However, the core of the criticism holds even against a nonindexical reading of Bazin, since his theory still reinforces the association between what is "real" and what is unmediated, outside its temporal relations and historical context. In Bazin's ontology the object's true reality is presented as static and unchanging, its own origins in human labor "spirited away," as Adorno would put it.[42] This blocks individuals from the awareness that, because they are a historical construct, it is possible to change the conditions and structures that cause suffering and alienation. Adorno's critique shows that Bazin's theory remains problematic (at least from the perspective of a critical theory of society), since it supports a type of filmmaking that affirms rather than criticizes the "real." Instead, to truly criticize and demystify reality, film has to be able to expose it as something produced, historical, transient.

A contemporary example of "realist" or "naturalist" filmmaking can be found in the work of the Mexican filmmaker Carlos Reygadas, in *Batalla en el cielo* (*Battle in Heaven*, 2005) or *Stellet Licht* (*Luz silenciosa / Silent Light*, 2007). Satisfying Bazin's claims that film can free the object from the conditions of time and place, Reygadas set *Stellet Licht* within a Mennonite community, which for him represented something "timeless and placeless." Reygadas's intention was to "produce an otherworldliness that removes the story from ideological inscriptions of time and place."[43] Just like in neorealism, he

39. Kluge and Eder, "Debate on the Documentary Film," 199.
40. Kluge and Eder, "Debate on the Documentary Film," 198.
41. Kluge, "Political as Intensity of Everyday Feelings," 284.
42. Adorno, *In Search of Wagner*, 90.
43. Penn, "Time-Image," 1160.

also used a nonprofessional cast, claiming that "his mode of working requires that his cast 'be rather than perform.'"[44] This attempt to depict nature as something "static," as the opposite of civilization, and trying to do so through the objective capturing of nature through the camera lens, would be rather dubious for Adorno. For him, every object—from the most "natural" to the most "artificial"—carries with it a historical process that is not transparent, not present in its appearance. This is why, to really grasp an object (and thus to be able to criticize it), such a process (which is nothing but the history and the set of relations that have constructed both the object and the way we experience it) must be brought to consciousness.[45] For Adorno, therefore, artworks must be devoted not to the "imitation of something real but rather [to] the anticipation of a being in-itself that does not yet exist" (*AT*, 100). Works like Reygadas's are trying to capture the beauty of nature and present it as the other side to a false society, but in doing so a historically constructed notion of nature is presented as a given. Ironically, in the attempt to cleanse the spectator from its prejudices, Reygadas reproduces a reified understanding of reality and reinforces an artificial separation between history and nature. Hence the critical intention turns into society's affirmation.

Classic examples of filmic realism or naturalism can be found in Rossellini's *Germany, Year Zero* (1948) or De Sica's *Bicycle Thieves* (1948). In the latter, Bazin argues, De Sica renounces authorship and, detaching himself from a subjective viewpoint, enables the audience to grasp the objectivity of the situation represented. "The *mise en scène* [in De Sica's films] seems to take shape after the fashion of a natural form in living matter," Bazin writes in *De Sica: Metteur en scène*.[46] Both Rossellini's and De Sica's films, he further contends, are "[stripped] away of all expressionism" and exemplify "the total absence of the effects of montage." Bazin concludes that neorealism can "give back to the cinema a sense of the ambiguity of reality."[47] But for Adorno, what would be missing in those claims is the awareness that the refusal of stylization is itself a stylistic principle: the rejection of subjective intention is impossible, since this itself is a conscious choice that brings intention back. According to Adorno, "For all its abstinence from aura and subjective intention, film technique inevitably feeds elements of meaning into the final prod-

44. Penn, "Time-Image," 1161. See also Reygadas and Higgins, "I Am the Only Normal Director." There Reygadas makes the claim that "authentic cinema 'doesn't mean anything' but rather, similarly to music, 'conveys feeling.'"

45. See, e.g., Adorno, *History and Freedom*, 135.

46. Bazin, quoted in Matthews, "Divining the Real."

47. Bazin, *What Is Cinema?*, 37.

uct" (AA, 386). As technical principles, the methods used to present the mate-
rial in its nakedness "inevitably preform it in the process" (AA, 386). Or as he
writes in "Transparencies on Film," "By choosing objects presumably cleansed
of subjective meaning, these films infuse the object with exactly that meaning
which they are trying to resist" (TF, 202). Despite their claim that reality is
presented "as it really is," what "realistic" or "naturalistic" films end up doing
is reproducing the mediated as if it were immediate. Hence the attempt to
cleanse film of subjective elements merely reproduces the mistakes of the
abstract rejection of the object and reinforces our reified perception of material
reality, rather than exposing it as the product of the instrumentalization of rea-
son and the commodification of social relations. In this blind pursuit of objec-
tivity, Adorno concludes, film "traverses the freedom of the subject" and aban-
dons itself "to thing-like alienated contingency" (*AT*, 327).

The mistake of realism and naturalism lies in confusing film's irreducible
relation to empirical reality with the possibility to apprehend it immediately.
But as Brian O'Connor aptly puts it, for Adorno, "experience is not mere
awareness: it is understanding."[48] Bazin could therefore be accused of wanting
to find coherence by forgoing the subject, as if the latter's conscious decisions
would interrupt the meaningful flow emerging from the thing itself. If there is
any meaning emerging from the object, however, this is a historically and
socially constructed one. Given that these connotations are affirmed as natural
for the sake of preserving the social order, and given that the camera, in repro-
ducing them, tends to reaffirm this illusion, the subject would have to make the
most out of its limited capacities—not (trying to) forgo them completely. As
Adorno writes in *Aesthetic Theory*, "That consciousness kills is a nursery
tale; only false consciousness is fatal" (280). For Adorno, the illusion of inten-
tionlessness is a product of false consciousness.

### Montage, Discontinuity, and the Aesthetic Fragmentation of Reality
Adorno rejects abstract and realist solutions to film's heteronomy, which move
too far toward the subjective or objective poles, uncritically negating film's lim-
itations. Film, he contends, should not try to negate its representational charac-
ter, since this is actually one of its defining characteristics. But this should not
lead to the conclusion that to "redeem physical reality," it is necessary to
renounce subjective stylization. Just as it is not possible for film to break from
its dependency on the extra-aesthetic object, neither is it possible to renounce
subjectivity. Adorno's critique thus seems to lead to a cul-de-sac. The object, as

48. O'Connor, *Adorno's Negative Dialectic*, 48–49.

foreign to subjectivity, limits the technical and formal capacities of the subject: because of the technological process of mechanical reproduction, something uncontrollable by the artist inevitably jolts into the filmic image. However, the subject limits the "objectivity" that mechanical reproduction could achieve. Because even the refusal to interpret or to stylize the film are subjective decisions, some degree of subjective manipulation is unavoidable. What type of film, then, can achieve Adorno's imperatives for the creation of a critical and emancipatory artwork?

## *Natural Beauty and the Redemption of Nature*

In "Transparencies on Film" Adorno argues that film's artistic character lies neither in the (technological) possibility of reproducing reality nor in the possibility of capturing the object. Instead, film should be based "on a subjective mode of experience," which it resembles. For example:

> A person who, after a year in the city, spends a few weeks in the mountains abstaining from all work, may unexpectedly experience colorful images of landscapes consolingly coming over him or her in dreams or daydreams. These images do not merge into one another in a continuous flow, but are rather set off against each other in the course of their appearance, much like the magic lantern slides of our childhood. (TF, 201)

Given that Adorno does not define the type of experience he is talking about, it is hard to give a clear account of what exactly this mode of experience means. Yet there are important elements that point toward an answer: the contrast he presents between the city and the mountains, the reference to dreams and daydreams, the discontinuity of the images. However, the key to understanding the full implications of this passage is found a few lines below, where Adorno refers to the category of natural beauty. This subjective experience, Adorno writes, "may be to film what the visible world is to painting or the acoustic world to music. As the objectifying recreation of this type of experience, film may become art. The technological medium *par excellence* is thus intimately related to the beauty of nature" (TF, 201).

As Hansen reads it, this implies that for Adorno, film's relevance lies in its capacity to hold true to nature's appearance while "[conveying] the presence of the apparatus" (*CE*, 231). For Hansen, then, what film can do is show that nature and technology are not to be understood separately, thus avoiding a romanticizing (and regressive) appeal to "nature" as well as a (just as regressive) negation of technology. As she writes, "[The] path to nature, seen as the

mute record of the stigmata of history, leads *through* technology, aesthetically instantiated by cinematic technique" (*CE*, 231). This element is central, but according to Adorno, film's relation to natural beauty goes well beyond it. Film is connected to natural beauty not only because it can expose the ideology behind certain appeals to nature but because it can allow us to experience what he calls "natural beauty."

In Adorno's work the concept of natural beauty refers to those elements *within* nature that point beyond its current unreconciled state and, therefore, should not be confused with an understanding of "nature" as the "vulgar antithesis" to technology, as Hansen points out (*CE*, 230). The experience of natural beauty, according to Adorno, transcends the experience of nature's phenomenal surface. "Natural beauty is the trace of the nonidentical in things under the spell of universal identity," he writes (*AT*, 95). Natural beauty is, for Adorno, the cipher of the nonidentical, of what transcends the given, and thus acts in his work as a category that signifies the potential to transcend our current state of alienation. If film reproduces the type of experience that characterizes our encounter with the beauty of nature, Adorno seems to imply, this would mean that, despite its heteronomy, film *can* have an emancipatory moment.

The category of natural beauty also implies the possibility of achieving a reciprocal receptivity between subject and object, that is, a moment where the subject opens itself up toward the object. Adorno's concept of natural beauty points to that "something" in the object itself that extends beyond its mere appearance and that compels us to see it as more than an object of science or exploitation. Hence Adorno describes natural beauty as that *within* nature, which is not human yet seems to express itself, pulling the subject toward it, allowing consciousness to "[immerse] itself lovingly" in its other (*AT*, 92). Thus, in the moment of natural beauty, subject and object interact: were there nothing more in nature than its appearance, we could not conjure up this moment of surplus, not in our experience of it or in its artistic depictions. But because we need to transcend the phenomenal surface of society or nature to "see" its beauty, that same object needs to go through the subject; it has to be rendered meaningful through its technical (yet nonviolent) manipulation. Without subjective mediation, the nonidentical in nature would not be experienceable.

The images of which Adorno speaks in the aforementioned passage, therefore, are not images of nature as it appears to the naked eye—or as it could be immediately captured with the camera. Neither are these images simply fragments of our imagination. Rather, these two must be understood together. Otherwise, Hansen's descriptions of the modality of imagination—

where images appear displaced from time and space, ephemeral and elusive—
would seem to counter Adorno's criticisms of Bazin and his demand to expose
the historical and social relations that lie behind what he perceives as real (*CE*,
223). Thus the critical thrust of imagination cannot be clearly spelled out with-
out reference to the category of natural beauty.

## Discontinuity and Montage

What remains unclear is how can film objectify this experiential content. Ador-
no's text provides two keys to comprehend this: first, he refers to the distinction
between continuity and discontinuity. "These images do not merge into one
another in a continuous flow, but are rather set off against each other in the
course of their appearance, much like the magic lantern slides of our child-
hood" (TF, 201). Second, he refers to montage as a technique that "does not
interfere with things but rather arranges them in a constellation akin to that of
writing" (TF, 203). Adorno thus points toward the possibility of reproducing
the experience of natural beauty and thus of criticizing the existent reality and
disclosing its hidden possibilities by creating a gap, *not* within the filmic
images, but between them. Here the relation between his work and that of
Kluge becomes visible once again.

In line with Adorno, Kluge argues that a true realism requires "the
knowledge of relationships."[49] Because of this, film must provide a way to
show what lies hidden between the shots, something achieved through mon-
tage. Adorno, for his part, argues that instead of manipulating the photo-
graphic image itself, the subject must introduce difference and discontinuity
in the space *between* the images. What Adorno suggests is to set the images
off against each other, much like the way the images of our imagination appear
in a discontinuous flow. In this way, filmic images do not mimic our reified,
everyday perception but an "internal monologue" where the sensual percep-
tions are already rearranged by our imagination. The contrast between two
shots would become the trope for what cannot be recorded—for the underlying
relations that constitute our experience—just as the contrast between those
images that appear in daydreams (those afterimages of nature) and our daily
experience interrupts the continuity of a perception numbed by the commodi-
fication and standardization of our daily life.[50]

To understand the difference, we could contrast the way "nature" is por-
trayed in Reygadas's *Stellet Licht* and the way it appears in Michelangelo Anto-

49. Kluge, "On Film and the Public Sphere," 46.
50. Cf. Kluge, "On Film and the Public Sphere," 46.

nioni's *L'eclisse* (1962)—the third part of the "alienation" trilogy that also includes *L'avventura* (1960) and *La notte* (1961). The last scene of Reygadas's film is paradigmatic of what Adorno would find an ideological representation of nature. There the spectator is presented with a five-minute scene of the sun setting behind a pair of leafless trees. As the sun sets in a time-lapse, the camera, almost imperceptibly, zooms in, while the image on the screen goes dark.[51] This is a classic example of nature presented as the idyllic other of a corrupt civilization—or as Hansen argues, "As mere contrast to the sphere of labor and exchange, the experience of immediacy promised by natural beauty becomes part of what it opposes" (*CE*, 230). For Adorno, the contrast between the purity and static character of nature and the historical dimension is merely reproducing an affirmative and passive stance toward our social reality. Wherever art shows nature, but not its wounds (wounds inflicted by humanity), it lies, since it covers up the damage human history has inflicted through centuries of domination and exploitation. As Adorno writes in *Aesthetic Theory*, "Consciousness does justice to the experience of nature only when, like impressionist art, it incorporates nature's wounds" (89).

Antonioni, for his part, seems aware that in a world where nature has been completely dominated, and where even the images of pristine nature are ideologically charged when presented as a contrast to industry and modern society, and even to reason, the "promise" of reconciliation that lies in its beauty can only be experienced as something blocked.[52] Rather than portray scenes of "nature," Antonioni captures what Adorno calls the "emptiness of time" by choosing as his setting Rome's stock exchange and a housing development described as "a tract of arid modernist buildings begun by the fascists and set within mostly empty lots." As a reviewer writes, "Antonioni finds at these locations remarkable settings for the film's vision of a modern wasteland."[53] The love triangle passes to a second plane vis-à-vis the images of Rome, which convey the existential dread and the weight of the (social) world over the individuals, thus criticizing the ideology of nature affirmed in movies like Reygadas's.

The most representative moment comes in the final sequence, where the characters disappear and a seven-minute-long montage presents many of the images and settings of the urban landscape as fragmented, turning the everyday into something alien. What we experience there is the absence of the main

51. Bradshaw, "Silent Light."
52. See Flodin, "Adorno and Schelling," 187.
53. Sharrett, "*L'eclisse.*"

characters: through this final montage, Antonioni conveys to the spectator the dread of "objects and spaces overtaking and supplanting people," as another commentator would write.[54] Contrary to a naive filmic realism, Antonioni does not attempt to give expression to the possibility of reconciliation that lies in nature directly, immediately. According to Adorno, if any such promise can still be shown, this must happen negatively, that is, by showing—through certain techniques (notably montage)—the human construction of our concept of nature, and thus that nature, as it stands, is not beautiful, not (yet) reconciled. Antonioni's *L'eclisse* achieves this when he presents us with time as we *experience* it in modernity, rather than as we *perceive* it—fragmented, alienating, rather than continuous—thus allowing us to gain a critical distance from the latter. This, not the affirmation of reality as it is, better presents the spectator with the potential to overcome alienation.

### *Conclusion*

Adorno described his own way of thinking as a "constellatory" process, where reality is not taken as immediately given but, in Susan Buck-Morss's words, the subject "actively [arranges] its elements, bringing them into various relationships until they [crystallize] in a way which [makes] their truth cognitively accessible."[55] As a procedure that "abides strictly to the material" instead of trying to control it, Adorno writes, as if prescribing a method for filmmaking, constellatory thought "reaches beyond them only in the smallest aspects of their arrangement."[56] This procedure, if successful, was to enter into the logic of the object by stepping into it, enabling its cognitive understanding through a rearrangement—not of the object itself, but of its position among other objects and the subject itself.

Montage, for its part, Adorno writes, does not interfere with images but "arranges them in a constellation" (TF, 203). Similarly, with concepts, the filmic images *by themselves* cannot prefigure what does not yet exist. By arranging them in constellations, however, the socially constructed meaning of those images, already embedded in our consciousness, can be opened up to questioning—as if fragmenting the seamless surface of reality. In so doing, film reproduces the temporality of the imagination—which contrasts that of a reified society. But while in the imagination those images are so fleeting that they can at best constitute what Oskar Negt and Kluge call an "unconscious

54. Rosenbaum, "Vigilance of Desire."
55. Buck-Morss, *Origin*, 86.
56. Adorno, quoted in Buck-Morss, *Origin*, 86.

practical critique of alienation," in objectifying them film can give them duration, thereby making them available to the attentive gaze.[57] Montage thus becomes a protest against those filmic practices that "synthesize [objects] gaplessly into the dynamic continuum" of the work and affirm rather than critique the alienated and heterogeneous. By incorporating the images of the empirical as fragments, a film based on montage turns what passes to our everyday perception as "natural" into "literal, illusionless ruins of empirical reality" (*AT*, 203). Montage, as Adorno puts it, is "the inner-aesthetic capitulation of art to what stands heterogeneously opposed to it" (*AT*, 203).

In the "sudden, discontinuous juxtaposition of sequences," Adorno writes, montage appears intentional "without damaging the intentionlessness of life as it is" (*AT*, 202). It seems that film, which can be an ideological tool to reproduce the reified consciousness of its spectators, can also give expression to nondiscursive and preconscious forms of experience such as dreams and daydreams, fantasies and desires—forms of experience that have been repressed with the rationalization of the world but that contain a hidden critical potential. That film, as a mass and heteronomous medium, can have such a critical function shows that art's political role is not a priori tied to hermetic, noncommunicative forms of art. Contrary to what has been argued, Adorno's aesthetic theory is not closed—fixing reality "[transcendentally], prior to all experience, in negative terms."[58] Neither is his position on film and modern art "decided in advance."[59] The "emptiness of time" that lurks unconsciously in our dreams and fantasies can be rendered visible by film, triggering a process of critical consciousness and closing that gap (previously deemed irreducible) between reality and utopia.

**Ricardo Samaniego de la Fuente** holds a PhD in philosophy from the University of Essex.

57. Negt and Kluge, *Public Sphere and Experience*, 33.
58. Wellmer, "Truth, Semblance, Reconciliation," 12.
59. Wellmer, "Truth, Semblance, Reconciliation," 12.

ity of Walter Benjamin," translated by Philip Brewster and Carl Howard Buchner. *New German Critique*, no. 17 (1979): 30–59.

Habermas, Jürgen. *Reason and the Rationalization of Society*. Vol. 1 of *The Theory of Communicative Action*, translated by Thomas McCarthy. Boston: Beacon, 1984.

Hansen, Miriam Bratu. "Alexander Kluge: Crossings between Film, Literature, Critical Theory." In *Film und Literatur: Literarische Texte und der neue deutsche Film*, edited by Sigrid Bauschinger, Susan L. Cocalis, and Henry A. Lea, 169–96. Bern: Francke, 1984.

Hansen, Miriam Bratu. *Cinema and Experience: Siegfried Kracauer, Walter Benjamin, and Theodor W. Adorno.* Berkeley: University of California Press, 2012.

Hansen, Miriam Bratu. "Introduction to Adorno, 'Transparencies on Film' (1966)." *New German Critique*, nos. 24–25 (1981–82): 186–98.

Horkheimer, Max, and Theodor W. Adorno. *Dialectic of Enlightenment: Philosophical Fragments.* Stanford, CA: Stanford University Press, 2002.

Hulatt, Owen. "Critique through Autonomy: On Monads and Mediation in Adorno's Aesthetic Theory." In *Aesthetic and Artistic Autonomy*, edited by Owen Hulatt, 171–96. London: Bloomsbury, 2013.

Huyssen, Andreas. "Introduction to Adorno." *New German Critique*, no. 6 (1975): 3–11.

Irr, Caren, and Jeffrey Nealon, eds. *Rethinking the Frankfurt School: Alternative Legacies of Cultural Critique.* Albany: State University of New York Press, 2002.

Jennemann, David. *Adorno in America.* Minneapolis: University of Minnesota Press, 2007.

Kluge, Alexander. "On Film and the Public Sphere," translated by Thomas Y. Levin and Miriam B. Hansen. *New German Critique*, nos. 24–25 (1981–82): 206–20.

Kluge, Alexander. "The Political as Intensity of Everyday Feelings," translated by Andrew Bowie. In *Alexander Kluge: Raw Materials for the Imagination*, edited by Tara Forrest, 283–90. Amsterdam: Amsterdam University Press, 2012.

Kluge, Alexander, and Klaus Eder. "Debate on the Documentary Film: Conversation with Klaus Eder, 1980," translated by Robert Savage. In *Alexander Kluge: Raw Materials for the Imagination*, edited by Tara Forrest, 197–208. Amsterdam: Amsterdam University Press, 2012.

Koch, Gertrud. "Mimesis and *Bilderverbot*." *Screen* 34, no. 3 (1993): 211–22.

Kracauer, Siegfried. *Theory of Film: The Redemption of Physical Reality.* Princeton, NJ: Princeton University Press, 1997.

Levin, Thomas Y. "For the Record: Adorno on Music in the Age of Its Technological Reproducibility." *October*, no. 55 (1990): 23–47.

Liebman, Stuart, and Alexander Kluge. "On New German Cinema, Art, Enlightenment, and the Public Sphere: An Interview with Alexander Kluge." *October*, no. 46 (1988): 23–59.

Matthews, Peter. "Divining the Real: The Leaps of Faith in André Bazin's Film Criticism." *Sight and Sound*, August 1999. www.bfi.org.uk/news-opinion/sight-sound-magazine /features/andre-bazin-divining-real-film-criticism-overview.

Morgan, Daniel. "Bazin's Modernism." *Paragraph* 36, no. 1 (2013): 10–30.

Morgan, Daniel. "Rethinking Bazin: Ontology and Realist Aesthetics." *Critical Inquiry* 32, no. 3 (2006): 443–81.

Negt, Oskar, and Alexander Kluge. *The Public Sphere and Experience*, translated by Peter Labanyi, Jamie Daniel, and Assenka Oksiloff. Minneapolis: University of Minnesota Press, 1993.

O'Connor, Brian. *Adorno's Negative Dialectic: Philosophy and the Possibility of Critical Rationality.* Cambridge, MA: MIT Press, 2004.

Paddison, Max. *Adorno's Aesthetics of Music.* Cambridge: Cambridge University Press, 1997.

Penn, Sheldon. "The Time-Image in Carlos Reygadas' *Stellet Licht*: A Cinema of Imma-nence." *Bulletin of Spanish Studies* 90, no. 7 (2013): 1159–81.

Reygadas, Carlos, and Charlotte Higgins. "I Am the Only Normal Director." *Guardian*, August 22, 2005. www.guardian.co.uk/film/2005/aug/22/edinburgh filmfestival2005. edinburghfilmfestival.

Rodowick, D. N. *What Philosophy Wants from Images*. Chicago: University of Chicago Press, 2017.

Rosenbaum, Jonathan. "A Vigilance of Desire: Antonioni's *L'Eclisse*." August 11, 2005. www.jonathanrosenbaum.net/2005/08/a-vigilance-of-desire-antonionis-leclisse-tk.

Seel, Martin. "Sitting Unobserved: Adorno's Outline for an Aesthetics of Cinema." In *Adorno: The Possibility of the Impossible*, edited by Michael Hirsch, Vanessa Joan Mül-ler, and Nicolaus Schafhausen, 25–32. New York: Lukas and Sternberg, 2003.

Sharrett, Christopher. "*L'eclisse*." *Senses of Cinema: Cinematheque Annotations on Film*, no. 62 (2012). sensesofcinema.com/2012/cteq/leclisse.

Thomson-Jones, Katherine. *Aesthetics and Film*. London: Continuum, 2008.

Waldman, Diane. "Critical Theory and Film: Adorno and 'The Culture Industry' Revis-ited." *New German Critique*, no. 12 (1977): 39–60.

Wall, Brian. *Theodor Adorno and Film Theory: The Fingerprint of Spirit*. New York: Pal-grave Macmillan, 2013.

Wellmer, Albrecht. "Truth, Semblance, Reconciliation: Adorno's Aesthetic Redemption of Modernity." In *The Persistence of Modernity*, translated by David Midgley, 1–35. Cam-bridge: Polity, 1991.

Zuidervaart, Lambert. *Adorno's Aesthetic Theory: The Redemption of Illusion*. Cam-bridge, MA: MIT Press, 1991.

Zuidervaart, Lambert. "The Social Significance of Autonomous Art: Adorno and Bürger." *Journal of Aesthetics and Art Criticism* 48, no. 1 (1990): 61–77.

# Days of the Cavemen?
# Adorno, Spengler, and the Anatomy of Caesarism

## Mikko Immanen

> Spengler sees something of the dual character of
> enlightenment in the era of universal domination.
> —Theodor W. Adorno, "Spengler after the Decline"

> I hope that the elaboration of Spengler [essay] means a real
> preparatory work for our things.
> —Theodor W. Adorno to Max Horkheimer, 1941

The Weimar Republic is often said to have lacked republicans. But surely this is an overstatement. Leading intellectuals of the time, such as the Kantian philosopher Ernst Cassirer, actively voiced their support for Germany's first democratic experiment. Yet in hindsight critics have pointed out that Cassirer and his like were unsuccessful because their trust in reason and progress was ill equipped to face harsher postwar realities and mounting antidemocratic sentiment fed by new radical voices. Commenting on Cassirer's legendary 1929 Davos disputation with the iconoclastic existentialist Martin Heidegger, Leo Strauss noted the contrast between the erudite but noncharismatic Cassirer and Heidegger, who "gave adequate expression to the prevailing unrest and dis-

For their valuable suggestions, I wish to thank Richard Wolin, an anonymous reviewer, and commentators at the "European Narratives of Crisis" conference in Helsinki in May 2018, organized by the Centre of Excellence in Law, Identity, and the European Narratives.

*New German Critique* 143, Vol. 48, No. 2, August 2021
DOI 10.1215/0094033X-8989316   © 2021 by New German Critique, Inc.

satisfaction."[1] Similarly, commemorating the seventieth birthday of Oswald Spengler in 1950, Theodor W. Adorno claimed that among his Weimar-era critics Spengler "found hardly an adversary who was his equal." In his best-selling *The Decline of the West* (*Der Untergang des Abendlandes*), published in two volumes in 1918 and 1922, Spengler had famously envisioned for Europe the fate reserved for all "great cultures": withering away of creative energies of *Kultur* and rise of a shallow civilization of Nietzsche's "last man."[2] Looking back at the Weimar academics' attacks on Spengler, Adorno concluded that the "German mind collapsed when confronted with an opponent who seemed to have inherited all the historical force of its own past."[3]

Adorno's comment was a reference to the prestigious philosophical journal *Logos*, which in 1920 had gathered an illustrious group of scholars to demolish the first volume of Spengler's book.[4] Notwithstanding the political gulf between Adorno (1903–69) and Spengler (1880–1936), Adorno would have none of the "pedantic punctiliousness" and "rhetoric of conformist optimism" of these condescending attacks. For Adorno and Strauss, both Jewish exiles from Nazi Germany, Weimar academics' inability to challenge popular and charismatic critics of reason had consequences far surpassing the university. "Led politically by Hitler and intellectually by Heidegger," Strauss concluded, "Germany entered the Third Reich." The weakness of Spengler's critics, Adorno contended, echoed "the political impotence of the Weimar Republic faced with Hitler."[5]

Adorno's view of Spengler was always ambiguous. Adorno was adamant that the fact of the Holocaust alone made supercilious dismissals of Spengler highly dubious. Yet he refused the label of Spenglerian, insisting in his famous criticism of German efforts to deal with the Nazi past, "Do not mistake my fragmentary and often rhapsodic remarks for Spenglerism."[6] Speaking against Spengler in the Germany of the 1950s, Adorno saw the economic miracle and general recovery of the social fabric. Given these criticisms, one wonders why Adorno chose to cast the *Logos* authors in such a negative light. For surely he agreed on the urgency to criticize Spengler's book, which made authoritative and influential claims about history and, moreover, not only described the

1. Strauss, "Kurt Riezler," 246. All translations are mine unless otherwise indicated.
2. Spengler, *Decline of the West* (hereafter cited as *Decline*).
3. Adorno, "Spengler after the Decline," 54 (hereafter cited as SD). For the German, see Adorno, "Spengler nach dem Untergang."
4. *Logos*, "Spenglerheft."
5. Strauss, "Kurt Riezler," 241; SD, 54.
6. Adorno, "Meaning of Working Through the Past," 99.

zeitgeist of the 1920s but played into the hands of antirepublican and antisocialist forces of Weimar Germany. As Adorno himself underscored, "Spengler and his like are not so much prophets of the course the *Weltgeist* will take as its diligent promoters" (SD, 66).

How should we interpret this ambivalence? Adorno's writings on Spengler are few; accompanying "Spengler after the Decline" is a shorter piece from 1955 and scattered remarks here and there.[7] Adorno's comments vacillate between harsh denouncements and unexpected praises. The latter should not come as a surprise. Although Adorno abhorred Spengler's protofascist worldview, considering Spengler's European-wide, even global impact, it is small wonder that Adorno too found it worthwhile to engage with his ideas.[8] However, there is a more specific, dialectical logic to Adorno's vacillation. The following passage from *Minima Moralia* (1951) offers a fine hermeneutic clue to make sense of this logic: "Not least among the tasks now confronting thought is that of placing all the reactionary arguments against Western culture in the service of progressive enlightenment."[9] My proposition is that Adorno's contestation with Spengler formed a major instance of his effort to repurpose right-wing *Zivilisationskritik* for left-wing ends. The vexed question of the presence of elements from radical right-wing critique of reason in Adorno's thought—dominated by critical Marxism, aesthetic modernism, psychoanalysis, and Jewish tradition[10]—has preoccupied scholars sporadically since the 1980s and the dispute over Carl Schmitt's influence on the Frankfurt School, claims that Adorno shared something of Walter Benjamin's fascination with Ludwig Klages's vitalist critique of reason, and Hermann Mörchen's study on the affinities between Adorno and Heidegger.[11] Yet Spengler's case remains largely uncharted, as George Friedman and David Roberts are the only ones to discuss it in any detail.[12]

I begin by showing that what Adorno found intriguing in Spengler's *Decline* was its analysis of "Caesarism" in post–World War I Europe—

7. Adorno, "Was Spengler Right?" (hereafter cited as WSR). For the German, see Adorno, "Wird Spengler recht behalten?"

8. On Spengler's impact, see Merlio and Meyer, *Spengler ohne Ende*; and Gasimov and Lemke Duque, *Oswald Spengler als europäisches Phänomen*.

9. Adorno, *Minima Moralia*, 192.

10. Jay, *Adorno*, 17–19. On right-wing *Zivilisationskritik* in interwar Germany, see Woods, *Conservative Revolution*; and Herf, *Reactionary Modernism*.

11. *Telos*, "Special Section on Carl Schmitt and the Frankfurt School"; Honneth, "Anthropologische Berührungspunkte"; Mörchen, *Adorno und Heidegger*. On Adorno and Heidegger more recently, see Gordon, *Adorno and Existence*; and Immanen, *Toward a Concrete Philosophy*.

12. Friedman, *Political Philosophy of the Frankfurt School*, 79–86; Roberts, *Art and Enlightenment*, 73–81.

"tendencies inherent in democracy which threaten to turn it into dictatorship" (SD, 55). Adorno's interest in *Decline*, however, predates his wish to give Spengler's analysis its due in the Adenauerian Germany struggling to "come to terms with the past." By going back to the article's original 1941 version, I trace Adorno's interest in Spengler to the New York exile in 1938–41, when Adorno took notice of the affinities between Spengler's analysis of Caesarism and Friedrich Pollock's thesis on "state capitalism." Moreover, given the appreciation shown to Spengler by both Adorno and Max Horkheimer at the time, I also interpret Spengler as an overlooked stimulus to their *Dialectic of Enlightenment* (1947). Finally, I ask whether it was exactly Adorno's daring effort to make Spengler's analysis of Caesarism serve progressive ends that today makes Adorno's critical theory an asset in understanding "Trumpism," the Caesarism of our own day.

### Caesarism: The Decline of the Weimar Republic

Richard Wolin stresses that as justified as it is to view the fascination with radical right-wing critics of reason as "an obligatory intellectual rite of passage" for many young left-wing intellectuals of interwar Germany, previous attempts to illuminate this connection have often lacked balance. "Proceeding by insinuation rather than sound argument," they have overemphasized the similarities and overlooked the differences.[13] This danger should be avoided by all costs. Therefore, let us bring forth all those countless aspects that Adorno objected to, indeed despised, in Spengler's *Decline*. This also serves as a brief recapitulation of the core themes of Spengler's book, for what Adorno rejected were just those arrogant historical and philosophical declarations that in 1918 had made Spengler's book part of the popular imagination almost overnight.

Adorno denounced as utter nonsense Spengler's "cultural morphology," that is, his notorious theory of the rise and fall of cultures. For Adorno, this theory was unfounded determinism that verged on astrological superstition at its worst. Equally untenable was Spengler's idea of collective cultural "souls," those unique dispositions to reality (e.g., classical "Apollonian" or Western "Faustian") that supposedly dictated every single expression of a given culture. Contrary to Spengler's view of cultures as such self-enclosed monads, Adorno pointed out that "Faustian" technology had become a part of the way of life globally, even in the allegedly most resistant Russia and Japan. Again, although Adorno found much to complain about in the *Logos* authors' attacks on Spengler, he shared their distaste of *Decline*'s "sweeping administrative

13. Wolin, "Walter Benjamin Today," 63–64.

gesture," which "strips all phenomena down to the formula 'that's all happened before.'" No matter how problematic the positivist emphasis on facts was as a scientific methodology, it held its own when set against *Decline*'s "tyranny of categories," a tyranny "closely related to the political tyranny about which Spengler is so enthusiastic." As for Spengler's political preferences, Adorno had nothing but contempt for his protofascist adoration of authority and sacrifice (SD, 61, 66–71; WSR, 28).[14] It is not an overstatement to say that Adorno found the entire idea of cultural morphology as a symptom of the zeitgeist characterized by cynical power politics, fatalistic celebration of will to power, and anti-Enlightenment polemics.

What, then, was Adorno's problem with the critical approach to Spengler shown by the *Logos* authors in 1920 and Weimar academe in general? While they may have demolished Spengler's claims about this or that question of historical detail, in their unshaken trust in the triumph of reason and progress they had missed some unnerving tendencies in modern Western society. Spengler's academic adversaries had made a grave error in refusing to ponder whether behind the undeniable flaws of Spengler's *Decline* there lay genuine insights, insights that they had paid scant attention to and which failed to resonate among laypeople as soon as the immediate postwar misery gave way to the Roaring Twenties. By these insights Adorno meant Spengler's observations, discussed under the label of Caesarism in the second, largely neglected, volume of *Decline* (1922), on post–World War I Europe: bureaucratization of the party system, emergence of a new personality type susceptible to propaganda, and the rise of manipulative mass media. For Spengler, these phenomena marked the coming of the age of Caesarism—an age of urban metropolis, shallow materialism, and ruthless thirst for power: an inevitable late stage that every "culture" had to face as it reached the old age of "civilization." For Adorno, however, these observations were valuable not as validation of Spengler's cultural morphology but as keys to more specific discontents of interwar Europe.

First, there was Spengler's view that democracy has been "well in the decline" since the war. Considering the collapse of four empires in 1918 and the establishment of numerous new republics from the Baltic to Iberia, this view invites skepticism. Spengler highlighted, however, the profound transformation of the parliamentary system. Modern political parties, employing thousands of people, were more interested in guarding special interests of their members than in deliberating over the common good in an open dialogue.

14. On Spengler's life and work, see Hughes, *Oswald Spengler*.

They had become bureaucratic machines far removed from the nineteenth-century ideal of a deliberative public sphere. This structural problem of the European party system, "Caesarism of the organizations," was reflected in the 1919 Weimar Constitution, which left itself vulnerable to undemocratic forces. Alluding to the infamous Article 48, which allowed governing by emergency decrees without consent of the parliament, Spengler claimed that a major problem in the constitution is "visible already. A few quite small alterations and it confers unrestricted power upon individuals" (*Decline*, 2:452, 457n2). Adorno found Spengler's observation on the bureaucratization of parties "radically confirmed in National Socialism—parties became followings." While echoing cyclical political theorists of the past, Spengler was superior to thinkers such as Niccolò Machiavelli "in having experienced the dialectic of history, though he never names it." Spengler never sympathized with democracy, yet he understood "the mechanisms which allow the party system to turn into dictatorship" (SD, 59).

Facilitating the bureaucratization of parties and the subsequent rise of authoritarianism were psychological changes. Spengler noted that in the nineteenth century people were filling to fight for "the great truths of Democracy" and "rights without which life seemed not worth the living." Today, however, when these rights have become reality, "the grandchildren cannot be moved, even by punishment, to make use of them." Behind political apathy Spengler found atomization of urban metropolises. "The splendid mass-cities harbour lamentable poverty and degraded habits, and the attics and mansards, the cellars and back courts are breeding a new type of raw man" (*Decline*, 2:432, 102). In Adorno's estimation, Spengler grasps the link "between atomization and the regressive type of man which revealed itself fully only with the onslaught of totalitarianism." Although unaware of the economic causes behind the emergence of this urban, "second nomad," Spengler was acutely aware of the role played by new mass media (SD, 55–56).

Indeed, Spengler lamented the replacement of "the book-world, with its profusion of standpoints that compelled thought to select and criticize" by newspapers. Today "the people reads the *one* paper, 'its' paper, which forces itself through the front doors by millions daily" and "spellbinds the intellect from morning to night." Depicting the "Caesars of the world-press," Spengler lamented that "no tamer has his animals more under his power. Unleash the people as reader-mass and it will storm through the streets and hurl itself upon the target indicated, terrifying and breaking windows" (*Decline*, 2:461–62). With a reference to the anti-Semitic *Kristallnacht* pogrom in

Germany in 1938, Adorno suggested that "Spengler predicted Goebbels." What Spengler discerned in "the modest press magnates" of the World War I era found "their mature form in the techniques of manipulated pogroms and 'spontaneous' popular demonstrations" (SD, 57). Further illuminating the decay of critical thinking was Spengler's farsighted polemics against modern mass culture. Urban metropolitans had little understanding of "genuine play, *joie de vivre*, pleasure," whereas sports, gambling, and other "conscious and practiced fooling" functioned as much-needed distractions from tense working life (*Decline*, 2:103). Adorno credited Spengler for predicting the "static state of culture," which "compels the incessant and deadly repetition of what has already been accepted" while "standardized art for the masses, with its petri-fied formulas, excludes history" (SD, 58).

I believe Friedman is correct to point out parallels between Spengler's analysis of Caesarism and Adorno's criticisms of modern Western societies. In *Dialectic of Enlightenment*, Adorno and Horkheimer sought to capture the complex constellation of economic, political, and cultural forces that had molded the public sphere, the greatest achievement of bourgeois revolutions, into a commodified "culture industry"—"enlightenment as mass deception."[15] Again, in *The Authoritarian Personality* (1950), Adorno, together with Else Frenkel-Brunswik, Daniel J. Levinson, and R. Nevitt Sanford, argued for the existence in the United States of authoritarian potential that in less favorable societal conditions could be set on fire by America's homegrown fascist dema-gogues.[16] Finally, decay of democracy was not an alien concern for Adorno, who considered "the growing concentration of the economy, the executive and the bureaucracy" a major obstacle to individual self-determination. Because of these structural problems, even formally democratic institutions of the post-1945 period struggled to keep alive an inner desire for freedom, threatened by political apathy and expanding allures of consumerism.[17]

Notwithstanding Spengler's chilling indifference to suffering, his *lebens-philosophisch* fatalism, and his economic dilettantism—that is, all the count-less aspects that made Spengler's thought a sign of the unhealthy zeitgeist poi-soned by right-wing *Zivilisationskritik*—Adorno thought that *Decline* had touched on something essential of an age rushing to become one of "extremes," of Europe turning into a "dark continent."[18] In Adorno's account, Spengler

15. Horkheimer and Adorno, *Dialectic of Enlightenment*, 94–136 (hereafter cited as *DE*).
16. Adorno et al., *Authoritarian Personality*.
17. Adorno, *History and Freedom*, 5–7.
18. See Hobsbawm, *Age of Extremes*; and Mazover, *Dark Continent*.

was not merely a symptom of his age but offered genuine insights about it as well. By waiving Spengler off as a vulgar charlatan, his Weimar adversaries, from liberals to Marxists, had missed the forest for the trees. By no means would Spengler have understood the real roots of the discontents of the times, let alone properly theorized their interconnections. Yet I believe that Adorno saw his observations as containing kernels of truth. No matter how problematic, they gave a lot of food for thought. This dialectical logic at work in Adorno's ambiguous stance toward Spengler is well captured in the following passage:

> Spengler is one of the theoreticians of extreme reaction whose critique of liberalism proved itself superior in many respects to the progressive one. It would be worthwhile to investigate the reasons for this. It is the differences in the relationship to ideology which are decisive. To the adherents of dialectical materialism liberal ideology seemed for the most part a false promise. Their spokesmen questioned not the ideas of humanity, freedom, and justice but rather the claim of bourgeois society to have realized those ideas. Ideologies were appearances for them, but the appearance of truth nevertheless. As a result, if not the existent itself at least its "objective tendencies" were endowed with a conciliatory gloss. Talk of the increase of antagonisms and the admission of a real possibility of a regression to barbarism were not taken seriously enough for anyone to recognize ideologies as something worse than apologetic disguises, as the objective absurdity that aids the society of liberal competition to turn into a system of direct oppression. (SD, 65)

Spengler had paid attention to early marks of a path that would lead to this new "system of direct oppression." This was possible, Adorno reasoned, because he rejected the optimistic conception of history as steadfast progress, a conception cherished by those who thought history was on its way toward something like a "realm of freedom." Liberals of Weimar Germany believed in the triumph of the parliamentary system. Marxists thought that capitalism would give way to socialism out of a historical necessity. Neither camp was truly alert to the possibility that a new kind of barbarism, fascism, was looming on the horizon. As much as Adorno cherished the enlightened ideals of liberals and Marxists, he applauded Spengler for offering insights into why the world was moving away from these ideals. "Spengler's harshness with his contemporaries," Adorno maintained, "might almost have constituted a shock which might have helped to save them" (WSR, 29).

Adorno would have considered it a disgrace that there ever was a serious debate whether history consisted of Spengler's self-enclosed and plant-like cul-

tures. Quoting approvingly James T. Shotwell's early criticism of *Decline*, he emphasized that historical civilizations "have been inherently lacking in equilibrium" not because of some cosmic forces but because "they have built upon the injustice of exploitation." There was, however, no reason to presume that "modern civilization must inevitably repeat this cataclysmic rhythm."[19] In other words, there were far more plausible explanations than Spengler's fanciful cultural morphology both for the demise of the classical Greco-Roman world and for the discontents of interwar Europe. At the same time, however, Adorno wished to give Spengler's suspicion of progress its due. Writing in 1950s Germany, Adorno wanted to avoid the mistakes of the progressives of the Weimar era, whose well-meaning celebrations of reason, culture, and justice had not been enough. "Spengler could laugh in the face of such blissful confidence. Rather, it is the barbaric element in culture itself which must be recognized" (SD, 71).

Adorno did not think that post-1945 Germany faced any imminent threat of repeating the fate of the Weimar Republic. There was no denying that many things had gotten better. But problems remained, most notably the concentration of societal power and Germans' inability to genuinely work through the past that had led to Adolf Hitler. As Adorno famously expressed his concerns, "The survival of National Socialism *within* democracy" was a more urgent threat than "survival of fascist tendencies *against* democracy" (i.e., marginal neo-Nazi organizations).[20] Adorno's appreciation of Spengler was, then, understandable after the horrors of total war and especially after the Holocaust. This appreciation, however, was not a product of the postwar era. The original version of Adorno's Spengler essay dates from 1941—a fact often overlooked in previous commentaries—and it needs to be understood in the context of the Frankfurt School's reflections on "state capitalism" in New York.

### Caesarism and State Capitalism: Rethinking Spengler in New York

In 1938 Adorno joined the Institute for Social Research in New York, where it had relocated from Frankfurt in 1934. Between 1938 and 1941, he lectured at least twice on Spengler at Columbia University.[21] Based on these lectures, an essay titled "Spengler Today" appeared in the institute's journal in 1941. Commenting on a draft of the essay, Horkheimer demanded that it "*naturally* has

19. SD, 72; Shotwell, "Spengler," 228–29.

20. Adorno, "Meaning of Working Through the Past," 90, 99; WSR, 26.

21. Adorno to Maria and Oscar Wiesengrund, March 28, 1944, in *Briefe und Briefwechsel*, 5:253–54; Adorno to Horkheimer, May 3, 1941, in *Briefe und Briefwechsel, 1938–1944*, 109.

to be in the next issue, it fits perfectly to the theme."[22] The theme was state cap-italism, introduced by Pollock, the house economist of Horkheimer's circle. Pollock maintained that in the wake of the 1929 Wall Street crash, capitalism had undergone a major transformation. Nazi Germany, the Soviet Union, and the New Deal USA had surrendered economic competition to state administra-tion, thereby eliminating the market as the dynamic regulator of social rela-tionships. This transformation culminated a longer historical trend, in which nineteenth-century "liberal capitalism," competition of private entrepreneurs, gave way at the turn of the century to "monopoly capitalism" of large corpora-tions, conglomerates, and joint-stock companies. This centralization of power reached its zenith in the fusion of economic and political power in the "state capitalism" of the 1930s.[23]

The somewhat ironic outcome of Pollock's thesis was that an economist surrendered economy as an independent realm to politics. In a well-known debate at the institute, Horkheimer and Adorno sided with Pollock while others, such as Franz Neumann, the author of *Behemoth: The Structure and Practice of National Socialism* (1942), did not. A lot was at stake, especially concerning the German situation. "State capitalism" meant the awkward real-ization that contrary to what more orthodox Marxists believed, Nazi Germany was not threatened from within by any insurmountable economic antagonism. To be sure, economic inequalities and systemic problems had in no way been overcome. Yet the "authoritarian state"—the Nazi Party, bureaucracy, military, and big industry—could deal with them in various ways, from investments to open terror. And as great as the differences between European totalitarianisms and the democratic USA were, also in the latter the individual mattered less and less amid the pressure of systemic forces.[24]

Adorno's Spengler essay was a contribution to this problematic. Adorno suggested that whereas Pollock had captured the economic dimension of the centralization of power, Spengler had observed, under the title of Caesarism, psychological, cultural, and political dimensions of this same tendency in the early 1920s. Characteristic of the era of Caesarism, Adorno emphasized, was its ahistorical character "in a most sinister sense." With a reference to Pollock's article—omitted from the 1950 version—Adorno continued that Spengler's "paradoxical prognosis is clearly paralleled by the tendency of present econ-omy to eliminate the market and the dynamics of competition" and replace

22. Horkheimer to Adorno, June 23, 1941, in *Briefe und Briefwechsel, 1938–1944*, 155.
23. Pollock, "State Capitalism."
24. Jay, *Dialectical Imagination*, 143–66; Wiggershaus, *Frankfurt School*, 280–91.

them with "static conditions" in which "the life of those who do the work is maintained planfully from above."[25] On Adorno's account, Pollock and Spengler registered the perplexing fact that history had in fact vanished. Certainly, there was no shortage of world-historical events in the early twentieth century. But the striking feature of this era was that individuals were increasingly not subjects of their fate but objects of supra-individual forces. Contrary to enlightenment promises of autonomy, individuals were not in charge of societal development but cogs in the machine. Besides the replacement of private entrepreneurs by monopolies and state administration, this tendency manifested itself also in political, psychological, and cultural realms, as demonstrated by Spengler.[26]

The similarities between Adorno and Spengler are, then, palpable. But what about Spengler's possible influence on Adorno? Friedman is vague about this question. He writes about Spengler's "direct influence" and maintains that the Frankfurt School "incorporated Spengler's criticism into their own." Yet he qualifies his position by stating that Spengler's ideas only "find echoes" in their writings.[27] If we follow Adorno's path of thinking up to his 1938 arrival in New York, it seems doubtful that Spengler would have left a notable imprint on his intellectual development. Indeed, the young Adorno's rare remarks on Spengler in the Weimar era suggest that he saw in the latter's ideas mere mystification of economic injustices.[28] Of course, the following scenario is possible. Adorno later conceded that while he had not expected Hitler's regime to last long—the average length of Weimar governments was eight months—already in the 1920s he had dark premonitions of things to come: "The outbreak of the Third Reich did, it is true, surprise my political judgment, but not my unconscious fear."[29] We could speculate that Spengler's *Decline* was one source behind Adorno's deeply felt unease amid the seemingly merry Roaring Twenties and that Pollock's "state capitalism" thesis later offered a more compelling economic explanation for it. But this speculation is just that. It seems more plausible that Spengler began to preoccupy Adorno's mind only in New York in the late 1930s.

25. Adorno, "Spengler Today," 310.

26. In the 1941 essay, unlike in the 1950 version, Adorno does not mention Michels, *Political Parties*, or Sombart, *Why Is There No Socialism in the United States?*, as likely influences on Spengler's idea of Caesarism. Perhaps Adorno saw Spengler as a more original thinker in 1941 than he did in 1950, when he suggested that doctrines like Michels's "iron law of oligarchy" had inspired Spengler (SD, 55, 59; WSR, 26).

27. Friedman, *Political Philosophy of the Frankfurt School*, 80, 85.

28. Adorno, *Der Begriff des Unbewussten*, 319–20.

29. Adorno, *Minima Moralia*, 192.

Adorno later described his Spengler essay as an outgrowth of debates in New York with other émigré intellectuals, among them the theologian Paul Tillich (Adorno's ex-supervisor and colleague in Frankfurt), and such American colleagues as the theologian Reinhold Niebuhr.[30] What all these discussants shared was a soft spot, despite their progressive political leanings, for Spenglerian pessimism.[31] It was in these surroundings that Adorno engaged in rethinking Spengler's worth. Rather than as an expression of Spengler's influence on Adorno, however, "Spengler Today" should be taken as an ex post recognition of certain parallels between two otherwise very different thinkers. Nevertheless, at the same time I believe that it would be equally incorrect to conclude that there is nothing more to be found in Adorno's essay than this ex post recognition. For we still have not touched on the question of whether Adorno's reflections on Spengler in 1938–41 suggest that Spengler influenced, or stimulated, his subsequent thinking. This question is pertinent, for Adorno's New York years were the incubation time of *Dialectic of Enlightenment* that he and Horkheimer began in 1941 in California.

"Masterpiece" was how Horkheimer described Adorno's Spengler essay; despite the preciseness of its treatment of details, Adorno's treatment adhered to what was essential in Spengler. Moreover, Horkheimer emphasized that the essay highlighted contemporary themes especially in need of further reflection, such as the idea of "ahistorical character of the present," a provocative and paradoxical idea in an era filled with events of world-historical magnitude (Hitler's invasion of Soviet Union had begun the previous day). Bespeaking Horkheimer's enthusiasm was that whereas Adorno had judged Spengler as a dilettante in economic matters, in Horkheimer's opinion Spengler had real insights here, too, particularly pertaining to the shift from liberal to monopoly capitalism.[32] These words should not come as a surprise, for by 1941 Horkheimer, who also attended the New York debates mentioned above, had begun to feel more at home amid such sweeping civilizational ruminations.

The debate over state capitalism, as often noted, marked a pessimistic turn in Horkheimer's thinking. Besides Pollock's thesis, affecting this turn were depressing political events, most notably the 1939 Hitler-Stalin Pact, and Horkheimer's increasing contacts with Adorno. Of course, for Horkheimer, philosophical perspective on historical and economic phenomena had always been

30. *Werk und Wirken Paul Tillichs*, 35. See also Adorno to Horkheimer, May 3, 1941, in *Briefe und Briefwechsel, 1938–1944*, 109.

31. On Spengler's impact on Tillich and Niebuhr, see Clayton, *Concept of Correlation*, 143; and Stone, *Professor Reinhold Niebuhr*, 41.

32. Horkheimer to Adorno, June 23, 1941, in *Briefe und Briefwechsel, 1938–1944*, 153–54.

essential. Thus, if Pollock saw state capitalism as the culmination of a decades-long economic trend, Horkheimer viewed it through the lens of an "anthropology of the bourgeois epoch," a sort of Hegelian-Freudian-Marxist modification of Max Weber's idea of the ascetic Protestant roots of modern capitalism. By 1941, however, Horkheimer's scope had expanded from centuries to millennia, as evidenced by his article "The End of Reason," in which his earlier differentiations between historical periods, thinkers of the same period, and present political systems had given way to a more ruthless critique of Western reason as such. This transformation was certainly not straightforward, and Horkheimer's life-long admiration of Schopenhauer's pessimism remains a challenge for his biographers.[33]

Anyhow, with regard to Spengler there is an apparent change in Horkheimer's stance. Earlier he had not minced words over Spengler's dilettantism and irrational reduction of human history to blind nature.[34] But Horkheimer's praise of Adorno's Spengler essay shows that by 1941 he had changed his mind. This did not go unnoticed by Adorno. "I am especially happy," the latter replied, "that you really liked the Spengler [essay]. You cannot imagine what our agreement in these things means to me."[35] Hence, considering that both Adorno and Horkheimer showed appreciation for Spengler in 1941, I believe that it is not far-fetched to weigh the possibility that Spengler stimulated *DE*, that the book was partly an immanent critique of his ideas. Adorno had criticized Spengler's progressive adversaries in the 1920s for taking the easy way out by playing culture against barbarism instead of recognizing "the barbaric element in culture" itself. Is not *DE* with its narrative of the entwinement of myth and reason an effort at just such a recognition? When Adorno mentioned the book's future title for the first time, he referred to it as "dialectic of enlightenment or dialectic of culture and barbarism."[36]

### Spengler as a Key to Dialectic of Enlightenment?

In 1944 Adorno and Horkheimer circulated a few copies of *Philosophical Fragments*, a work that was officially published in 1947 as *Dialectic of Enlightenment*. Uniting this darkest of books was a desperate effort to comprehend why after two and a half millennia of Western rationalism "the wholly enlightened earth is radiant with triumphant calamity": with Nazism, Stalin-

---

33. Abromeit, *Max Horkheimer*, 394–424; Horkheimer, "End of Reason."
34. Horkheimer, "Zur Emanzipation der Philosophie," 295.
35. Adorno to Horkheimer, July 2, 1941, in *Briefe und Briefwechsel, 1938–1944*, 159.
36. Adorno to Horkheimer, November 10, 1941, in *Briefe und Briefwechsel, 1938–1944*, 286.

ism, and the Western culture industry (*DE*, 1). The emergence of human subjectivity from nature, Adorno and Horkheimer argued, had come with a high price of domination of outer and inner nature. Since pre-Socratic times, self-preservation had been bought with self-renunciation, and periods of genuine freedom seemed like aberrations from the norm. To make at all convincing my tentative reading of Spengler as a key to this narrative, it is imperative to show why Spengler, who is not mentioned in *DE*, can hold his own against such often-cited influences as Weber, Sigmund Freud, and Benjamin. Encouraging this attempt are Adorno's remarks in and on his Spengler essay (the epigraph) and Horkheimer's endorsement of it in 1941.[37]

*DE* is often seen as inspired by Weber's portrait of "the apparently ever-moving but, in reality, static iron cage of modernity,"[38] in which calculative rationality of capitalism suffocates different value spheres of politics, law, science, and art. The resemblance between Weber's diagnosis and the idea of state capitalism, in which "the enthronement of the means as the end" has come to approximate "overt madness," is striking (*DE*, 43). Although *DE* does not mention Weber, Dana Villa is the latest to argue that "it is impossible to imagine the book without him." Whether this omission was due to "authorial pride," or "the anxiety of influence," or suspicion of possibly reactionary political ramifications of Weber's thought, it enabled Adorno and Horkheimer to downplay the extent to which Weber offered "the foundation and basic conceptual structure of much, if not all, of their work."[39] Indeed, besides the phenomenon to be explained, the modern "iron cage," Weber has also been seen as an inspiration for *DE*'s explanative efforts. In Jürgen Habermas's estimation, both Weber and *DE* held the societal crisis of twentieth-century Europe as an almost inevitable result of Western reason. Weber saw behind the iron cage the "disenchantment of the world," a development that in the post-Reformation era freed science, morality, and art from the straitjacket of religious and metaphysical dogmas but also let loose calculative economic rationality. The opening page of *DE* contains an allusion to Weber's theory: "Enlightenment's program was the disenchantment of the world."[40] Echoing Weber, *DE* saw modern differentiated reason as unreason; science served bureaucratization, secular morality disclosed itself as immorality (Marquis de Sade), and the commodified culture industry swallowed critical impulses of art. Read through the lens of "reifica-

37. Adorno to Horkheimer, May 3, 1941, in *Briefe und Briefwechsel, 1938–1944*, 109.
38. Bernstein, "Negative Dialectic as Fate," 21.
39. Villa, "Weber and the Frankfurt School," 266–68.
40. *DE*, 1; Weber, "Science as a Vocation," 139, 155.

tion" of Weber's Marxist student Georg Lukács, Weber's theory of rationalization became *DE*'s theory of instrumental reason.[41]

Apart from the above allusion, however, *DE* does not discuss Weber, and besides occasional remarks elsewhere there is no evidence of Adorno's and Horkheimer's sustained engagement with his thought. To be sure, this need not mean that Weber would not have influenced them. But lack of such explicit concessions invites consideration of other candidates, such as Spengler. Weber's theory of rationalization, Adorno noted in 1964, was preoccupied with the same phenomenon as Spengler's "perspectives on solidification in Caesarist late times." Both Weber and Spengler offered trenchant observations on interwar Europe. Adorno applauded Weber for having predicted the victory of bureaucracy over democracy in Soviet Russia,[42] while elsewhere he praised Spengler's observations on ominous tendencies at work behind the sunny republican facade of Weimar Germany.

Moreover, commenting enthusiastically on Adorno's meditations on Caesarism in his 1941 Spengler essay, Horkheimer proposed that "one should consider in detail whether or not history has actually always consisted in being no history at all—except for a few moments. Perhaps the concept of history requires disintegrating criticism."[43] Horkheimer's comment indicates that Spengler, besides his provoking diagnosis of the present (Caesarism), may also have offered important theoretical stimulation to *DE*'s idea of instrumental reason, and indeed more so than Weber's rationalization thesis. By this I do not mean Spengler's "cultural morphology" but his anthropological conception of the origins of human species and domination of nature, a conception that already underlay *Decline* but was only explicitly articulated in the 1931 *Man and Technics* (*Der Mensch und die Technik*). Whereas Weber traced occidental rationalization to Calvinist reformation, Spengler saw the roots of the domination of nature in the origins of civilization. He thus came closer than Weber to *DE*'s effort, in Habermas's words, to trace instrumental reason "back behind the capitalist beginnings of the modern age into the very beginnings of hominization."[44] Indeed, in his Spengler essay Adorno claimed that *Decline*'s biggest flaw was its mistaken conception of the relationship between humans and nature. Spengler's seemingly concrete, but in truth, idealist conception had no room for real material needs, for humanity's "desire to survive." Culture was

41. Habermas, *Reason and the Rationalization of Society*, 366–99.
42. Adorno, *Nachgelassene Schriften*, 18–19.
43. Horkheimer to Adorno, June 23, 1941, in *Briefe und Briefwechsel, 1938–1944*, 154.
44. Habermas, *Reason and the Rationalization of Society*, 366.

not, Adorno argued, "the life of self-developing collective souls" but contained "an element of resistance to blind necessity: the will for self-determination through Reason." He insisted that "freedom develops only through the natural world's resistance to man. Freedom postulates the existence of something non-identical."[45]

This would become the central argument of *DE*; from the struggle between humanity and nature resulted *both* the domination of *and* the emancipation from natural forces. Manfred Gangl notes this crucial difference between *Decline* and *DE* without, however, suggesting that *DE* resulted from an actual contestation with Spengler.[46] Indeed, apart from Friedman's brief take on the topic, Spengler's possible presence in *DE* has received scant attention, as previous attempts to identify the book's anonymous *lebensphilosophisch* interlocutor have, following Axel Honneth, turned to Ludwig Klages and his vitalist attack on modern "logocentrism" in *The Spirit as Adversary of the Soul* (*Der Geist als Widersacher der Seele*, 1929–32).[47] Even David Roberts, who underscores the domination of nature as the common theme Adorno shared with Spengler, limits his exploration to Adorno's *Philosophy of New Music* (*Philosophie der neuen Musik*) and the traces of Spengler's morphology of Faustian music in Adorno's theory of musical rationalization.[48] Yet, as the epigraphs of the present article indicate, besides Klages's doctrines we should also see Spengler's "anthropological dialectics of nature"—as Adorno dubbed Spengler's conception in his critical 1932 review of *Man and Technics*[49]—as the source that provoked Adorno and Horkheimer to meditate on instrumental reason. Further speaking for this conclusion is yet another intriguing comment by Horkheimer on Adorno's Spengler essay. Horkheimer suggested that Adorno's critique of Spengler's conception could function as a springboard for *DE*: "We can reopen [the theme of] the dialectic of nature from here."[50]

In *Man and Technics* Spengler cast the human being as a beast of prey, "a foe to everyone, killing, *hating,* resolute to conquer or die." With his hand and thought this "inventive carnivore" had imprinted the entire globe to such a

---

45. Adorno, "Spengler Today," 322.
46. Gangl, "Controversy over Friedrich Pollock's State Capitalism," 30–31.
47. Friedman, *Political Philosophy of the Frankfurt School*, 82–84; Honneth, "Anthropologische Berührungspunkte." See also Wellmer, *Persistence of Modernity*, 3–4; and Stauth, "Critical Theory and Pre-fascist Social Thought."
48. Roberts, *Art and Enlightenment*, 73–74, 81; Adorno, *Philosophy of New Music.*
49. Adorno, review.
50. Horkheimer to Adorno, June 23, 1941, in *Briefe und Briefwechsel, 1938–1944*, 154.

degree that it seemed appropriate "to call *his* brief history 'world-history.'" Yet this history, in which nature formed merely "a background, an object, and a means," was not that of freedom and justice. Instead, a path led "from the primeval warring of extinct beasts to the processes of modern inventors and engineers" and "from the trick, oldest of all weapons," to modern technology. But this was a Faustian tragedy in Goethe's sense, for domination turned against human beings themselves. "The thinking, the intellect, the reason" sets "itself up against soul and life." To his mighty calculative capacity, the human being "sacrifices an important element of *his own* life," for it "requires a firmer and firmer hold on the life of the soul." This tragedy was universal, but it reached its climax in modern European "machine culture," which was rapidly moving toward its end. Yet Spengler saw something dignifying in all this. It resided in resolutely following the dictates of one's own culture, its soul. "The honourable end is the one thing that can *not* be taken from man."[51]

Adorno and Horkheimer often come close to Spengler's view that there is only one logic in history: "The awakening of the subject is bought with the recognition of power as the principle of all relationships." This history begins with myths, first attempts at the rational mastery of nature, which conceive the world in terms of "cyclical motion, fate, [and] domination." Self-preservation can be won only by sacrificial adjustment to the rules of the game without a hope for changing them. Enlightenment continues this mythic logic by other means. "Repetition, in the guise of regularity, imprisons human beings in the cycle now objectified in the laws of nature." Francis Bacon's celebration of the "'happy match' between human understanding and the nature of things" conceives knowledge as power and utility. Modern positivism has as little room for myths and religion as it has for unsystematic and unmathematical ideas like freedom or human rights (*DE*, 2–10, 20–22).

*DE* diverged decisively, however, from Spengler by stressing that cognitive domination was founded on social domination: "The distance of subject and object, the presupposition of abstraction, is founded on the distance from things which the ruler attains by means of the ruled." Again, the impulse to dominate originates not in some carnivore ethics or mysterious dictates of the Faustian "soul" but in real fear in the face of overpowering nature. Most important, Horkheimer and Adorno see a way out. Civilization has advanced "not only mastery but also the prospect of its alleviation." Everything depends on thinking becoming self-reflective. Besides abstract formalism that distances

---

51. Spengler, *Man and Technics*, 11–12, 22, 25–26, 40–44, 57–59, 69, 90, 103–4.

humans from nature and each other, thinking also "enables the distance that perpetuates injustice to be measured. Through this remembrance of nature within the subject, a remembrance which contains the unrecognized truth of all culture, enlightenment is opposed in principle to power." This happens in G. W. F. Hegel's "determinate negation," which understands truth as not increasing distance from objects but disclosing their "social, historical, and human meaning" (*DE*, 9, 17–22, 32).[52]

From *DE*'s perspective, Spengler's eyes, although a little selective, did not lie in viewing previous history as unrestrained domination. Yet by seeing no alternative, Spengler misunderstood second nature as first, appearance as essence. In *Decline*, Spengler constructed his cyclical theory of history on an unquestionable belief in an all-encompassing will to power. For Adorno and Horkheimer, this was a view of history caught in myth. Again, in *Man and Technics*, subtitled "a contribution to a philosophy of life," Spengler ironically succumbed to overt intellectualism by ignoring material needs and bodily affectivity as the real motor of history. By celebrating resignation as something heroic, Spengler took the domination of inner nature to its extreme. It was Adorno's emphasis on just this dubious connection in Spengler's thought between absolute subjectivity ("cultural souls"), unaffected by natural factors, and absolute bondage (resignation to the dictates of these souls) that Horkheimer had praised in his comments on Adorno's essay and proposed as a point of departure for their own meditations on history.

This analysis suggests, then, that Spengler stimulated Adorno and Horkheimer's critique of domination of nature. Both saw in Adorno's Spengler essay important insights that could function as a springboard for *DE*. Certainly, other works were considered, too: Adorno's *Philosophy of New Music* (the first part of which dates from 1940–41) and Horkheimer's "End of Reason." Nor should we forget the 1942 debate in the institute over Friedrich Nietzsche as another signpost in the early Frankfurt School's (especially Horkheimer's) path from Marxist ideology critique to a more sweeping critique of the whole of Western civilization.[53] The core theme in these works and in the Nietzsche

---

52. Although Friedman rightly sees Spengler as an inspiration behind *DE*, he oversimplifies by maintaining that Horkheimer and Adorno "had profound sympathies with Spengler's emphasis on the cultural event as the ground of historical being" (*Political Philosophy of the Frankfurt School*, 82). I would contend, in contrast, that although the Marxist critique of political economy has taken a back seat in *DE*, the book builds on a materialist foundation by stressing affectivity and material needs as well as social domination as decisive in history.

53. Horkheimer to Adorno, August 28, 1941, in *Briefe und Briefwechsel, 1938–1944*, 212–18; Abromeit, *Max Horkheimer*, 394–95.

debate, however, was the same as in Adorno's Spengler essay: domination of outer and inner nature as the definitive feature of Western history.

What about Freud? The Frankfurt School would be unthinkable without Freud's libido theory and his emphasis on human beings' natural condition as a key to understanding their history. Freud offered a psychoanalytic account of the emergence of human subjectivity from nature and bemoaned how this civilizing process had hardened humans' affective capacities to such a degree that they struggled to enjoy the fruits of this process.[54] As to modern Europe, Freud questioned "the liberalistic illusion that the progress of civilization would automatically bring about an increase of tolerance and a lessening of violence against out-groups."[55] *The Authoritarian Personality* relied on Freud to explain what it saw as a new authoritarian character type: "enlightened and superstitious, proud to be an individualist and in constant fear of not being like all the others, jealous of his independence and inclined to submit blindly to power and authority."[56] One commentator even describes the book as "a continuation of the *Dialectic of Enlightenment* by other means."[57]

But as undeniable as Freud's presence in *DE* is, Adorno and Horkheimer never identified with him entirely. For them, racist prejudice, or psychological phenomena in general, was not independent from larger societal forces. Indeed, contrary to the official stand of *The Authoritarian Personality*, they maintained that most recent history, with its increasing concentration of power, had made psychoanalysis obsolete. The autonomous individual of the liberal-capitalist period, the model for Freud's thought, no longer existed. For Adorno and Horkheimer, fascism and the culture industry had undermined the very foundations of the individual and were, in the words of their colleague Leo Löwenthal, "psychoanalysis in reverse."[58]

Spengler's analysis of Caesarism, in contrast, paid attention to modern political and cultural factors facilitating the decline of the individual. Although the exact dialectic interconnecting these factors escaped Spengler, their outcome, the atomized city dweller, was at the heart of his analysis. Adorno always insisted that ego weakness was not limited to people living under totalitarian regimes. In 1950, the year *The Authoritarian Personality* was published, he wrote to Thomas Mann about Spengler's "caveman" as a fitting characteriza-

54. Freud, *Civilization and Its Discontents*.
55. Adorno, "Freudian Theory," 129.
56. Adorno et al., *Authoritarian Personality*, lxxi.
57. Müller-Doohm, *Adorno*, 292.
58. Gordon, "Authoritarian Personality Revisited," 59–67. For Adorno's deviation from the official line of *The Authoritarian Personality*, see Adorno, "Remarks on *The Authoritarian Personality*."

tion not only of the Germans of the Nazi era but also those of the postwar period.[59] And in 1964, in discussing Spengler and Freud, Adorno cited David Riesman's idea of the other-directed character as an apt diagnosis of the widespread ego weakness in the United States.[60] To be sure, Adorno applauded Freud's *Civilization and Its Discontents* (*Das Unbehagen in der Kultur*) for the attention it gave to the qualitatively new pressures of modern industrial society, simultaneously criticizing Spengler's ahistorical cultural morphology (WSR, 28). Yet elsewhere Adorno praised Spengler's historically sensitive analysis of Caesarism for similar insights against Spengler's own self-understanding as a morphologist of historical invariants.

Finally, we have Benjamin. "There is no document of culture which is not at the same time a document of barbarism."[61] This sentence from Benjamin's so-called theses on the philosophy of history, written shortly before his suicide in 1940 and published posthumously as "On the Concept of History" (*Über den Begriff der Geschichte*), reads like a crystallization of the message of *DE*. Indeed, on receiving a copy of Benjamin's theses from Hannah Arendt in June 1941, Adorno reported in an often-cited letter to Horkheimer that "none of Benjamin's works shows him closer to our own intentions. More than anything it is about the idea of history as a permanent catastrophe, the critique of progress as domination of nature, and the stance towards culture." On less well-known lines of the letter, however, Adorno continued: "Here there is a coincidence that has moved me a lot. The sentence in thesis VII on culture und barbarism stands *verbatim* in the last paragraph of Spengler [essay]."[62] In his Spengler essay, Adorno had polemicized against the naivete of Weimar intelligentsia by demanding awareness "of the element of barbarism inherent in culture itself." Written in April 1941, Adorno had composed his essay independently of Benjamin's theses: "We both knew nothing about each other's formulations."[63]

Nothing would be more foolish than to belittle Benjamin's weighty, and well-recorded, influence on Adorno and, by extension, on *DE*. Adorno's

59. Adorno to Mann, June 3, 1950, in *Briefe und Briefwechsel*, 3:61.
60. Adorno, *History and Freedom*, 6–7; Riesman, *Lonely Crowd*, 19–24.
61. Benjamin, "On the Concept of History," 392.
62. Adorno to Horkheimer, June 12, 1941, in *Briefe und Briefwechsel, 1938–1944*, 144–45.
63. Adorno to Horkheimer, June 12, 1941, in *Briefe und Briefwechsel, 1938–1944*, 145. The original draft, titled "Spengler und die gegenwärtige Situation," is dated April 18, 1941, Theodor W. Adorno Archive Ts 23399–23419, Institute for Social Research, Goethe University, Frankfurt am Main. Adorno sent his essay to Horkheimer in late May; Adorno to Horkheimer, May 31, 1941, in *Briefe und Briefwechsel, 1938–1944*, 126.

*Habilitation* on Kierkegaard (1933) and his lecture "The Idea of Natural-History" (1932)—which both offered a proto version of *DE*'s idea of the entwinement of myth and reason—built on Benjamin's 1928 *Origin of the German Trauerspiel* (*Ursprung des deutschen Trauerspiels*). Again, over the 1930s Adorno, despite his differences with Benjamin, waited enthusiastically for his friend to complete his grandiose lifework on the Paris arcades ("Passagenwerk").[64] And by 1941 Horkheimer, who earlier had disliked the *geschichtsphilosophisch*, quasi-theological bent of Benjamin's cultural criticism, had changed his mind. In the same letter that endorsed Adorno's Spengler essay, Horkheimer proposed that they adopt as "theoretical axioms" some of Benjamin's ideas, such as Benjamin's claim that official historiography, by sympathizing with the victor, adores "cultural treasures" that "owe their existence not only to the efforts of the great geniuses who created them, but also to the anonymous toil of others who lived in the same period."[65]

To conclude, it would be a mistake not to consider Spengler as a stimulation to *DE*'s view that Western history, driven by science and technology, was not *by chance* anything but a linear and unambiguous triumph of freedom. As Adorno insisted, Spengler "more strikingly than almost anyone else" has shown how "the raw nature of culture" time and again "drives it toward decay and how, as a form and order, culture is affiliated with that blind domination which, through permanent crises, is always prone to annihilate itself and its victims."[66] Spengler's insight into "the dual character of enlightenment," in addition to those of Weber, Freud, and Benjamin, opened Adorno's eyes to the Janus-faced character of Western civilization. He credited Spengler for the ability to direct "attention towards the 'system' in the individual, even where it assumes a semblance of freedom which conceals the universal dependency." At the same time, Spengler was utterly incapable of conceiving a qualitatively different future beyond the Hobbesian *bellum omnium contra omnes* that he, echoing the nihilistic zeitgeist of interwar Germany, adored with morbid fascination. *DE*, as an effort at genuinely historical thinking, should be read as an attempt to divorce Spengler's *Zivilisationskritik* from its radical-conservative universe and to put it into service of "impulses which go beyond all previous history as the history of domination" (SD, 57, 61–62).

64. Buck-Morss, *Origin of Negative Dialectics*, 59, 168–75; Hullot-Kentor, "Foreword," xi, xv; Wolin, *Walter Benjamin*, 265–72.

65. Horkheimer to Adorno, June 23, 1941, in *Briefe und Briefwechsel, 1938–1944*, 155; Benjamin, "On the Concept of History," 391–92.

66. Adorno, "Spengler Today," 324.

### Trumpism: Adorno and the Neoliberal Caesarism

Spengler had spent his energies, Adorno lamented, on obscure speculations on "how and why various historical epochs blindly displace each other," as if such blindness would have to accompany human undertakings for good. "The important question," Adorno emphasized instead, is "whether mankind will learn to determine itself." Potential for such a learning process did not look unrealistic, "for reason and its objective virtues make possible a rational and genuinely free organization of the world" (WSR, 29). Until then, however, cheap dismissals of Spengler were premature. In the 1950s Adorno found Spengler's challenge anything but untimely, no matter how much things had improved after 1945. What about our twenty-first-century West? The social-democratic welfare state was a promising step in the right direction, yet the neoliberal havoc since the late 1970s has created a world in which, especially in the aftermath of the 2008 economic crisis, Adorno's question appears urgent. Moreover, recent interest in Adorno's thought provoked by Donald Trump's racist, misogynist, and lie-filled presidency raises the question of whether it was Adorno's effort to make Spengler's analysis of Caesarism serve progressive ends that today makes his critical theory—instead of obsolete gloominess—an asset in analyzing authoritarian populism.

Not long ago Adorno's thought was deemed outdated pessimism out of touch with the twenty-first century. But now he seems to have returned to shake the Frankfurt School tradition, guided for decades by the efforts of his most famous student, Habermas, to update critical theory, shaped in the dark interwar era, to the more hopeful postwar world. Notwithstanding Habermas's laudable achievements in filling the "liberal-democratic deficit" of the early Frankfurt School, defending enlightenment against postmodernism and EU technocrats, and acting as Germany's public conscience over the past seventy years, critics claim that in his hands the Frankfurt School tradition has come to resemble the Anglo-American liberal tradition of John Rawls and others. Critics complain that Habermas is too focused on normative questions and too detached from deep historical analyses to explain why the world is moving toward inequality, racism, and ethnopopulism instead of universal justice. In this situation, many commentators have argued for Adorno's relevance in explaining these troubling phenomena.

*The Authoritarian Personality* has been particularly appealing. Richard Wolin calls attention to authoritarians' hostility to all racial minorities (e.g., Jews and Muslims) and distrust of liberal-democratic principles. Persuaded by racist images of populist rhetoric, they replace "rational thought and policy

goals with libidinal cathexis" with demagogic leaders like Trump. Although always controversial, *The Authoritarian Personality* has found corroboration in more recent American studies on Trumpism.[67] Again, Samir Gandesha suggests that while ours is no longer the Ford-Keynesian economy of Adorno's days, his insights may be even more relevant today at the time of the "neoliberal personality." Neoliberal marketization of social relations promised to create a world in which individuals "can exercise their capacity to articulate their own interests autonomously and rationally within the context of a genuine plurality of other such interests." But by undermining the welfare state, it has instead increased "a sense of social insecurity," created "surplus of aggression, humiliation and guilt," and strengthened "atavistic allegiances, xenophobic nationalism, racism and sexism."[68] Even commentators less convinced by social-psychological explanations seek to build on Adorno's legacy. For Peter E. Gordon, right-wing populism is less about the fury of allegedly authoritarian, uneducated workers manipulated by Fox News than about the long-term negative impact of the "culture industry" on critical thinking throughout the political spectrum. In similar vein, Max Pensky joins Adorno and Alexis de Tocqueville to trace the current authoritarian backlash to the depoliticizing potentials inherent in liberal democracy itself.[69]

Remarkably, the problems highlighted by these scholars—the psychological effectiveness of populist propaganda, uncritical mass media, and decay of parliamentary virtues—are very much the same that Adorno called attention to in Spengler's portrait of Caesarism. For Adorno, Spengler's merit was his attention to phenomena, ignored by the progressives of the 1920s, that showed the world moving away from rather than toward freedom and justice. From the perspective of the resurgence of authoritarianism today, it seems that Adorno's effort to repurpose Spengler's Caesarism for left-wing ends gave him an edge over other progressive, but too optimistic, social theorists, such as Habermas, as well as those countless commentators who in the 1990s bought into Francis Fukuyama's notion of the "end of history." Nevertheless, we should carefully weigh the pros and cons of Adorno's effort to critically appropriate Spengler.

I would contend that Adorno both succeeded and failed in repurposing Spengler. The fruitfulness of Adorno's thought lies in his sober suspicion of historical progress and sensitivity to the fragile nature of democracy. The

---

67. Wolin, "Our 'Prophet of Deceit'"; MacWilliams, *Rise of Trump*.
68. Gandesha, "'Identifying with the Aggressor,'" 148–51.
69. Gordon, "Authoritarian Personality Revisited," 67–79; Pensky, "Radical Critique and Late Epistemology."

important thing is not to repeat the mistakes of Weimar champions of reason and enlightenment; today this would mean, for example, rejecting the uncritical belief in a necessary coexistence of capitalism and liberal democracy. I see this sober caution as a fruit of Adorno's engagement with dark thinkers such as Spengler. Yet this engagement had as its downside Adorno's occasionally disproportionate pessimism. This is most visible in *DE*, which, even when acknowledged was written in the darkest possible hour, resulted in an almost total equation of Western reason with instrumental calculation. Even if it is true that *DE*'s rare optimistic moments came more from Adorno's, rather than Horkheimer's, hand, only in comparison to thinkers like Spengler do these moments appear optimistic.[70] From other perspectives, heartened by such recent examples as the Occupy movement, Black Lives Matter, the MeToo campaign, and young people's climate marches, *DE* succumbs to the similar undifferentiated conception of bondage that Adorno criticized in Spengler. Adorno's thought is an asset in grasping the causes and appeal of authoritarianism today. Yet the Frankfurt School tradition contains even better sources to make sense of our neoliberal and authoritarian era. Rather than Adorno's pessimistic or Habermas's optimistic positions, which both suffer from a lack of historical specificity, we should update Horkheimer's original, historically concrete idea of critical theory as a multidisciplinary analysis of capitalism, a position Horkheimer abandoned at the turn of 1940s largely due to Adorno's— and, as I have tried to show, Spengler's—influence.[71]

**Mikko Immanen** teaches philosophy at the University of Jyväskylä, Finland.

70. On these rare glimpses of hope in *DE* and on the question of authorship, see Rabinbach, *In the Shadow of Catastrophe*, 169–71.

71. For what this update might look like today, see Abromeit, *Max Horkheimer*, 1–18; and Fraser and Jaeggi, *Capitalism*.

## References

Abromeit, John. *Max Horkheimer and the Foundations of the Frankfurt School*. Cambridge: Cambridge University Press, 2011.

Adorno, Theodor W. *Briefe und Briefwechsel*. Vol. 3, *Theodor W. Adorno/Thomas Mann: Briefwechsel, 1943–1955*, edited by Christoph Gödde and Thomas Sprecher. Frankfurt am Main: Suhrkamp, 2002.

Adorno, Theodor W. *Briefe und Briefwechsel*. Vol. 4, *Theodor W. Adorno/Max Horkheimer. Briefwechsel 1927–1969, Bd. II: 1938–1944*, edited by Christoph Gödde and Henri Lonitz. Frankfurt am Main: Suhrkamp, 2004.

Adorno, Theodor W. *Briefe und Briefwechsel*. Vol. 5, *Briefe an die Eltern, 1939–1951*, edited by Christoph Gödde and Henri Lonitz. Frankfurt am Main: Suhrkamp, 2003.

Adorno, Theodor W. *Der Begriff des Unbewussten in der transzendentalen Seelenlehre*. In *Philosophische Frühschriften*. Vol. 1 of *Gesammelte Schriften*, edited by Rolf Tiedemann, 79–322. Frankfurt am Main: Suhrkamp, 1973.

Adorno, Theodor W. "Freudian Theory and the Pattern of Fascist Propaganda." In *The Essential Frankfurt School Reader*, edited by Andrew Arato and Eike Gebhardt, 118–37. New York: Continuum, 1988.

Adorno, Theodor W. *History and Freedom: Lectures, 1964–1965*, edited by Rolf Tiedemann, translated by Rodney Livingstone. Cambridge: Polity, 2008.

Adorno, Theodor W. "The Meaning of Working Through the Past," translated by Henry W. Pickford. In *Critical Models: Interventions and Catchwords*, 89–103. New York: Columbia University Press, 2005.

Adorno, Theodor W. *Minima Moralia: Reflections from Damaged Life*, translated by E. F. N. Jephcott. London: Verso, 2000.

Adorno, Theodor W. *Nachgelassene Schriften. Abteilung IV: Vorlesungen*. Vol. 12, *Philosophische Elemente einer Theorie der Gesellschaft*, edited by Tobias ten Brink and Marc Phillip Nogueira. Frankfurt am Main: Suhrkamp, 2008.

Adorno, Theodor W. *Philosophy of New Music*, edited and translated by Robert Hullot-Kentor. Minneapolis: University of Minnesota Press, 2006.

Adorno, Theodor W. "Remarks on *The Authoritarian Personality*." In *The Authoritarian Personality*, by Theodor W. Adorno, Else Frenkel-Brunswik, Daniel J. Levinson, and R. Nevitt Sanford, xli–lxvi. London: Verso, 2019.

Adorno, Theodor W. Review of *Der Mensch und die Technik: Beitrag zu einer Philosophie des Lebens*, by Oswald Spengler. *Zeitschrift für Sozialforschung* 1, nos. 1–2 (1932): 149–51.

Adorno, Theodor W. "Spengler after the Decline." In *Prisms*, translated by Samuel Weber and Shierry Weber, 51–72. Cambridge, MA: MIT Press, 1981.

Adorno, Theodor W. "Spengler nach dem Untergang: Zu Oswald Spenglers 70. Geburtstag." *Monat* 2, no. 20 (1950): 115–28.

Adorno, Theodor W. "Spengler Today." *Studies in Philosophy and Social Science* 9, no. 2 (1941): 305–25.

Adorno, Theodor W. "Was Spengler Right?" *Encounter* 26, no. 1 (1966): 25–29.

Adorno, Theodor W. "Wird Spengler recht behalten?" *Frankfurter Hefte* 10, no. 12 (1955): 841–46.

202   Days of the Cavemen?

Adorno, Theodor W., Else Frenkel-Brunswik, Daniel J. Levinson, and R. Nevitt Sanford. *The Authoritarian Personality*. London: Verso, 2019.

Benjamin, Walter. "On the Concept of History," translated by Harry Zohn. In vol. 4 of *Selected Writings*, edited by Howard Eiland and Michael W. Jennings, 389–400. Cambridge, MA: Harvard University Press, 2003.

Bernstein, Jay M. "Negative Dialectic as Fate: Adorno and Hegel." In *The Cambridge Companion to Adorno*, edited by Tom Huhn, 19–50. Cambridge: Cambridge University Press, 2004.

Buck-Morss, Susan. *The Origin of Negative Dialectics: Theodor W. Adorno, Walter Benjamin, and the Frankfurt Institute*. New York: Free Press, 1979.

Clayton, John P. *The Concept of Correlation: Paul Tillich and the Possibility of a Mediating Theology*. Berlin: de Gruyter, 1980.

*Constellations: An International Journal of Critical and Democratic Theory*. "Special Section on Frankfurt School and Nietzsche." 8, no. 1 (2001): 127–47.

Fraser, Nancy, and Rahel Jaeggi. *Capitalism: A Conversation in Critical Theory*, edited by Brian Milstein. Cambridge: Polity, 2018.

Freud, Sigmund. *Civilization and Its Discontents*, translated by David McLintock. London: Penguin, 2002.

Friedman, George. *The Political Philosophy of the Frankfurt School*. Ithaca, NY: Cornell University Press, 1981.

Gandesha, Samir. "'Identifying with the Aggressor': From the Authoritarian to Neoliberal Personality." *Constellations: An International Journal of Critical and Democratic Theory* 25, no. 1 (2018): 147–64.

Gangl, Manfred. "The Controversy over Friedrich Pollock's State Capitalism." *History of the Human Sciences* 29, no. 2 (2016): 23–41.

Gasimov, Zaur, and Carl Antonius Lemke Duque, eds. *Oswald Spengler als europäisches Phänomen: Der Transfer der Kultur- und Geschichtsmorphologie im Europa der Zwischenkriegszeit, 1919–1939*. Göttingen: Vandenhoeck und Ruprecht, 2013.

Gordon, Peter E. *Adorno and Existence*. Cambridge, MA: Harvard University Press, 2016.

Gordon, Peter E. "The Authoritarian Personality Revisited: Reading Adorno in the Age of Trump." In *Authoritarianism: Three Inquiries in Critical Theory*, by Wendy Brown, Peter E. Gordon, and Max Pensky, 45–84. Chicago: University of Chicago Press, 2018.

Habermas, Jürgen. *Reason and the Rationalization of Society*. Vol. 1 of *The Theory of Communicative Action*, translated by Thomas McCarthy. Boston: Beacon, 1984.

Herf, Jeffrey. *Reactionary Modernism: Technology, Culture, and Politics in Weimar and the Third Reich*. Cambridge: Cambridge University Press, 1986.

Hobsbawm, Eric. *The Age of Extremes: The Short Twentieth Century, 1914–1991*. London: Abacus, 1994.

Honneth, Axel. "Anthropologische Berührungspunkte zwischen der lebensphilosophischen Kulturkritik und der 'Dialektik der Aufklärung.'" In *21. Deutscher Soziologentag 1982: Beiträge der Sektions- und ad hoc-Gruppen*, edited by Friedrich Heckmann and Peter Winter, 786–92. Opladen: Westdeutscher Verlag, 1983.

Horkheimer, Max. "The End of Reason." *Studies in Philosophy and Social Science* 9, no. 3 (1941): 366–88.

Horkheimer, Max. "Zur Emanzipation der Philosophie von der Wissenschaft." In *Nachgelassene Schriften, 1914–1931*. Vol. 10 of *Gesammelte Schriften*, edited by Alfred Schmidt, 334–419. Frankfurt am Main: Suhrkamp, 1990.

Horkheimer, Max, and Theodor W. Adorno. *Dialectic of Enlightenment: Philosophical Fragments*, translated by Edmund Jephcott. Stanford, CA: Stanford University Press, 2002.

Hughes, H. Stuart. *Oswald Spengler: A Critical Estimate*. New York: Scribner's Sons, 1952.

Hullot-Kentor, Robert. "Foreword: Critique of the Organic." In *Kierkegaard: Construction of the Aesthetic*, by Theodor W. Adorno, edited and translated by Robert Hullot-Kentor, x–xxiii. Minneapolis: University of Minnesota Press, 1989.

Immanen, Mikko. *Toward a Concrete Philosophy: Heidegger and the Emergence of the Frankfurt School*. Ithaca, NY: Cornell University Press, 2020.

Jay, Martin. *Adorno*. Cambridge, MA: Harvard University Press, 1984.

Jay, Martin. *The Dialectical Imagination: A History of the Frankfurt School and the Institute of Social Research, 1923–1950*. Berkeley: University of California Press, 1996.

*Logos: Internationale Zeitschrift für Philosophie der Kultur*. "Spenglerheft." 9, no. 2 (1920–21): 133–295.

MacWilliams, Matthew C. *The Rise of Trump: America's Authoritarian Spring*. Amherst, MA: Amherst College Press, 2016.

Mazover, Mark. *Dark Continent: Europe's Twentieth Century*. New York: Penguin, 1998.

Merlio, Gilbert, and Daniel Meyer, eds. *Spengler ohne Ende: Ein Rezeptionsphänomen im internationalen Kontext*. Frankfurt am Main: Lang, 2014.

Michels, Robert. *Political Parties: A Sociological Study of the Oligarchical Tendencies of Modern Democracy*, translated by Eden Paul and Cedar Paul. New York: Free Press, 1962.

Mörchen, Hermann. *Adorno und Heidegger: Untersuchung einer philosophischen Kommunikationsverweigerung*. Stuttgart: Klett-Cotta, 1981.

Müller-Doohm, Stefan. *Adorno: A Biography*, translated by Rodney Livingstone. Cambridge: Polity, 2005.

Pensky, Max. "Radical Critique and Late Epistemology: Tocqueville, Adorno, and Authoritarianism." In *Authoritarianism: Three Inquiries in Critical Theory*, by Wendy Brown, Peter E. Gordon, and Max Pensky, 85–124. Chicago: University of Chicago Press, 2018.

Pollock, Friedrich. "State Capitalism: Its Possibilities and Limitations." *Studies in Philosophy and Social Science* 9, no. 2 (1941): 200–225.

Rabinbach, Anson. *In the Shadow of Catastrophe: German Intellectuals between Apocalypse and Enlightenment*. Berkeley: University of California Press, 1997.

Riesman, David. *The Lonely Crowd: A Study of the Changing American Character*. New Haven, CT: Yale University Press, 2001.

Roberts, David. *Art and Enlightenment: Aesthetic Theory after Adorno*. Lincoln: University of Nebraska Press, 1991.

Shotwell, James T. "Spengler." In *The Faith of an Historian and Other Essays*, 221–29. New York: Walker, 1964.

Sombart, Werner. *Why Is There No Socialism in the United States?*, translated by Patricia M. Hocking and C. T. Husbands. London: Macmillan, 1976.

Spengler, Oswald. *The Decline of the West*, translated by Charles Francis Atkinson. 2 vols. New York: Knopf, 1994.

Spengler, Oswald. *Man and Technics: A Contribution to a Philosophy of Life*, translated by Charles Francis Atkinson. London: Allen and Unwin, 1932.

Stauth, Georg. "Critical Theory and Pre-fascist Social Thought." *History of European Ideas* 18, no. 5 (1994): 711–27.

Stone, Ronald H. *Professor Reinhold Niebuhr: A Mentor to the Twentieth Century*. Louisville, KY: Westminster / John Knox, 1992.

Strauss, Leo. "Kurt Riezler." In *What Is Political Philosophy? and Other Studies*, 233–60. Chicago: University of Chicago Press, 1988.

*Telos*. "Special Section on Carl Schmitt and the Frankfurt School." No. 71 (1987): 37–109.

Villa, Dana. "Weber and the Frankfurt School." In *The Routledge Companion to the Frankfurt School*, edited by Peter E. Gordon, Espen Hammer, and Axel Honneth, 266–81. New York: Routledge, 2019.

Weber, Max. "Science as a Vocation." In *From Max Weber: Essays in Sociology*, edited and translated by H. H. Gerth and C. Wright Mills, 129–56. New York: Oxford University Press, 1958.

Wellmer, Albrecht. *The Persistence of Modernity: Essays on Aesthetics, Ethics, and Postmodernism*. Cambridge, MA: MIT Press, 1991.

*Werk und Wirken Paul Tillichs: Ein Gedenkbuch*. Stuttgart: Evangelisches Verlagswerk, 1967.

Wiggershaus, Rolf. *The Frankfurt School: Its History, Theories, and Political Significance*, translated by Michael Robertson. Cambridge: Polity, 1994.

Wolin, Richard. "Our 'Prophet of Deceit': WWII-Era Social Scientists Explained Trump's Appeal." *Chronicle of Higher Education*, October 30, 2016. www.chronicle.com /article/Our-Prophet-of-Deceit/238176.

Wolin, Richard. *Walter Benjamin: An Aesthetic of Redemption*. Berkeley: University of California Press, 1994.

Wolin, Richard. "Walter Benjamin Today." In *Labyrinths: Explorations in the Critical History of Ideas*, 55–82. Amherst: University of Massachusetts Press, 1995.

Woods, Roger. *The Conservative Revolution in the Weimar Republic*. New York: Palgrave Macmillan, 1996.

# On Anson Rabinbach's Staging the Third Reich

## Steven E. Aschheim

Reading Anson Rabinbach's exciting volume *Staging the Third Reich: Essays in Cultural and Intellectual History* is a demanding but worthwhile intellectual adventure. Happily lacking in fashionable jargon and ideological dogmatism, these essays typify a lifetime of sophisticated historiographical inquiry and critical political and cultural reflection. Rabinbach, an emeritus Princeton historian and, as its readers are aware, a cofounder of *New German Critique*, is well known for his books *The Crisis of Austrian Socialism: From Red Vienna to Civil War, 1927–1934* (1983), *The Human Motor: Energy, Fatigue, and the Origins of Modernity* (1990), *In the Shadow of Catastrophe: German Intellectuals between Apocalypse and Enlightenment* (1997), and his original take on conceptual history, *Begriffe aus dem Kalten Krieg: Totalitarismus, Antifaschismus, Genozid* (2009). Together with Sander Gilman, he edited *The Third Reich Sourcebook* (2013). Most recently he has elaborated on his earlier work in *The Eclipse of the Utopias of Labor* (2018). The volume under review here, skillfully edited and introduced by Stefanos Geroulanos and Dagmar Herzog, brings together twenty essays, some of which were originally published in *New German Critique*, as well as other less accessible pieces covering a long period from 1973 to a revealing 2019 interview.

*Staging the Third Reich* focuses on Nazism, fascism, and antifascism and the inextricably related aftermath of these movements in politics, public memory, and historiography, respectively. The very title of the volume reflects this dialectic. It refers not only to the ways in which Nazis, fascists, and antifascists

*New German Critique* 143, Vol. 48, No. 2, August 2021
DOI 10.1215/0094033X-8989330   © 2021 by New German Critique, Inc.

presented, or literally staged, their respective movements in real time but also to the politically inflected, dynamic rehearsing[1] of their significance (or otherwise) in subsequent years. Throughout the five decades in which these essays were written, one finds a remarkable consistency in sensibility, thought, and method. As the volume's editors insightfully note, while Rabinbach has always been open to various theoretical (most prominently) post-Marxist, Frankfurt School, Foucauldian, and psychoanalytic approaches, which have helped him think through various methodological problems and substantive issues afresh, he has never been straitjacketed by them. Rather, his almost instinctive drive is to draw not on "theory" but on a broadly conceived notion of "culture" that functions not merely as a superstructural component of political and socioeconomic phenomena but as a "driver of historical change in its own right" (3).

More specifically, from the start of his career Rabinbach dismissed the contention that Nazism had no culture, was bereft of any ideas, and was simply a kind of doctrineless nihilism. Rejecting notions that Nazism had to fit into the rubric of either "fascism" or "totalitarianism," Rabinbach, like his teacher, George L. Mosse, endowed Nazism with distinctive cultural and intellectual content. "Cultural" history was essential if one were to grasp National Socialism.[2] This approach also characterized the writings of other German Jewish exiles such as Fritz Stern and Peter Gay, whom Rabinbach cites as influences in his interview. Yet various aspects distinguish Rabinbach's approach from those of his mentors. His work is marked by more detailed empirical analyses and nuanced assessments of the political and cultural dynamics constantly at work. His historical players, be they elites, ordinary people, the masses (or "the mob," as one essay employing Hannah Arendt's terminology has it), are always in interactive and coconstitutive mode. This infuses his notion of culture with its dynamic and multivalent character. He argues, for instance, that there are no permanent fascist or Nazi or antifascist ideological essences, just "sensibilities" (*Gesinnungen*) and shifting interested fusions and syntheses, both in real time and in their subsequent deployments. Thus, in numerous essays on National Socialist popular acquiescence and support—as well as the highly dubious role of academics and universities—Rabinbach demonstrates that intellectual fealty required an "ethos," a willingness to adhere to a worldview vague and indistinct enough to embrace related perspectives (122).

1. While in contemporary theater the word refers to performance preparation, its etymology from the Old French fits what is intended here: "to rake over," "to give an account of" (www.etymonline.com /word/rehearse).

2. For an analysis of the cultural turn among German Jewish exiles, see the chapter "The Tensions of Historical *Wissenschaft*: The Émigré Historians and the Making of German Cultural History" in Aschheim, *Beyond the Border*.

To be sure, Rabinbach does not leave things entirely open-ended: even though no single version of "Nazi ideology" became hegemonic in the Third Reich, the general *Gesinnung* presupposed and thereby set the normative agenda. As he puts it: "Whether 'race' was to be defined biologically, culturally, anthropologically, or philosophically, remained, at least in principle and for a time, a relatively open and controversial question. What was crucial, however, was not that compulsory concepts were *decided upon*, but that such questions were *discussed* in the schools, the judiciary, and in the university faculties" (122). In this way, the basic political premises of the regime, and the subtle shifts in meaning attached to traditional concepts like *Reich*, *Führung*, and *Volk*, transformed them into daily, uncontroversial, matter-of-fact realities.

In other essays Rabinbach moves from reflections on evolving Marxist understandings of Nazism and general observations of the relations—and tensions—between the sacred, the aesthetic, and the popular dimensions in Nazi culture, to his pioneering 1976 study of the Nazi Beauty of Labor programs (and their surprising progressive antecedents) and the role of women in Nazi leisure and work organizations. He also provides close readings of popular literature to illuminate some of the subtleties and functions of major—though by now entirely forgotten—cultural offerings of the time. Thus, in his 1991 essay "Reflections on Private and Public Experience in the Third Reich," he demonstrates that a certain kind of literature under dictatorship, rather than reinforcing the potentially threatening distinction between the private and the public spheres, could actually reconcile the two. In a detailed study of Josefa Berens-Totenohl's 1934 best seller, *Der Femhof*, he shows that subtle reconciliation was partly achieved by a valorization of locality, the depiction of a sacred inner sanctum in which the external world is portrayed as a threat, the root of destruction. External incursions of outsiders such as Jews and Gypsies symbolized a disintegrative heterogeneity; freedom lay in guarding that homogeneous space. Such plots, moreover, resolved many of the tensions inherent to the regime: the universal law of justice with the "matriarchal" rebirth of nature and society, the irrational and the demonic with the rational, the paternal, and the productive (99).

While there is not enough space here for me to convey the richness and variety of topics covered in this volume, it is important to note some of the continuing concerns and insights that from early on have marked Rabinbach's work. Thus, already in 1976, he emphasized the dynamic dual nature and structure of Nazi policy, its tense fusion of "modernity" with premodern values. At the time, this was by no means a commonplace. In the "Beauty of Labor" essay, he was among the first to note National Socialist modernist

emphases on design, its cult of efficiency and technological productivity. These, he argued, forced Nazism to sidestep (if not abandon) its *völkisch* agrarian, anti-urban, anticapitalist rhetoric in favor of the imperatives of war production (22). With numerous variations and refinements, this theme recurs throughout the volume. Thus, in the realm of National Socialist culture, mythical and aesthetic stagings of premodern Nordic and Grecian heroics, with its emphases on peasant literature and medieval motifs, coexisted (or even sat comfortably) with modern commercial and pop culture. Mass consumption of love stories, comedies, and thrillers devoid of ideological motifs proceeded apace. Rabinbach also notes parenthetically that it was not perpetual anti-Semitic propaganda and mass ideological mobilization but these more quotidian offerings which made accommodation to the regime easier. In such an atmosphere Nazi racial dogmas and political utopias underwent a kind of domestication. Provocatively, he even suggests that the "potential for destruction may lie in the very normality and conventionality of many of the cultural concepts promoted by the Nazis" (119).[3]

For Rabinbach, then, Nazism and fascism are not simply atavistic throwbacks or capitalist reactions in an extreme mode. Nazism, fascism, Soviet totalitarianism, and American liberal democracy each represent alternative models of modernity, differing economic, cultural, and political responses to the challenges and crises of modernization. (Perhaps a future Rabinbach essay will consider the China model, which certainly could have been included here.) Thus National Socialism clearly was not, as many early interpretations had it, simply a revolt against or a rejection of modernity. *Völkisch* antimodernity could coexist with advanced industrial society, simply as an alternative form of modernity. Rabinbach formulates the relationship thus: "An embrace of technology and innovation was entirely compatible with Germanic spirituality, anti-materialism, imperial ambitions and a racist worldview" (123). Indeed, the interview with Rabinbach included in the collection takes as its title his insistence that "Nazism was a unique modernist project" (123). Rabinbach's ongoing emphasis on this aspect of Nazism in many ways complements the work of Jeffrey Herf and his concept of Nazism as "reactionary modernism."[4]

While the question of the National Socialist relation between "modernity" or its rejection has by now surely been settled, it inevitably becomes embedded in particular contested Holocaust interpretations. Its "modernity,"

3. Despina Stratigakos confirms Rabinbach's thesis by focusing on the architectural-cultural aspects of Nazi domesticity that embodied in many ways such feelings of "normality and conventionality" (*Hitler at Home*).

4. See Herf, *Reactionary Modernism*.

Rabinbach writes, is typically represented in terms of "administrative bureau-cracy, faceless desk-killers, mass factory death camps, social engineering on a grandiose scale, eugenics, population control and demographic planning, pub-lic hygiene, the modern drive to mastery and control—all this can be seen within the mainstream of European modernity" (399). But this is a description rather than an explanation. Rabinbach is quite aware that accounts which indict generalized and often ambiguous notions of "modernity" or "Enlightenment" as somehow explanatory of the event occupy such levels of removed abstrac-tion that a serious flattening of the historical particularities of the Jewish geno-cide is unavoidable. The debate has come to rest less on the question of its modernity than on that of the relation between "universal" factors as opposed to particular, context-grounded, ones. While Rabinbach leaves no doubt that more general or "universal" structures may be indispensable if we are to grasp the deeper motivational and civilizational dimensions underlying Nazi atrocities, if these are to transcend ahistorical abstractions, they must demon-strate the mediated connections, the transmission belts and concrete ties link-ing such general structures with the actual event, the particular transgressive context in which it unfolded and the taboo-breaking behavior that character-ized it.

Rabinbach has his own standpoint on the nexus between the Holocaust's "universal" and "particular" dimensions. But before arriving there, he shrewdly critiques the intellectual strategies of some of its major interpreters. His insightful comments on Claude Lanzmann's *Shoah* (1985) are both appre-ciative *and* critical. The film's achievement, he writes, is its evocation of the Holocaust as a particular experienced reality; its limitation is that a more general historical understanding is sacrificed to that end. Lanzmann excludes every-thing about its antecedents. Nothing is included that goes beyond the bounds of the killing mechanism. According to Rabinbach: "There is a break in conti-nuity, a hiatus, a leap, an abyss between the enabling conditions for the exter-mination and the fact of the extermination itself. Extermination cannot be deduced from prior causes. The Holocaust thus becomes a historical event that is at the same time not a historical event" (415). Thus, Rabinbach writes, given its "timelessness," *Shoah* creates its own countermyth, a mythical uni-verse: a *monde concentrationnaire*.

Similarly, for all his respect for the Frankfurt School, Rabinbach—rather than simply critiquing Max Horkheimer and Adorno's anthrocivilizational (albeit dialectical) blanket indictment of the "West," the "bourgeoisie," and "enlightenment" as directly complicit in Nazism and its atrocities—situates

their explanatory scheme partly in psychocultural terms. He argues that for these German Jewish exiles, the great scandal of Auschwitz could not be simply and exclusively a "German" matter but inherent in a dialectically disastrous European enlightenment. Figures like Horkheimer and Adorno (and Arendt) resorted to these universalizing, large civilizational schemes, Rabinbach argues, precisely because their attachment to German culture and its tradition of *Bildung* was so deep that they were impelled to seek elsewhere for the barbarism of their time. While such an approach could easily be interpreted by Germans as a form of exculpation, Rabinbach writes that it was non-Jewish German intellectuals, such as Thomas Mann, who directly indicted Germany, its politics and culture, as a pathological *Sonderweg* and the main culprit of the disaster.

This is not entirely convincing. Certainly, not all German Jewish emigrants rejected the *Sonderweg* approach. Indeed, Rabinbach partly attributes these universalizing accounts as a defensive reaction to the virulent "anti-German" fulminations of Emil Ludwig, their similarly exiled Jewish contemporary. Moreover, while perhaps a small generational divide may account for differences between these two cohorts, it was the cultural historians that Rabinbach lists as his formative influences—Mosse, Stern, and Gay—who at one time and in one way or another most certainly attributed much of National Socialism to German cultural and political tendencies. Similarly, the attachment to German culture did not necessarily involve a deflective strategy. Indeed, it was quite possible, as Mosse later showed, to continue valorizing that same tradition of *Bildung* while arguing that Nazism and those who supported it had abandoned its humanizing premises in favor of far less savory local *völkisch*-national and other impulses.[5]

These debates aside, Rabinbach proposes his own formula with regard not just to the event's modernity but to the universal-particular dilemma, one that seeks correctly to integrate these two in some concrete form. He puts it thus: "The omnipotence of the human will to control, the principle of human unlimited technical possibilities for the perfection of the nation or race, and finally an inner readiness to embrace 'final solutions' as a form of politics—and thereby to throw moral inhibitions overboard—created the climate for National Socialism" (423). Moreover, while maintaining the Holocaust's specificity, he also argues for its universality. In so doing, he not only provides it with contemporary political relevance but also salvages the universalism of the German Jewish exiles: the Holocaust's

5. See Mosse, *German Jews beyond Judaism*.

universality pertains everywhere that the project of creating multiethnic, sec-
ular, and democratic societies engenders new, postmodern ideologies of reen-
chantment, particularly those that "racialize" or "theologize" perceived
threats to the integrity of a mythologized community. The conditions for con-
temporary civil war and genocide are historically different from the Judeo-
cide, but the dynamic is not entirely dissimilar. That insight may at some
level be unspectacular, but it was the point that the German-Jewish exiles
were insisting on when they rejected the *Sonderweg* and looked into what
Arendt called "the abyss that opened up before us." (410)

For all that, I would maintain that stubborn lacunae remain. Very few formu-
lations can account for, or even grapple with, the elusive, massive taboo-
breaking, transgressive murderous drive that so marked this particular event.
Moreover, the universal-particular dilemma—especially around the question
of the nature of victimization—remains tensely poised. As Rabinbach himself
admits in his interview, anti-Semitism "is like any other victimhood, but also it
isn't" (475)!

———

Perhaps the most original essays in this collection are the ones on the less-
known—politically and philosophically diverse—antifascist movement(s)
and their colorful, often dubious, leading personalities. Rabinbach's original
intention—"the road not taken," as he remarks in his interview, was to write
this as a book (462). Fortunately, we have these essays that more than make
up for this lacuna. They treat the varieties of antifascism with the same serious-
ness and scholarly attention one usually devotes to the "sexier" fascist move-
ments, their ideological dilemmas, institutional loyalties, and intellectual polit-
ical acrobatics. There is little consensus as to antifascism's historical role. This
is not surprising given its dual status as perhaps the great mobilizer of some of
the world's leading intellectuals, but also tainted by its—usually disguised—
ties with Stalinist communism. Some of its proponents were conscious of this
and committed participants, others less so. Clearly, however, while a rallying
cry of the Left, and often a pragmatic compromise cobbled together to meet the
Hitler emergency, its declarations differed greatly from those of the Comin-
tern. This, Rabinbach concludes, was a genuine movement that mobilized
real popular support, but, perhaps because of its Manichaean nature dividing
the world into two hostile camps for which there was no middle ground, it also
often created a fatal blindness rendering Western intellectuals to often sacrifice

both their moral and political judgments (189–90). They were not, he suggests, sufficiently aware that already in the 1920s "Communists invested the term Fascism with an elasticity and imprecision, encompassing capitalism, social democracy, liberalism, imperialism, and ultimately all those who stood outside their own camp" (209). Throughout this volume Rabinbach traces the afterlife of such antifascist representations. It is no surprise that after 1945 "antifascism" became a foundational myth, the Cold War calling card throughout the Soviet bloc. The new iterations of fascism, they proclaimed, were to be found in the present, in the militarism and imperialism of the United States and the West.

As with fascism and Nazism, Rabinbach shows how antifascism "staged" and propagated its narratives and myths. The antifascist, Paris-produced, 1933 *Brown Book of the Reichstag Fire and Hitler Terror*, he writes, "was more than a book. It was a staged event and the center of an international campaign that convinced much of the world that the Nazis had conspired to burn the Reichstag as the pretext to establishing a dictatorship. . . . It created the prism through which most of the world saw Nazism for more than a generation" (205–6). That best-selling book, replete with a brilliant photomontage by John Heartfield, and the accompanying campaign were the work of the renowned communist impresario and Reichstag deputy Willi Münzenberg, who, with his genius for propaganda, invented the new face of Stalinism: antifascist communism (210). Münzenberg skillfully drew a counterconspiracy narrative in which it was not the communists who had planned the fire, as the National Socialists had claimed, but a Nazi intrigue to set the scene for the destruction of democracy. In his analysis Rabinbach never wavers from his critical non-ideological perspective. The *Brown Book*'s conspiracy theory, he writes, "was in many respects the mirror image of the communist conspiracy that Nazi leaders believed in from the outset" (225). An essential part of the propaganda was the characterization of the rather pathetic Marinus van der Lubbe (a communist accused of setting the fire) as a homosexual prostitute serving the Nazis, a working-class communist turned into a hopelessly confused vagabond. Left antifascists hardly propagated a progressive pro-gay program. As Rabinbach notes, "Coding fascism as homosexual created the image of a regime driven by a lethal combination of calculation and degeneracy, rationality and depravity, the obverse of the new proletarian virilism deemed necessary for the antifascist struggle" (216). While Rabinbach does not equate Nazism with antifascism, his description of their respective tactics and intrigues renders "a more complex reading of the borrowings and interplay of these two political enemies" (225).

While Rabinbach's analyses of Nazism and fascism are about impersonal cultural tropes, ideological content, and wider socioeconomic structures, his studies on "antifascism" vibrate with complex, exotic, and often questionable characters, whose personalities are put on center stage. Thus, apart from Münzenberg, we have the dashing communist defense lawyer at the Lubbe trial, Georgi Dimitrov, famous for his thrashing of Hermann Goering on the witness stand, who became a genuinely popular "democratic" hero (225), the updated image of 1930s antifascist communism, no longer the dour proletarian "but the well dressed, articulate, and cultivated European capable of quoting Goethe and Lenin in the same breath" (225). In separate chapters, Rabinbach focuses on the trial, imprisonment, and less successful campaign of the much duller, narrow-minded, Orthodox communist and anti-Semitic Ernst Thälmann. With his eye for the exotic (and tragic), Rabinbach reveals the bizarre life and career of one communist activist–cum–con man, dandy, and mysterious associate of Münzenberg, Otto Katz (whom he calls "Man on Ice"). Operating under various identities, this "cosmopolitan," chameleon-like German-speaking Czech Jew spoke multiple languages; was comfortable in European capitals as well as in Hollywood, where he attended antifascist gatherings that included Charlie Chaplin, Greta Garbo, Fritz Lang, and other luminaries; founded the Anti-Nazi League and boasted of an affair with Marlene Dietrich; was the author of many books (most not under his own name); was reputed to be a Soviet agent (others regarded him as a Nazi agent as well!); and was credited with the murder of Leon Trotsky. Katz was hanged in December 1952 after being convicted of treason and espionage in the notorious Slánský trial in Prague, in which his cosmopolitanism was treated as proof of a Jewish conspiracy.

It is also in the "antifascism" section that Rabinbach pens the volume's only studies of individual theorists: Wilhelm Reich and Ernst Bloch. (The essay on Alexander Mitscherlich is not really an exposition of his work but a *Rezeptionsgeschichte* that delves into his "myth and legacy.") Given his—albeit critical—sensitivity to psychoanalytic theory, Rabinbach traces Reich's initial politicization in the crucible of post–World War I Austrian politics. Early on, he shows that Reich's penchant for heterodoxy was apparent. Unlike Freud, Reich regarded the Viennese crowd not as a herd seeking an authority figure but as a diffuse group acting justifiably against the authoritarian state. His clinical work rendered him sensitive to what he saw as the sexual misery of the working class and the politically manipulated nature of sexual repression. He rejected the Freudian notion of the infantile origins of neurosis, placing in its stead a concept of the "natural" genital character. That repression produced rigid, obedient subjects was not an accident but a consciously intended strategy

of the bourgeois social order. More than his early attempts at synthesizing Marxism and psychoanalysis, Rabinbach argues, Reich's most significant contribution was his attempt to discover the class character of sexual repression. (He notes that in Reich's notorious American period, that class dimension disappeared [203].)

Rabinbach's early and brilliant exposition of Bloch from 1977 is surprising. I say "surprising" because Mosse had warned him away from Bloch as a mere "*Schwätzer*" (454). Mosse's admonition was doubly surprising given his own insistence on taking "irrational" ideas seriously. What Rabinbach shows is that this is what Bloch, uniquely in his time, did. Though a determined antifascist, Bloch alone among his Marxist contemporaries took seriously the power of fascism's putatively irrational ideas as an appealing cultural synthesis, not reducible to its capitalist and class functions. Bloch sought not to reveal the illusory character of the ideological remnants of past epochs that fascism had appropriated and which had been essential to their victory but to accept their authenticity and to refigure them into a progressive anticapitalist heritage. The romanticized image of the German *Volk* was not purely mythological, and the concept of rootedness in nature was not depraved but corresponded to real needs and life conditions. Additionally, and unusually for that time, Bloch's work was marked by its optimism and the drive to restore utopia to its original meaning as an immanent force, a "waking dream" of the possible. For Bloch, the past illuminated possibilities that had not yet become apparent, possibilities only vaguely intuited in myths, dreams, and fantasies. Uniquely, Rabinbach shows, Bloch understood fascism's appeal because he took seriously those mythic and "irrational" elements that dry Marxism and nihilism had expunged. Those were the ingredients that Bloch sought to reappropriate for the radical heritage of the Left. Bloch's heterodox contribution, Rabinbach concludes, "is to show where *fascism* filled a void at the heart of the Enlightenment. . . . [It] is also an indictment of the Left for abandoning the terrain of fantasy to fascist colonization . . . a polemic against the irrationalism of the rational, precisely because it fails to grasp what is 'rational in the irrational'" (253, 257, 258).

———

In Rabinbach's account, history, historiography, and memory are inextricably entangled, shaped, and transformed not just by intellectual fashions (which is also the case) but by generational shifts, changing political interests, and newly emerging power imperatives. "The task of the historian," he notes, "is not to

moralize about remembering and forgetting, but to identify the ways that certain metaphoric pasts can be cathected to contemporary events, how they are mobilized at different conjectures, and how these events are then rearticulated in the framework of a politically and morally charged 'past'" (364). This sentence could well serve as a guide to all reception history. Thus Rabinbach also sneaks in a piece on an American reception history in the essay "Eichmann in New York," an examination of the furor over *Eichmann in Jerusalem*, Arendt's most notorious book. There he argues that the highly contested responses to the work were "a lightning rod for all of the changes taking place in American-Jewish intellectual life in that era, changes that can be summed up as a subtle shift from causes to culture" (331). However, as Rabinbach is fully aware, the stakes and potency of these charged processes of memory and historiography are most vividly alive and fraught in Germany. This is where his intellectual energies are most focused and where they most clearly underlie his overall thesis that "since 1945 German cultural history can be written as a study in the mobilization of a metaphoric past for the politics of the present" (365). Here I can provide only a taste of the detailed ways in which this is concretely presented.

A vivid example is the 1989 essay, "The Emotional Core of Fascism in Its Most Virulent Psychic Manifestations," written with Jessica Benjamin and intended as an introduction to the English translation of Klaus Theweleit's two-volume work *Male Fantasies* (1987, 1989). The essay deals not only with Theweleit's bawdy thesis that violent male fantasies constituted the raw emotional core of the German Freikorps and fascism but also with how it subtly mirrored the political needs and generational sensibilities of the freewheeling, radical German sixty-eighters. In one sense, Theweleit's work recapitulated a familiar strategy of a generalized reduction of National Socialism into fascism. Like other "antifascist" ideologies, it insisted on the surviving reality of this mentality not just as a matter of the past but as a threat to the present. What was new was not simply its overtly feminist, gendered standpoint, in which the conflicted male body was placed at the center, but a version of fascism as a fundamental psychocultural fact irreducible to any economic or other externality. For Theweleit, it was the pre-oedipal threat of the male ego being swamped and in danger of being disintegrated by a threatening femininity that created the masculine warrior and fascist compulsion to destruction. Hardness and killing, rather than pleasurable heteroerotic release, would produce the relief that such tensions engendered.

While Rabinbach, the responsible historian, points out the undifferentiated nature of the thesis—the blurring of lines between the Freikorps and

Nazis (not all Freikorps became Nazis), of soldiers in general, indeed the possibility that this malady afflicted all men regardless of class—he shrewdly pointed to the brazen contemporary tone of the work, the ways in which Theweleit, the cheeky sixty-eighter, challenged the prevalent staid authoritarian discourse: "This undaunted quality, which is the strength of the work, also sometimes leads to its excesses, its wild quality. . . . It is full of unsolicited opinions, digressions, commentaries, and political judgments. In counterpoint to its subject matter it is 'undisciplined.' And this is what is so 'unGerman' and at the same time perhaps so very (post-1968) German about *Male Fantasies*" (80).

Memory and the politics of remembrance are also linked to the intellectual and generational shifts in Rabinbach's treatment of the myth and legacy of Mitscherlich and his 1967 book, written with Margarete Mitscherlich, with the self-explanatory title *The Inability to Mourn*. That work, Rabinbach declares, was "more a symptom than a diagnosis," an expression of the mood of the second post-Nazi German generation outraged by their "silent" parents who were mute about the troubled past. This theory of the "inability to mourn" was uniquely attuned to its times. Nowhere else, he argues, "did a psychoanalytic model of [not] coming to the terms with the past reach such a level of mass acceptance" (360). For all that, less-convinced conservative circles dismissed it as mere denunciation masquerading as psychoanalysis. Paradoxically, though, Rabinbach notes, the book's success was also explicable in that it offered a kind of absolution through the shift from individual guilt to a collective "inability to mourn." While indicting continuities of German history and culture, it also notably did not do so for particular individuals or institutions.[6] With time, however, Rabinbach notes, the book's message was blunted by the strategic political ironies and necessities of remembrance and forgetting. He points out that in the postunification Germany of the 1990s, the mood and political needs had so altered that blaming the inability of the putatively "good" ordinary German to mourn was to hold one to an unattainably high moral standard. Moreover, there was now not a single troublesome past but a double tyranny with which one had to deal. Understanding and compassion for one's parents was now the order of the day, reconciliation more important than a moralistic fixation on the horrors of Nazism.

---

6. Elsewhere, and in related fashion, Rabinbach points out that the astonishing continuity of ex-members of the Nazi Party at work in both East and West German universities was sustained not only by private discretion but "by a strongly enforced taboo on public discussion of the Nazi era until the 1960s. Even during the student upheavals of the decade, preoccupation with generic theories of 'fascism' frequently served to draw attention away from the incriminating details of individual biographies and embarrassing departmental decisions" (146).

Similarly, in "The Jewish Question in the German Question" Rabinbach examines the post-Holocaust evolution of how German representations of the "Jewish Question" have not simply been linked to shifting images and narratives of the Nazi past but, more critically, to the issue of German sovereignty itself. He shows that it was the Holocaust reparations agreement of the 1950s that rendered Germany more respectable and thus acceptable to the international order (while restricting payment only to Holocaust—and no other—survivors and sidelining all other aspects of the Nazi era to the periphery). In different ways, he notes, the "singularity" postulate of the Holocaust implicit in the reparation treaty served legitimation processes not just in Germany but also in Israel.

West German political reality of the 1980s, however, was quite different from that of the 1950s and 1960s. "Normalization" now became the ruling imperative. As Helmut Schmidt put it in April 1981 (pointedly on a return flight from Israel), "German foreign policy can and will no longer be overshadowed by Auschwitz" (382). Above all, Rabinbach shows, it was the Bitburg affair, the May 1985 ceremonial attended by President Ronald Reagan at the site where two thousand German soldiers were buried, including forty-nine soldiers of the Waffen-SS, that reversed the symbolism by which the Jewish Question, through singling out the uniqueness of the Holocaust, had been placed above the German Question. The singularity postulate was now questioned. Reconciliation was possible, Helmut Kohl insisted, "when we are able to mourn for human beings, independent of whatever nationality the murdered, the fallen, the dead once belonged." At Bitburg, Rabinbach concludes, "the German Question (the NATO partnership) was placed *above* the Jewish Question" (383). For those on the revisionist side, the famous, ensuing *Historikerstreit* of the 1980s reinforced these normalizing tendencies either by relativizing the Holocaust (indeed, Ernst Nolte insisted that it was secondary, a "copy" of Stalin's murders) or by placing the moral burden on Adolf Hitler, thereby relegitimizing German national identity. This was a dispute, Rabinbach quotes Charles Maier approvingly, over nothing less than the controlling discourse of the Federal Republic (295).

Rabinbach's special talent for linking intellectual and historiographical issues to their historical moment and noting their function within changing contemporary political culture is nowhere more evident than in his 2006 essay "Moments of Totalitarianism," one of the most recent writings in the collection. His foray into *Begriffsgeschichte* (history of concepts) takes the form of what he calls a dynamic and politically charged "semantic stockpile" in which he demonstrates the contested temporal accretion and politically inter-

ested revival of the protean notion of totalitarianism after years of its submergence. While not entirely contesting the validity of the concept (and thoroughly documenting its varied analyses and changing applications), he concentrates on its rhetorical work and the fact that the debate over the term has never been a purely academic exercise.

> It has also been an intensely political concept, defining the nature of enmity for the Western democracies for more than half a century. "Totalitarianism" can be productively regarded as a "semantic stockpile" that combines the content-oriented logic of the academic disciplines (history, philosophy, political theory) with flexible strategies for calculating public resonance. . . . As a rhetorical trope . . . it fundamentally serves not so much as a "heuristic" concept but as a "consolidator" of any number of "isms"—most obviously anti-fascism and anti-communism—that can supply it with meaning at any given moment so long as it remains opposed to another "ism," liberalism or liberal democracy. (432)

Rabinbach's nuanced conclusion has contemporary resonance in our increasingly populist, simplifying times:

> The return of totalitarianism evinces nostalgia for the clarity of the old enmities. . . . In the U.S. it looks back longingly to the "fighting faith" of the 1940s and 1950s. But enmities change and so do enemies; what is distinctive about the current situation is that the clarity is elusive, complexity is with us once again. "Totalitarianism" remains as ambiguous today as ever: as a historical concept it is insecure and contested, as memory it is geographically promiscuous and unstable, and nebulous; only as a semantic marker of new political constellations, identities and ideological alliances is it, as ever, indisputable. (433)

---

The volume ends with a fascinating personal and professional interview with Anson Rabinbach—or Andy, as his many affectionate and admiring friends call him. One cannot make the claim that having read it, one can explain the work in terms of the life (such exercises are inevitably slippery, if not downright futile). Nevertheless, it is in that interview that much of Andy's biography, self-understanding, and personal qualities are revealed. Despite his interest in Jewish (rather than Judaic) matters, both political and intellectual, he insists that he is not a "Jewish historian." Yet his (ironically very "Jewish") cosmopolitan

viewpoint and sense of self are not far from Isaac Deutscher's famous defini-
tion of the "non-Jewish Jew." "I come from a Jewish tradition and political cul-
ture," he declares, "that is pre-Zionist, that is not religious but cosmopolitan,
socialist, to some extent Bundist, a product of the East European *shtetl* culture.
I identify with these, shall we say, post-national cultures" (450). An inveterate
New Yorker (with his accent and intonation he could not lay claim to any other
urban citizenship), his intellectual influences are "German and East European
thinkers who navigated the transatlantic," most central among them Mosse. No
wonder, then, that with its focus on such thinkers, *New German Critique* is
what he calls his "*intellektuelle Heimat.*" Yet, for all the cosmopolitanism, a
certain intimate ethnic sense of identification remains. On reading *New York
Times* obituaries, he comments: "I'm always interested in who grew up in the
Bronx. And when I see one, like maybe Nathan Glazer or Harold Bloom or
someone like that, I feel some affinity with these people who come from my
culture" (473). Similarly, his initial interest in Nazism and fascism sprang from
deep, if insecure, Jewish sources. His account of that also displays his charac-
teristic wit and irony: "The way I experienced it as a kid what fascism had
meant was that once a year we would go see the celebration of the Warsaw
ghetto uprising and I would watch as the Jewish resisters defeated the Nazis.
In fact, I was convinced for a long time that the Jews had won the Second World
War" (452). The same almost hilarious mix of identifications is evident when he
tells us that he attended a Yiddish school in which both Passover and the Bol-
shevik Revolution were celebrated!

That interview also illuminates some of Rabinbach's most endearing
personal qualities. His intellectual honesty is clearly on view when he openly
admits that during an interview of Albert Speer for a study of Nazi aesthetics,
Rabinbach was fooled by the charm, knowledge, and intelligence of the man:
"I was duped" (464–65). His distaste for ideological dogmatism is also on view
in his verdict of Thälmann "as a really negative character. He shows that you
could have really evil people on the Left" (465). Perhaps that sensitivity to doc-
trinally related error is related to his Polish father's communism, especially his
bizarre 1934 immigration from the United States to Birobidzhan, Stalin's Jew-
ish agricultural colony in remote eastern Russia. We are apprised, too, of
Rabinbach's distaste for moral admonitions. Addressing Tzvetan Todorov's
injunction that "Germans should talk about the singularity of the Holocaust,
Jews should talk about its universality," he insists that there should be "no
place in intellectual history for prescriptive comments. . . . I don't care who
they come from or where they end up" (476). Similarly, though obviously crit-

220 Rabinbach's *Staging the Third Reich*

ical of Donald Trump's authoritarian tendencies, Rabinbach is wary of current glib parallels to earlier fascisms. (Trump, he remarks, has no alternative doctrine, nor, unlike previous fascist intellectuals, does he read books! Still, at the time that Rabinbach was interviewed, Trump's capacity for mobilizing violent, hotheaded mobs was perhaps not quite so obvious.) Rabinbach's intellectual and cultural history, then, is about complex mapping and empathic analysis, not a manual in putative political correctness. The present volume is testimony to that and an ongoing life filled with refined scholarship and intellectual passion.

**Steven E. Aschheim** is professor emeritus of history at the Hebrew University.

### References

Aschheim, Steven E. *Beyond the Border: The German-Jewish Legacy Abroad*. Princeton, NJ: Princeton University Press, 2007.

Herf, Jeffrey. *Reactionary Modernism: Technology, Culture, and Politics in Weimar and the Third Reich*. Cambridge: Cambridge University Press, 1984.

Mosse, George L. *German Jews beyond Judaism*. Bloomington: Indiana University Press, 1985.

Rabinbach, Anson. *Staging the Third Reich: Essays in Cultural and Intellectual History*, edited by Stefanos Geroulanos and Dagmar Herzog. Abingdon: Routledge, 2020.

Stratigakos, Despina. *Hitler at Home*. New Haven, CT: Yale University Press, 2017.

Theweleit, Klaus. *Male Fantasies*. Vol. 2. Cambridge: Polity, 1989.

# Keep up to date on new scholarship

Issue alerts are a great way to stay current on all the cutting-edge scholarship from your favorite Duke University Press journals. This free service delivers tables of contents directly to your inbox, informing you of the latest groundbreaking work as soon as it is published.

To sign up for issue alerts:

1. Visit **dukeu.press/register** and register for an account. You do not need to provide a customer number.

2. After registering, visit **dukeu.press/alerts**.

3. Go to "Latest Issue Alerts" and click on "Add Alerts."

4. Select as many publications as you would like from the pop-up window and click "Add Alerts."

**read.dukeupress.edu/journals**